The Arts of South America
1492–1850

Papers from the 2008 Mayer Center Symposium
at the Denver Art Museum

Edited by Donna Pierce

A publication of the Frederick and Jan Mayer Center
for Pre-Columbian and Spanish Colonial Art
at the Denver Art Museum

Frederick + Jan
MAYER
CENTER
Pre-Columbian +
Spanish Colonial
A R T

DENVER ART MUSEUM

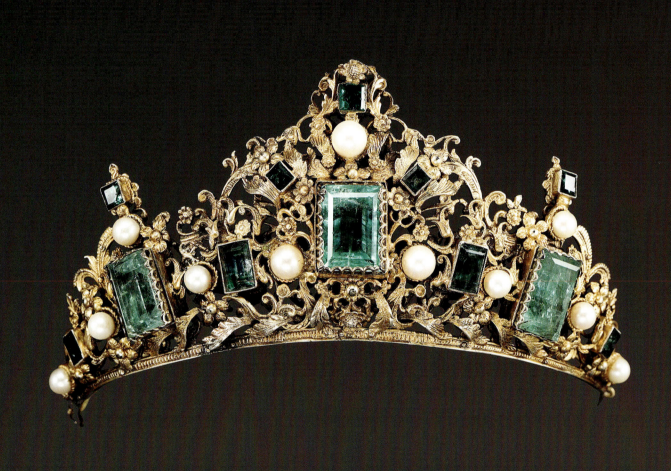

Dedicated with affection and gratitude
to Jan Mayer and to the memory of Frederick Mayer
for their vision, passion, and generosity.

Copyright © Denver Art Museum 2010
Published in the United States of America
by The Mayer Center for Pre-Columbian & Spanish Colonial Art at the Denver Art Museum
100 West 14th Avenue Parkway
Denver, CO 80204
http://mayercenter.denverartmuseum.org

Printed and bound by CS Graphics Ltd., Singapore
Distributed by the University of Oklahoma Press, www.oupress.com

ISBN 978-0-8061-9976-4

Editor: Donna Pierce, with the assistance of Nancy Mann
Project Coordination, Design, and Production: Julie Wilson Frick

Cover illustration: *(front and back views)* Finial cross. Colombia, 17th c. Gold, emeralds, pearls. 4 x 1.5 in.
Denver Art Museum, Gift of the Stapleton Foundation of Latin American Colonial Art, made possible
by the Renchard Family; S-0519.
Frontispiece: Tiara. Popayán, Colombia, c. 1730. Silver gilt, pearls, emeralds. 2.5 x 5.5 x 3.75 in.
Denver Art Museum, Gift of Robert J. Stroessner; 1992.74.

CONTRIBUTORS
Luisa Elena Alcalá, *Universidad Autónoma de Madrid, Spain*
Michael Brown, *Denver Art Museum*
Thomas B. F. Cummins, *Harvard University*
Sabine MacCormack, *University of Notre Dame*
Jorge F. Rivas-Pérez, *Colección Patricia Phelps de Cisneros, Caracas, Venezuela*
Nuno Senos, *Universidade Nova de Lisboa, Portugal*
Susan Verdi Webster, *College of William and Mary*

Table of Contents

Foreword

The Denver Art Museum is indeed fortunate in being able to count among its greatest resources a Spanish Colonial collection rich in art from all over Latin America. Although the museum's Spanish Colonial collection might be said to have begun with Anne Evans's 1936 gift of a group of *santos* from southern Colorado and northern New Mexico, its true genesis should probably be credited to Otto Bach, the museum's director in the mid-1940s. Ignoring the advice of eastern colleagues to carve out a special niche in regional art, Bach boldly set out to build an encyclopedic collection of world art. In 1952, the museum made its first purchase of Pre-Columbian art, and in 1968 Bach established a New World Department that brought Pre-Columbian and Spanish Colonial objects from Latin America together under the curatorship of Robert Stroessner.

The New World Department flourished through the interest and support of longtime museum trustee Frederick Mayer and his wife, Jan, and the spirited leadership of Stroessner. Cultivating collectors nationally as well as in the Denver area, Stroessner increased the holdings of the department dramatically before his death in 1991. In 1993, the New World Department collections were reinstalled in their present galleries, continuing the museum's commitment to permanent galleries dedicated to both Pre-Columbian and Spanish Colonial art, and maintaining its role as the only major museum in the country, at that time, to do so.

The growth of the New World collections and programs received a major boost with the enlightened endowment gift of Frederick and Jan Mayer in 2003. This gift made it possible to establish separate curatorial positions in Pre-Columbian and Spanish Colonial art and to underwrite the department's administrative costs, support staff, publications, and programs. In 1999, Donna Pierce and Margaret Young-Sánchez came to the museum as the Frederick and Jan Mayer Curators of Spanish Colonial Art and Pre-Columbian Art, respectively. As a result of the Mayers' generosity, the Denver Art Museum has the only curator in the United States dedicated exclusively to colonial Latin American art.

The Mayers also founded the Frederick and Jan Mayer Center for Pre-Columbian and Spanish Colonial Art at the Denver Art Museum, dedicated to increasing awareness and promoting scholarship in these fields by sponsoring scholarly activities including annual symposia, fellowships, study trips, and publications. Since the first one in 2001, Mayer Center symposia have taken place nearly every year. During November 7–8, 2008, the Mayer Center hosted "The Arts of South America, 1492–1850" with speakers from Europe, Latin America, and the United States; those papers are presented in this volume.

Over the years, the Mayers generously supported the museum's larger mission at every turn. The untimely death of Frederick Mayer in 2007 was a great loss to the community. His generosity of spirit and infectious enthusiasm were an inspiration to all. We are fortunate to have the ongoing support of Jan Mayer and offer warm thanks to her for her steadfast dedication to the museum as a whole and to the study of New World art in particular.

Christoph Heinrich
Director, Denver Art Museum

Introduction and Acknowledgments

The Frederick and Jan Mayer Center for Pre-Columbian and Spanish Colonial Art at the Denver Art Museum sponsors annual symposia alternating between these fields of art. Held in November 2008, the eighth symposium in the series, "The Arts of South America, 1492-1850," examined the arts of South America during the culturally complex period of Spanish and Portuguese colonialism in the early modern era. Specialists in the arts and history of Latin America traveled from Venezuela, Spain, Portugal, and throughout the United States to present recent research. Their presentations encompassed architecture, painting, sculpture, furniture, and decorative arts, as well as the history of collecting during the period. The discussions covered art from the geographic areas of modern-day Ecuador, Colombia, Venezuela, Peru, Bolivia, and Brazil.

The Mayer Center sponsors the publication of proceedings of the symposia. Revised and expanded versions of the 2008 papers are issued in this volume. Thomas B. F. Cummins, Dumbarton Oaks Professor of the History of Pre-Columbian and Colonial Latin American Art at Harvard University, opens the volume with a discussion of the reception and re-interpretation of American motifs by European artists in the centuries after contact. Through a detailed analysis of the architecture of Franciscan churches in Brazil, Nuno Senos, Associate Researcher at the Center for Overseas History at the Universidade Nova, Lisbon, discerns political alliances and posits a structural timeline. Susan Verdi Webster, Mahoney Professor in Art History and American Studies at the College of William and Mary, uses new evidence from Ecuadorian archival documents to recover the names and works of native artists in colonial Quito. Sabine MacCormack, Reverend Theodore M. Hesburgh Professor of Arts and Letters in History and Classics in the Medieval Institute at the University of Notre Dame, analyzes a series of mural paintings in the monastery of St. Augustine in colonial Lima and traces their graphic and theological sources. Luisa Elena Alcalá, Associate Professor in the Department of Art History and Theory at the Universidad Autónoma de Madrid, examines the treatise of one of the earliest documented Indian artists in Peru, Francisco Tito Yupanqui, and his famous carving of the Virgin of Copacabana. Through a detailed analysis of drawings of furniture and architecture in the manuscript by native artist Guaman Poma of Cuzco, Jorge Rivas-Pérez, Curator of Colonial Art at the Patricia Phelps de Cisneros Collection in Caracas, Venezuela, analyzes their accuracy and relationship to actual examples of the early colonial era. Michael Brown, Mayer Center Curatorial Fellow at the Denver Art Museum, concludes the volume with an essay on Daniel Casey Stapleton and the collection of Spanish Colonial art he acquired while working and traveling in South America at the turn of the century, now housed at the Denver Art Museum. We are grateful to these scholars for their participation in the symposium and their contributions to this publication.

The colonial arts of South America is a topic particularly relevant to the Denver Art Museum and its collection of Spanish Colonial art. Within a year of its founding in 1968, the New World Department received the Frank Barrows Freyer Memorial Collection of seventeenth- and eighteenth-century colonial art from Peru and Bolivia. Assembled by Maria Engracia Freyer during the 1920s while her husband, Frank, was chief of a United States naval mission to Peru, the collection received special export status in recognition of Freyer's contributions to the reorganization of the Peruvian navy. Then in 1991, the Stapleton Foundation of Latin American Art gifted its extensive collection of colonial art from northern South America to the museum, a donation made possible by the Renchard family of Washington, D.C. Both of these collections of art from South America are extremely significant because of their breadth and depth, but also due to the fact that they were acquired quite early in the history of collecting in colonial Latin America, with the Stapleton Collection acquired between 1895 and 1914 and the Freyer

Collection during the 1920s. Through the years other generous donors have added to the collection or assisted with acquisitions in this area, including Jan and Frederick Mayer, Lorraine and Harley Higbie, Dr. Belinda Straight, Marilynn and Carl Thoma, and Mary Beth and Jim Vogelzang. The symposium and this publication are a tribute to the efforts of all the collectors and contributors to this significant collection of the arts of colonial South America.

I would like to acknowledge the staff of the New World Department for their efforts in organizing the symposium: Julie Wilson Frick, Mayer Center Program Coordinator; Trish Tomlinson, Curatorial Assistant in the New World Department; Anne Tennant, New World Research Associate; Michael Brown, Mayer Center Fellow; and Piper Mitchell, New World intern. Denver Art Museum Events staff headed by Mary K. Dillon, Audiovisual staff under Elizabeth Gilmore, and Security staff led by Tony Fortunato and Terri Cross provided significant and cheerful support. As always, I thank my New World Department colleague, Margaret Young-Sánchez, Frederick and Jan Mayer Curator of Pre-Columbian Art and Chief Curator, for her support.

In the preparation of this publication, I am grateful to Nancy Mann of the University of Colorado for her superb editing skills. Anne Tennant and Michael Brown provided valuable bibliographic and editing assistance. I also thank Laura Caruso, former Director of the museum's Publications Department, for ongoing advice and editing. Denver Art Museum photographer Jeff Wells was always quick to provide his expert services; this volume would not be complete without his assistance. Digital mapmaker Fabrice Weexsteen enthusiastically offered his technical and scholarly knowledge in the creation of the enclosed maps, developed in collaboration with the New World Department.

Thanks are due to the staff of CS Graphics for printing the volume and to the University of Oklahoma Press for distribution. My profound gratitude goes to Julie Wilson Frick, Mayer Center Program Coordinator, for book coordination, image gathering, compilation, map research, contract negotiation, and most important, for the elegant and clean design of this, and all Mayer Center symposia publications.

On behalf of all of us at the Denver Art Museum and those who participated in the symposium, I want to express our deepest gratitude to the late Frederick Mayer and his wife Jan for providing the opportunity to bring such a distinguished group of scholars together from many parts of the world to share ideas and then to be able to publish the proceedings. Creating an ongoing forum for this type of scholarly exchange was a major part of the Mayers' vision and formed the basis of the founding of the Mayer Center for Pre-Columbian and Spanish Colonial Art and its programming. The Mayers represent the ideal supporters, interested in all aspects of museums and the scholarship behind them. The Denver Art Museum in general and the New World Department in particular have been blessed to have them as our guardian angels. We dedicate this publication to the memory of Frederick Mayer and to the ongoing support, enthusiasm, and friendship of Jan Mayer.

Donna Pierce
Frederick and Jan Mayer Curator of Spanish Colonial Art / Head of the New World Department
Denver Art Museum

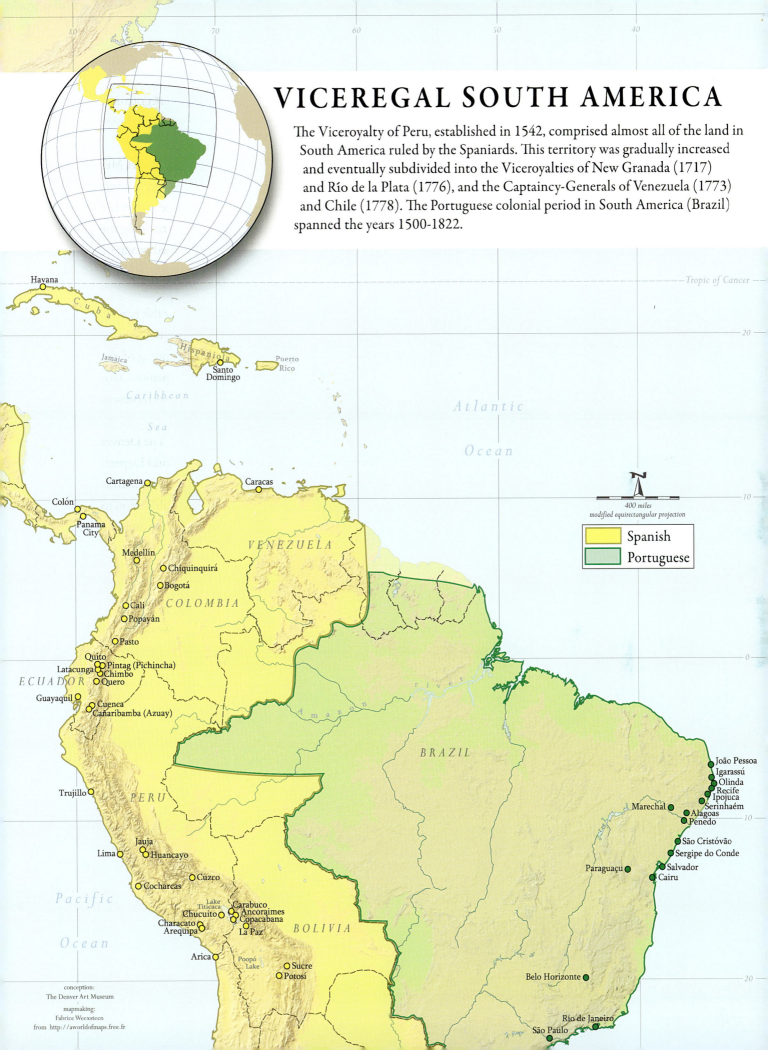

VICEREGAL SOUTH AMERICA

The Viceroyalty of Peru, established in 1542, comprised almost all of the land in South America ruled by the Spaniards. This territory was gradually increased and eventually subdivided into the Viceroyalties of New Granada (1717) and Río de la Plata (1776), and the Captaincy-Generals of Venezuela (1773) and Chile (1778). The Portuguese colonial period in South America (Brazil) spanned the years 1500-1822.

400 miles
modified equirectangular projection

	Spanish
	Portuguese

Tropic of Cancer

Havana

Cuba

Jamaica

Hispaniola

Santo Domingo

Puerto Rico

Caribbean

Sea

Atlantic

Ocean

Cartagena

Caracas

Colón

Panama City

VENEZUELA

Medellín

Chiquinquirá

Bogotá

Cali

COLOMBIA

Popayán

Pasto

Quito

Pintag (Pichincha)

Latacunga

Chimbo

ECUADOR

Quero

Guayaquil

Cuenca

Cañaribamba (Azuay)

Amazon river

BRAZIL

João Pessoa

Igarassú

Olinda

Recife

Ipojuca

Serinhaém

Marechal

Alagoas

Penedo

São Cristóvão

Sergipe do Conde

Salvador

Cairu

Paraguaçu

Trujillo

PERU

Jauja

Lima

Huancayo

Cúzco

Cocharcas

Lake Titicaca

Carabuco

Ancoraimes

Chucuito

Copacabana

Characato

La Paz

Arequipa

BOLIVIA

Pacific

Arica

Poopó Lake

Sucre

Potosí

Ocean

Belo Horizonte

Río de Janeiro

São Paulo

conception:
The Denver Art Museum

mapmaking:
Fabrice Weexsteen
from http://aworldofmaps.free.fr

Through the "Devil's Looking-glass" Darkly:
Brazilians, Peruvians, Aztecs, and Zemis in Europe;
Serlio and Hercules in the Americas

Thomas B. F. Cummins

From the title of this essay one can sense that it might be rather eclectic. And it is. It will have more digressions than in all of *Tristam Shandy*. However, there is an underlying theme. And so just as we might look at the surface of a jet-black piece of obsidian (Fig. 1), where the reflected image lies just below the surface and quickly disappears if we move, or it does, the intent of this essay is to point out how oblique, interdependent, contradictory, confusing, and overlapping images and objects are in the sixteenth century. This specific historical condition has produced a partial and fragmented history, created, to be sure, by the events of European conquest and settlement of the Americas. But it is most important to remember that we still really know very little about the circulation of images and objects going to and coming from the Americas and by consequence around the world. What could they come to mean and to be as they appeared in new circumstances and contexts? This question moves well beyond the static idea that they were regarded simply as marvelous things to be placed in the "cabinets of curiosities" that often came to be the place of exhibition at the end of the sixteenth century. It requires us to think anew of how the world was seen anew through different antiquities. The coming of the European Renaissance, north and south, to Spain, and then Spain's coming to the Americas, were importantly and inexorably linked in the creation of knowledge and the arts, as well as magic. And so I will return to this black piece of volcanic stone to understand how it could be seen to simultaneously reflect a European future even as it passed from being the "smoking mirror" of an ancient American past. In other words, globalization is new only to those who know no history.

Classical Reflections of the New World

Before we gaze back into that looking glass darkly, let us begin with one of the first great artistic intersections between the New World and the Old. It is Albrecht Dürer's image of a Tupinamba man, a native of coastal Brazil, which illustrates folio 44r in the *Prayerbook of Maximilian I*, created in 1515 (Fig. 2).[1] To draw the resident of this newly found world in this context is an act that has not really been sufficiently pondered. Recently, art historians Esther Pasztory (2005, 120) and Edward Sullivan (2007, 30) have written about this image in terms of the relatively faithful accuracy of the dress and ceremonial club, but they both suggest that Dürer never saw a Brazilian and that the figure could just as well be a European dressed in a feathered costume of skirt and collar: that the feathers and club index the marvelousness or exoticism of the newly discovered.

Fig. 1. Anonymous, Mirror. Mexico, black obsidian, 18.4 cm. dia. © Trustees of the British Museum.

Indeed, the figure of the Tupinamba appears very familiar to a European viewer. The idealized figure stands erect in a conventional *contrapposto* pose. The body is classically proportioned, with long torso and long muscular legs. Furthermore, there are no specific physiognomic features that mark the figure, so that it seems clearly to be based on an idealized model rather than on an actual Tupinamba warrior (Massig 1991, 516). Fair enough, I suppose, but is that really what is at issue: whether the figure actually does or does not have Native American physical features, whatever those might be? I think not. After all, even if Dürer had seen a Tupinamba (and he may have), why would this experience have caused him to forsake the conventions in which he

was trained and worked? By such logic we should also suppose that the native artist who created images of Europeans in Mexican colonial manuscripts, such as the portrait of Nuño de Guzman on folio 44r of Telleriano-Remensis, never saw a European, merely because he follows the conventions of the *tlacuilo* (Mexica artist) in which he was trained (Fig. 3).[2] Was the classicizing of the Tupinamba body due simply to the fact that Dürer had not seen a Tupinamba and therefore could not render one in an ethnographically or racially accurate form?[3] Or could it not have a rhetorical purpose in relation to the genre in which it appeared? As Panofsky observed,

> Dürer did not "illustrate" in the accepted sense of the term, but proceeded like a musician extemporizing on a given theme. A sentence, a phrase, or even a mere word would conjure up a visual association which could, in turn, "be fruitful and multiply." (Panofsky 2005 [1943], 189)

So can Dürer's figure be understood as something more, perhaps as an artistic gesture of tremendous sincerity and longing? The placing of the figure of a Brazilian in the *Prayerbook of Maximilian* might be understood as giving the same redemptive space to Americans as to their European brethren, placing them all within the universal history of Christendom enacted through the prayers of Maximilian I, Holy Roman Emperor and grandfather of the next Holy Roman Emperor, Charles V, and the members of Maximilian's newly founded Order of St. George, for whom the planned printed book was intended as a gift.[4] The psalm to be read as the Tupinamba image was to be contemplated is the 24th Psalm, which in the King James Version is as follows:

Fig. 2. Albrecht Dürer, *Psalm 24 with an Image of an American*. In *Prayer Book of Maximilian*, Folio 41r, Germany, 1515, pen and ink drawing. Bayerische Staasbibliothek, Munich.

1 The earth is the Lord's, and the fullness thereof; the world, and they that dwell therein.

2 For he hath founded it upon the seas, and established it upon the floods.

3 Who shall ascend into the hill of the Lord? or who shall stand in his holy place?

4 He that hath clean hands, and a pure heart; who hath not lifted up his soul unto vanity, nor sworn deceitfully.

5 He shall receive the blessing from the Lord, and righteousness from the God of his salvation.

6 This is the generation of them that seek him, that seek thy face, O Jacob. Selah.

7 Lift up your heads, O ye gates; and be ye lifted up, ye everlasting doors; and the King of glory shall come in.

8 Who is this King of glory? The Lord strong and mighty, the Lord mighty in battle.

9 Lift up your heads, O ye gates; even lift them up, ye everlasting doors; and the King of glory shall come in.

10 Who is this King of glory? The LORD of hosts, he is the King of glory. Selah.

As Jean Michel Massig (1991, 515) has pointed out, the image of a Brazilian within the words of this psalm is not incidental. Massig suggests that word and image together represent the fullness of the Lord's earth as well as the temporal dominion of Maximilian over it, a world that had just increased unimaginably.[5] But the Brazilian, perhaps one of the very first innocent savages,[6] might also be seen as "He that hath clean hands, and a pure heart; who hath not lifted up his soul unto vanity, nor sworn deceitfully." As such the Tupinamba can also be understood to be held within this Catholic embrace as one of those who "shall receive the blessing from the Lord, and righteousness from the God of his salvation."

When push came to shove, the doctrinal reality of such an ecumenical proposition by Dürer was argued against by some sixteenth-century theologians;[7] but at least the marginalia drawn in 1515 seem to

draw those who were at the margins of the Christian world directly to the center of the universe. Dürer's image alters—or better, offers a new exegesis to—an Old Testament text, in a manner that could not have been thought twenty-four years earlier. Moreover, it seems to address effectively the epistemological and theological crisis that had been brought about by the discovery of the New World: if the Bible was the totality of God's word, how then could it be that this New World and its peoples were not in it, were not known?[8] Dürer has, by placing the image of the Tupinamba in the context of the psalm, resolved this critical epistemological issue most economically. That is, when reading the psalm's verses one could see that they referred not only to the community of Christian readers to whom God's word had been

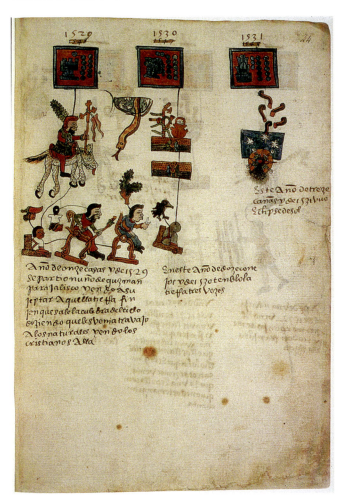

Fig. 3. Anonymous, *Figure of Nuño Beltrán de Guzman on Horseback*. In *Telleriano-Remensis*, Folio 44r, Mexico, mid-16th century (after 1561), Bibliothèque Nationale de France.

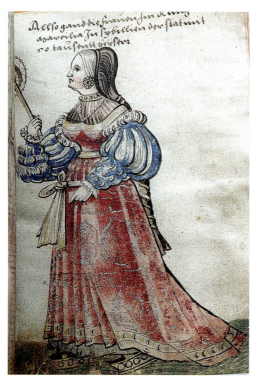

Fig. 4. Christoph Weiditz, *This is how the ladies go about in the Kingdom of Marcilia in Seville, a city of fifty thousand houses.* In *Trachtenbuch*, Folio 60r, Germany, 1529. Germanisches Nationalmuseum, Nuremberg.

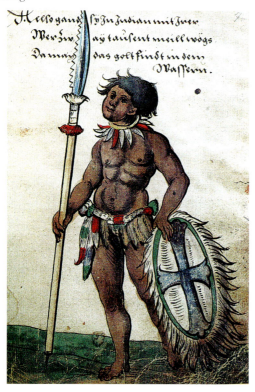

Fig. 5. Christoph Weiditz, *Armed Indians go two thousand leagues in order to find gold in the water.* In *Trachtenbuch*, Folio 7r, Germany, 1529. Germanisches Nationalmuseum, Nuremberg.

preached by His son, but also to the inhabitants of the New World, even though the latter were not specifically mentioned in the Old or New Testament and were only just now receiving Christ's word. One might contemplate similarly Dürer's preceding illustration while reading verses 7 through 10 of Psalm 19 on the facing folio (40r). The psalm begins on folio 39v. Verses 1–4 reflect on the glory of God as it reaches to the ends of the world:

> 1 The heavens declare the glory of God; and the firmament showeth his handiwork.

> 2 Day unto day uttereth speech, and night unto night showeth knowledge.
> 3 There is no speech nor language, where their voice is not heard.

> 4 Their line is gone out through all the earth, and their words to the end of the world. In them hath he set a tabernacle for the sun,

Dürer illustrates folio 39v with the figure of Hercules, the pagan hero who preceded Christ as the champion of virtue and conqueror of evil (Strauss 1974, 78), as he draws back his bow shooting upward toward the three harpy-like Stymphalian birds, one of the Twelve Labors of Hercules. The figure of Hercules is an allegorical reference to Maximilian himself, who had already been depicted in a woodcut of around 1500 as Hercules Germanicus and deemed restorer of order and promoter of virtue (Silver 2008, 23, 127–129). This image refers therefore to the emperor not only as the defender of the faith but also as one in whose time the glory of God has been heard throughout the world. And one therefore cannot look at the following figure of the Tupinamba without still hearing verse three: "There is no speech nor language, where their voice is not heard." Just as important, verses 7–10 make further reference, albeit obliquely, to the inhabitants of the New World:

7 The law of the LORD is perfect, converting the soul:
the testimony of the LORD is sure, making wise the simple.

8 The statutes of the LORD are right, rejoicing the heart: the commandment of the LORD is pure,
enlightening the eyes.

9 The fear of the LORD is clean, enduring for ever:
the judgments of the LORD are true and righteous altogether.

10 More to be desired are they than gold yea, than much fine gold:
sweeter also than honey and the honey-comb.

One cannot but think of the gold that was beginning to flow from the New World as one reads these verses. How much more to be valued is it that the word of God has gone "to the end of the world" than "gold, yea fine gold." The classicizing of the Tupinamba body therefore places the figure of America within a recognizable genealogy. That is, the figure of the pagan Tupinamba is akin to the pagan body of classical antiquity from Christian Europe's own pagan past, as seen in the figure of Hercules in the preceding illustration. This is an equation that we shall see had resonance in the Americas as well.

Less than thirteen years later, another German artist, Christopher Weiditz, was at the court of Charles V in Spain, where he took a more prosaic view of the citizens of the Americas. They appear within his beautiful *Trachtenbuch* or costume book, which primarily depicts the various regional dresses of Spain. And just as Maximilian's *Prayerbook* comes almost at the end of the great medieval tradition of private devotional manuscripts (it was printed on vellum), Weiditz's manuscript initiates a secular Renaissance genre that would prove to have lasting popularity in the early modern world as printing on paper moved to widespread popular consumption.

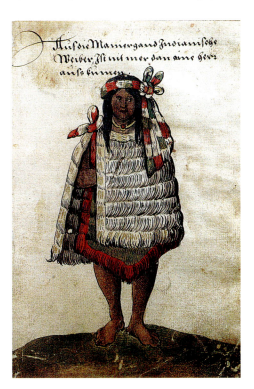

Fig. 6. Christoph Weiditz, *This is how women of the Indies go about, and until now not more than one has come (to Spain)*. In *Trachtenbuch*, Folio 1r, Germany, 1529. Germanisches Nationalmuseum, Nuremberg.

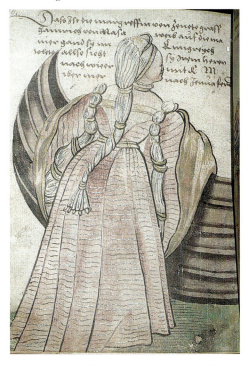

Fig. 7. Christoph Weiditz, *This is the Countess of Zenete, the wife of the Count of Nassau, the way that (women) go about in the Kingdom of Toledo; here she follows with her eyes as her husband is weighing anchor for the high seas to go Genoa*. In *Trachtenbuch*, Folio 59v, Germany, 1529. Germanisches Nationalmuseum, Nuremberg.

Figure 4 shows how women in Seville were dressed; the single figure is shown isolated against a neutral background and standing upon a curved green foreground that gives the impression of a hillock. There are some 150 other similar watercolor images of both men and women, and they set the formula for such figures for the next one hundred years; however, the manuscript opens with something even more revelatory. Weiditz begins with thirteen watercolor images of natives from America who were at the court of Charles V. Several of them appear to be Brazilians, and they are dressed only in feathers (Fig. 5). In fact, one of the standing male figures seems extremely close in both pose and costume elements to Dürer's figure in *Maximilians's Prayerbook* (Fig. 2), even though Weiditz probably did not have a chance to see that book. There are, of course, slight changes: the end of Dürer's club has been turned into a saw-toothed steel blade, and the shield now carries the blue cross of the knights of Malta. The feather collar, however, is identical, as is the tousled hair. The text

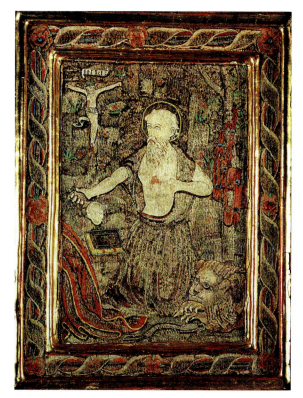

Fig. 8. Anonymous, *St. Jerome*. Mexico, mid-16th century, featherwork, 32 x 25.5 cm. Museum of Ethnography, Vienna.

above Weiditz's figure does not specifically identify it, but simply states that this Indian walks a thousand leagues to collect gold. So perhaps this is already a stock figure, created by Dürer in an ecumenically hopeful moment but associated in Weiditz's *Trachtenbuch* with the worldly desire of gold, an item that, sadly, the New World had all too much of.

But whether or not this figure is an already stock image,[9] the very first image in the manuscript is not. It is the figure of a woman from America, about whom Weiditz writes, "this is how women of the Indies dress, and until now not more than one has come to Spain" (Fig. 6). So this is a portrait of sorts: it represents not only a type, an Indian woman, but also an individual, the only Indian woman at the court of Charles V. There are in fact many other portraits in the manuscript, so that this *Trachetenbuch* is an historical record of individuals in Spain at the time of Weiditz's visit, as well as a record of regional dress, work, and customs. That is, the manuscript combines the generic and the specific, the universal and the historical. For example, on folio 59v, we see the portrait of Mencia de Mendoza (Fig. 7). She is posed in an extraordinary way; her back is to us and we see only a glancing view of her face. She does not engage the viewer at all but rather looks off into the background, toward her husband, Henry III count of Nassau, who was in Barcelona on his return journey to Flanders via Genoa.[10] She leans against the prow of a launch, gazing toward the ship that will take her husband to sea. Even though Weiditz could not know it at the time when he created this extraordinary image imbued with a sense of absence and longing, Mencia would never see her husband again, as he died in Flanders. Married again and widowed a second time, Mencia then became one of the richest women in Spain and one of the great patronesses of the arts. In her vast inventory of possessions made in 1548, in which are listed paintings by Bosch and works of other notable northern and southern artists, we find listed a feather painting from Mexico (Indies) of Saint Jerome and another of Mary Magdalene. Feather paintings from Mexico

were some of the first indigenous works commissioned and valued by Spaniards. Cortés tells of how in his very first days in the Aztec capitol, he commissioned several based on devotional prints he had with him, and in the first history of art by a Spaniard, Felipe de Guevara's 1560 *Comentarios de la Pintura*, the author mentions the feather images of the Aztec as one of the great contributions to painting.

The feather works listed in Mencia's inventory surely had to have been commissioned by her uncle Antonio de Mendoza, the first viceroy of Mexico (1535–1550), who also commissioned the Mendoza Codex, a manuscript about Aztec history and life intended for Charles V. While the two feather works mentioned in the inventory may not have survived, there is a remarkable sixteenth-century feather depiction of the penitent Saint Jerome in the Museum of Ethnography in Vienna (Fig. 8). This piece is thought to have been presented by Charles V to Ferdinand II along with a bishop's miter that most probably came to Europe in the late 1530s (Anders 1970, 35; Estrada de Gerlero 1994, 106–107). While much of the vibrant color has faded, the resplendent design and traces of brilliant yellow, red, and quetzal green demonstrate the qualities that this image and the two feather paintings must have shared. Also listed in Mencia's inventory are two miters, both of which depicted in feathers the image of God the Father on one side and the Crucifixion and the instruments of the passion on the other.[11] One of them was decorated with the Mendoza coat of arms. Miters similar in both media and iconography were brought to Europe before 1576 to be worn by the bishops of Madrid, Milan, and Paris (Fig. 9). All of these objects, already circulating within the collections of some of the greatest patrons of the arts in Spain and Italy, had been made by Aztec artists who had turned their talents to producing objects of Christian expression for European desires.

The most significant portrait in Weiditz's manuscript is of Hernán Cortés, who appears on folio 77 in a full-length portrait with his coat of arms (Fig. 10). He is identified by name, and his age, 42, is listed.

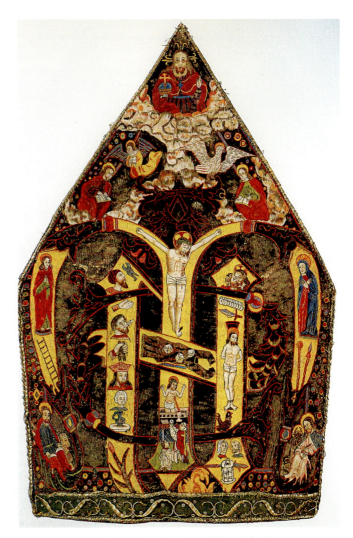

Fig. 9. Anonymous, *Miter with Crucifixion and Mass of St. Gregory.* Mexico, mid-16th century, featherwork, 43 x 30 cm. Cathedral of Milan.

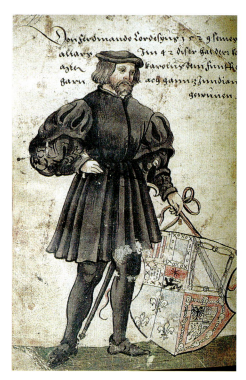

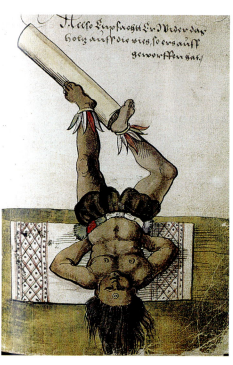

Fig. 10. Christoph Weiditz, *Hernán Cortés at the age of forty-two; he conquered all of the Indies for His Majesty Charles V*. In *Trachtenbuch*, Folio 77v, Germany, 1529. Germanisches Nationalmuseum, Nuremberg.

Fig. 11. Christoph Weiditz, *This is an Indian lying on his back who with the heels of his feet throws a log of wood as thick and as heavy as a man into the air. He lies on a skin on the ground that is as large as a calf's skin, and this is the way he catches the log*. In *Trachtenbuch*, Folio 9r, Germany, 1529. Germanisches Nationalmuseum, Nuremberg.

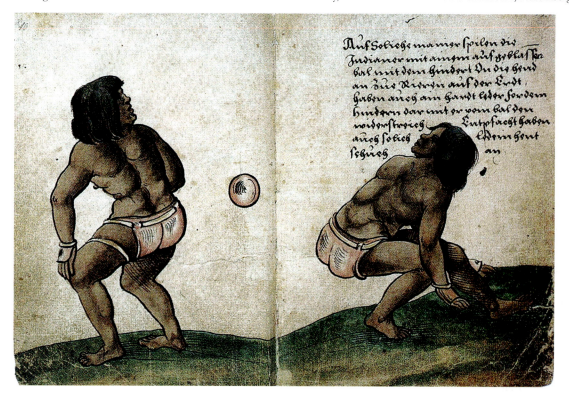

Fig. 12. Christoph Weiditz, *This is the way the Indians play with a ball without touching it with their hands. They also wear a thick leather [padding] on their backsides in order to return with even more force the ball that is hit to them, and they also have leather gauntlets*. In *Trachtenbuch*, Folio 10v-11r, Germany, 1529. Germanisches Nationalmuseum, Nuremberg.

Fresh from the conquest of Tenochtitlan and needing to press his legal claims, Cortés sought to endear himself to the Holy Roman Emperor by presenting objects of splendor such as feather work—and also by bringing to court several residents of Tenochtitlan, people we now call Aztecs. Their images are included among the thirteen Indians that begin the manuscript. Three are extraordinary in that they are engaged in action. Three images depict a juggler, lying on his back with his legs in the air as he balances and spins a log with his feet (Fig. 11).[12] Another folio shows two Aztecs dressed in short pants that pad their hips in order to protect them as they play against each other with a solid rubber ball (Fig. 12). Still another image shows these same two ball players engaged in a kind of Aztec betting game, something like dice, a favorite royal pastime in Tenochtitlan. These athletic figures strike animated poses and clearly demonstrate Weiditz's firsthand observation of their performances at the court of the Holy Roman Emperor and king of Spain. Weiditz uses color to distinguish among the Europeans, Americans, and Africans. Cortés has light skin with ruddy cheeks, while the Mexicans and Brazilians have a darker complexion, and the Africans have a much darker complexion still. However, the pose of Cortés and that of the standing Brazilian are almost mirror images. In other words, even though it seems that Weiditz offers a more "ethnographic" representation with dynamic figures of the Aztecs, he, like Dürer, calls upon shared conventions to create most of them.

These images of Americans are nonetheless remarkable in their directness in terms of what they attempt to convey. In both manuscripts, figures of Americans and Europeans exist in a shared imaginary and coeval space, be it the universal time of private devotion or the contemporary time of 1528 at the imperial court in Spain. But other images, equally new and brought from the Americas to Europe, offer a different kind of interchange. A figure that was made at almost the same as the Mexican feather painting of Saint Jerome represents its antithesis (Fig. 13). It is a pagan idol, a Zemi, or sacred figure of the Taino peoples who had greeted Columbus on Hispaniola some forty years earlier. This Zemi was seized, most probably by a Catholic priest, on one of the Caribbean islands and brought to Europe as evidence of American idolatry. It is a Janus-faced figure of tremendous energy and power that seems to combine the human and animal in the two faces. Whereas in the feather painting native artistic traditions and material were turned to creating Christian Renaissance images, here, native Caribbean materials (the pink and white shell beads) are combined with new materials. The shell beads are interspersed with green glass beads, the eyes and ear pendants are mirrors of Venetian glass, and rhinoceros horn from Africa was used for the human face. Clearly, the ancient religions of the Americas could turn the new materials to their own religious expression. But Christianity did not tolerate such heterodoxy, and these new expressions could be seen only as heathen idolatry. Thus, while the images by Dürer and Weiditz of New World peoples tend to normalize them through artistic conventions that harked back ultimately to classical antiquity, America's pagan present was to be treated as a different form of antiquity, a dangerous one.

Classical Antiquity in the New World

In the Aztec city of Tenochtitlan, as seen in the 1524 map that accompanied Cortés's *2nd Letter,* published in Nuremberg (Fig. 14), we can see this carried out in a most dramatic fashion. Even before Cortés returned to Spain bearing newly made feather images with Christian themes, he had begun to destroy images of the Aztec gods in Mexico. In the center of the map is depicted the walled sacred precinct of the Aztec city with the main temple, before which appears a standing headless figure in *contrapposto* pose holding giant snakes in its outstretched hands. The figure almost recalls classical sculpture in style and form, but this is no Laocoön of Virgil, it is either Coyolxauqui or Coatlique, goddesses of Aztec primordial myth. This is an idol of stone, as it is called in the Latin of the *Aeneid* written below

Fig. 13. Anonymous, *Zemi* (two-faced figure). Caribbean, early to mid-16th century, rhinoceros horn, wood, shell, glass beads, and mirror, 81.3 H x 19.5 dia. cm. Museo Nazionale Preistorico Etnografico L. Pigorni, Rome.

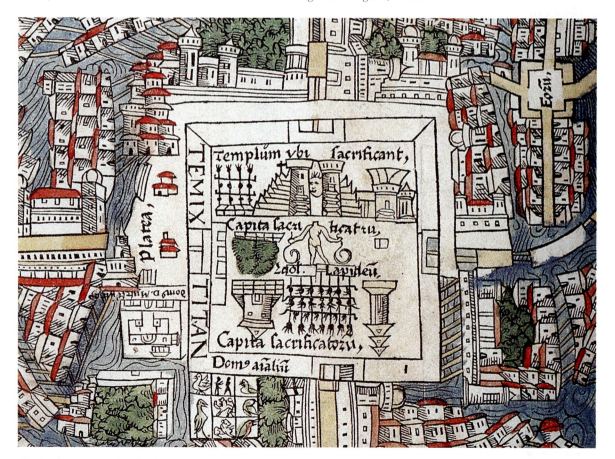

Fig. 14. Anonymous, *Detail of Map of Tenochtitlan and the Caribbean Showing the Central Sacred Precinct of the City*. In Hernán Cortés, *Praeclara de Nova maris Oceani Hyspanai Narratio…*, Nuremberg, 1524, hand colored woodcut. Newberry Library, Chicago.

it. It is therefore much more dangerous than any stone sculpture of the Laocoön, and it was to be destroyed like all the others in Tenochtitlan, which were cast down and broken, buried, or, if of precious metals, melted down. The same was soon to happen in an even more dramatic fashion in Peru, where the ransom of Atahualpa was to bring an undreamed-of fortune to the Spanish empire. And although we all more or less know this history of iconoclastic fervor, we rarely stop to understand precisely how these images were understood in relation to the history of Christianity and its rediscovery of its own ancient past and its sculptural legacy.

Why is all this at question? This New World was literally both a world before the state of salvation brought by Christ, and a world at a lesser state of development (Pagden 1981). But it could also be conceived as historically parallel to the ancient world of Greece and Rome. In the *Prayerbook of Maximilian*, the image of the pagan hero Hercules as an allegory for the emperor himself is juxtaposed with the classicized image of the New World. His grandson, Charles V, also took on the guise of Hercules, on the reverse of a medal cast in 1547 in commemoration of his victory at Mühlberg (Sauerlander 2006, 60). The reference to classical antiquity through the image and cult of Hercules had already been greatly broadened by the new device and motto chosen by Charles V in 1516 to express himself and Spain in relation to the discovery of the New World (Cummins 2005; Silver 2008, 128). We see it emblazoned on the walls of the town hall or *Ayuntamiento* of Seville, begun in 1527, and it was added to even greater effect on the apse of Seville's cathedral as well as to his palace at the Alhambra (Fig. 15). The emblem is composed of the Pillars of Hercules, which supposedly stood at the gates of Gibraltar, and the French motto *Plus Oultre,* more commonly known through the ungrammatical Latin translation *plus ultra,* which can be translated as "further beyond."[13] The text *plus ultra* came to be understood in the seventeenth century as being in opposition to the phrase *non plus ultra* (nothing further beyond). It was imagined to

have been inscribed on the mythological columns, indicating their antique function as the border of the known world and the vast emptiness of the Atlantic. So at one level *plus ultra* means seeing the straits instead as the passage into the Atlantic and the New World. Thus one can also think of these pillars as the allegorical sign of a temporal passing, a radical transition from the antiquity of Hercules, an antiquity that had fired the imagination of Renaissance, to a modernity that fired an entirely new imagination. This view is clearly articulated by Sarmiento de Gamboa who was commissioned to write a defamatory history of the Inca for Philip II in 1571–72. In fact, he is the first author to associate Charles V's emblematic phrase *plus ultra* in opposition to the ancients who had been contained in the Mediterranean:

> [God] gave them [the kings of Spain and the conquistadores] an apostolic office, choosing them amongst all the kings of the world as the evangelizing ambassadors of His divine word carrying it to the remotest and unknown regions of these barbaric and blind gentiles, whom we now call the Indies of Castile so that by their pastoral care the

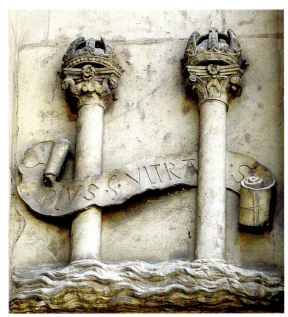

Fig. 15. Diego Riaño (architect) and Juan Sánchez (sculptor), South facing door with detail of Pillars of Hercules on upper left. *Ayuntamiento,* Seville, begun 1527.

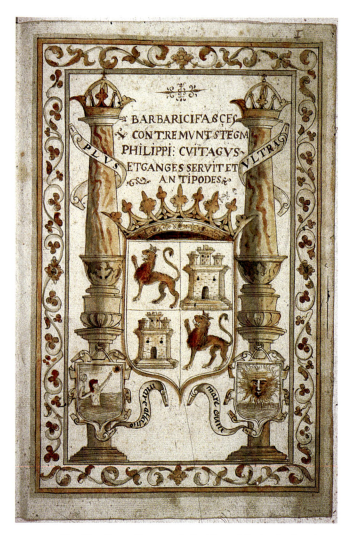

Fig. 16a. Coat of arms of Castille and León. In Sarmiento de Gamboa, *Historia Indica*, 1572, Georg-August-Universität Göttingen.

natives could be placed onto the road of salvation; God being the true pilot who made the crossing of the dark and frightful Atlantic Ocean easy, which terrified the ancient Argives, Athenians, Egyptians, and Phoenicians and what is more, made the proud Hercules fearful upon seeing the vast expanse of the Atlantic Ocean and believing that the world ended here and that there was no more land he placed his columns with these words *Ultra Gades Nil*. That is, "Beyond Cádiz there is nothing." But as human knowledge about God is ignorance and the force of the earth weakens in His presence, it was easy for your holy grandparents [Ferdinand and Isabella] by the grace of God to break and dissolve the mists and difficulties of that enchanted ocean. And mocking Alcides and his blazon [columns and Latin phrase *Ultra Gades Nil*] with good reason, they discovered the Indies, populated with a multitude of souls to whom Heaven could be shown the pathway to heaven and here was also a great variety of precious treasures and by which they recovered the great costs they had incurred, and they became the richest princes in the world, and they therefore continued their holy and most Christian generosity until death. And due to this very famous voyage and the miraculous and new discovery, the epigraph on the columns of Hercules was corrected removing *Gades nil*, and placing *Plus* in front of *Ultra*. Which truly means, "Further ahead there are many lands." From then on the wording *Plus Ultra* was used as the blazon on the coat of arms and insignia of the Indies of Castile (Sarmiento de Gamboa 2007 [1572], 18–19).

Two of the four illuminations that begin Sarmiento de Gamboa's manuscript, the Coat of Arms of Castile and León and the Royal coat of arms of Phillip II, depict the columns of Hercules as the framing for the escutcheons (Fig. 16 a & b). *Plus Ultra* is written on the cartouches that drape around the columns. It is clear that Sarmiento's discussion of *Plus Ultra* and its meaning are made in relation to these images and the wealth discovered in Peru. The Latin motto

BARBARICI FASCES CONTREMVNT
STEGMA PHILIPPI: CVI TAGVS ET
GANGES SERUIT ET ANTIPODES

appears in both illuminations and translates as "The barbarians of high office shudder at the noble lineage of Philip, who is served by the Tajo and the Ganges and the Antipodes."[14] At the base of the columns are two allegorical images of the Atlantic and China oceans as identified again in Latin as *Mare atlanticum – Mare eoum*.

We also can see this symbolic relationship between the mythical constraints of the Columns of Hercules and Spain's expansion into a New World, which is at once as real as it is epistemological, in the coat of arms granted by Charles V to Pizarro in 1538 in recognition of the great treasure he had received from the ransom of the Inca king, Atahualpa. According to the *Provisión Real,* the Inca king was to be placed in the center of the escutcheon. His arms were to be open with his hands thrust into coffers of gold. He was to be depicted wearing the Inca crown on his forehead as well as a golden necklace. Around the border were to be placed the seven Indian captains (*caciques*), identified by name. They were connected by a golden chain that went around their necks, and their hands were tied in order to demonstrate that they were prisoners. The shield was surmounted by a helmet on which was a lion holding a drawn and bloody sword. In the first section, on a silver background, a black eagle crowned with gold embraces two silver columns, joined by a silver banner that reads *PLUS ULTRA* in sable lettering. Be-

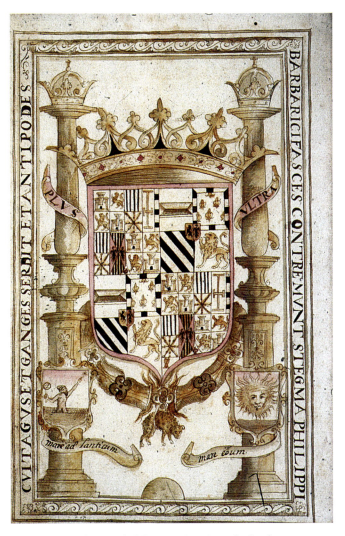

Fig. 16b. Coat of arms of Philip II. In Sarmiento de Gamboa, *Historia Indica*, 1572, Georg-August-Universität Göttingen.

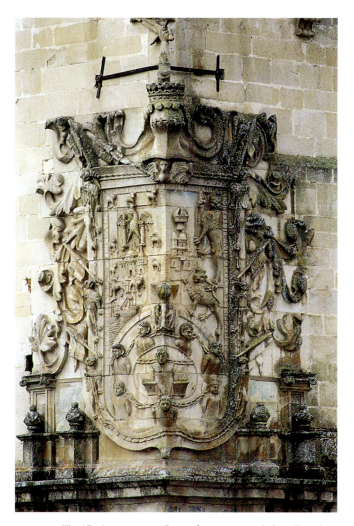

Fig. 17. Anonymous, Coat of arms conceded to Francisco Pizarro by Charles V, 1538. Sculpted late 16th century. House of the Pizarro Family, Trujillo, Spain.

low, a city (Túmbez, where Pizarro first put ashore) is shown with boats arriving. The *Provisión Real* gave Pizarro and his descendents license to display his coat of arms, sculpted and painted, wherever appropriate.[15] And so this heraldic image adorns the facade of the palace built by Hernando Pizarro, the brother of Francisco Pizarro, and his wife-niece Francisca Pizarro Yupanqui in the ancestral city of Trujillo in Extremadura (Fig. 17). This decidedly Spanish Renaissance palace displays one of the very first public images of an Inca king and makes explicit the associations between the defeat of Atahualpa at Cajamarca, the wealth it delivered to Spain in the form of gold, and the Herculean symbol of Charles V.

This new coat of arms anticipates by more than fifty years a very different imagining of the Pillars of Hercules and Hercules himself, an imagining that allegorically represents Potosí, the greatest silver mine ever discovered. An improbable city established at nearly 14,000 feet above sea level, Potosí grew within the span of fifty years after its discovery in 1545 to be one of the largest in the world, with a population of 150,000. The two images appear in two intimately colonial manuscripts: one by a Spanish monk, Martín de Murúa, entitled *Historia del Origen y Genealogía Real de los Reyes Incas del Perú* (1590), and the other by a native Andean, Guaman Poma de Ayala, entitled *Nueva córonica i buen gobierno* (1615). They form a part of city views that end both manuscripts. These two images of Potosí are very different from all others, and are much more complicated in their composition and intent.

I shall concentrate only on Murúa's illustration, as it is more complex and was the model copied by Guaman Poma de Ayala (Fig. 18). We see the mountain rendered rather schematically while two Andeans appear on the slopes, climbing upwards along the paths. The figure on the proper right slope follows and pushes a loaded llama. The scale of the figures is not proportional to the mountain; a realistic image is not intended. Rather, this is also an allegorical composition that combines several different images to evoke the connection between

Spain and Peru, between the Inca past and colonial present and the ancient legacy of Spain. The figures ascending the mountain are to be read as personifying the human force that extracts the silver from the dark interior mine shafts, which are depicted as a set of crisscrossing black lines set against a dark green background. This last color is deceptive; before oxidation, it would have been bright and shimmering, as actual silver, probably silver from the mine itself, was used to represent the plentitude of Potosí's riches. The allegorical reading of the image, however, is dependent on the figure of an Inca who stands behind and dwarfs the great mountain, embracing the two columns that represent the Pillars of Hercules. And while this figure has an allegorical function, it is quite specific in iconographic detail and figural rendering. Dressed in a green *uncu* with a v-neck, a red cape, large spool earrings, and the *mascaipacha* or Inca crown, the figure has a strikingly portrait-like countenance. He grasps the Pillars of Hercules, which have crowns placed above the capitals just as they do in Seville. Above the pillars is written *Plus Ultra*. The Inca, however, enunciates something else: "*Ego fulcio collumnas eius*," or "I hold its columns upright." That is, the Andeans who produce the new wealth of Peru are here shown to be allegorically the support of the empire. The Pillars of Hercules now are no longer the gateway to a New World. The New World now supports the Old, and without it the pillars would collapse.

That the myths of classical antiquity could be used in both Europe and the Americas to express allegorically both the transition from the Old World to the New and the transfer of power from native to European should not be surprising. This was the stuff of the Renaissance.[16] However, such classical references could be turned from allegory to history in a remarkable way. We see this in the opening pages of one of the most famous manuscripts produced in New World, the *Codex Florentino* by the Franciscan Bernardino de Sahagún. Composed of twelve books with some 1800 illustrations, the *Historia General de las Cosas de Nueva España* is the single greatest source

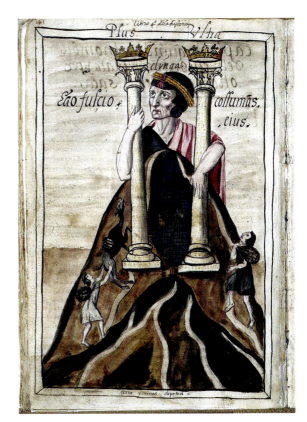

Fig. 18. Martín de Murúa, *Allegorical Image of Potosí*. In *Origen y genealogía Real de los Reyes Incas del Perú* (Galvin manuscript), Folio 141v, Peru, 1590–1600, color washes and silver. Private Collection, Ireland.

on the history and customs of the Aztecs. The manuscript begins after a prologue with illustrations of the principal Aztec deities, the subject of the following chapters. Fray Sahagún tells the reader in the prologue why he begins with Aztec deities: just as any good doctor must know the disease before prescribing a cure, to evangelize New Spain (Mexico), one must know the natives' ancient religion so as to convert them. At the end of the prologue, he writes that God has given to Spain and Catholicism this new world as recompense for the territories of England, Germany, and France that had been gained by the Devil in the Reformation. That is, the New World is placed in direct parallel with the Old. Furthermore, the pagan state of Mexico is comparable to the pagan state of classical antiquity just before the coming of Christ. This is a common trope used by many sixteenth-century friars in the New World. And so we find in the illustrations that follow the prologue

that the titular Aztec divinity Huitzilopochtli is called another Hercules, and the Aztec god of nobility, Tezcatlipoca, is called another Jupiter (Fig. 19). In a parallel pantheon, other deities are compared with Venus, Circes, Juno, etc. Here allegory is not at issue. In Murúa's image we saw the human personification of Peru sustaining the mythic symbol of Spain; in Sahagún's image we see the human guise of a deity. In Sahagún we therefore draw very much closer to Renaissance Europe's own recent encounter with its idolatrous past. One need only think of the recent discoveries of classical sculptures such as the Laocoön in 1506 and their display in Rome Therefore it is possible that Sahagún and other Europeans in Mexico were consciously or unconsciously seeing in Aztec sculpture forms of expression that reminded them of seeing the images of their own classical heritage.[17] Take, for example, the only recently discovered (1489) sculpture of the Apollo Belvedere (Fig. 20). This ancient pagan diety appears in the form of a beautiful young man. How different would that have appeared to the Aztec sculpture of the God of Wind Ehecatl. which depicts an equally perfect young man, almost nude. The human form

of both sculptures makes Sahagún's illustrations and his analogies between ancient and Aztec pantheons understandable. The gods are understandable by attributes, and, in the case of Ehecatl, we see a man wearing the mask of the god (Fig. 21).

Sahagún's and other friars' comparisons between pagan antiquity and pagan Mexico were not shared by all. For example José de Acosta wrote at almost exactly the same time about his experiences in the Americas, and he rejected any straightforward analogy between American paganism and that of antiquity. Chapter nine of his *De Procuranda Indorum Salute*, published in 1588, is entitled "Why Preachers of Christ's word do not perform Miracles now as [they did] in Antiquity in the conversion of the pagans" (Acosta [1588] 1984, 312–325). The lack of visible miracles had caused a crisis of faith for some of the missionaries who had struggled against the idolatry of the Mexicans and Peruvians. Why, it had been ventured, had God not shown himself through his miracles to the missionaries as he had to Paul and the other evangelists? To Acosta the lack of miracles demonstrated the difference between then and now. In antiquity God needed to

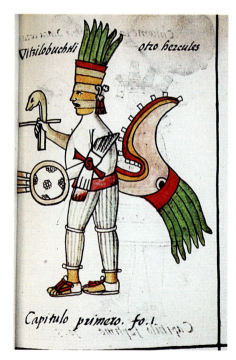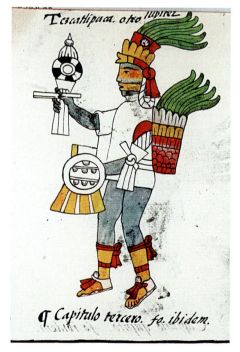

Fig. 19. Bernardino de Sahagún, *Huitzolpichitli Otro Hercules, Tetzcalipoca Otro Jupiter*. In *Historia General de las Cosas de Nueva España*, Mexico, 1585, colorwash on paper. Biblioteca Medicea Laurenziana, Florence.

provide miracles because the people of that time, the Greeks and the Romans, were at the height of reason. Moreover, Christianity was a new religion in comparison to the pagan practices of the Mediterranean world. The ancients therefore could not be persuaded by mere words: "the Christian religion was founded by God with miracles because human agency was completely lacking in effect because the early Christians did not have sufficient strength" (312). But the pagans of Acosta's day, the Mexicans, Andeans, and others, were quite different:

> the situation of our era is very distinct. Those to whom the priests announce the faith are inferior in everything: in reason, in culture, and in power, and those who announce the Gospel are superior in terms of the great age of Christianity, by the number of its faithful, their wisdom and erudition and all other means of persuasion. (312)

The Mexicans, Andeans, and other Indians, according to Acosta, lacked the intelligence and wisdom of the ancients.[18] One and only one miracle was therefore needed, and that miracle was embodied by those who had come to the Americas to preach the word of God under the protection of the military force of Spain, as can be seen in an image from a manuscript presented to Philip II at court in Spain in 1584 (Fig. 22). It commemorates the first sermon preached to the Tlaxcalans, the rivals of the Aztecs and steadfast allies of the Spanish. For the Franciscans and Jesuits, as Acosta writes, the miraculous in the New World was manifested through the righteous life of the evangelizing priests, who simply through example and teaching could lead the Indians into the community of Christians.[19] Only the power of their piety was required for conversion in light of the simplicity of the Indians—their weak intellect and culture.

This dichotomy between strong and weak cultures also defined an artistic difference between Renaissance Europe and Renaissance America. Juan Meléndez, a Dominican from

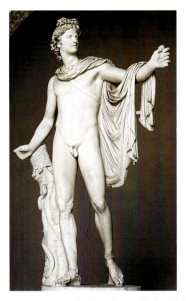

Fig. 20. Copy after Leochares (?), Apollo Belvedere. Roman copy of a lost bronze original made between 350 and 325 BC, marble, 224 cm. Vatican Museums, Vatican City. Photo by Marie-Lan Nguyen (2009).

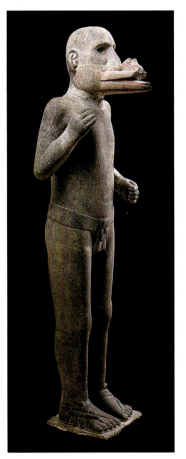

Fig. 21. Anonymous, *Quezalcoatl-Ehecatl*. Mexico, c. 1500, basalt, 176 cm. Museo de Antropología e Historia del Estado de México, Toluca.

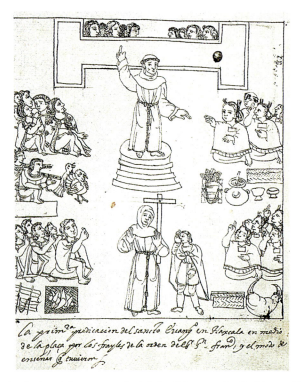

Fig. 22. Diego Muñoz Camargo (author) and Anonymous (artist), *La Primera predicación del sancto Evangelio en Tlaxcala en Medio de la plaza por los frailes de la orden de San Francisco y el modo de enseñar que tuvieron.* In *Historia de Tlaxcala*, Mexico, c. 1585. Glasgow University Library, Special Collections, MS Hunter 242 (U.3.15).

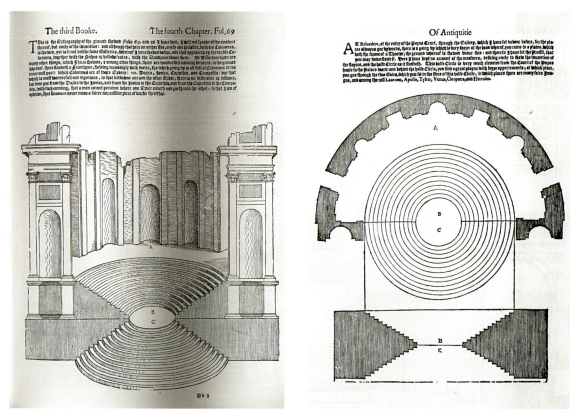

Fig. 23. Sebastiano Serlio, *Design and Plan for Belvedere Theatre.* In *Il terzo libro di Sabastiano Serlio… nel qval si figvrano, e descrivono le antiqvita di Roma, e le altre che sono in Italia, e fvori d'Italia*, Folio 68 v 69r, Italy, 1540.

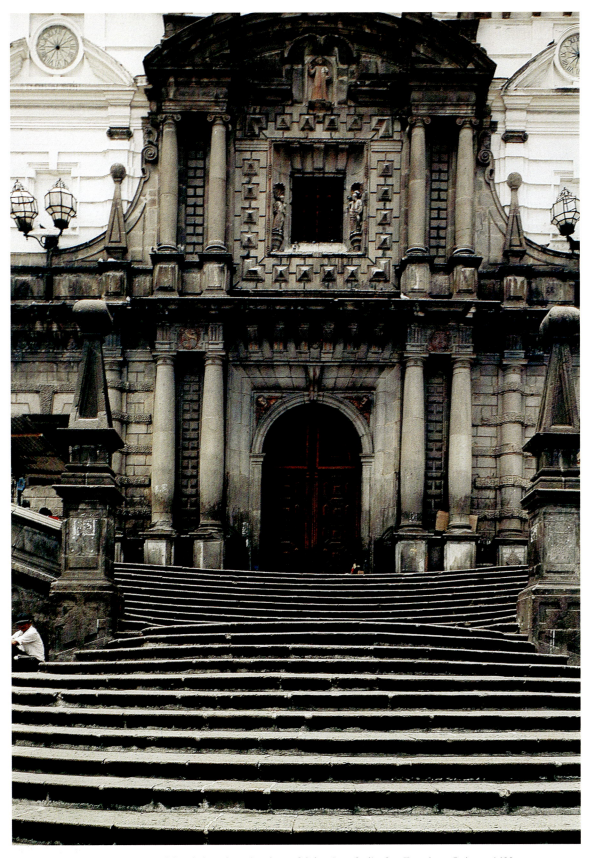

Fig. 24. Anonymous, Staircase and façade based on the plans of Sebastiano Serlio. San Francisco, Quito, c. 1600.

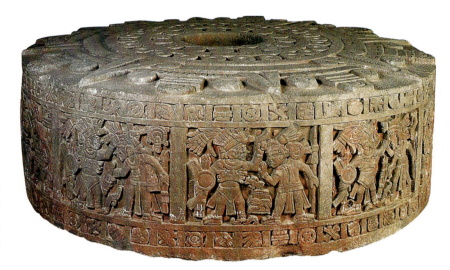

Fig. 25. Anonymous, *Temalacatl-cuauhxicalli* or sacrificial stone dedicated to Moctezuma I (1398–1469). Mexico, c. 1469, 26 H x 62 dia. in. Museo Nacional de Antropología, México.

Peru, wrote about this distinction directly:

> In many parts of Christendom, especially in Rome there is so little risk of idolatry that they preserve the ancient statues of their idols, celebrating in them only the delicacy of their artistry and the antiquity of their marble, because as the Christian faith, by the grace of God, is so deeply rooted in the hearts of the faithful there that now there is no risk that anyone believes that there is divinity in the stones, and so the palaces, gardens and galleries are filled with them. But in the Indies, because the natives of those countries are only recently converted to the Faith, and the Christian faith has only recently taken root in the hearts of those descendents of the ancient pagan religion, and while there are many good Christians among them, there are still many weak ones. And all of them, being generally of such easy nature, can be moved by evil or weakness, as is more often the case, to return to their ancient idols, rituals and ceremonies and so it is that it is not permitted that their idols be either kept or preserved as they perpetuate their memory and demonstrate their antiquity.[20]

So let us think about how this difference plays out in practice, taking one specific example. It begins with the architectural treatise of Sebastian Serlio, first published in Italian in Venice, but quickly translated into many languages including Spanish (it was published in Toledo in 1552). Serlio's *Third Book* treats the antiquities of Rome. One of his most famous structures, shown in plan and elevation in a woodcut print, is the proposed Belvedere theatre for the Vatican (Fig. 23). The apse-like structure with niches would be a neoclassical setting, as Serlio writes, for displaying the Laocoön, the Apollo Belvedere, and "*il bellisimo torso di Hercole*" among other ancient sculptures. To approach these works, one was to ascend a semicircular staircase that was first convex, then concave, with the transition created in the middle by a complete circle. This theater was never built in Rome. But it was built in the Americas at the beginning of the seventeenth century—not to display sculptures of pagan deities, but to create a dramatic entrance from the Plaza of San Francisco in Quito to the central portal of the church, built over an Inca site (also see Webster, Figure 4). The staircase leads the devout from the secular space of the plaza to the spiritual embrace of the Gospels (Fig. 24). The transition occurs precisely at the meeting of the convex and concave, which is at the level of the lintels of the shop doorways. And when the doors of the church are opened for the salvation of all, one sees not an image of antiquity but rather a painting that takes its theme from the New Testament. Here then, Renais-

sance architecture is deployed differently, using the differences laid out by Meléndez, as discussed above.

Or, to put it another way, the new churches built throughout the Americas at the end of the sixteenth century triumphantly displayed the strength of Christianity against the weakness of America's pagan past. For example, in 1596 the Florentine trader Francesco Carletti visited the City of Mexico, and in 1606 he described its new cathedral, which

> had not been completed in my time. (But) there one still sees a tablet formed from a huge, thick stone worked in a round shape on which are carved various figures in half-relief, and with a small gutter in the middle through which ran the blood of the men who were sacrificed in the times of the Mexican nobles, in honor of their idols, of which ones sees the remains still throughout the city, walled up in the exterior walls of buildings erected by the Spaniards, placed there to express the triumph of their foundation. (Carletti 1965 [1606], 59)

Here, an Aztec *temalacatl-cuauhxicalli* or sacrificial stone had been embedded as spolia in the wall of the cathedral not as a monument of the glorious past but as mark of its defeat. There are at least two *temalacatl-cuauhxicallis*, [one created during the reign of the Aztec leader Motecuhzoma I (1440–1469) and the other created during the reign of Tizoc (1481–1486)] that are remarkably close to Carletti's description of the "thick stone worked in a round shape on which were carved various figures in low-relief" (Fig. 25).

The figures Carletti describes are images of the Aztec king (*tlatoani*) defeating the kings of other city-states. On both the Motecuhzoma I and Tizoc monuments, the Aztec king is depicted dressed as the Aztec titular deity, Huitzilopochtli. The left foot curls upward to indicate the sign for obsidian, or smoking mirror as it was termed in Nahuatl, an attribute of the god Tezcatlipoca, lord of Aztec nobles, whom Sahagún called another Jupiter. This

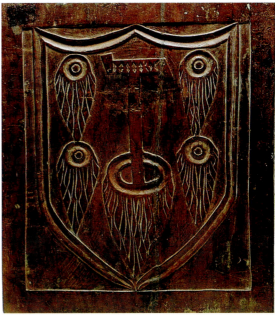

Fig. 26. Anonymous, Franciscan mirror or portable altar (front and back). Mexico, c. 1534, wood, obsidian, paint, and gilding, 31.5 x 28.5 x 2.8 cm. Dumbarton Oaks Research Library and Collection, DC. PC B. 78.

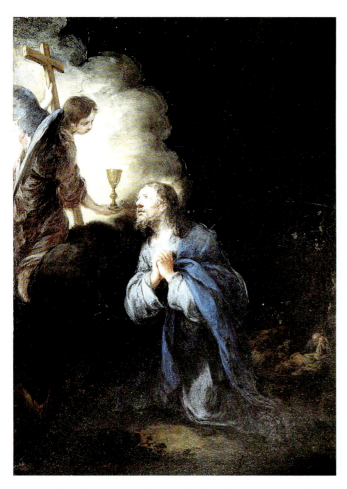

Fig. 27. Bartolomé Esteban Murillo, *Agony in the Garden*. Spain, before 1683, oil on obsidian, 33.7 x 30.7 cm. Musée du Louvre.

Aztec attribute was part of the demonic nature of the Aztec pantheon, but the material, volcanic glass, was itself wondrous and, like Aztec featherwork, could be turned to Christian needs. For example, several exquisitely polished obsidian stones received Franciscan frames, such as the rectangular, almost square, example in the Dumbarton Oaks collection (Fig. 26), which served either as a portable altar or as a mirror. The back of the frame carries the Franciscan emblem and is strikingly similar to the wooden back of a feather painting of the Mass of St. Gregory made in Mexico City in 1539 to be sent to Rome. In fact, both pieces came to light only in the twentieth century, the obsidian mirror being bought in Madrid in a flea market. Other pieces of obsidian continued to find their way to Europe. Two of the most extraordinary examples, later than that at Dumbarton Oaks but of roughly the same proportion, were used by Bartolomé Esteban Murillo to paint an *Agony in the Garden* (Fig. 27) and the *Penitent Saint Peter before Christ at the Column*. As Meslay (2001, 73–79) points out, Murillo incorporates the quality of the polished black obsidian surface to create an ethereal effect in the painting. It is as if Murillo has exorcised the demonic by placing Christian images on the surface of this sacred Mexican material.

Mirrored Reflections: Seeing Angels and Demons in the Old World and New

And this European interest in obsidian, the smoking mirror, brings us back to the black object mentioned in the introduction (Fig. 1). This object and its case are now part of the British Museum's collection. The mirror is recorded as having belonged to the Elizabethan mathematician Dr. John Dee (1527–1608).[21] The case was made by Sir Horace Walpole, who acquired the mirror after first mentioning it in a 1771 letter: "found in an old catalogue of her [Lady Betty Germaine's] collection this Article "*The Black Stone into which Dr. Dee Called his spirits*" (Walpole as cited in Tait 1967, 208). Dr. John Dee was no ordinary doctor or mathematician. He was, as Walpole goes on to write, "a great conjurer in the days of Queen

Elizabeth." But he was no ordinary conjurer. He was at the same time advisor to Queen Elizabeth on matters of science, and he took a great interest in optics, especially the works of Francis Bacon, in part because the mathematical study of rays provided the basis for a mathematical method for astrology (Clulee 1988, 48, 64–65). He was asked in 1553 to cast the horoscope of Queen Mary and that of her prospective husband Philip II of Spain, and it has been suggested that the mirror might have been given to him by Philip in reward for his favorable prognostication. But he also could have received it from Sir Walter Raleigh or other British marauders/pirates with whom he was in close contact. In fact, John Dee coined the phrase "The British Empire," or at least was the first to use it in print (Canny 1998, 62), and he developed an expansionist program for Elizabeth in the Americas, that he termed "this British discovery and recovery enterprise." He based the priority of British claims on his use of the myth of a Welsh Prince Madoc who sailed to America three-hundred years before Columbus and left behind a tribe of Welsh Indians (Sherman 2006: 113–114).

However it was that Dr. Dee came into possession of this Mexican obsidian mirror, by 1581, he actively began to practice magic in an attempt to communicate with the angels. In 1583 he was working with Edward Kelly as his medium or scryer. In 1588, Dee wrote in his diary that he "gave to Mr. Ed. Kelly my Glass, so highly and long estemed of our Quene and Emperor Randolph the second, de quo in praefatione Euclidis fit mentio" (as cited in Tait 1967, 197.) As Tait notes, "Dee alludes describes [sic] a 'certaine glasse' which causes an image to appear between the beholder and the glass" (Tait 1967, 198). The surface of obsidian casts such an ethereal reflection. It was upon this kind of surface that Dee and Kelly communicated with the other world. Through reflecting objects called "shew-stones," angels revealed themselves to Dee and Kelly with instructions (communicated by pointing to one square after another in tables of letters and unknown symbols that Dee and Kelly had transcribed) that

they share everything, including exchanging wives (Clulee 1988, 205). In 1664, Samuel Butler published a satirical poem about an astrologer entitled *Hudibras*, which includes the following two lines:

Kelly did all His Feats upon
The Devil's Looking-glass, a stone

This is the verse that Walpole placed upon the leather case for Dee's obsidian stone, adding that "Kelly was Dr. Dee's associate and is mentioned with this very stone in Hudibras, Prt 2. Canto 3 v631" (Tait 1967, 195). Thus the smoking mirror of the Aztecs, *tezcatl* (Molina 1970 [1571], 59, 112), became first a "shew-stone" of "angels" and then, eighty years later, the "Devil's looking-glass," in purely European terms.

In truth, Dee was a devout Christian who longed to have direct contact with the divine. His incantations evoking the angels describe a hierarchy that, like the Aztec world, was divided into the four cardinal directions:

Each one of these 4 Angels is a mighty prince, a mighty Prince of the Lord, and are by him according to his divine order and decree as chief watchman and overseers set over several & respective parts of the world of the Lord, viz East, West, North, South. (Skinner and Rankine 2004, 64–65)

Dee and Kelly conjured up these angels through their "shew-Stones" so that the voice of the Lord might be further spread. In this, Dee's desire is not unlike that voiced in Psalm 24, which Dürer illustrated with the figure of a Brazilian in Maximilian's *Prayerbook* (Fig. 2). At the same time, Dee's words, as well as some of his wax tablets, also seem to conjure up the image of Tezcatlipoca as it appears in the *Fejéváry-Mayer Manuscript*. Here the composition is divided into the four quadrants where Tezcatlipoca appears four times, placed at the cardinal points of the world. In both the Mexican manuscript and Dee's imagination, what is sought is the collapsing of the sacred and the tem-

poral world, and it is through Tezcatlipoca, the lord of the smoking mirror, that this union was achieved.

And so, whereas Murillo might paint sacred images of Christ on this Mexican material to take advantage of obsidian's effect upon the viewer, Dee, like the Aztecs, gazed into the surface so that he could actually see and communicate with God's angels. The fortune Dee cast for the success of the marriage of Philip II and Mary was way off the mark, and the joining of the nations was never to be achieved, but he probably came closer to realizing the power of the shiny black surface than Murillo. But in either case, the pagan magic of the New World was overcome as Europe passed through the gates of Hercules to bring its own Christian magic.

Notes

[1] Dürer's image appears in one of the portions of the printed *Prayerbook*, created in 1513 by Johannes Schoensperger at Augsburg using movable type. Sections were given to Hans Burgkmair, Lucas Cranach the Elder, Hans Baldung Grien, Jog Breu, and Albrecht Altdorfer as well as Dürer. The drawn illuminations were models of what were to be then printed as woodcuts as a part of a highly personalized prayer book designed by Maximilian and his literary adviser, Conrad Peutinger. It is composed of a Book of Hours and a collection of psalms, biblical passages, and hymns (Panofsky 1943; Koerner 1993, 224–231; Silver 2008, 120–127).

[2] Of course both Native and European artists were capable of using the artistic conventions of the other, most especially when copying the genres of the other, such as religious paintings or documents. But in the depiction of the other in a genre and medium particular to the artists' own culture their own indigenous conventions are followed.

[3] One need only look at Dürer's portraits of Africans, such as the one in the Albertina Vienna done around 1508, to see that he was perfectly capable of rendering specific facial characteristics, or at his 1514 watercolor copy of two Turks and a servant, reworked from Bellini's Procession of the Relic of the True Cross, to see that he is doing something different with this figure in the *Prayerbook*.

[4] The Order of the Knights of Saint George was established by Maximilian's father Emperor Fred-

erick III in 1467, but upon his death Maximilian expanded it to a lay brotherhood. Although never completed, the *Prayerbook* was Maximilian's main artistic and religious project for this order (Silver 2008, 114–120).

[5] Massig is simply expanding slightly on Panofsky's original observation (2005, 189).

[6] While the noble savage is really an Enlightenment figure, the innocent and pure savage begins with Columbus, who wrote, "they do not hold any creed nor are they idolaters; but they all believe that power and good are in the heavens and were very convinced that I, with these ships and men, came from heaven" (Columbus[1493]1960,196). Full citation in Christopher Columbus 'Letter of Columbus, Describing the results of his first voyage,' in *The Journal of Christopher Columbus,* C. Jane trans., (New York: Clarkson N. Potter Inc. 1960 [1493]).

[7] The theological and political debates, mostly in Spain, about the human nature of Indians and Africans were very intense, see Pagden (1981).

[8] Upon Columbus's discovery, which Peter Martyr d'Anghiera immediately christened the New World, *Nova Orbis,* there was a crisis of doubt concerning both the origin of its peoples and its geographic place in the universal history of the Bible (Pease 1981). This led finally to the publication of Gregorio Garcia's 1607 *Origen de los Indios del Nuevo Mundo.* This challenge to the structure of history and knowledge caused a rethinking of the nature of history (Todorov 1984; de Certeau 1988).

[9] Numerous Brazilians had been brought to Portugal and Spain by the time that Weiditz visited the court of Charles V (Metcalf 2005).

[10] The German gloss to the image identifies the figure as the "Countess of Zenete, dressed in the manner of the kingdom of Toledo, the wife of Henry the Count of Nassau; and so she follows with her eyes as her husband departs upon the high seas bound for Genoa."

[11] - Más una imagen hecha de pluma de las Indias de san Jerónimo guarnecida en su tabla con unos árboles en la misma pintura de diversos colores.
-Más una imagen de la Magdalena a lo galano hecho de pluma, guarnecida en su tabla.
-Más una mitra hecha de pluma de muchas colores que tiene en la una parte y en (Folio 11r) la otra a Dio Padre y a Ntro. Señor crucificado con toda la passion y con dos tiras que se mezclan (?) a la mitra por atras y a los dos cabos de ellas las armas de

Mendoza con un letrero (?)

- Más otra mitra de pluman hecha de muchas colores, tiene de lo alto a Dios Padre y en el medio a Jesu Christo crucifcado con todos los martirios de la passion, tiene los dos pedacillos que se mezclan (?) detrás con las mismas armas de Mendoza, (Folio 11v) (Augustín de Cuellar 1548)

[12] Folios 6v, 8v and 9r seem to represent the same juggler lying on his back in three slightly different positions so as to demonstrate the movements of the log; however, while the figure and facial features are almost the same, there are slight differences in the dress and facial ornaments of each figure.

[13] See Earl E. Rosenthal, **"Plus Ultra, Non plus Ultra, and the Columnar Device of Emperor Charles V"** *Journal of the Warburg and Courtauld* Vol. 34, (1971), pp. 204–228; and "The Invention of the Columnar Device of Emperor Charles V at the Court of Burgundy in Flanders in 1516," *Journal of the Warburg and Courtauld Institutes,* 36 (1973): 199–211.

[14] I thank my colleague Jeffery Hamburger for assisting with this translation.

[15] AGI Lima 565 L. 2, folios 327R–329R. On a silver field, a king in carnation, bound by two golden chains, flanked by two trunks, on which the king lays his hands. The image bordered in azure [blue] and loaded with seven monarchs in carnation bound by a golden chain. It is divided into three parts. In the first section, on a silver background, a sable [black] eagle crowned with gold, embracing two silver columns, joined by a silver banner that reads *PLUS ULTRA* in sable lettering. In azure, a city [Túmbez]; in silver, a lion and a tiger standing on their hind legs; and on waves of azure and silver, two ships with drawn sails. A double border contains a vert [green] background with eight silver sheep, and around that, a silver banner with sable lettering which reads *Carol Caesaris auspitio et labore ingenio ac impensa ducis Pizarro inventa et pacata.* In the second section, a silver lion with a golden crown held by a golden chain holds a golden F between its front paws, and around it a silver banner with the lettering *Indefesso labore meo. Fidem pro oculis habens tot comparavi divitas.* The third section has an azure border with seven golden griffins bound with a gold chain. Each griffin holds an azure banner. The coat of arms is crested with a helmet in gold and azure. Parting from the helmet is a demi-lion in gold wielding an unsheathed sword dripping in blood. Above the lion is a crown, which marks the emblem as that of a marquis. Over everything is a smaller coat of arms bearing the emblem of the Pizarro family [a vert pine tree on silver, with golden fruits, and two sable bears on their hind legs].

[16] The reading of the New World through classical history is a well-studied subject; see among others Hogden (1964), Lupher (2003), and McCormack (2006).

[17] Although the most famous Roman classical statues were being displayed in Italy, Spain too had them on display. One of the best and most public collections was in the Casa de Pilatos in Seville, where many devout Spaniards visited, before leaving for the New World. The better part of this collection of classical antiquities was formed by Per Afán de Ribera, I Duque de Alcalá, who as Viceroy of Naples (1558–1571) gathered together a remarkable collection that he sent to Seville. Juan de Verzosa y Ponce de León, the archivist of Philip II wrote that the Duke of Alcalá's passion for and collection of antiquities should be compared to those of Gran Duque Cosme de Medici and Cardinal Farnese. Pope Pius V, contributed to the Duke of Alcalá's collection in recognition of his passion. Among his collection were sculptures of Apollo and Pallas. But even before this addition, the Casa de Pilatos, which was begun at the end of the fifteenth century, already had numerous classical statues. (Mora 2001; Trunk 2002: 21–26)

[18] Acosta is here also refuting Bartolomé de Las Casas's paralleling of antiquity and the New World, a strategy through which Las Casas attempted to demonstrate the rationality of the Indians, in his *Apologética historia sumaria* (Las Casas 1967).

[19] Acosta's argument for why there was a lack of miracles in the New World of the kind produced for the conversion of the ancient world is followed very closely by Grijalva ([1624] 1924) in his chapter entitled "De la poca razon con que algunos dizen, q no vuo milagros en la conuersion de los Indios."

[20] En muchas partes de la christianidad, por el poco, ó ningun peligro, que ay de la Ydolatria se conservan, especialmente en Roma, la estatuas antiguas de los Ydolos, celebrando en ellas solo el primor de sus artifices, y la antiguedad de sus marmoles, porque como la fé, por gracias de dios, estan tan arraygada en las coracones de los fieles, ya no corre aquel peligro, de persumir, que ay diuinidad en

piedras: y assi con ellas las palacios, y los jardines, y Galerias.

Pero en las Yndias, como los Yndios originarios de aquellas paises, todavia son recien convertidos a la Fé, y esta tiene tan pocos años de possession, en los corazones de los descendientes de su Antigua gentilidad, aunque ay muy Buenos Chrisitanos entre ellos, todavia ay muchos flacos, y porque siendo todos generalmente de naturales facilamos de mudarse, ó ya fea de malicia, ó de falqueza suele suceder, que se buelven a los idolos, y á sus ritos, cerimomias antiques, no se permitan guadar, ni conferbar su idolos, ni sus huacas, ni por raçon de memoria, y demonstracion de la antiguedad. Assi se tiene mandado, que no solo en las yglesias, sino que en ninguna parte, ni publica, ni secreto de los pueblos de los Yndios, se pinte el Sol, La Luna, ni las estrellas; y en muchas partes, ni animals terrestres, volatiles, ni marinos, especialmente algunas especies de ellos, por quitarlos la occasion de bolver… á sus antiguos delirios, y deparates. (Melêndez 1681, 2:6163).

The distinctions being made between objects of beauty and idolatrous images of horror as sketched here might suggest a slight reworking of Belting's discussion of religion and art and the crisis of the image at the beginning of the modern age (1994). [21] This connection between John Dee's mirror and Tezcatlipoca is also made by Mezlay in his enlightening discussion of the Murillo paintings, which I happily came across after first writing this discussion of John Dee's mirror.

Bibliography

Acosta, José de
 1984 (1588) *De Procuranda Indorum Salute.* Madrid: Consejo Superior de Investigaciones Científicos.
Anders, Ferdinand
 1970 "Las artes menores." *Artes de México* 17, no. 137: 4–68.
Belting, Hans
 1994 *Likeness and Presence: A History of the Image before the Era of Art.* Chicago: University of Chicago Press.
Canny, Nicholas
 1998 *The Origins of Empire, The Oxford History of the British Empire Volume I.* Oxford: Oxford University Press.

Carletti, Francesco
 1965 (1606) *My Voyage around the World: A Sixteenth-Century Florentine Merchant.* Translated by H. Weinstock. London: Methuen.
Clucas, Stephen, ed.
 2006 *John Dee: Interdisciplinary Studies in English Thought.* Dordrecht, Netherlands: Springer.
Clulee, Nicholas H.
 1988 *John Dee's Natural Philosophy: Between Science and Religion.* London and New York: Routledge.
Columbus, Christopher
 1960 (1493) "Letter of Columbus, Describing the results of his first voyage." In *The Journal of Christopher Columbus*, translated by C. Jane, 191–202. New York: Clarkson N. Potter Inc.
Cummins, Thomas B. F.
 2005 "La Fábula y el Retrato: imágenes tempranas del Inca." In *Los Incas, Reyes del Perú*, 1–41. Lima: Banco de Crédito.
de Certeau, Michel
 1988 *The Writing of History.* Translated by Tom Conley. New York: Columbia University Press.
Estrada de Gerlero, Elena Isabel
 1994 "La Plumaria, Expresión artística por excelencia." In *México en el Mundo de las colecciones de arte*, 73–117. México: El Gobierno de la República.
García, Gregorio
 1981 (1607) *Origen de los Indios del Nuevo Mundo.* México: Fondo de Cultura Económica.
Grijalva, Juan de
 1624 *Cronica de la Orden de n. p. s. Augustín en las prouincias de la Nueva España, en quatro edades desde el año de 1533 hasta el de 1592. Por el p. m. f. Ioan de Grijalua, prior del Conuento de n. p. s. Augustín de México.* México, En el religiosissimo conuento de S. Augustín, y imprenta de Ioan Ruyz.
Guevara, Pedro de
 1788 (1560) *Commentarios de la Pintura…se publican por la primera vez con un discurso preliminario algunas notas de Antonio Ponz, quien ofrece su trabajo al Excelentísimo Señor Conde de Florida-Blanca, protector de las nobles artes (1560).* Madrid: Don Gerónimo Ortega: Hijos de Ibarra y Compañía, 1788.
Hogden, Margret T.
 1964 *Early Anthropology in the Sixteenth and*

Seventeenth Centuries. Philadelphia: University of Pennsylvania Press.

Koerner, Joseph Leo
1993 *The Moment of Self-Portraiture in German Renaissance Art*. Chicago: University of Chicago Press.

Las Casas, Bartolomé de
1967 (1552–61 *Apologética historia sumaria. Edición preparada por Edmundo O'Gorman, con un estudio preliminar, apéndices y un índice de materias*. México: Instituto de Investigaciones Históricas, Universidad Nacional Autónoma de México.

Lupher, David A.
2003 *Romans in a New World: Classical Models in Sixteenth-Century Spanish America*. History, Languages, and Cultures of the Spanish and Portuguese Worlds. Ann Arbor: University of Michigan Press.

Markham, Sir Clements
1999 "Introduction." In *History of the Incas*, Sarmiento de Gamboa, English translation and edited by Sir Clements Markham I-XXII. Originally published: Cambridge: Printed for the Hakluyt Society, 1907. (Works issued by the Hakluyt Society, 2nd ser., no. 22). Mineola, NY: Dover Publications.

Massig, Jean Michel
1991 "Early European Images of America: The Ethnographic Approach." In *Circa 1492: Art in the Age of Exploration*, edited by Jay Levenson, 515–520. New Haven and London: Yale University Press.

McCormack, Sabine
2006 *On the Wings of Time: Rome, the Incas, Spain, and Peru*. Princeton: Princeton University Press.

Meléndez, Juan
1681 *Tesoros Verdaderos de las Indias Historia de la Provincia de San Baptista del Peru de la Orden de Predicadores*. Rome: Nicolas Angel Tinassio.

Meslay, Olivier
2001 "Murillo and 'Smoking Mirrors.'" *Burlington Magazine* 143, no. 1175 (Nov.): 73–79.

Metcalf, Alida C.
2005 *Go-Betweens and the Colonization of Brazil 1500–1600*. Austin: University of Texas Press.

Mora, Gloria
2001 "La escultura clásica y los estudios sobre la Antigüedad en España en el siglo XVI, Colecciones, tratados, y libros de diseños." In *El coleccionismo de escultura clásica en España Actas del simposio*, edited by Matteo Mancini, 115–142. Madrid: Museo del Prado.

Murúa, Martín de
1590 *Historia del Origen y Genealogía Real de los Reyes del, Piru, de sus hechos. costumbres, trajes, maneras de gobierno*. Private Colllection.

Pagden, Anthony
1981 *The Fall of Natural Man*. Cambridge: Cambridge University Press.

Panofsky, Erwin
2005 (1943) *The Life and Art of Albrecht Dürer*. Princeton and Oxford: Princeton. University Press.

Pasztory, Esther
2005 *Thinking with Things: Toward a New Vision of Art*. Austin: University of Texas Press.

Pease G. Y., Franklin
1981 "Estudio Preliminar." In *Origen de los Indios del Nuevo Mundo*, ix–xli. México: Fondo de Cultura Económica.

Rosenthal, Earl E.
1971 "Plus Ultra, Non plus Ultra, and the Columnar Device of Emperor Charles V" *Journal of the Warburg and Courtauld* 34: 204–228.
1973 "The Invention of the Columnar Device of Emperor Charles V at the Court of Burgundy in Flanders in 1516." *Journal of the Warburg and Courtauld Institutes* 36:199–211.

Sarmiento de Gamboa
1988 (1572) *Historia de los Incas*. Madrid: Ediciones Polifemo.

Sauerlander, Willibald
2006 "Herkules in der poliyischen Ikonographie." In *Herkules besiegt die lernäische Hydra: der Herkules-Teppich im Vortragssaal der Bayerischen Akademie der Wissenschaften*, edited by Sabine Heym and Willibald Sauerlander, 21–94. München: Bayerische Akademie der Wissenschaften: In Kommission beim Verlag C.H. Beck.

Serlio, Sebastiano
1563 *Tercero y qvarto libro de architectura de Sebastian Serlio boloñes. En los quales se trata de las maneras de como se pueden adornar los edificios: con los exemplos de las antiguedades. Traduzido ã toscano en lengua castellana, por Francisco de Villalpando,*

impresso en Toledo en casa de Ioan de Ayala, 2nd. Spanish edition.

Silver, Larry
 2008 *Marketing Maximilian: The Visual Ideology of a Holy Roman Emperor.* Princeton: Princeton University Press.

Sherman, William
 2006 "John Dee's Columbian Encounter." In *John Dee: Interdisciplinary Studies in English Thought*, edited by Stephen Clucas, 131–140. Dordrecht, Netherlands: Springer.

Skinner, Stephen and David Rankine
 2004 *Practical Angel Magic of John Dee's Enochian Tables: From Four Previously Unpublished Manuscripts on Angel Magic, Being a Complete Transcription of* Tabula bonorum angelorum invocationes *in Manuscripts BL Sloane 307 and 3821 and Bodleian Rawlinson D1067 and D1363.* London: Golden Hoard Press.

Sullivan, Edward
 2007 *The Language of Art of the Americas.* New Haven: Yale University Press.

Strauss, Walter L.
 1974 *The Book of the Emperor Maximilian the First.* New York: Abaris Books.

Tait, Hugh
 1967 "'The Devil's Looking-Glass': The Magical Speculum of Dr. John Dee." In *Horace Walpole, Writer, Politician and Connoisseur: Essays on the 250th Anniversary of Walpole's Birth*, edited by W.C H. Smith, 195–212. New Haven: Yale University Press.

Trunk, Markus
 2002 *Die "Casa de Pilatos in Sevilla: Studien zu Sammlung, Aufstellung und Rezeption antiker Skulpturen im Spanien de 16Jhs.* Mainz am Rhein: Verlag Philipp von Zabern.

Todorov, Tzvetan
 1984 *The Conquest of America.* New York: Harper and Row.

Weiditz, Christoph
 1529 *Trachtenbuch.* Germanisches Nationalmuseum, Nuremberg.

Buildings at War:
Franciscan Architecture in Colonial Brazil

Nuno Senos

In the 1940s, the French scholar and curator of European painting at the Musée du Louvre Germain Bazin visited Brazil and developed an intense interest in the country's colonial architecture. He wrote a book—*The Religious Architecture of Baroque Brazil*, published in 1956–1958—that instantly became a reference and remains one to this day.[1] In his book, Bazin identified the thirteen convents of the Franciscan province of Saint Anthony, in the northeast, as a coherent group of architectural forms that seemed to be the result of an identifiable evolution in which each building influenced the next. These convents, Bazin declared, "are one of the most original creations of religious architecture in Brazil."[2] Yet the Franciscan convents of the northeast were never again the object of renewed, systematic attention. Bazin's proposal was very influential, and has been repeated, without any substantial revisions, ever since its publication in every survey on Brazilian colonial architecture.

In essence, Bazin identified two architectural typologies. The first came to life in the captaincy of Pernambuco, in the north, and is best exemplified by its earliest example, the church of Ipojuca (Fig. 1). Sparse in its usage of decorative motifs, it is very different from the second typology identified by Bazin, which formed in the captaincy of Bahia, in the south. Its earliest example can be found in the more ambitious church of Cairu (Fig. 2). Given that both churches were built in the 1650s, Bazin deemed the northern style too restrained by mannerist solutions (to use Bazin's terminology) and therefore conservative, while its southern counterpart, agitated and baroque (again in Bazin's terms), was judged progressive. In Bazin's view, the subsequent history of the Franciscan churches of northeastern Brazil exhibited the triumph of baroque, progressive forms over the mannerist, conservative proposals of Pernambuco.

Thus the church of Penedo (Fig. 3), for instance, exemplified the introduction of some curved animation in a solution that remained rectangular and still rejected the stepped proposal of Cairu, as did the later church of Santa Maria Madalena (Fig. 4), recently rechristened Marechal Deodoro. On the contrary, Igarassú (Fig. 5) represented an attempt at replicating the model of Cairu through the adoption of the vertically receding façade enlivened by large flanking scrolls, a solution that would come to its apex in Paraíba (Figs. 6–7).

Before moving on to my critique of Bazin's proposal I would like to acknowledge the importance of his contribution. The French scholar was correct in pointing out the exceptional interest of these churches, and by underscoring it he placed them on the thenceforth mandatory map of Brazil's colonial architecture. In fairness it should also be said that his study of the Franciscan churches was but a chapter in a much larger and still exceptionally valuable book.

This said, my own research has led me to diverge from Bazin's conclusions in several respects. First, in fine-tuning and often correcting the chronology Bazin worked with, I realized that the clean-cut and very attractive development process he proposed was not valid.

Second, looking into the political context of the 1650s made it clear to me that the order's choices in church architecture were not a matter of taste or fashion, mannerism *versus* baroque, conservative *versus* progressive, as Bazin proposed, but were rather political and ideological. In this article I will argue that certain fundamental issues regarding power and religion gave rise to the creation of two parties inside the Brazilian branch of the Franciscan order, each of which developed its own architectural discourse as a public manifestation of its standing and allegiance in the issues at stake.

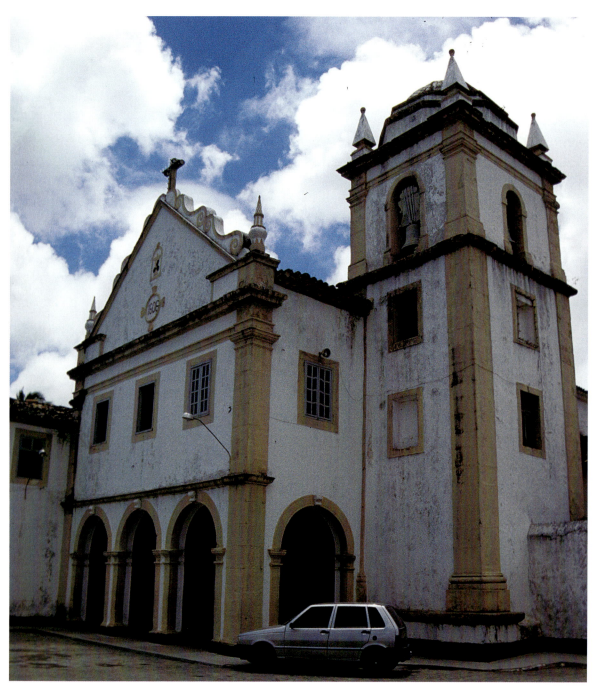

Fig. 1. Church of Santo António, Ipojuca, Pernambuco, 1653–1657. Façade. Photo by the author.

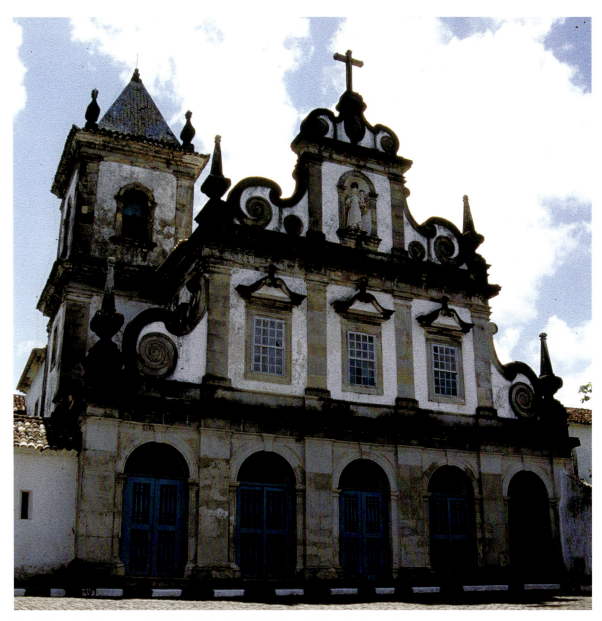

Fig. 2. Church of Santo António, Cairu, Bahia, 1654–1661. Façade. Photo by the author.

Fig. 3. Church of Nossa Senhora dos Anjos da Porciúncula, Penedo, Alagoas, c. 1716. Façade. Photo by the author.

Third, and as a consequence, the transformations that Bazin noted in the architecture of these churches were not the result of a blending of the two models or of the triumph of baroque solutions over conservative ones. In the context I am looking at here, architectural transformation attests to the victory, not of one style over the other, but rather of one of the parties over its opponent.

A full discussion of my own approach to these churches involves analyzing various parts of the convents, not only the churches, in both architecture and decoration. It also entails addressing doctrinal and ideological matters that were at the center of the conflict. In this article, however, I limit my remarks to church façades, the most visible part of a convent, often the most prominent architectural presence in its city's physiognomy, and the element that received by far the most careful architectural treatment.[3]

The Pernambuco Type

The façade of the Franciscan church of Ipojuca is the earliest of the group. It was built between 1653 and 1657 and is organized in three levels.[4] In the first one, three arches open onto a porch, inside which a single central door provides access to the church (the lateral doors we see today were added in 1929).[5] This porch was originally open on both its flanks by means of two arches, only one of which remains intact. Its counterpart was walled in later but is still visible.

The second level of the façade is defined by a thin cornice at the bottom and, at the top, by a full entablature. Three very simple windows are open at this level, corresponding to each of the arches below. The third and last level of the façade is composed of a triangular pediment animated by a series of discreet scrolls. The ornamental treatment

Fig. 4. Church of Santa Maria Madalena, Marechal Deodoro, Alagoas, constructed c. 1700; alterations between 1784-1793. Façade. Photo by the author.

Fig. 5. Church of Santo António, Igarassú, Pernambuco, completed 1664; façade additions in 18th century. Façade. Photo by the author.

of the whole is very plain, mostly relying on flat, whitewashed, plastered surfaces interrupted only by stone (or its painted appearance) in the structural elements, pilasters, cornices, and window frames.

Writing in the middle years of the eighteenth century, the chronicler of the order, Jaboatão, is the first to remark on the similarities between this church and those of Serinhaém and Recife.[6] Of the three, Ipojuca is the only façade preserved mostly untouched until today. The church of the convent of Recife received a new façade in 1770, and the one in Serinhaém collapsed in the mid-nineteenth century, being subsequently replaced by a modern façade (Fig. 8) that vaguely preserves the memory of the original one.[7]

There are no images of the original façade of Serinhaém, but a close analysis of the original single arch and the fragment of cornice sitting on it, combined with Jaboatão's mention of a three-arched porch and of two other arches that would have opened on the flanks of the porch, makes it easier to imagine the original porch of Serinhaém as prob-

ably following Ipojuca's model. Above the arches there are three (now rounded) windows, and the whole is crowned by a triangular pediment topped by a series of modern steps that probably preserve the memory of the scrolls that, as in Ipojuca, once adorned the pediment. The two towns are very close to one another, and their Franciscan churches were probably built at around the same time, in the 1650s.

Also in Pernambuco is the slightly more problematic church of Igarassú (Fig. 5). Finished in 1664, this façade presently incorporates elements that are inconsistent and that have remained so far unnoticed. The two segments of blind wall that extend to unequal widths at the sides of the three canonical arches seem not to belong to the original building. They disturb the rhythm established by the arches and replace it with a rather awkward and excessive white surface. In Ipojuca and Serinhaém, two pilasters flank the façade, marking its limits. In Igarassú, the two segments of wall extend beyond the pilasters. Moreover, they make no attempt at

Fig. 6. Church of Santo António, João Pessoa, Paraíba, constructed 1680s; façade additions 1779. Façade. Photo by the author.

Fig. 7. Church of Santo António, João Pessoa, Paraíba. View of the porch; central door 1680s, flanking doors 1734. Photo by the author.

replicating either the entablature or the arches. The scrolls on top of these lateral sections do match the same motifs used in the top level of the façade, but whoever built them did not know how to design a proper spiral and therefore made them uneven.

The pediment in Igarassú is no longer triangular but was replaced with a square section flanked by similar scrolls, and topped by a smaller structure that again repeats the scrolls motif. Lateral segments and pediment are similar to each other and therefore probably belong to the same campaign. But they do not seem to belong to the same reasoning that designed the central part of the façade. It can therefore be assumed that this façade is the product of two different campaigns, one that designed the three arches of the porch and the windows above, finished in 1664,[8] and an eighteenth-century one, which I come back to later in this text, that added the rest.

Essentially, the oldest part of the façade of Igarassú corresponds to a refinement of the model established by the two previous churches. All three are located in Pernambuco, all were built around the same time, and all are organized into a lower level composed of three radial arches, with three corresponding windows on the first floor. Presumably, Igarassú too was originally topped by a triangular pediment.

Like Igarassú, all other façades in Pernambuco have been altered from their original design at a later date. In most cases, however, some vestige of the earlier version remains and can be identified. Such is the case of the slightly later church in Paraíba (Fig. 6), probably finished in the 1680s. The spectacular façade we see today dates to 1779.[9] Inside the porch as it exists today, however, we find an inconsistency that needs to be clarified (Fig. 7). The three doors that open onto the nave have always been dated to 1734 on the basis of an inscription above a lateral door. However, even a quick look at all three doors makes it clear that they cannot belong to the same campaign. Not only does the central door look entirely different from the lateral ones, it also looks much older. The central door belongs, in fact, to the original building, and can be dated

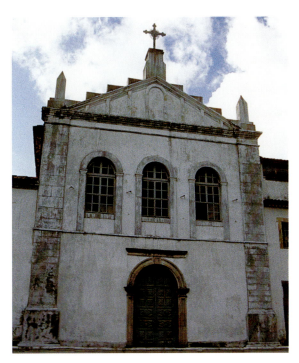

Fig. 8. Church of Santo Francisco, Serinhaém, Pernambuco. Original façade constructed 1650s; current façade a modern replacement. Photo by the author.

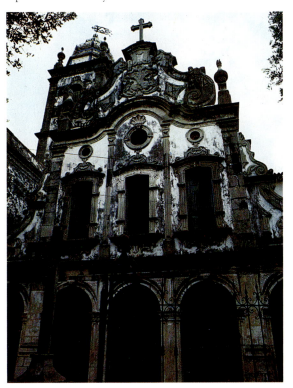

Fig. 9. Church of Santo António, Recife, Pernambuco. Completed 1695; façade rebuilt 1770. Photo from AA. VV. *Arte no Brasil* (São Paulo: Abril Cultural, 1979).

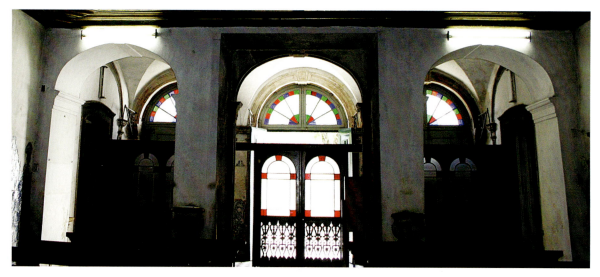

Fig. 10. Church of Santo António, Recife, Pernambuco. View of original porch from the nave, 1695. Photo by the author.

Fig. 11. Church of Bom Jesus da Glória, São Cristóvão, Sergipe. Façade, lower porch c. 1700; altered late 18th century. Photo by the author.

to the 1680s.[10] In the absence of any other data, I cannot conclude that the façade of the church of Paraíba originally looked like the other ones just described. Nevertheless, the first church had only one door into the nave, and not three as it does today. At least in this respect we can be sure that the model established in Ipojuca was followed in Paraíba.

This typological series is completed by three more façades built in the 1690s or in the early years of the eighteenth century: Recife, Alagoas, and São Cristóvão. The present façade in Recife dates to 1770 (Fig. 9).[11] The original one was built in 1695,[12] and we know it belonged to this genealogy because Jaboatão established a parallel with those of Ipojuca and Serinhaém.[13] Inside the now five-arched porch, the original three-part structure and even its lateral arches are still visible (Fig. 10).

The façade in Marechal (Fig. 4), originally built c. 1700,[14] was also altered even later, between 1784 and 1793.[15] From the original design it retains the three ground-floor arches and, most important, the remains of a fourth one on the flank, which was walled in, presumably during the late eighteenth-century campaign.

The church of São Cristóvão (Fig. 11) is the last in the series that is still standing. The analysis of this façade makes it clear that only the porch, with its three radial arches resting on solid pillars and a fourth opening in the flank, was built c. 1700.[16]

Fig. 12. Church of Nossa Senhora das Neves, Olinda, Pernambuco. Façade built 1714; altered 1750s. Photo from Leonardo Dantas Silva, *Pernambuco Preservado* (Recife: 2002).

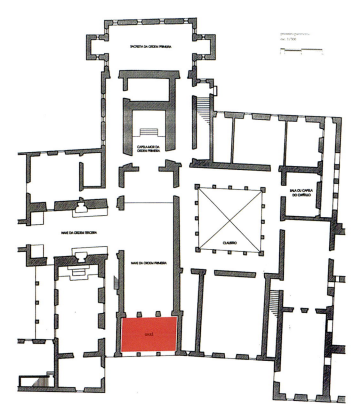

Fig. 13. Church of Nossa Senhora das Neves, Olinda, Pernambuco. Plan by Instituto do Património Histórico e Artístico Nacional, adapted by the author.

A particular feature that this church shares with Marechal is that its bell tower is not set back, as in the other examples, but is aligned with the façade. This accounts for the lack of the fifth arch that should open on the side where the tower is located.

The archaeology of the façade of Olinda (Fig. 12) remains somewhat tentative. The church was originally built in 1714 and then altered by a later, 1750s campaign.[17] As we see it today, this church has no porch. However, the original one is immediately readable on the plan of the building (Fig. 13). It was simply integrated into the nave by displacing the doors from their original location to the front arches of the façade. The 1750s campaign Olinda went through is very similar to that of Igarassú, and, as in Igarassú, only the central part of the façade remains relatively untouched.

Last in this series, the façade of the church of Penedo (Fig. 3) dates from around 1716, and the essential design of its first two floors remains con-sistent with the model we have been looking at.[18]

All the examples mentioned so far are located in the captaincy of Pernambuco or in its sphere of influence. In spite of later changes, it is clear that they share a set of architectural features that are repeated with few variations. We are therefore in the presence of an architectural typology that I will call the Pernambuco type.

The Bahia Type

Between 1654 and 1661,[19] at the same time when the façade of Ipojuca (Fig. 1) was devised, a considerably different model was being formulated at the southern tip of the Franciscan province of Saint Anthony, in the town of Cairu (Fig. 2). Various features separate this façade from the ones we have looked at before. The five-arched porch, entirely faced in carefully molded stone, though still in the same family as the three-arched porches, lends the building a sense of sophistication absent in the Per-

Fig. 14. Church of Santo António, Paraguaçu, Bahia, 1658–1686. Façade. Photo from Edgar de Cerqueira Falcão, *Relíquias da Bahia* (São Paulo: 1940).

nambuco churches. Furthermore, there is an overall sense of unity to this façade that comes from the fact that it was the product of a single campaign. In this church the fourth and fifth bays, as well as the giant volutes, were not added to an earlier structure; they were part of it from the beginning. In fact, there are no scars, no inconsistencies, no mismatched forms in this façade; no element is out of scale, nothing looks like it was pasted on at a later date.

The most fundamental feature of this façade, however, which gives it a distinctive flavor, is the indentation of its floors in relation to those immediately below, and the use of volutes for the transition between them. Especially when seen against the background of the Pernambuco type façades, this one reveals an ambition, a care invested in its decorative elements and in its impact on the approaching worshiper, that we have not seen so far.

The same sense of monumentality is evi-

dent in what is perhaps the most impressive of the buildings under analysis here, the convent of Paraguaçu (Fig. 14), the only one in the province that has been abandoned. Today it is a glorious ruin, slowly collapsing near the quiet waters of a remote area of the inner Bay of All Saints.

Built between 1658 and 1686,[20] it was, obviously, modeled on the nearby church of Cairu. Again in Paraguaçu we find the fully developed, five-bay porch, surmounted by three bays of windows, in turn topped by a single bay with a niche. Stone was used to face the entire lower floor but only some of the structural elements on the remaining two floors. And finally, giant volutes flank each of the two top floors.

Cairu and Paraguaçu pertain to a different realm of architectural thinking than the churches of the Pernambuco type. While severity and economy of means are key to the Pernambuco façades, monumentality and exuberance replace

Fig. 15. Church of São Francisco, Salvador, Bahia, 1708–1723. Façade. Photo by the author.

them in the Bahia type. Two more southern churches need to be mentioned before I move on to the eighteenth-century campaigns that altered the aspect of the churches of Pernambuco.

The present-day Franciscan church of Salvador (Fig. 15) was started in 1708, and its façade was completed in 1723.[21] No doubt the status of Salvador as capital of the viceroyalty, as well as the rivalry with the neighboring Jesuits, explains the exceptional character of this façade. Like all cathedrals in Portugal (but unlike any of the churches discussed so far), this one has two bell towers (instead of a single one) at the front of the façade, which is also unique in that its central section is entirely faced in stone. The first floor does not contain a porch; as the chronicler explains, the friars expected to be able to buy an extra piece of land but in the end could not do so. The three central doors therefore adopted the format of the Roman triumphal arch. Consequently, the second floor is still organized in three bays but they are no longer of the same width. Above each window, a

pair of scrolls is reminiscent of the design of the windows in Cairu, also the model for the elaborate pediment. All in all, in spite of the differences, there is still a familiar Franciscan look to this church.

In emulation of neighboring Salvador, Sergipe do Conde (Fig. 16) rebuilt its convent entirely, starting in 1718.[22] The means available were not as abundant and therefore the façade is not entirely faced in stone. However, there was more land at the friars disposal and thus Conde was able to construct the full, five-bay porch that could not be built in Salvador. Again, in spite of the variations, the façade of Conde remains within the Bahian formal family analyzed so far. The porch is perhaps the most recognizable feature, but the treatment of the pediment also makes it part of the same formal family.

To continue the family metaphor, Salvador and Conde are cousins removed from the rest of the nuclear family by only one or two degrees. Without the knowledge of the chain of buildings to which they belong, an important part of the identity of these

Fig. 16. Church of São Francisco, Sergipe do Conde, Bahia, begun 1718. Façade. Photo by the author.

churches is lost. In turn, the chain does not make as much sense if they are not taken into consideration.

Buildings at War

Why did these two typologies form? What did they mean? Until the middle of the seventeenth century, the Franciscan friars of Brazil were institutionally dependent on their Portuguese brothers.[23] From the 1640s onwards, a dispute formed in which some Brazilian brothers who wanted to become independent opposed others who wanted to remain under the supervision of the metropolis. Jaboatão, the main written source on this episode, shows that once independence became a fact, the core of the discussion shifted from the issue of autonomy to that of hegemony: who was going to be in charge in the newly independent Brazilian province?[24]

The anti-independence party centered in Pernambuco, with its capital in Olinda, the oldest city in the colony and the historical headquarters of the Franciscans in Brazil; the pro-independence party was headquartered in Salvador, Bahia, the center promoted by the crown. In the 1650s, a different

provincial (the head of the province) was appointed in each city, each of them refusing to obey the other. Offensive words, letters, and gestures were exchanged; friars were excommunicated, arrested, and sent to Portugal under military custody; papal briefs, royal letters, and even the personal intervention of the viceroy were nullified and ignored.

In the last days of 1685 the situation had become so intense and hopeless that one of the parties obtained the support of the royal army to enforce its authority, and had the convent of Olinda surrounded in a siege that failed only because the local army decided to defend its convent. For Jaboatão, these conflicts were like "civil wars, which, so pernicious in secular republics, are all the more abominable in sacred and religious ones."[25] A civil war indeed.

The following year, the king himself ordered his army to intervene and lay siege to the convent of Recife. Eventually the surrounded friars surrendered and left their holy shelter in a procession, parading a monstrance through the streets of Recife while singing a psalm entitled *Thus the subjugated people of Israel left Egypt*. Outside, tears mingled with "some less than religious words" as the defeated friars passed by.

This extraordinary episode is not the most dignifying in the history of the Franciscan order in Brazil, which is probably why it is virtually absent from modern scholarship. Jaboatão, however, dedicates over one hundred detailed and rather strong pages to what he calls "an abominable civil war." The metaphor of war I use in the title of this article, which also pays due homage to Serge Gruzinski's book,[26] is therefore not entirely mine—and it is not entirely a metaphor, either. What Jaboatão (as well as all the historians and art historians who succeeded him) did not understand is that architecture was deployed as a weapon in this war.

Models

In order to understand the formal choices made in Ipojuca, we need to look at the models that inspired it, starting with the church of Saint Anthony in Castanheira do Ribatejo, near Lisbon, Portugal (Fig.

17), built a little over a century earlier. Like that of its younger sister in Ipojuca, the façade of Castanheira is organized in three levels, a porch on the first, windows on the second, and a triangular pediment on the third. The pediment is especially important because it is animated by a series of scrolls similar to those in Ipojuca. The most important difference is the configuration of the porch, with a single arch in the Portuguese example and three in the Brazilian one. This difference is explained by the fact that in the intervening century a tradition of Franciscan façades with porches developed in Portugal.

This tradition, which can only be briefly sketched here, starts with early examples such as Évora (1490s), where the porch is a multi-arched external structure that leans on the façade. In time, porches became a one-arched element and were integrated into the body of the church itself, as in Castanheira (1540s). This solution endured throughout the century, as is shown, for instance, by the Franciscan church of Penamacor (1571). The church of Saint Francis in Chaves (1635–1637) illustrates the next step in the process, in which the single arch was replaced by a triple partition, a solution that, as we have seen, traveled to Brazil (Fig. 18).

These examples make it clear that the Pernambuco churches were modeled on the image of their Portuguese Franciscan counterparts. From the later examples, Ipojuca took the three-arched porch, but it is Castanheira that provides the model for the scrolls that decorate the Brazilian pediment.

In contrast, Cairu and its Bahian companions did not aim at replicating the same model. They still preserve the Franciscan trademark porch, but the differences are more striking than the similarities. Where Ipojuca is simple and bare, Cairu is complex and elaborated: the porch is more developed; stone is more prominent; and the indented floors combined with the gigantic volutes repeated at three different levels make the overall effect much more dynamic.

To establish a genealogy of forms for Cairu is also a less obvious task. True, the five-arched porch can be seen as a development of its three-

Fig. 17. Church of Santo António, Castanheira do Ribatejo, Lisbon. 1540s. Façade. Photo by the author.

Fig. 18. Church of Saint Francis, Chaves, Portugal. 1635—1637. Façade. Photo by the author.

Fig. 19. Church of São Francisco, Salvador, Bahia. View of the nave, decorated between 1723-1743. Photo by the author.

part Portuguese and Pernambucan counterparts. Volutes, important protagonists in this façade, were also common in European architectural design. However, I could find no other previous example in which these identifiable elements were combined in the specific arrangement they have in Cairu: ever-narrower floors where volutes are consistently repeated to ease the transition between floors. Cairu combines parts of several other buildings but achieves a final result that ultimately stands on its own. This solution, soon replicated in other churches in its area, needs to be considered a genuinely new invention, perhaps the first truly Brazilian building.

Symptoms of Allegiance

Why was it that the Pernambuco churches adopted a Portuguese model while their Bahian counterparts decided to invent a formula of their own? Can mean-

ing be assigned to these formal choices? I think so. If Franciscan Brazil was to be an extension of the Portuguese province, it was only logical that the churches on both sides of the Atlantic should look alike. Consequently, the Pernambuco party, which wanted to stay attached to the Portuguese mother province, chose a Portuguese model for its own churches— ones whose façades became the architectural symbol of a political allegiance. In contrast, the friars from Bahia wanted a different Brazil and so they built different churches. Whereas the churches in Pernambuco followed a Portuguese model to demonstrate their intention to remain under Portuguese jurisdiction, those in Bahia created a new, independent model to proclaim their desire for independence.

After the question of independence was resolved, the two parties remained at war over the control of their newly established province, and

Fig. 20. Franciscan convent, Olinda, Pernambuco. Entrance hall, 1754. Photo from Clarival do Prado Valladares, *Nordeste Histórico e Monumental* (Salvador: Odebrecht, 1982–1990).

buildings continued to be used as weapons in this conflict. When the dispute was finally resolved in 1689 and the time came to reconstruct the church of Salvador, headquarters of the triumphant party of Bahia and therefore the new, undisputed center of the province, it became clear that monumentality was the new official tone. Although in this essay I have confined myself to the façades, at this point I cannot resist referring to the interior of this church to underline my point (Fig. 19). The new convent of Salvador put an end to the architectural ideal of simplicity and severity embodied in the churches of Pernambuco and consecrated monumentality and splendor as values for the order to embrace.

Eighteenth-Century Campaigns in Pernambuco

Art and architecture had been used as weapons in times of war. Now that peace had come, they were used to spread the values and the image of the winner. After the resolution of the conflict, construction and decoration campaigns transformed most of the Pernambuco convents to make them look like those of Bahia. These campaigns were not about updating artistic choices; they were rather a way of proclaiming the triumph of Bahia over Pernambuco.

The façade of the church of Igarassú (Fig. 5) provides a good example of these campaigns. To the original, seventeenth-century central section of the façade, two lateral walls topped by large volutes were added, as was a third level replacing what might have originally been a triangular pediment. These new additions tried to transform Igarassú from the severe Pernambuco type to the more playful and complex model of Bahia. A comparison between these new additions and the façade of Cairu (Fig. 2) shows that the latter was the model for the former.

Fig. 21. Franciscan convent, Olinda, Pernambuco. Detail of the painted ceiling of the entrance hall, 1754. Photo by the author.

Olinda, as headquarters of the Pernambuco party, had lost the war, and its convent was consequently transformed through a campaign that, as in the previous example, extended the façade by means of two segments of blind wall, and introduced two tiers of giant volutes in its façade (Figs. 12–13). In Recife, changes were even more radical, as a whole new façade was attached to the former building, making it disappear under its new physiognomy (Figs. 9–10). Such was also the case in Paraíba, perhaps the most spectacular of the lot (Figs. 6–7).

Conclusion

Little by little, all of the Pernambuco churches were changed to look like Bahian ones. The Franciscan war was over, and other aspects of the life of the colony dictated subsequent changes and events. By the middle of the eighteenth century, a whole new and extremely wealthy region, Minas Gerais (area around Belo Horizonte), had been added to Brazil. The new great quarrel no longer opposed Pernambuco to Bahia, Olinda to Salvador. In fact, Olinda was not even one of its terms. In 1763, the capital of the colony was transferred further south, to Salvador's new rival, Rio de Janeiro.

As if unaware of these changes in the larger dynamics of the life of the colony, Olinda kept on fighting, no longer with armies but rather with art and architecture. In 1754, a new entrance hall was added to the convent (Fig. 20). Decorated with a spectacular set of tiles that line the walls, it is completed with a monumental painted ceiling that is actually too low to be seen as a whole. If one takes the time to look at it carefully, one ends up understanding that this ceiling depicts the triumph of the Franciscan Order in the four parts of the world, personifications of which surround the image of its founder, Francis (Fig. 21).

Olinda, however, was no longer triumphant. Its fight was vain and the city was slowly forgotten. Visiting it today, the tourist has a constant impression of being in a semi-abandoned town always on the verge of being swallowed by the jungle. Its churches and little else preserve the memory of a seventeenth-century Franciscan war and of other days gone by.

Notes

1 Germain Bazin, *L'Architecture Religieuse Baroque au Brésil*, 2 vols. (Paris and São Paulo: Librairie Plon and Museu de Arte, 1956–1958). This book was later republished in a Portuguese, revised edition which is the one that will be used here: *A Arquitectura Religiosa Barroca no Brasil*, 2 vols. (Rio de Janeiro: Editora Record, 1983).

2 Bazin 1983, 1:137. See the chapter titled "Uma tradição arquitectónica: a escola franciscana do Nordeste," 112–130.

3 For a full discussion of this topic see Nuno Senos, "Franciscan Art and Architecture in Colonial Brazil: 1650–1800" (PhD diss., Institute of Fine Arts of New York University, 2006).

4 Venâncio Willeke, OFM, ed., "Livro dos Guardiães do Convento de Santo Antônio de Ipojuca, 1603–1892," *Revista do Instituto Arqueológico, Histórico e Geográfico Pernambucano* 46 (1961): 374–415. The dates for the construction of the façade are on p. 382.

5 Venâncio Willeke, OFM, "Convento de Santo Antonio de Ipojuca," *Revista do Patrimônio Histórico e Artístico Nacional*, no. 13 (1956): 255–353. The information on the new doors is on p. 315.

6 The first part of Jaboatão's chronicle was published in 1761, in two volumes. The second part remained unpublished until the nineteenth century, when both parts were published in a single edition, which is the one used here: Antonio de Santa Maria Jaboatão, OFM, *Novo Orbe Serafico Brasilico, ou Chronica dos Frades Menores da Provincia do Brasil*, 5 vols. (Rio de Janeiro: Typ. Brasiliense de Maximiano Gomes Ribeiro, 1858–1862). The information pertinent at this point can be found in vol. 2, pp. 480 and 509.

7 Bazin 1983, 2:150.

8 Dates for this first campaign are in Jaboatão, 1858–1862, 2:332–333.

9 According to an inscription on the façade.

10 For the full argument that leads to this chronology see Senos 2006, 57ff.

11 According to an inscription on the façade.

12 According to an inscription on the porch.

13 Jaboatão 1858–1862, 2:480, 509.

14 For the full argument that leads to this chronology see Senos 2006, 60.

15 These dates come from two inscriptions on the façade, one above the window in the bell tower (1784), the other just under the niche in the pediment (1793).

16 For the full argument that leads to this chronology see Senos 2006, 60ff.

17 For a full discussion of the complex chronology of the construction of the convent of Olinda see Senos 2006, 62ff.

18 For the full argument that leads to this chronology see Senos 2006, 61ff.

19 Jaboatão 1858–1862, 2:565 and Bazin 1983, 2:14.

20 Jaboatão 1858–1862, 2:538; Bazin 1983, 2:17; and Fernando Luiz da Fonseca, *Santo Antonio do Paraguaçu e o Convento de São Francisco do Conde* (Salvador: Universidade Federal da Bahia, 1988), 19.

21 The successive campaigns that entirely changed the original convent are exceptionally well documented, especially when compared to the other convents. Jaboatão 1858–1862, 2:259 ff., and Venâncio Willeke, OFM, ed., *Livro dos Guardiães do Convento de São Francisco da Bahia (1587–1862)* (Rio de Janeiro: IPHAN, 1978).

22 Jaboatão 1858–1862, 2:503ff. Fragments of a *Livro dos Guardiães* of this convent seem to have survived. They are mentioned in Willeke's introduction to Venâncio Willeke, OFM, ed., "Livro dos Guardiães do Convento de Santo António da Paraíba," *Revista do Patrimônio Histórico e Artístico Nacional*, no. 16 (1968): 253–304 (mention on p. 173) and in Fonseca 1988, 97. If these fragments still exist, I did not find them.

23 Besides the already mentioned Jaboatão, the other important source for the history of the Franciscans in Brazil is Manuel da Ilha, OFM, *Narrativa da Custódia de Santo António do Brasil (1584/1621) Divi Antonii Brasiliae Custodiae Enarratio Seu Relatio*, ed. Venâncio Willeke, OFM and Ildefonso Silveira, OFM (Petrópolis: Vozes, 1975). The most important studies are Dagoberto Romag, OFM, *História dos Franciscanos no Brasil (1500–1659)* (Curitiba: 1940); Basílio Roëwer, OFM, *A Ordem Franciscana no Brasil*, 2nd. rev. ed. (Petrópolis: Vozes, 1947); and Roëwer, *Páginas de História Franciscana no Brasil*, 2nd. rev. ed. (Petrópolis: Vozes, 1957).

24 For a full discussion of this previously unmentioned fierce institutional war see Senos 2006, 146ff.

25 Jaboatão 1858–1862, 1, p. 318. Translation by author.

26 Serge Gruzinski, *Images at War: Mexico from Columbus to Blade Runner (1492–2019)* (original ed. in French, 1990; Durham & London: Durham University Press, 2001).

La voz del anonimato:
Authorship, Authority, and Andean Artists in the Construction of Colonial Quito

Susan Verdi Webster

Histories of colonial Latin American architecture frequently celebrate the essential role of indigenous construction workers, without whom "the most extensive building program ever undertaken by a colonial power"[1] could not have been realized. However, characterizations of this process tend to perpetuate Renaissance notions regarding the supremacy of idea over praxis (*invenit* versus *fecit*), and to assign the intellectual design and direction to European masters and the manual labor to native people. This formula characterizes the Andean participants as laborers and "artisans" rather than artists and skilled professionals, and denies them agency by asserting that they were only and always "following orders."

The history of architecture in colonial Quito between 1580 and 1720, the period of greatest architectural expansion in the city, contradicts this interpretation. Systematic study of all notarial records, city council records, and numerous related archival materials reveals the ubiquitous presence of Andean masters of the building trades and demonstrates the high level of control that they exerted over both architectural design and construction. This study seeks to restore agency and identity to Andean artists and architects by documenting their authorship and authority in the construction of colonial Quito.

Again according to previous scholarship, the imposition of the Spanish guild system throughout the Americas permitted close control over the membership, training, and production of the building trades.[2] Because administrative control of the guilds lay in the hands of the city council, scholars have often presented the builders as dominated by Spanish professionals and the colonial hierarchy. Indeed, the structure and regulations of the guilds often did reflect racial and class tensions, and in some regions of the colonial Americas European professionals actively fought to keep trade secrets and practices out of indigenous hands.[3] Because many guilds excluded nonwhite members, in some regions "informal" trade groups were established among indigenous professionals, which operated in a manner parallel to that of the "official" guilds.[4] Spanish control over the guilds was not as ubiquitous as it might sometimes appear in the literature.

Another frequent assumption is that native participation was anonymous. Scholarship often focuses on the authorship of buildings, designs, and plans, attributing them to Spaniards or other European masters and/or locating their sources in European architectural treatises. In general, native contributions tend to be recognized only en masse as the work of anonymous skilled and/or unskilled labor. Naming, which admits the possibility of individual agency, is largely absent with respect to native artists. Although scattered references to the name of one or another indigenous master builder appear in the literature, they are typically cited as remarkable exceptions to the rule.[5] No systematic studies of such masters have been undertaken. Elizabeth Wilder Weismann's insightful 1975 remarks on this theme still resonate today:

> Sixteenth-century anonymity, explained by the special conditions of the Conquest (and not without reference to the apparent anonymity of pre-Conquest artists) merged into Baroque anonymity, for an art of communal projects, impersonal styles, and faceless craftsmen.[6]

But, as we shall see in the case of Quito, systematic examination of notarial records in Latin American urban centers can reveal the names, activities, and works of numerous native masters.

Indeed, the enormous contribution of indige-

nous artists and workers to the realization of colonial architecture is indisputable in virtually all aspects of the process, from extracting and manufacturing and purveying the necessary materials—stone, wood, bricks, mortar, etc.—to constructing the buildings themselves. Although the widespread erection of immense colonial churches and monasteries was perforce a collaborative effort, the generalized assumptions regarding authorship, authority, and agency outlined above warrant further and more nuanced examination in terms of their applicability to specific regional and temporal examples.

One such specific case is colonial Quito, the center of an important Spanish *audiencia* (kingdom) during the sixteenth and seventeenth centuries. By 1700, more than a century and a half after it was founded, the city merited the sobriquet "cloister of the Andes," for it was home to nearly a dozen monasteries and convents, seven parish churches, and a cathedral, as well as numerous religious retreats, hermitages, and independent chapels, all in a population of approximately fifty thousand (Fig. 1).[7] Quito was the first city to be named a UNESCO World Heritage Site, to a great extent because of its remarkable architectural patrimony (Fig. 2).

The vast majority of the colonial buildings extant today were constructed during the late sixteenth and seventeenth centuries—Quito's "golden age" of architectural expansion—replacing earlier more ephemeral structures of adobe and thatch or smaller masonry buildings (Fig. 3). Although Europeans designed and supervised the construction of some of Quito's colonial buildings, from an early date numerous skilled Andean masters (as well as countless journeymen and laborers) were also intimately involved in architectural production. Many of these masters were undoubtedly the descendants of earlier indigenous professionals who accumulated knowledge of European construction techniques and styles from friars and colonists after the founding of the city in 1534.[8] Despite their omnipresence, the names, activities, and works of these Andean profes-

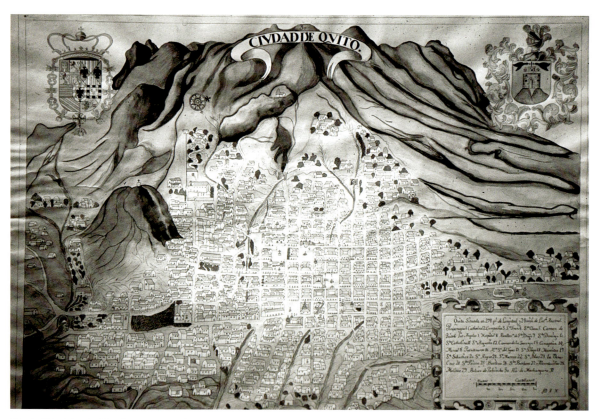

Fig. 1. Dionisio de Alcedo y Herrera, *Map of Quito*, 1734. Colección Mena Caamaño, Centro Cultural Metropolitano, Ecuador. Photo: Hernán L. Navarrete.

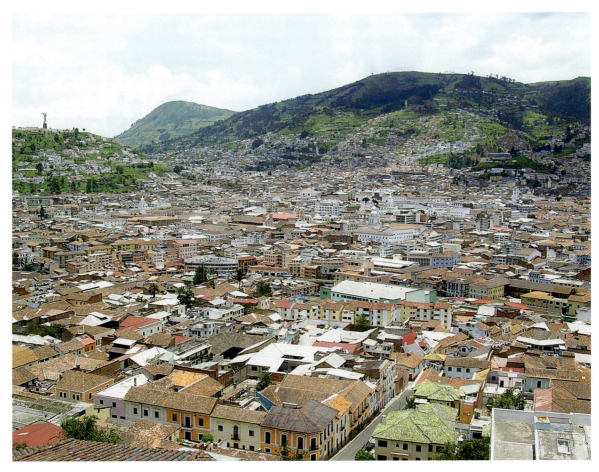

Fig. 2. Colonial center of Quito, Ecuador. Photo: Susan V. Webster.

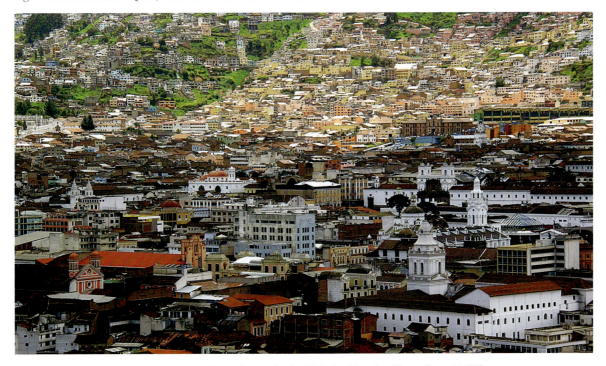

Fig. 3. Churches, monasteries and convents in the heart of colonial Quito, Ecuador. Photo: Susan V. Webster.

sionals have been virtually ignored in the literature.[9]

Quito serves as a useful case study because of its high percentage of indigenous inhabitants compared to other Latin American urban centers of the late sixteenth and seventeenth centuries. Although in population Martin Minchom ranks mid-colonial Quito as "a member of the relatively exclusive club of great Spanish American cities, alongside Mexico City, Lima, or the major mining centers like Potosí at their cyclical peaks;" indeed, its demographic composition appears to align it more closely with many of the medium-sized provincial cities of the period, such as Cuzco or Sucre.[10] Unlike Lima, Mexico City, and several other major Latin American urban centers, Quito did not possess a significant African population; thus, it is perhaps not surprising to find that members of the building trade were overwhelmingly indigenous.[11] Systematic archival research remains to be undertaken for other comparable urban centers in order to locate Quito more precisely within the larger demographic pattern of colonial Latin American cities.

La voz del anonimato

Architectural histories of Quito tend to follow the pattern established in the general literature on colonial Latin American architecture: Europeans are characterized as the "masterminds," while the manual labor is attributed to the "masses of anonymous 'Indian' workers." To cite a few examples from the local literature, José María Vargas describes the work of indigenous builders as "the voice of anonymity,"[12] and Filoteo Samaniego writes of "the overwhelming participation of native labor . . . this immense anonymous multitude that carried out works . . . guided by European masters."[13] José Gabriel Navarro asks, "Who were these [native] artisans? No one knows, or, for the moment, no one has identified them."[14]

The lack of systematic archival research has produced in the literature a kind of leveling of identity and artistic endeavor. In the case of Quito, the multitude of indigenous names that appear in the archival record document the diversity of ethnic participation and contribution, for the surnames of Andean artists frequently stand as ethnic indicators. A multitude of south and central Andean as well as aboriginal surnames appear in the documentary record, indicating the participation of a variety of ethno-linguistic groups, including aboriginal groups, Quechua, and Aymara. A number of these were likely *mitmajkuna* (transplanted populations) established in the region by the Inca before the Spanish invasion or relocated by Spanish colonists. For example, the surnames "Rimache," "Cayllagua," and "Paucar," which figure prominently among Quiteñan woodworkers, point to origins in the Quechua heartlands of the Andean region. Individuals with the surname "Tomayco," which is associated in numerous documents with an ethnic as well as professional group of woodworkers, were relocated from the region of Huánuco in central Peru.[15] Aboriginal surnames likely include "Collaguazo" (stonemasons), "Pillajo" (carpenters, sculptors, and stonemasons), and "Aulis" (stonemasons).[16] Surnames such as "Cañar" and "Amaguaña," which figure among woodworkers and stonemasons, derive from local and regional toponyms (see appendix). Although a surname does not necessarily locate an individual's birth in a particular region, collectively the names link Quito's Andean artists with diverse roots and traditions.[17] In particular, the continuity of certain indigenous surnames associated with the building profession highlights powerful hereditary ties within ethno-linguistic groups throughout the colonial period (see appendix).

Much more onomastic and ethnographic research is needed in order to clarify the ethno-linguistic origins and variety of Quiteñan surnames; any detailed consideration is beyond the scope of this study. Still, the rich diversity of Andean surnames in Quito, as well as their documented continuity within specific artistic professions throughout the colonial period, undermines the leveling effect of the catchall terms "Indian," "native," and even "Andean" that dominate the literature. The naming permitted by archival documentation reveals ethnic and cultural pluralism as well as

individual identity, and thereby offers a richer understanding of artistic production in colonial Quito.

The account books of seventeenth-century Quiteñan buildings provide abundant evidence of native contributions to all aspects of construction, offering lengthy lists of Andean names divided according to profession: stonemasons, bricklayers, carpenters, and peons.[18] Beside each name appears a series of slashes marking the days worked and the corresponding payment made according to each artist's level in the professional hierarchy. Frequently, a native name carries the title of "*maestro*," although *oficiales* (journeymen) and *peones* (laborers) make up the majority of entries. In some instances indigenous professionals are named in the records as the *maestro de obra* (construction foreman) of a given building, and they also appear as *maestro alarife* (master builder or engineer) and as *arquitecto*. Such references indicate the presence of highly skilled native artists involved in the construction trade who operated in capacities that went well beyond simple manual labor. Who were these masters and how did they obtain their titles? How and to what extent were they trained?

Quiteñan Trade Guilds and the Question of Authority

Following European precedent, trade guilds were established in colonial urban centers throughout the Americas to regulate and control the prices and production of goods and services.[19] Typically, control over the guilds rested with the *cabildo* (city council), which established prices, approved professional regulations, and elected annually the *maestro mayor, alcalde y veedor* (head master, magistrate and overseer) of each guild. The role of the *maestro mayor* was to enforce guild regulations and oversee production, quality, and training. The professional guilds established regulations regarding apprenticeship that involved several years of on-the-job training in order to acquire the title of journeyman. After many more years of practice, the journeyman could acquire the title of master upon successful examination by the officially appointed *maestro mayor* of the trade, thereby becoming an authority in the profession. Such authorities were frequently called upon by the *cabildo*, not only to construct public works, but also to assess the value of buildings and to evaluate damaged structures.

Guilds associated with the construction trade were established at very early dates in urban centers throughout the Americas. For example, guilds of carpenters were formed in Lima in 1549 and in Mexico City, with regulations, in 1557. The bricklayers' guild of Mexico City published its regulations in 1599.[20] In the city of Puebla, the guild of bricklayers and carpenters was established, with regulations, in 1570.[21] Even in Santiago de Chile, far from the viceregal power centers, the *cabildo* appointed a *maestro mayor* of the carpenters' guild as early as 1555.[22]

It is thus surprising and indeed significant that, in Quito, the *cabildo* did not officially recognize any guilds or name any masters related to the building professions until the last decade of the seventeenth century. Guilds of tailors, shoemakers, locksmiths, and tanners appear as early as 1574,[23] and in subsequent decades the election of masters expanded to include silversmiths, blacksmiths, dyers, potters, and even confectioners (*confiteros*). But not until 1690 was the first *maestro mayor* of the sculptors' guild elected; that of the carpenters' guild was named two years later. Moreover, these are the only guilds of the building trade for which masters were appointed by the *cabildo* during the colonial period, with the exception of master *alarife* or architect—a post always held by a European, if one was available, and, if not, left vacant.[24] It is likely that the joiners and other specialized woodworkers, such as *ensambladores* and *entalladores*, were subsumed within the carpenters' or sculptors' guilds in 1693; however, the *canteros* (stonemasons) and *albañiles* (bricklayers) remained outside the officially recognized professional guilds throughout the colonial period.

Moreover, the regulations of guilds related to construction, commonly approved and/or published in other regions of the Americas, do not appear to have existed for Quito. In contrast, the Quiteñan guilds of silversmiths and gilders did submit their

regulations for approval.[25] These and many other guilds also registered their examinations for the title of master with local notaries; however, not a single such examination record exists for the any of the building professions.[26] Similarly, systematic study of all extant notarial records for Quito between 1580 and 1720 reveals a complete lack of apprenticeship contracts for any trade related to construction, though such contracts abound for silversmiths, gilders, tailors, blacksmiths, hat-makers, and many other professions.[27] Apparently, the building trades were acquired in a more informal or traditional manner, in which knowledge and instruction were passed on within families and communal groups. In sum, during Quito's era of greatest architectural construction and expansion in the late sixteenth and seventeenth centuries, there was an almost complete lack of official recognition, control, and vigilance over the building trades, even when the city itself depended upon these professions for the construction of public works.

One reason for this omission may be that much of the manual labor related to construction was already provided through the *mita*—an obligatory labor tribute (*corvée*). The *mita* supplied large numbers of indigenous workers for the extraction and manufacture of materials and the construction of buildings, roads, bridges, and other public works, in addition to churches, convents, and other religious establishments. Additionally, the tradition of *yanacona* (nominally paid native servitors of an individual or group) inherited from the Inca, often associated with local monasteries such as that of San Francisco, must have provided many indigenous building professionals and laborers.[28]

Moreover, dating from the Inca occupation and undoubtedly earlier, there existed extended kin groups (*ayllus*) and entire communities that specialized in certain aspects of construction, in which professional knowledge and practice were transferred from generation to generation. For example, the "Indian carpenters" of the town of Quero (Riobamba) constituted a type of communal guild that was not legally subject to the *mita* in the seventeenth century.[29] In 1602, an ethnic group calling themselves the "yndios Tomaicos carpinteros" drafted a letter to the viceroy requesting the confirmation of certain unspecified privileges that they had previously been conceded, which probably exempted them from the *mita*.[30] To a great extent, the pre-Hispanic traditions of the *mita*, the *yanacona*, and ethnic or communal professional groups appear to have found new forms and continuity in the colonial context. Indeed, some type of organization and structure of the building trades must have existed in Quito to account for the abundant documentary presence of titled native masters and journeymen; and, given the lack of official Spanish control over these professions, the authority would appear to have resided elsewhere.

Who's Minding the Shop?

Frequent references to indigenous master carpenters, bricklayers, and masons appear in the notarial record, while other native builders simply bear the title of journeyman or practitioner.[31] Given the official, legal nature of these documents, the use of specific titles can hardly have been accidental or arbitrary. How was a "master" distinguished from a "journeyman" or a mere practitioner? How were these specific titles obtained by members of the indigenous population when no such masters, guilds, or professional regulations were recognized, regulated, or enforced by the *cabildo*?

The evidence indicates that the building professions operated almost completely under the purview of the indigenous community. References pointing to the existence of specifically indigenous guilds related to the building trade appear in the early seventeenth century. For example, in 1628, Cosme de Caso, a wealthy Spanish merchant, commissioned Andrés Machaguán, *alcalde de los indios canteros* (magistrate of the Indian stonemasons), and Simón Anba, *alguacil de los indios canteros* (sergeant or second in command of the Indian stonemasons) to construct an elaborate stone portal for his private residence. Machaguán and Anba were instructed to create a portal that was to be "just as nicely finished [and] in perfectly

carved form as that of the main portal of the house of his mother-in-law, Doña mariana de xaramillo."[32]

Another such example appears in a letter written in 1677 by the native *caciques* (lords) and governors of the province of Quito to the Spanish king. The *caciques* denounced the abuses of the local Spanish magistrates, who had demanded that indigenous carpenters and other construction workers support their building campaigns even though the natives had other professional obligations and their own workshops to run. In this letter, the *caciques* observe that

> throughout this diocese each year Indian Master magistrates and Sergeants are elected for each profession that the said indians have, [and] among them the election of magistrate is not excused, even for

the Butchers, Pig-stickers, Fruit vendors, [although] these like others in reality do not appear to be professions. . . .[33]

It would appear that in Quito, the *república de los indios* (Indian Republic), an administrative body instituted by the Spanish that was parallel but subservient to the *república de los españoles* (Spanish Republic), maintained control over the building trade for most—if not all—of the colonial period.[34] Evidently, the *república de los indios* did not document its acts and elections in the same manner as the Spaniards, likely employing more informal and oral transactions. Therefore, our knowledge of its administrative structure and operations depends on disparate references that crossed over into the Spanish system, such as the notarial and judicial records cited above.

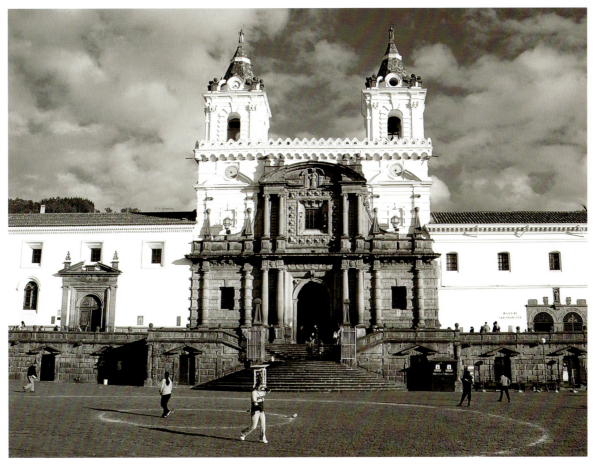

Fig. 4. Jorge de la Cruz and Francisco Morocho (directors), Church of the Monastery of San Francisco. Quito, Ecuador, c. 1580s–1620s. Photo: Hernán L. Navarrete.

Andean Masters and
the Question of Authority

The 1690 and 1692 *cabildo* elections of *maestros mayores* of the sculptors' and carpenters' guilds represent a significant change in the standing of such professions in the eyes of the Spanish administrators, although the reasons for such attentions are not entirely clear. The shift may point to a newfound valuation of the professions, or it may indicate a perceived need for greater official Spanish control and vigilance. Another related issue was likely the decline of the *mita* that began during this period, for the crown was promoting its elimination. Whatever the reasons, it bears repeating that these are the only construction-related professions ever recognized or controlled by the *cabildo* as documented in the *Actas*.

In 1690, the *cabildo* appointed "don Francisco Tipán yndio" as *maestro mayor* of the sculptors' guild. Two years later, the indigenous or mestizo master Andrés de Ybarra was named *maestro mayor* of the carpenters, and "el Capitán don Francisco

Fig. 5. Marcos Tituaña, Carved doors. Chapel of Nuestra Señora de los Ángeles. Quito, Ecuador, 1659. Photo: Alex Segundo Carrera Apolo.

Tipán yndio" was reelected to his post as head of the sculptors.[35] After 1694, Andrés de Ybarra disappears from the records, while Francisco Tipán was named *maestro mayor* of both the sculptors' and the carpenters' guilds for twelve successive years "because of his intelligence in both arts."[36] Tipán appears in a variety of documents as a master architect, sculptor, joiner, and woodworker, titles that demonstrate his domination of virtually all aspects of the building trade. In 1706, the last of his sixteen years as *maestro mayor*, Tipán was also designated *Alcalde mayor de los naturales del Partido de Anansayas*,[37] a position of great administrative prestige that formed an important bridge between the *república de los indios* and that of the *españoles*. The fact that the *cabildo* first and then consistently elected an Andean master to head important professions related to the building trade serves as yet another indicator of native dominance and authority in those fields.

Francisco Tipán was by no means the only indigenous master of the building profession; a systematic review of the notarial archives in Quito names more than forty such masters for the seventeenth century alone, along with hundreds of native journeymen and practitioners. These numbers make it clear that the Andean contribution of manual labor to the building profession was certainly no myth; indeed, only a small fraction of such artists in late sixteenth- and seventeenth-century Quito were Europeans. Andean master architects, *alarifes*, stonemasons, bricklayers, carpenters, joiners, sculptors, and woodworkers not only worked on projects, they also designed buildings and directed their construction.

A selection of examples may serve to underscore the point. For several years starting in 1602, the native master carpenters Francisco Morocho and Antonio de Guzmán directed the construction of the Church of San Agustín.[38] Morocho also served for more than twenty years as foreman of construction (*maestro de obra*), along with his father, the native master builder Jorge de la Cruz, of the Church of San Francisco (Fig. 4), and was responsible for the erection of the Franciscan church in Riobamba.[39]

Fig. 6. José Jaime Ortiz (designer and director, 1694–1707) and Mauricio Suárez (director, 1707–1715), Church of El Sagrario. Quito, Ecuador, 1694–1715. Photo: Susan V. Webster.

Fig. 7. Blas Cimbaña and Pascual de Rojas, Interior cornices and capitals. Church of El Sagrario, Quito, Ecuador, 1712. Photo: Hernán L. Navarrete.

Fig. 8. Blas Cimbaña and Pascual de Rojas, Relief sculpture of St. Matthew the Evangelist. Church of El Sagrario, Quito, Ecuador, 1712. Photo: Hernán L. Navarrete.

In 1613, Martín Taguada, native master carpenter, contracted to construct the roof and the *artesonado* (elaborate coffered wooden vault) of the Church of San Roque, and directed a crew of indigenous journeymen and officials according to his own designs.[40] In 1659, the native master carpenter Marcos Tituaña was commissioned by the confraternity of Nuestra Señora de los Ángeles to design and build a massive set of elaborately carved doors for its chapel, and to construct the choir loft and other interior furnishings (Fig. 5).[41] In 1662, Don Juan Bilatuña, native master sculptor and joiner, signed a contract to design and construct the *artesonado* of the Church of La Merced, for which he was paid the remarkable sum of two thousand *pesos*. Bilatuña was also charged with overseeing a team of indigenous workers and providing for their payment and meals.[42]

During the construction of the Church of El Sagrario in the late seventeenth and early eighteenth centuries, Mauricio Suárez, native master bricklayer, served as the *maestro de obra* and master builder for more than ten years (Fig. 6), and the native master sculptors Blas Cimbaña and Pascual de Rojas carved the cornices and capitals of the pilasters, together with the monumental relief sculptures of the four Evangelists that adorn the pendentives of the dome (Figs. 7 and 8).[43] In the reconstruction of the Church of La Merced during the early eighteenth century, Joseph Landa, native master bricklayer, was commissioned as *maestro de obra* and master builder after the death of the Spanish architect José Jaime Ortiz, a post in which he served until the building was completed in 1715 (Fig. 9).[44] In 1711, a native professional known only as Bartolomé Yndio was

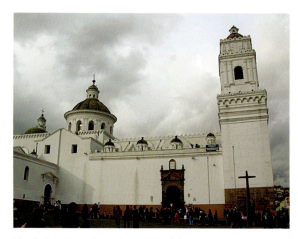

Fig. 9. José Jaime Ortiz (designer and director of reconstruction, 1700–1707) and Joseph Landa (director, 1707–1714), Church of the Monastery of La Merced. Quito, Ecuador, 1700–1714. Photo: Hernán L. Navarrete.

Fig. 10. Lorenzo Aulis, Main portal. Colegio de la Compañía de Jesús, Quito, Ecuador, 1664. Photo: Susan V. Webster.

contracted by the *cabildo* as "master architect of Quito," to assess earthquake damage to the Church of Ipiales.[45] In 1712, the *cabildo* commissioned Pedro Tipán *yndio alarife*, because of his "intelligence and experience," to assess the cost of reconstructing of one of the city's important bridges.[46]

In the realm of residential construction, Juan Auqui, native master bricklayer, signed a contract in 1582 with a wealthy Spanish *vecino*, Juan Bautista Arias, to build his two-story house and construct corridors, arches, fireplaces, stairways, a patio, a fountain, and other elements.[47] In 1587, Ventura de San Francisco, native master bricklayer, was commissioned by Juan Pacheco to build his house and shop.[48] In 1598, Felipe Yndio, master stonemason, and his son Joan Yndio, journeyman stonemason, contracted with Diego de Niebla to construct his luxurious residence in the center of Quito.[49] Later in 1628, Andrés Machaguán, *alcalde de los yndios canteros*, and Simon Anba, *alguacil de los yndios canteros*, were commissioned by Cosme de Castro to erect an elaborate stone portal for his house.

Even the Jesuits, famed for employing their own European architects and designers, commissioned Andean masters for their many local constructions. The Jesuits recognized the talents of Lorenzo Aulis, native master stonemason, when in 1664 brother Marcos Guerra, himself an architect, commissioned Aulis to erect an enormous stone portal for their *Colegio* and to direct teams of indigenous workers (Fig. 10).[50] Later, in 1694, the Jesuits signed a contract with Francisco Tipán to design and build the main altarpiece for their new church, and to provide and supervise his own crew of indigenous artists.[51]

Native Quiteñan masters were also in high demand in other regions of the *audiencia*, and numerous contracts demonstrate the striking mobility of these skilled Andean artists. A contract celebrated in 1592 between the native Quiteñan master painter Andrés Sánchez Galque and Don Diego Pillamunga, *cacique* of the town of Chimbo, is particularly noteworthy in this regard, as both artist and patron were Andean. According to the contract, Galque was to

travel to Chimbo (Bolívar) to design and construct an elaborate altarpiece for the church, which was to include specific images and iconography chosen by the patron.[52] In 1612, Joan Pacha, a native carpenter from Oyumbicho (outside Quito), was called away from his work in Cuenca (Azuay) to carry out the construction of a mill in Latacunga (Cotopaxi).[53] In 1638, the native Quiteñan *albañiles* Francisco and Agustín Cobacango signed a contract to travel to Pintag (Pichincha) to design and construct the buildings and ovens of a tile factory.[54] In 1661, the Jesuit *procurador* in Quito commissioned three Andean master stonemasons, Pablo and Juan Paraypuma and Bartolomé Cauascango, to travel to Cuenca, where they were to organize and oversee the construction of the Jesuit *convento*.[55] In 1667, the native master stonemason Marcos Bermejo signed a contract in Quito to travel with his team of indigenous stonemasons and bricklayers to Pasto (present-day Colombia) to construct the principal church of the town, now the Church of San Juan.[56] Importantly, the model employed by Bermejo and his team for the main portal of the church in Pasto was Aulis's 1664 portal for the Jesuit *colegio* in Quito. The mobility of Quito's Andean masters led to the diffusion of professional practices and styles throughout the *audiencia*.

These are only a fraction of the examples in the archival record, but they are enough to seriously undermine the assumption that, at least in Quito, native artists participated in colonial architecture solely as manual laborers. The documents make it clear that Andean masters were in high demand, that they often designed the works, controlled the construction process, and directed teams of artists and laborers. The following case studies of three indigenous masters offer greater insight into native authorship, authority, and participation.

Diego Ventura de Santiago and the Capilla de Letrán

The Chapel of San Juan de Letrán (Fig. 11), adjacent and connected to the church of La Merced, is considered to be "the oldest remaining part of the early

Fig. 11. Diego Ventura de Santiago and Juan Ventura, Chapel of San Juan de Letrán. Quito, Ecuador, 1609. Photo: Susan V. Webster.

Fig. 12. Diego Ventura de Santiago and Juan Ventura, Main portal. Chapel of San Juan de Letrán, Quito, Ecuador. Photo: Susan V. Webster.

constructions [of the order]."⁵⁷ In 1559, the powerful and wealthy local citizen Don Diego de Sandoval left a fortune in his will to build the chapel, which was to serve as a family sepulcher, and to pay for a variety of special masses and memorials in perpetuity. It was not until 1609, well after Sandoval's death, that the Mercedarians set about fulfilling his testamentary bequest. In that year, they signed a contract with Diego Ventura de Santiago, native master bricklayer, and his son Juan Ventura, native journeyman bricklayer,

> to construct the church and Chapel of san juan de letran of this monastery . . . according to the design that they have made . . . building a chancel arch and a portal on the plaza . . . and a bell tower . . . all completely finished and done in complete perfection.⁵⁸

Father and son were charged with designing the chapel, with the direction and payment of crews of indigenous bricklayers, stonemasons, and carpenters, and with providing meals to the workers each day. For their labors and expertise, each received 280 *patacones*, a tidy sum for the period.

The rectangular-plan chapel is constructed atop a sturdy stone foundation that supports immensely thick brick walls pierced by several small windows and a barrel-vaulted interior. The chancel arch referred to in the contract bisects the nave, providing additional

Fig. 13. Signature of Juan Benítez Cañar. ANH/Q, Notaría 6ª, vol. 34, 1622, Diego Rodríguez Docampo, fol. 775v. Photo: Susan V. Webster.

support for the vault. The main portal of the chapel, which opens onto the atrium of the Mercedarian church, is designed in a severe, classical style that features a dentilated pediment and cornice supported by engaged Doric columns atop soberly carved plinths (Fig. 12). Although relatively simple in form, plan, and decoration, the chapel clearly demonstrates the ability of the indigenous master and his journeyman son to manipulate the language of European architectural forms. It bears repeating that this is the only building of the original Mercedarian complex that has survived the frequent earthquakes that have wrought destruction in the city over the centuries.

Juan Benítez Cañar, Master of Altarpieces

During the colonial period, the art of designing and constructing *retablos* (large, elaborately carved wooden altarpieces) was closely associated with architecture; indeed, in the literature of the period, the makers of altarpieces were generally referred to as *arquitectos*.⁵⁹ Mastery of drawing was essential for such professionals, and preparatory drawings and plans, signed by the master, the notary, and/or the patron, are typically referred to in the contracts for such works.

Among the many Andean masters who excelled in altarpiece design and construction was Juan Benítez Cañar, active in Quito during the first quarter of the seventeenth century. His second surname, "Cañar," indicates ancestral origins in Cañaribamba (modern Azuay) in the southern part of Ecuador, or his association with groups of ethnic Cañari that were relocated by the Inca and/ or Spaniards.⁶⁰ Benítez Cañar first appears in the documentary record in 1615, purchasing a small plot of land in the parish of San Roque for ten *patacones*, with the title of *yndio, oficial escultor* (native journeyman sculptor).⁶¹ After 1617, a variety of titles are attached to his name, including "Don," which demonstrates his newly elevated social status with respect to the Spanish establishment. Additionally, he is identified in the documents as "governor of the Indians of the parish of San Roque," and as "master architect, sculptor, joiner, and woodworker."

Fig. 14. Juan Benítez Cañar (?), West side altar. Chapel of the Rosary, Church of Santo Domingo, Quito, Ecuador, 1623 (?). Photo: Susan V. Webster.

To this master can be assigned at least nine contracts for major altarpieces, including the main altars of the churches of Santo Domingo[62] and San Agustín,[63] and the altarpiece of the silversmith's guild-confraternity of San Eloy.[64] Benítez Cañar was commissioned to design and construct four altarpieces in San Agustín, three in Santo Domingo, one in San Francisco, and another in La Merced, as well as independent sculptures, including an image of San Valerio commissioned for export to the Mercedarian monastery in Puerto Viejo (in present-day Costa Rica).[65] The documentation makes reference to designs and drawings created and signed by Benítez Cañar, who also signed his name to the contracts (Fig. 13). Unfortunately, none of the master's drawings accompany the documents of commission in the notarial volumes.

Sadly, these *retablos* have been lost or remain to be identified. Given their early dates, most were likely replaced during the eighteenth century when changing tastes propelled the "modernization" of church interiors. The original altarpieces may have been sold to other churches in the region or recycled into newer, more stylish pieces. Indeed, in one case involving Benítez Cañar himself, as part of a commission to construct a private altarpiece, the artist was given the old *retablo* to do with as he wished.[66]

A possible example of a reused Benítez Cañar altarpiece may be found in the interior decoration of the impressive Chapel of the Rosary in the Church of Santo Domingo (Figs. 14 and 15). In 1623, Doña Gerónima de Galarza, wife of the secretary of the *real audiencia*, commissioned Don Juan Benítez Cañar, *yndio ladino maestro escultor*, to design and build

Fig. 15. Juan Benítez Cañar (?), East side altar. Chapel of the Rosary, Church of Santo Domingo, Quito, Ecuador, 1623 (?). Photo: Susan V. Webster.

a wooden two-story altarpiece and its pediment and cornice above with five images sculpted in the round in three niches, the principal [of which] must have our lady and saint Joseph and the child Jesus in the middle holding hands with his blessed mother and saint Joseph—and in the [other] two niches saint ildefonso and saint john the evangelist, and the columns of [the altarpiece] must be *melcochada* [?] and fluted and the capitals of the corinthian [order]—and fantasies on both sides of the uppermost part—and the second story above need not have sculptures in the round because it has to have paintings as can be more extensively seen in the design and model of the said altarpiece on parchment that is signed by me, the present notary and by the said Don Juan Benitez. . . .[67]

Additionally, the master was to oversee the work and direct teams of indigenous artists. For his labors and expertise, Benítez Cañar received five hundred *patacones*, a quite handsome sum.

The altarpiece was to be located along one of the lateral walls of the side chapel dedicated to Saint Joseph that was owned by a relative of the patron, Captain Juan de Muñoa Ronquillo. Later in the century this chapel became the property of the Confraternity of the Rosary, although it is unclear whether the confraternity took charge of the original altarpieces. During the eighteenth century, the confraternity undertook a very large expansion of the chapel, extending it out over an impressive architectural span that bridged the street alongside the church.[68] Still extant within the first section of the chapel nearest the church are two *retablos* that contain elements and iconography related to the original altarpieces of the chapel (Figs. 14 and 15), including images of Saint Joseph, Saint John the Evangelist, and Saint Ildefonso. Additionally, these altarpieces employ elaborately adorned columns topped by fanciful Corinthian capitals and exhibit a variety

of whimsical decorative elements that may correspond to the "fantasies" referred to in the contract.

Like other native masters of altarpieces in seventeenth-century Quito, Benítez Cañar appears in many documents with the title of master architect, as well as those of master sculptor, joiner, and woodworker. Although there is no documentary evidence that he designed and constructed buildings, given his titles and abilities, it is certainly possible that he did so.

Don Francisco Tipán, Master Builder and Entrepreneur

The professional career of the native master Francisco Tipán illustrates the potential for social, professional, and political advancement available to Andean artists during the seventeenth and early eighteenth centuries.[69] Tipán came to enjoy fame, fortune, and a multitude of important titles and appointments during his long career in Quito (c. 1670–1706), in addition to being recognized as an expert and a master of various trades related to construction and artistic production. Elected by the *cabildo* for sixteen years as *maestro mayor* of the sculptors' and carpenters' guilds, after 1693, he is identified in the documents as "Capitán" Don Francisco Tipán. Although documentary evidence as to how he obtained this military title is lacking, it is likely that he served in one of the native battalions that protected the city and accompanied missionary expeditions to other regions.[70] Toward the end of his career, he appears in the documents as Capitán Don Francisco Tipán,

Fig. 16. Signature of Francisco Tipán. ANH/Q, Notaría 1ª, vol. 293 (1705-06), Gregorio López, fol. 370v. Photo: Hernán L. Navarrete.

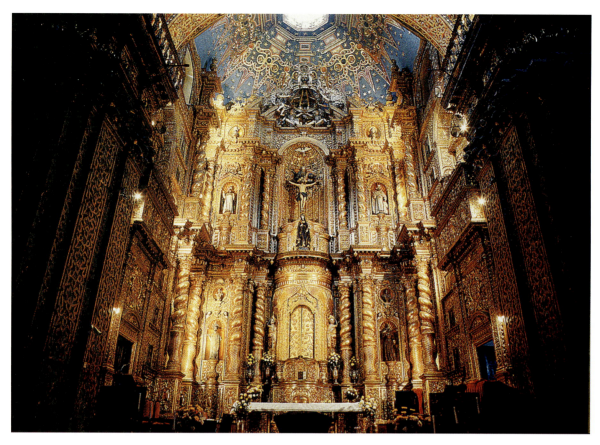

Fig. 17. Francisco Tipán and Jorge Vinterer, Main altar. Church of La Compañía, Quito, Ecuador, 1694–1695 and 1735. Photo: Hernán L. Navarrete.

"Indian master sculptor, woodworker, joiner, and architect,"[71] indicating that he had come to dominate virtually all aspects of the building profession.

The surname "Tipán" is apparently Araucano in origin, although Francisco was almost certainly born and raised in the region of Quito, perhaps in the nearby community of Oyumbicho.[72] Numerous seventeenth-century documents testify to the presence of families with the surname Tipán in the town of Oyumbicho and the region known as Panzaleo, which included native communities in valleys to the southeast of Quito, among them Machachi, Aloag, and Aloasí.[73] Parts of this region were heavily forested, Oyumbicho in particular, and supported numerous communities of carpenters.[74] The ethnographic evidence indicates that this region was occupied before the Spanish conquest by Inca *mitmajkuna* transplanted from central Peru, including Guayacundos from Huancavelica, and by others

from regions further south.[75] Although Francisco Tipán was probably not a recent transplant to the region, his origins likely lie with kin groups of the same surname who resided in Oyumbicho and Panzaleo: the specialized woodworkers who provided materials, products, and expertise for the urban center.

A quite large number of records document Tipán's life and career. He appears for the first time in the notarial records in 1670 as a native master carpenter, acquiring a small, vacant plot of land in the parish of San Roque.[76] Over the next 35 years, Tipán purchased four adjoining houses and plots of land in the same parish that made up nearly a city block, wherein he likely established his workshop. In 1691, he purchased large tracts of land in nearby Nayón and Conocoto, which served as sheep ranches, providing additional income from the sale of wool.[77] During the 1690s, Tipán rented a pulpería—a shop that sold foodstuff and merchan-

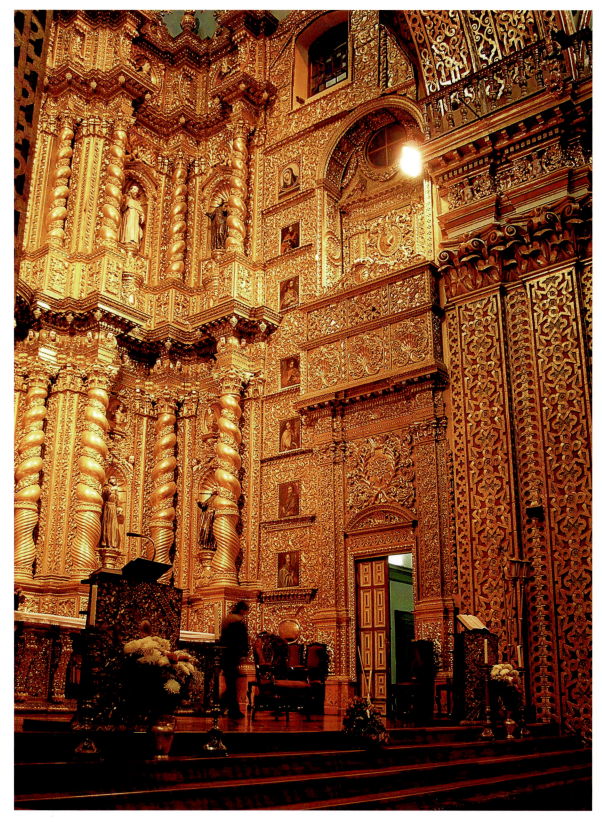

Fig. 18. Francisco Tipán and Jorge Vinterer, Lateral wall of apse. Church of La Compañía, Quito, Ecuador, 1694–1695 and 1735. Photo: Hernán L. Navarrete.

Fig. 19. Francisco Tipán, Altar niche. Sacristy of the Church of San Francisco, Quito, Ecuador, 1697–1699. Photo: Hernán L. Navarrete.

dise—on the corner of the popular plaza of Santo Domingo.[78] It was likely from this shop that, together with indigenous associates who were involved in the construction business, he traded in local and Castilian textiles.[79] It appears that Tipán maintained close contact with the Dominicans; his pulpería was located nearby, he purchased a small house from them (which he soon sold), and he served for several years as Prioste de los Naturales (native official) in the Confraternity of the Rosary, which maintained a chapel in the Church of Santo Domingo.[80]

Tipán's family life is fairly well documented in the archives, and affords an important perspective on his professional trajectory. He was married to an Andean woman, Doña María de Zúñiga Olmos Pizarro, with whom he purchased the land in San Roque in 1570.[81] María de Zúñiga came from an extended family of important native artists, above all painters and sculptors. Moreover, she had close family ties to several powerful *caciques* and governors. Among her relatives, she counted the native master sculptors Don Bernal de Zúñiga and Don Ventura de Zúñiga (note the titles), and other members of her immediate family were involved in related artistic professions.[82]

On the Olmos Pizarro side of her family, María de Zúñiga's aunt, Doña Angelina de Olmos Pizarro, was married to Don Ventura Chuquicondor, master guitar-maker and *cacique principal* of the parish of San Roque in the last quarter of the seventeenth century.[83] In 1700, Ventura and Angelina's sons, Juan and Gregorio Chuquicondor Olmos Pizarro, are identified in the documents as *caciques principales* and governors of the provinces of Mindo, Yambe, and the surrounding areas.[84] Don Gregorio Chuquicondor appears in 1697 with the title of *cacique de la provincia de los Yumbos*.[85] All of María de Zúñiga's relatives— Chuquicondor, Olmos Pizarro, and Zúñiga—lived in houses next door to hers, or very nearby, in the parish of San Roque. Francisco Tipán thus married into a powerful family that undoubtedly benefited his professional aspirations and social standing.

While it is difficult to pinpoint precisely where Tipán's first property was originally located, it would appear to have been fairly close to the houses that belonged to Francisco Topatauchi Ynga "El Auqui," son of Atahualpa, and his heirs, near the division between the parishes of San Sebastián and San Roque. Both the seller and the neighbors were people associated with the traditional native power structure, and many were master woodworkers and artists. The seller, Doña María Ucclo, the sister of Don Andrés Chuquicondor, declared that she had inherited it from her mother, María Ñusta. The surnames Ucclo, Ñusta, and Chuquicondor indicate descent from Inca nobility and therefore significant power and prestige within the community. The neighboring houses were occupied by members of the Rimache family, also of Inca origin; several *caciques principales* and numerous important painters, sculptors, and carpenters of the time figured among their ranks (see appendix).

Although neither Tipán nor María de Zúñiga Olmos Pizarro bore an Inca surname, through María de Zúniga's family connections Tipán gained association with the hereditary Inca power structure. Tipán's apparently humble origins are highlighted by his adding his wife's surname, "Olmos," to his own on several occasions, signaling that it conferred significant prestige.[86] María de Zúñiga's second surname, "Olmos Pizarro," was clearly an indicator of high sociopolitical status at the time, for none of Tipán's three children adopted his surname, preferring to use only "Olmos Pizarro."[87] In the 1707 baptismal record of the daughter of "Governador Asiencio Olmos Pizarro," don Francisco Tipán is named as her godfather.[88]

Tipán appears to have capitalized on the benefits that such associations granted him. A chronological review of the titles accorded Tipán in the documents is instructive: he appears first in 1670 as *Francisco Tipán, yndio maestro carpintero*; in 1683, as *don Francisco Tipán, yndio maestro ensamblador*; in 1685, as *don Francisco Tipán, yndio maestro escultor*; in 1704, as *don Francisco Tipán, yndio alarife y arquitecto*, and in 1705 as *Capitán don Francisco Tipán, yndio maestro escultor, entallador, ensamblador, y arquitecto*. This chronology clearly demonstrates Tipán's rising professional as well as sociopolitical status within the community. Another pattern also appears in the documents. In the 1670s and 1680s, Tipán did not sign his name to contracts, asking witnesses to sign in his stead because he did not know how. Beginning in 1694, however, Tipán's own signature appears on all documents (Fig. 16), indicating his definitive entry into the world of *indios ladinos*, or hispanicized Andeans who spoke the Spanish language and/or wore European dress.

Overall, the documentation presents Tipán as an individual of great talent, ambition, and tenacity, whose life and career exemplify the possibilities for upward professional, social, and political mobility available to Andean artists. From his origins as an "illiterate" native carpenter who purchased a small vacant plot of land in 1670, Tipán came to possess substantial real estate and financial resources, engage in a variety of business ventures,

Fig. 20. Francisco Tipán, Altar niche. Sacristy of the Church of San Francisco, Quito, Ecuador, 1697–1699. Photo: Hernán L. Navarrete.

achieve widespread recognition as an outstanding master in the construction world, acquire titles of great sociopolitical importance within the community, and obtain major artistic commissions.

Given Tipán's prominence in the community during the late seventeenth and early eighteenth centuries, it seems remarkable that he has not been accorded more attention by modern historians. Among the twentieth-century art and architectural historians of Quito, José María Vargas does not mention Tipán at all, while Joël Monroy, Benjamín Gento Sanz, and José Gabriel Navarro each make only one minor reference to him. Perhaps equally surprising is the fact that, at present, only four documented contracts involving Tipán have been recovered, of which only two works are partially extant. Nonetheless, Tipan's earliest documented commission clearly demonstrates his status as a master

Fig. 21. Francisco Tipán, Altar niche. Sacristy of the Church of San Francisco, Quito, Ecuador, 1697–1699. Photo: Hernán L. Navarrete.

and his high professional standing in the community.

In December 1694, in the company of the *Protector General de los Naturales*, "Captain Don Francisco Tipán, native master joiner," signed a contract with the *procurador* of the Jesuits to construct the main altarpiece of their church. According to the document, the work was to be

> of wood, six-sided, thirteen varas in Height and eight in width, in a square [format] with full length [sculptures of] twelve Apostles of two varas in height, and four evangelists . . . according to the drawing that he has submitted, within a year and a half. . . .[89]

The Jesuits were to provide all materials for the work, in addition to the meals for Tipán and his team of twenty-five indigenous artists. For his labor as designer and director of the work, Tipán was paid an impressive 1,800 *pesos*, a small fortune at the time. This was clearly a major commission, and must have served to solidify Tipán's reputation as an artist of considerable importance within the community.

The altarpiece created by Tipán was reconfigured during the eighteenth century with work begun in 1735 by the German Jesuit Jorge Vinterer (Fig. 17). Close inspection suggests that some elements of Tipán's original altarpiece were integrated into the work directed by Vinterer, and that other parts were installed along the lateral walls of the apse (Fig. 18). However, until further documentation is recovered, one can only lament the loss of this monumental work by an important Andean master.

Several years after the Jesuit commission, Tipán undertook two projects in the Church of San Francisco; these have been published respectively by Navarro and Gento Sanz. Describing the first project, Navarro observed simply that

> there worked in Quito a sculptor, Francisco Tipán, who appears in the years 1697 to 1699, together with a gilder named Andrés, [as the maker of] the altarpiece and the niches of the sacristy of [the Church of] San Francisco.[90]

Regrettably, the main altarpiece no longer exists, nor do two of the six original altar niches; however, the four extant niches provide at least some idea of the master's abilities. The large niches are conceived in pairs that face each other across the sacristy. The first pair (Figs. 19 and 20) is designed with a distinctive series of fluted columns with fanciful capitals topped by a projecting cornice that supports a corresponding series of arches. Columns and arches diminish in size and displace in depth in a play of perspective that creates a telescoping optical focus for the central sculpture.

The second pair of altar niches (Figs. 21 and 22) bears Corinthian pilasters and columns crowned by entablatures and projecting cornices that support barrel-vaulted interiors. Each niche is lined with a series of elaborately framed paintings. One contains images of archangels; the other bears scenes from the lives of Franciscan saints. Although they are not monumental works, as the Jesuit altarpiece surely was, these altar niches clearly demonstrate Tipán's mastery of the European architectural language.

Gento Sanz documented a second project undertaken by Tipán in the Church of San Francisco.[91] On the basis of evidence recovered from the Franciscan archive, Gento Sanz asserted that the original altarpiece dedicated to San José, which once belonged to Don Francisco Topatauchi Atabalipa Inga, a son of Atahualpa, was completely reconstructed in 1698. In passing, the author notes that

> one of the sculptors who intervened in its creation, apparently indigenous, is called Francisco Tipán "sculptor," who was paid 14 *pesos* for his work, as well as the name of a certain "Andrés the Gilder," who received 20 *pesos*. . . .[92]

The present altarpiece dedicated to San José in the Church of San Francisco contains elements that appear to date from this period; however, judging from the small payment, Tipán's work on the project may not have been extensive enough to permit significant conclusions to be drawn about the nature of his contribution.

Another slightly later work by Tipán was first published by Monroy in a general study of the Monastery of La Merced, although assigned an incorrect date.[93] An account book for the years 1703 to 1736, maintained in the Mercedarian archive, records the expenses incurred in the decoration of the monastery's *portería* (public entrance vestibule). Among the expenditures for the year 1703 appears the notation

Fig. 22. Francisco Tipán, Altar niche. Sacristy of the Church of San Francisco, Quito, Ecuador, 1697–1699. Photo: Hernán L. Navarrete.

to the Master tipan for the manufacture of the tabernacle . . . and the doors of the Holy Christ sculpted on the exterior . . . the two lateral Niches of Our Lady and Saint John and . . . the [carved] frames of the Mirrors, and for sculpting the doors on the interior. . . .[94]

According to the account book, the cost of the work, including the materials and the meals of Tipán and his team of indigenous journeymen, totaled 81 *pesos* 5 *reales*, although Monroy asserts that Tipán was paid 216 *pesos* for the sculptural work.[95]

Unfortunately, all of the works in the *portería* were dismantled by the selfsame Mercedarian friar Monroy in the mid-twentieth century, and parts of them were reconfigured to create the altarpiece dedicated to the

Lord of Justice that stands today in the church.[96] Additional research is required in order to identify elements of the *retablo* that may be attributable to Tipán.

Although only a fraction of Tipan's documented work is extant, a large body of designs must once have existed, particularly given his important contract with the Jesuits, his official titles and recognition by the *cabildo*, and his stature within the community. It is also possible that Tipán was involved in the construction of houses and other architectural projects.

During much of his career, Tipán served as an officially recognized assessor of real estate. Two examples underline the importance of this role in his career and for his relationship to the indigenous community. In 1704, Doña Luciana Duque de Estrada, an influential Spanish citizen, brought a major lawsuit against the Spanish architect José Jaime Ortiz. The two parties had signed a contract in 1701, in which they agreed to trade houses.[97] Three years later, Duque de Estrada filed suit against the architect, alleging that he had traded her a house in abysmal condition, cleverly camouflaged beneath a covering of paint and whitewash in order to hide the deceit.[98] To evaluate her claim, the *real audiencia* named an official assessor, Francisco Tipán, *alarife y arquitecto desta Ciudad*.

Tipán undertook an extremely detailed assessment that not only reveals his extensive knowledge of construction techniques but also implies a substantial rivalry with the Spanish architect Ortiz, his only serious competition at the time. In his report, Tipán observed that the house was

> badly constructed Because the walls are of a single row of adobe [bricks] and for a two story house, [alternating and crossed] double rows of adobes are required, and because the attic is all [made] of *chacllas* [sticks] and mud and in order to conceal [the fraud] it is lined with reed mats and all of the wood is Worm-eaten and because of this [Ortiz] ordered [that it be] Whitewashed and the beams Painted, [together

> with the] Walls, reed mats of the roof and Doors. . . .[99]

Despite Tipán's extensive and revealing report, the political and peninsular power of the Spanish architect held sway, resulting in a lengthy lawsuit that continued for many years after the deaths of Duque de Estrada, Ortiz, and Tipán.

Another intriguing lawsuit involving a dispute over the value of a house, filed in 1706 by an indigenous woman, Doña Michaela Pillajo, against a Spanish woman, Doña Ana Martínez de Sigüenza, highlights contemporary tensions, alliances, and competition. In this case, each party was required to appoint an independent assessor of the building. Pillajo, hoping that the house would bring a high price, named as her assessor *Francisco Tipán, yndio Maestro ensamblador y Arquitecto*. Martínez de Sigüenza, holding out for a lesser value, named her countryman *Joseph Jaime Ortiz, alarife desta ciudad*. Tipán assessed the value of the house in question at 1,100 *pesos*, while Ortiz placed its worth at only 700. In order to resolve the issue, the court appointed a third assessor, identified only as Joseph Guerrero, town resident. His appraisal, at 950 *pesos*, was obviously designed to appease both parties and avoid a protracted court case.[100]

Tipán appears with the title of architect and/or *alarife* in these and many other appointments as a real estate assessor. It is therefore likely that he designed and constructed houses and other buildings in the city, although no contracts for such works have yet been identified.

The official recognition accorded Tipán during his career as a master of the building trade appears to mark a change in the administrative perspective of the Spanish authorities toward at least some of the indigenous masters of construction. At least in part, this official recognition may be attributed to Tipán's professional expertise and sociopolitical standing within the community. It is perhaps not surprising that, after his death, the *cabildo* nominated a series of indigenous *maestros mayores* of the carpenters' and sculptors' guilds. In 1707, the na-

tive master Pedro Pillajo assumed that title.[101] As noted previously, in 1712, Pedro Tipán, perhaps some relation to the earlier master, was elected by the *cabildo* as "a person of intelligence and experience" for the assessment and reconstruction of an important local bridge.[102] In 1718 and 1719, the *cabildo* nominated Cristóbal Monga, whose surname reflects a connection to a long familial tradition of local Andean woodworkers.[103] Despite the fact that never once during the colonial period did the *cabildo* officially elect an Andean *maestro mayor* of architects or *alarifes*, the professional and sociopolitical achievements of Francisco Tipán and other native masters demonstrate that opportunity and upward mobility were potentially accessible to the indigenous artists, and their accomplishments appear to have rendered more permeable the professional frontiers between the *república de los indios* and that of the *españoles*.

The documentary evidence demonstrates that the indigenous community controlled and dominated the building trade in Quito for nearly two centuries —the apogee of the city's construction. Indeed, it highlights the decisive role of Andean masters from a rich variety of ethnic backgrounds in the construction and adornment of colonial Quito. Far from their general characterization as manual laborers, in many cases native masters exercised intellectual and administrative control over the full process of architectural production, from the contract and design to the supervision of the workers and the construction itself. Moreover, these masters are not the anonymous native laborers generally referred to in the literature: they possessed individual and ethnic identities, professional titles, and master works that can and should be reinserted into the historical record.

Notes

* The present study is a revised and expanded version of my earlier article, "Masters of the Trade: Native Artisans, Guilds, and the Construction of Colonial Quito," *Journal of the Society of Architectural Historians* 68, no. 1 (March 2009): 10–29. I am grateful to the editors of JSAH for their permission to reproduce material from that study. My research has been generously supported over the past seven years by grants from the Graham Foundation for Advanced Studies in the Fine Arts, American Philosophical Society, National Endowment for the Humanities, American Council of Learned Societies, Fulbright Senior Scholar Program, University of St. Thomas, and College of William and Mary. In Quito, I would particularly like to thank Ximena Carcelén for her invaluable assistance, and also Jorge Salvador Lara, Christiana Borchart de Moreno, Segundo Moreno, and Susana Cabeza de Vaca. I am especially grateful to Hernán Lautaro Navarrete for his consistent encouragement and support, and for many of the photographs that grace this study.

1 Alfred Neumeyer, "The Indian Contribution to Architectural Decoration in Spanish Colonial America," *Art Bulletin* 30, no. 2 (1948): 104.

2 For colonial guilds, see especially Ramón Gutiérrez, *Arquitectura y urbanismo en Iberoamérica* (Madrid: Cátedra, 1997), chap. 15; and Manuel Carrera Stampa, *Los gremios mexicanos. La organización gremial en Nueva España* (México: Iberoamericana de Publicaciones, 1954).

3 One particularly well-known example is that of the native painters of Cuzco, Peru, who, because of abuses by European and Creole members, in the late seventeenth century renounced their membership in the local painters' guild and formed their own guild of exclusively native artists. For a succinct account, see Gauvin Alexander Bailey, *Art of Colonial Latin America* (London: Phaidon, 2005), 199–203.

4 Gutiérrez, *Arquitectura y urbanismo*, 344–345.

5 For example, Rubén Vargas Ugarte's dated but still unrivaled and oft-cited biographical compilation of artists in Central and South America contains several hundred entries for the sixteenth and seventeenth centuries; however, only nine of these are indigenous artists whose professions are related to the building trade. Vargas Ugarte, *Ensayo de un diccionario de artífices coloniales de la América meridional* (Lima: Talleres Gráficos A. Baiocco, 1947), 66, 93, 99, 139, 154, 155, 194, 271, 273. In a similar vein, Emilio Harth-Terré's study of colonial Peruvian artists cites only four Andean artists and states that "mestizos, creoles and Spaniards, from the first years of the conquest to the dawn of Independence, worked on the marvelous art of architecture which, in America, has splendid examples"

(author's translation). Harth-Terré, *Artífices en el Virreinato del Perú* (Lima: Torres Aguirre, 1945), 10, 29, 30, 31. One exception is the brief monograph on a native Peruvian sculptor by an unnamed team of researchers, *El escultor de la colonia D. Tomás Tuiro Túpac Inca* (Cuzco, 1964). By comparison, my current database of Andean artists in the city of Quito, culled primarily from a systematic review of all notarial records between 1580 and 1720, documents well over 400 such professionals associated with the building trade.

[6] Elizabeth Wilder Weismann, "The History of Art in Latin America, 1500–1800. Some Trends and Challenges in the Last Decade," *Latin American Research Review* 10, no. 1 (1975): 13.

[7] Debate is ongoing regarding population counts for Quito at the turn of the seventeenth century. This figure is based on the calculations of Martin Minchom and John Leddy Phelan. Minchom estimates a population of over 40,000 for the decade 1670–1680, and demonstrates a gradual decline over the course of the eighteenth century; Phelan places the population around 1650 at approximately 50,000 souls. See Minchom, *The People of Quito, 1690–1810: Change and Unrest in the Underclass* (Boulder, CO,: Westview Press,1994), 135, 257–258; and Phelan, *The Kingdom of Quito in the Seventeenth Century* (Madison, WI: University of Wisconsin Press, 1967), 49.

[8] Relatively little is known about the training of the first generations of building professionals, although most authors cite the Franciscan Colegio San Andrés as an important locus of early indigenous education in the arts. See, for example, José María Vargas, *Patrimonio artístico ecuatoriano*, 3rd ed. (Quito: Trama Ediciones, 2005), 18–21; Sonia Fernández Rueda, "El Colegio de Caciques de San Andrés. Conquista espiritual y transculturación," *Procesos* 22 (2005): 5–22; Roswith Hartmann and Udo Oberem, "Quito. Un centro de educación de indígenas en el siglo XVI," in *Contribuções à Antropologia em homenagem ao Professor Egon Schaden*, 105–127 (São Paulo, 1981). Although the Colegio de San Andrés was undoubtedly an important and influential educational endeavor, it is likely that most "training" in the construction trades was the result of hands-on experience in raising the city's first buildings. For a general discussion of the training and practice of early generations of builders in colonial Peru, see Valerie Fraser, *The Architecture of Conquest: Building*

in the Viceroyalty of Peru, 1535–1635 (Cambridge and New York: Cambridge University Press,1990), 82–108. Andrea Lepage, "The Arts of the Franciscan Colegio de San Andrés in Quito: A Process of Cultural Reformation," Ph.D. diss., Brown University, 2008.

[9] Although the names of a very few indigenous artists appear repeatedly in the literature, no systematic study has been undertaken, and most authors resort to generalizations about the "anonymous masses" of native workers.

[10] Although demographic and census data are incomplete, Quito certainly possessed a substantial indigenous majority during the late sixteenth and seventeenth centuries. Minchom, *People of Quito*, 66, cites a 1681 letter written by the president of the *audiencia*, Lope Antonio de Munive, in which "he claimed that 30,000 Indians were employed in the capital." Although the figure is likely inflated, it nonetheless provides a general sense of the city's demographics if we consider the total population count for this period to fall between 40,000 and 50,000 souls.

[11] Minchom points out that "the city's racial mix was largely Indian-White," emphasizing that the small African population of Quito "marks a real difference with nearly all other major Spanish American urban centers." Minchom, *People of Quito*, 50. Emilio Harth-Terré's extensive archival research on the building trade in colonial Lima demonstrates that the viceregal center of Peru, with its large population of African slaves and freemen, boasted far more African than indigenous masters and journeymen of the building trade, affirming that the latter played a substantially lesser role. Harth-Terré, "El artesano negro en la arquitectura virreinal limeña," *Revista del Archivo Nacional del Perú* 25, vol. 1 (1961): 360–430.

[12] Vargas, *Patrimonio artístico ecuatoriano* (Quito, 1972), 30–31.

[13] Samaniego, "Determinantes del primer arte hispanoamericano," in *Arte colonial del Ecuador, siglos XVI–XVII* (Quito: Salvat Editores, 1985), 25.

[14] Navarro, *La escultura en el Ecuador durante los siglos XVI, XVII y XVIII*, 2nd. ed. (Quito: Trama Ediciones, 2006), 187.

[15] Chantal Caillavet's rediscovery of a "Relación Geográfica de Oyumbicho y Amaguaña" of 1582 demonstrates that a group of carpenters called "Tomaycos" were "naturales de Guanuco, traydos

por el ynga a esta tierra" (432). Caillavet, *Las Étnias del norte. Etnohistoria e historia de Ecuador* (Quito: Abya Yala, 2000), 429, 432. The Inca relocated numerous colonies of *mitmajkuna* to the areas around Quito. These transplanted groups had origins throughout the Andean region, including Cañar, Chachapoyas, Huancabamba, Caxas, and Ayabaca. Waldemar Espinoza Soriano, *La etnia Guayacundo en Ayabaca, Huancambamba y Caxas* (Lima: Instituto de Ciencias y Humanidades, Fondo Editorial de San Marcos, 2006); Frank Salomon, *Native Lords of Quito in the Age of the Inca* (Cambridge and New York: Cambridge University Press, 1986), 158–167; and Linda A. Newson, *Life and Death in Early Colonial Ecuador* (Norman and London: University of Oklahoma Press, 1995), 130–131.

[16] Although, for Frank Salomon, the geographical and ethnic origins of the Collaguazos and Pillajos are not entirely clear, archival sources led him to surmise that "[t]he ancestral *llajta* [politically defined native group] of the Collaguazos, soon to become a widespread but mysterious group, is not known for sure; it is likely to have been in the area of Guayllabamba-El Quinche-Puritaco" (166). His documentary sources indicate that the Pillajos, "whose original *llajta* is not known, may have been true Quiteños" (146). Salomon, *Native Lords*, 146, 166, 168, 182.

[17] The assignation of hereditary ethnicity on the basis of surnames is clearly complicated by numerous factors, including the strikingly inconsistent manner in which surnames were passed to offspring among indigenous families during the colonial period. Sons and daughters were frequently given surnames that differed from those of their parents and grandparents, and which often varied with gender. Surnames that present a high degree of consistency in the documentary record over time, for example Tomayco, Collaguazo, and Tituaña, appear to derive from the names of *ayllus* or *llajta*, and underline the continued strength of ethnic (and professional) association throughout the colonial period (see appendix).

[18] See, for example, Archivo Histórico de la Orden de la Merced, Quito (hereafter AHOM/Q), Sección C. VI, G.8, 1700–1736, "Libro de Gasto y reciuo en la fabrica de la Yglesia de este Conu[en]to Maximo, siendo Prou[incia]l el R. P. Pdo. Fr. Manuel Mosquera de Figueroa" (Church of La Merced); Archivo Nacional de Historia, Quito (ANH/Q), Censos y Capellanías, caja 5, expte. 2, "Libro de la Cofradía del Santissimo Sacramento, que sea alabado, y bendito para siempre, fu[n]dada en la capilla de n[uest]ra Señora de Copacabana . . . año de 1689" (Church of El Sagrario); and ANH/Q, Notaría 1ª, Juicios, caja 6 (1700) "[M]emoria del cargo Y descargo, que se le hisso a Antonio de Herrera, quien quedo como Maiordomo trabajando en la montaña de la yglesia" (Church of San Juan Evangelista).

[19] For colonial guilds, see Carrera Stampa, *Los gremios mexicanos*; Gutiérrez, *Arquitectura y urbanismo*, 343–345; Héctor Humberto Samayoa Guevara, *Los gremios de artesanos en la Ciudad de Guatemala* (Guatemala: Editorial Universitaria, 1962).

[20] Gutiérrez, *Arquitectura y urbanismo*, 343–344.

[21] José Antonio Terán Bonilla, "La formación del gremio de albañiles de la ciudad de Puebla, en el siglo XVI y sus ordenanzas," *Cuadernos arquitectura docencia* 11 (1993): 14.

[22] Julio Alemparte R., "La regulación económica en Chile durante la colonia (II)," *Anales de la Facultad de Derecho* 2, nos. 6–7 (1936): 78.

[23] Archivo Municipal de Historia, Quito (hereafter AMH/Q), Actas del Cabildo de Quito, 1573–1574, fol. 156.

[24] For a discussion of the contemporary definitions and roles of *arquitecto*, *alarife*, and *albañil*, see Martha Fernández, "El albañil, el arquitecto y el alarife en la Nueva España," *Anales del Instituto de Investigaciones Estéticas* 14, no. 55 (1986): 49–68.

[25] For silversmiths, see Jesús Paniagua Pérez, *Los gremios de plateros y batiojas en la ciudad de Quito, siglo XVIII* (México: UNAM, 2000), 23, 227–236; and ANH/Q, Notaría 1ª, Juicios, caja 19, 1735–1737, fols. 13–15v (*batiojas*).

[26] For selected examples, see ANH/Q, Notaría 1ª, vol. 67, 1610–1614, Juan García Rubio, fols. 302–303 (*herrador*), fol. 340 (*sastre*), fol. 361 (*sastre*), fol. 392v (*sombrerero*); and ANH/Q, Notaría 1ª, vol. 87, 1617–1619, Diego Suárez de Figueroa, fols. 1028–1028v (*sederos, cordoneros, botoneros*), fol. 1063 (*sastre*), fol. 1065 (*herrador*), fols. 1076v–1077 (*sombrerero*).

[27] For selected examples, see ANH/Q, Notaría 5ª, vol. 1, 1599–1600, Juan de Briñas Marrón, fols. 223–234v (*platero*); ANH/Q, Notaría 5ª, vol. 11, 1628, Gerónimo de Castro, fols. 1201–1202 (*sombrerero*); ANH/Q, Notaría 5ª, vol. 13, 1630, Gerónimo de Castro, fols. 710v–711v (*ollero*); ANH/Q, Notaría 5ª, vol. 14, 1631 Gerónimo de

Castro, fols. 385v–386v (*batioja*), fols. 531–531v (*sastre*); ANH/Q, Notaría 5ª, vol. 31, 1642, Juan de Arce, fols. 443v–444v (*batioja*), 527–527v (*guantero*); ANH/Q, Notaría 5ª, vol. 45, 1656, Juan de Arce, fols. 354–354v (*platero*); and ANH/Q, Notaría 5ª, vol. 49, 1660–1661, Juan de Arce, fols. 32–32v (*batioja*), fols. 413–413v (*ollero*).

[28] For the *yanacona* system, see Fraser, *The Architecture of Conquest*, 93–98.

ANH/Q, Fondo Especial, caja 3, vol. 7, 1661–1674, fols. 80–92. In 1665, the Quero carpenters filed suit with the *real audiencia* citing a royal provision of 1662 that granted them exemption from the *mita*.

[30] ANH/Q, Fondo Especial, caja 3, vol. 7, 1661–1674, fol. 81.

[31] The two highest ranks appear in the documents as *maestro* (master) and *oficial* (journeyman), while the unspecified practitioner is simply listed by the trade name (*carpintero, albañil*, etc.).

[32] ANH/Q, Notaría 5ª, vol. 10, 1628, Gerónimo de Castro, fols. 613–613v, "tan bien acauada [y] labrada de perfeccion y moldura como la que tiene la puerta de la calle de la casa de Dona mariana de xaramillo su suegra." Cosme de Caso was the brother-in-law of Mariana de Jesús Paredes y Flores, who later became Quito's first saint. After the death of her parents, the young Mariana was raised by her elder sister Jerónima and her husband, Cosme de Caso; thus, the portal constructed by Machaguán and Anba was that of the house in which "la Azucena de Quito" spent her childhood, and which later became a part of the Carmelite convent of San José.

[33] Archivo General de Indias (hereafter AGI), Quito 33, no. 45 (1677), fol. 39, "en todo este obispado cada año se eligen alcaldes y Alguaciles Maiores Indios de cada offiçio que tienen d[ic]hos indios, en ellos no se escusan la elecçion de alcalde, aun en los Carnereros, Mata puercos, Fruteros, que estos como otros en la realidad, parece q[ue] no son offiçios. . . ."

[34] For a detailed discussion of the *república de los indios* with respect to that of the *españoles*, see especially Phelan, *Kingdom of Quito*, chap. 3.

[35] AMH/Q, Actas del Cabildo de Quito, 1691–1697, fol. 75v. Andrés de Ybarra's ethnicity is not noted in the document. Although his mother was indigenous, the ethnicity of his father remains unclear. Andrés de Ybarra was the *hijo natural* (out-of-wedlock son) of the indigenous or mestizo man Agustín de Aciencio and an indigenous woman, Inés Mexía, although Ybarra took the surname of the man in whose home he was raised, Andrés de Ybarra, the elder. In the 1669 last will and testament of Inés Mexía, she confesses that her son Andrés "is not the son of the said Andrés de Ybarra, but of Agustin de aciencio, With whom I had a friendship before the aforementioned [Andrés de Ybarra], and Andrés de Ybarra himself acknowledged that he was not his son because he turned out very similar to the said Agustín de aciencio, his father" (author's translation). ANH/Q, Notaría 5ª, vol. 59, 1669, Francisco Valverde de Aguilar, fols. 15v–17. Andrés de Ybarra the elder was a master sculptor, as Mexía notes in her will when she refers to "all the tools of sculpting that were left upon the death of the said Andrés de Ybarra And the books related to the art" (fol. 16v).

[36] AMH/Q, Actas del Cabildo de Quito, 1691–1697, fol. 121.

[37] AMH/Q, Actas del Cabildo de Quito, 1705–1707, fol. 61v.

[38] ANH/Q, Notaría 6ª, vol. 11, 1602, Diego Rodríguez Docampo, fols. 392–393.

[39] José Gabriel Navarro, *Contribuciones a la historia del arte en el Ecuador* (Quito: Imprenta de la Universidad Central, 1923) I, 51–52; and Archivo General de la Orden Franciscana del Ecuador, Quito (hereafter AGOFE/Q), serie 10, 10.4, Varios, no. 10–86, fol. 86. According to the latter source, Jorge de la Cruz and Francisco Morocho were responsible for "la hechura desta iglesia y capilla mayor y coro de San Fran[cis]co."

[40] ANH/Q, Notaría 1ª, vol. 78, 1613, Alonso López Merino, fol. 285. It is worth noting that, in a number of cases, both the patrons and the artists of a given work were Andean. Such was the case with this commission, wherein the patrons of the *artesonado* were Marcos de la Cruz, native *alcalde* of the parish of San Roque, and Francisco Cayllagua, native carpenter and *mayordomo* of the church.

[41] ANH/Q, Notaría 4ª, vol. 17, 1659, Antonio de Verzossa, fols. 120–120v.

[42] ANH/Q, Notaría 6ª, vol. 63, 1662–1663, Diego Rodríguez de Mediavilla, fols. 50–50v.

[43] ANH/Q, Censos y Capellanías, caja 5, 1690–1695, expte. 3-VI-1690, fols. 122 passim.

[44] AHOM/Q, Sección C.VI, G.8, 1700–1736, "Libro de Gasto y reciuo," fols. 22 passim.

[45] ANH/Q, Religiosas, caja 11, 1709–1712, expte. 1711-V-9, fol. 9v.

[46] AMH/Q, Actas del Cabildo de Quito, 1710–1714, fols. 71v–72v.

[47] Archivo Histórico del Banco Central, Quito (hereafter AHBC/Q), Fondo Jijón y Caamaño 194, fol. 1028.

[48] ANH/Q, Notaría 1ª, vol. 1, 1582–1587, Diego de Avendaño, fols. 467v–468v.

[49] ANH/Q, Notaría 6ª, vol. 8, 1598, Diego Rodríguez Docampo, fols. 452–454.

[50] ANH/Q, Notaría 4ª, vol. 23, 1664, Antonio de Verzossa, fols. 310v–312. The source for this portal has long been recognized as a design attributed to Michelangelo for the Vigna Grimani in Rome. Most authors cite its appearance in the first Spanish edition of Vignola, published by Eugenio Caxés in 1593, as the means by which the design was introduced to the colonial Americas. The source and its spectacular realization in the Jesuit Colegio of Quito have led some authors to simply assume that it was the work of either a master architect or brother Marcos Guerra himself. See, for example, *Historia del Arte Hispanoamericano*, ed. Diego Angulo Iñíguez (Barcelona: Salvat Editores, 1950), 2:108; Mario Buschiazzo, *Historia de la arquitectura colonial en Iberoamérica* (Buenos Aires: Emecé Editores, 1961), 78; and Graziano Gasparini, *América, Barroco y Arquitectura* (Caracas: Ernesto Armitano Editor, 1972), 271. Although Guerra likely selected the design, it was realized by the native master Lorenzo Aulis and his team of Andean masons, with a number of changes and additions that warrant further investigation. Several of these authors also note that this model was repeated in the main portal of the Church of San Juan Bautista in Pasto, Colombia, and later in several churches in Bogotá. Documentary evidence recovered in Quito demonstrates for the first time that the portal, and in fact the entire church, of San Juan Bautista in Pasto was the work of the indigenous Quiteñan master mason Marcos Bermejo, who was contracted in Quito in 1667 to travel with his team of native masons to the town of Pasto to build the church. ANH/Q Notaría 1ª, vol. 224, 1667, José Gutiérrez, fols. 70–71v.

[51] ANH/Q, Notaría 3ª, vol. 17, 1694, Nicolás de Leguía, fols. 828v–829v.

[52] ANH/Q, Notaría 1ª, vol. 3, 1588–1594, Diego Lucio de Mendaño, fols. 317v–318v. Unfortunately, the altarpiece is no longer extant.

[53] Minchom, *People of Quito*, 39.

[54] ANH/Q, Notaría 1ª, vol. 159, 1638, Pedro Pacheco, fols. 97–98v.

[55] ANH/Q, Notaría 1ª, vol. 206, 1661–1662, Thomas Suárez de Figueroa, fols. 532v–534.

[56] ANH/Q, Notaría 1ª, vol. 224, 1667, José Gutiérrez, fols. 70–71v.

[57] Alfonso Ortiz Crespo, *Guía de arquitectura de la ciudad de Quito* (Quito and Seville: Junta de Andalucía, Municipio de Quito, 2004), 2:190.

[58] ANH/Q, Notaría 1ª, vol. 60, 1609, Alonso López Merino, fols. 615v–616v, "para gaçer la yglesia y Capilla de san jua[n] de letran de este conuento . . . conforme el ttrazado que tienen hecho . . . gaziendo un arco toral y portada a la plaça . . . y un canpanario . . . todo de todo punto y puesto en toda perfección."

[59] Gutiérrez, *Arquitectura y urbanismo*, 345.

[60] Salomon, *Native Lords*, 160–161.

[61] ANH/Q, Notaría 1ª, vol. 82, 1615, Alonso Dorado de Vergara, fols. 92v–93.

[62] ANH/Q, Notaría 6ª, vol. 29, 1620, Diego Rodríguez Docampo, fols. 552–555.

[63] Piedad y Alfredo Costales, *Los Agustinos. Pedagogos y misioneros del pueblo, 1573–1869* (Quito: Abya Yala, 2003), 22; and ANH/Q, Notaría 1ª, vol. 98, 1622, Gerónimo de Heredía, fols. 394v–395v.

[64] ANH/Q, Notaría 1ª, vol. 98, 1622, Gerónimo de Heredía, fols. 394v–395v.

[65] AHN/Q, Notaría 1ª, vol. 103, 1603, Gerónimo de Heredía, fols. 573–574v.

[66] ANH/Q, Notaría 1ª, vol. 105, 1623–1624, Juan García Rubio, fol. 18v: "dasele con los d[ic]hos 300 p[eso]s el Retablo q[ue] oy esta en la capilla de jua[n] de bera por su trauajo."

[67] ANH/Q, Notaría 6ª, vol. 35, 1622–1623, Diego Rodríguez Docampo, fols. 383–384: "un rretablo de madera de dos cuerpos y su frontispicio y cornija en lo alto con cinco ymajines de bulto en tres nichos el principal a de tener a n[uest]ra s[eño]ra y a san Joseph y el niño Jesus en medio asido de las manos de su bendita madre y san Joseph—y en los dos nichos san ylefonso y sant joan evangelista y a de llevar las columnas melcochadas y estriadas y los capiteles de corintio—y al remate del rretablo por los lados fantasias—y el cuerpo segundo hazia arriba no a de tener bulto porque an de ser las pinturas de pinzel como mas por extenso paresçe de la planta y modelo del dicho rretablo que quede firmado de mi el presente escribano y del dicho

Don joan Benitez en pergamino. . . ."

68 Susan Verdi Webster, "Confraternities as Patrons of Architecture in Colonial Quito, Ecuador," in *Early Modern Confraternities in Europe and the Americas: International and Interdisciplinary Perspectives*, ed. Christopher Black and Pamela Gravestock, 210–213 (London: Ashgate, 2006)

69 For a useful study of indigenous social mobility in the colonial Andes, see Karen Spalding, "Social Climbers: Changing Patterns of Mobility among the Indians of Colonial Peru," *Hispanic American Historical Review* 50, no. 4 (1970): 645–664.

70 Indigenous battalions have not been accorded much attention in the literature on the *audiencia* of Quito. Nonetheless, specific examples may be cited, including that of Don Diego Sancho, *cacique* of Latacunga, who in 1580 wrote a letter to the king requesting that he be awarded the title of *Alcalde Mayor* of all the indigenous groups in his district in return for his service as captain of the battalion of Indians from Latacunga who were sent to "pacify" the Quixos. AGI, Quito, 46, N. 49, 23-I-1580, n.p. Another example is that of Don Francisco Toaquiza, who in the 1680s served as sergeant major in the native battalion of the city of Quito. ANH/Q, Notaría 1ª, vol. 247, 1681, Juan García Moscoso, fols. 158–159v.

71 "yndio, maestro escultor, entallador, ensamblador y arquitecto." ANH/Q, Testamentarias, caja 47, 1717, expte. 20-IV-1717, fols. 82–82v.

72 A 1659 contract, drawn up with the aid of an "Ynterprete de los naturales," involved an indigenous man named Francisco Tipán, "yndio del pueblo de Oyumbicho." Because his profession is not specified, it is unclear whether he is the same Francisco Tipán who would later be identified as master sculptor and carpenter of Quito. ANH/Q, Notaría 5ª, vol. 48, 1659, Juan de Arce, fols. 333r–333v. The latter Francisco Tipán died in 1708 or 1709; thus, it is possible that he and the resident of Oyumbicho referred to in the 1659 contract are the same.

73 See, for example, ANH/Q, Notaría 1ª, vol. 89, 1617–1618, Alonso Dorado de Vergara, fols. 560–561v [Don Juan Tipán Tasic, resident of Oyumbicho]; ANH/Q, Notaría 1ª, vol. 190, 1649, Diego Bautista, fols. 25–26v [Isabel Muzinziches, viuda de Francisco Tipán, natural de Panzaleo]; ANH/Q, Notaría 4ª, vol. 9, 1652–1653, fols. 93–95 [Francisco Tipán, yndio de Oyumbicho]; and

ANH/Q, Notaría 1ª, vol. 213, 1664–1665, Francisco Hernández Marcillo, fols. 137–137v [Ventura Tipán, resident of Oyumbicho]. Minchom, *People of Quito*, 39, has noted that Oyumbicho was a site of "local craft specialization in carpentry for the urban market."

74 Caillavet, *Étnias*, 429, 432; Salomon, *Native Lords*, 112; and Minchom, *People of Quito*, 39.

75 Espinoza Soriano, *La Étnia Guayacundo*, 78–80; Salomon, *Native Lords*, 48–51; and Newson, *Life and Death*, 40–46.

76 ANH/Q, Notaría 5ª, vol. 62, 1670, Juan de Arce, fols. 320v–321.

77 ANH/Q, Notaría 5ª, vol. 86, 1691, Francisco Dionisio de Montenegro, fols. 257v–258v.

78 ANH/Q, Real Hacienda, caja 43 (1684–1780), vol. 1694, fol. 66; Archivo General de la Nación, Lima (hereafter AGN/L), Real Hacienda, Caja Real, C-7, leg. 1275, 1693, Quito, C.3, fol. 67; AGN/L, Real Hacienda, Caja Real, C-7, leg. 1275, 1692, Quito C.2, fol. 76; and AGN/L, Real Hacienda, Caja Real, C-7, leg. 1275, 1690, Quito, C.1, fol. 71v.

79 ANH/Q, Notaría 1ª, vol. 293, 1705–1706, Gregorio López, fols. 370–370v.

80 ANH/Q, Notaría 1ª, Juicios, caja 3, 1666–1683, expte. 15-07-1677, fol. 15.

81 ANH/Q, Notaría 1ª, vol. 232, 1670–1673, Miguel de Ortega, fols. 7v–8v.

82 The testament of Doña Francisca Llactapalla, widow of Don Bernal de Zúñiga, notes various unfinished sculptures left by her deceased husband, and mentions "que el d[ic]ho mi marido difunto me Dixo [sic] en Vida que una piedra de moler colores de pintura tubiesen entre ambos hermanos los d[ic]hos mis hijos. . . ." ANH/Q, Notaría 5ª, vol. 80, 1685–1687, Francisco Dionisio de Montenegro, fols. 214–217. For María de Zúñiga's relationship to Don Bernal de Zúñiga, see ANH/Q, Notaría 1ª, vol. 279, 1698, Antonio López de Urquía, fols. 21–22v. For her relationship to Don Ventura de Zúñiga, see ANH/Q, Notaría 5ª, vol. 80, 1685–1687, Francisco Dionisio de Montenegro, fols. 218–220v.

83 ANH/Q, Indígenas, caja 6, 1654–1657, expte. 14-XII-1657, fols. 9–108.

84 ANH/Q, Autos Acordados, caja 1, 1578–1630, vol. 1 (1578–1722), fols. 183–184v.

85 ANH/Q, Notaría 4ª, vol. 47, 1697, Manuel Cevallos y Velasco, fol. 114.

86 ANH/Q, Casas, caja 3, expte. 3, 1704, fols. 47–47v.

[87] It is particularly revealing that Tipán's only son, Bartolomé Asiencio, who is identified by the notary in the documents as "Bartolomé Asiencio Tipán," chose to sign the same documents with the name "Bartolomé Asiencio Olmos Pizarro." ANH/Q, Notaría 1ª, vol. 303, 1709–1710, Francisco Durango, fols. 742–744v.

[88] Archivo Parroquial del Sagrario, Quito (hereafter APS/Q), "Libro de bautizos de yndios, 1693–1719," fol. 80.

[89] ANH/Q, Notaría 3ª, vol. 17, 1694, Nicolás de Leguía, fols. 828v–829v, "de madera seis sabado de treze baras de Alto y ocho de ancho, en quadro con doce Apostoles de Cuerpo entero de dos baras de Alto, y quatro ebanjelistas . . . segun el dibujo que le tiene entregado dentro de año y medio. . . ." One vara is approximately three feet; thus, Tipán's altarpiece stood an impressive 39 feet high.

[90] José Gabriel Navarro, *La escultura en el Ecuador* (Madrid: Academia de Bellas Artes, 1929), 168.

[91] Benjamín Gento Sanz, *Historia de la obra constructiva de San Francisco* (Quito: Imprenta Municipal, 1942), 54–55: "[t]rabajaba en Quito un escultor, Francisco Tipán, de quien consta por los años de 1697 a 1699, junto con un dorador llamado Andrés, hizo el retablo y los nichos de la Sacristía de San Francisco."

[92] Ibid., 55: "[u]no de los escultores que intervinieron en su factura, al parecer indígena, responde al nombre de Francisco Tipán 'escultor', a quien se le paga por su trabajo 14 *pesos*, así como tambien el nombre de un tal 'Andrés el Dorador', a quien se le entregan 20 pesos. . . ."

[93] Joël Monroy, *El Convento de la Merced de Quito (de 1700 a 1800)* (Quito: Imprenta del Clero, 1943), 141–142.

[94] AHOM/Q, Sección C. VI, G. 8, 1700–1736, "Libro de gasto y reciuo," fols. 12–12v: "al M[aest]ro tipan por la hechura del tabernaculo . . . y puertas del Santo Christo labradas por afuera . . . los dos Nichos colaterales de N[uestra] M[adr]e y S[a]n Jo[an] y . . . las molduras de los Espejos, y labrar las puertas por adentro. . . ."

[95] Compare AHOM/Q, Sección C. VI, G.8, 1700–1736, "Libro de gasto y reciuo," fols 12–12v, with the information provided by Monroy, *El Convento de la Merced*, 142.

[96] Luis Octavio Proaño, *La Merced, arte e historia* (Quito: Editorial Rivadeneira, 1989), 188–190.

[97] ANH/Q, Notaría 4ª, vol. 51, 1701, Manuel Cevallos y Velasco, fols. 61–62v; Susan Verdi Webster, *Arquitectura y empresa en el Quito colonial: José Jaime Ortiz, Alarife Mayor* (Quito: Abya Yala, 2002), 94–98.

[98] ANH/Q, Casas, caja 3, 1704, expte. 3, fols. 11–250.

[99] Ibid., fols. 49–49v: "mal edificada Por tener las paredes de adobes sensillos y que para alto y bajo es nesesario de adobe y tras adoue, y que el soberado es todo de chacllas y barro y por dissimularlo esta aforrado de esteras y que toda la madera esta Polillada y que por eso mando [Ortiz] Blanquear Y Pintar bigas, Paredes esteras de la cubierta y Puertas. . . ."

[100] ANH/Q, Testamentarias, caja 47, 1717, expte. 20-IV-1717, fols. 81v–88v.

[101] AMH/Q, Actas del Cabildo de Quito, 1705–1707, fol. 102v.

[102] AMH/Q, Actas del Cabildo de Quito, 1710–1714, fols. 71v–72v.

[103] AMH/Q, Actas del Cabildo de Quito, 1715–1719, fol. 90v, fol. 143.

Appendix

Chronology of selected Andean surnames from Quito related to artistic and building professions.

Amaguaña (regional toponym)
Lorenzo: stonemason.
1651, contract with La Merced.
AHOM/Q, C. VI, 6.4, 1644–1656, "Libro de gastos," fol. 237v.
Francisco: carpenter.
1666, sale of land.
ANH/Q, Notaría 1ª, vol. 222, 1666–1669, Pedro de Aguayo, fols. 16–17v.
Lorenzo: carpenter.
1716, contract with La Merced.
AHOM/Q, C.VI, G. 8, 1700–1736, "Libro de Gasto y reciuo," fol. 36v.

Aulis (aboriginal?)
Simón: stonemason.
1632, purchase of land.
ANH/Q, Notaría 1ª, vol. 139, 1631–1632, Diego Rodríguez Urban, fols. 255–255v.
Lorenzo: master stonemason.
1664, contract with La Compañía.
ANH/Q, Notaría 4ª, vol. 23, 1664, Antonio de Verzossa, fols. 310v–312.
1671, purchase of land.

ANH/Q, Notaría 5ª, vol. 62, 1670–1671, Juan de Arce, fols. 521–521v.

Diego: journeyman stonemason.

1667, purchase of land.

ANH/Q, Notaría 1ª, vol. 224, 1667, José Gutiérrez, fols. 94–96.

Blas: stonemason.

1716, contract with La Merced.

AHOM/Q, C.VI, G. 8, 1700–1736, "Libro de Gasto y reciuo," fol. 36v.

Collaguazo (Collaguaso, Collahuaso)(aboriginal?)

"Yndios Collaguazos": carpenters.

1552, contract with governor.

AMH/Q, Actas del Cabildo de Quito, vol. 5, 1552–1568, fol. 97v.

Luis: blacksmith.

1568, petition to the crown.

AGI, Quito, 20B, N.63 [1568].

Francisco: master mason (albañil).

1689, contract for evaluation and reconstruction of building.

ANH/Q, Fondo Especial, caja 5, vol. 12, fols. 362 ff.

Manuel: stonemason.

1698, contract with San Francisco.

AOGFE/Q, "Libro que tiene el síndico," 1694–1736, Leg. 10, no. 1, L.2, fol. 55.

Diego: stonemason.

1698, contract with San Francisco.

AOGFE/Q, "Libro que tiene el síndico," 1694–1736, Leg. 10, no. 1, L.2, fol. 55.

Marcos: carpenter and/or mason.

1728–1729, contract with Santo Domingo. AGODE, vol. 5, fol. 72v.

Manuel: carpenter and/or mason.

1728–1729, contract with Santo Domingo. AGODE, vol. 5, fol. 72v.

Machaguay (Machacay, Machaguan) (aboriginal?)

Francisco: carpenter.

1560–1570, contract with cathedral.

Salvaguarda de la Catedral Primada de Quito (Quito, 1997), 41.

Joan: carpenter.

1601, purchase of land.

ANH/Q, Notaría 1ª, vol. 19, 1601, Francisco García Duran, fols. 761v–763.

1603, sale of land.

ANH/Q, Notaría 1ª, vol. 25, 1603, Alonso Dorado de Vergara, fols. 366–366v.

Diego: stonemason.

1603, purchase of land.

ANH/Q, Notaría 1ª, vol. 25, 1603, Alonso Dorado de Vergara, fols. 366–366v.

Andrés: *alcalde de los yndios canteros,* stonemason.

1628, private contract.

ANH/Q, Notaría 5ª, vol. 10, 1628, Gerónimo de Castro, fols. 613-613v.

Pedro: mason.

1674, private contract.

ANH/Q, Indígenas, caja 11, expte. 15, 1674, fols. 59v-60v.

Pedro: carpenter and sculptor.

1694, contract with parish of Santa Prisca.

ANH/Q, Religiosas, caja 4, 29-VI-1681, fol. 164v.

1704, contract with parish of Santa Prisca.

ANH/Q, Religiosas, caja 8, expte. 9, 1696-VI-14, fol. 20.

1705, contract with parish of Santa Prisca.

ANH/Q, Religiosas, caja 8, expte. 9, 1696-VI-14, fol. 22.

1707, contract with parish of Santa Prisca.

ANH/Q, Religiosas, caja 8, expte. 9, 1696-VI-14, fol. 23v.

Pillajo (Pillaxo) (aboriginal)

Francisco: journeyman painter.

1649, purchase of house.

ANH/Q, Notaría 1ª, vol. 175, 1643–1650, Diego Rodríguez Urbano, fols. 513v–515v.

Juan: master gilder.

1652, contract with confraternity.

ANH/Q, Notaría 5ª, vol. 42, 1652–1653, Juan de Arce y Velarde, fols. 466v–467.

Vicente: master silversmith.

1665, sale of land.

ANH/Q, Notaría 1ª, vol. 210, 1662–1665, Miguel de Ortega, fols. 123–124v.

Juan: sculptor and painter.

1669, named in land sale.

ANH/Q, Notaría 5ª, vol. 60, 1669, Juan de Arce y Velarde, fols. 238–238v.

Antonio: stonemason.

1698, contract with San Francisco.

AOGFE/Q, "Libro que tiene el síndico," 1694–1736, Leg. 10, no. 1, L.2, fol. 58v.

Pedro: master carpenter.

1707, named *Alcalde Mayor y Veedor* of carpenters' guild.

AMH/Q, Actas del Cabildo de Quito, 1705–1707, fol. 102v.

Francisco: carpenter.

1716, contract with La Merced.
AHOM/Q, C.VI, G. 8, 1700–1736, "Libro de Gasto y reciuo," fol. 34.

Marcos: carpenter.

1728–1729, contract with Santo Domingo.
AGODE, vol. 5, fol. 72v.

Luis: carpenter.

1728–1729, contract with Santo Domingo.
AGODE, vol. 5, fol. 72v.

Laureano: master mason.

1783, named as building assessor.
ANH/Q, Gobierno, caja 33, expte. 10, 23-IV-1783.

Rimache (Inca transplants)

Mateo (Atau Rimache): painter.

1617, recipient of land donation.
ANH/Q, Notaría 1ª, vol. 88, 1617–1618, Alonso Dorado de Vergara, fols. 306–307v.

1628, *principal de San Roque*; sale of land.
ANH/Q, Notaría 1ª, vol. 121, 1627–1628, Diego Baptista, fols. 257–257v.

Domingo: blacksmith and *cacique de los yanaconas*.

1621, power of attorney.
AGOFE/Q, 7.2, Títulos de tierras, aguas, III, fols. 5–8.

1621, power of attorney.
ANH/Q, Notaría 1ª, vol. 94, 1621, Álvaro Árias, fols. 568–568v.

Estéban: master blacksmith.

1647, sale of land.
ANH/Q, Notaría 1ª, vol. 186, 1647, Diego Baptista, fols. 71–72v.

1647, purchase of land.
ANH/Q, Notaría 1ª, vol. 186, 1647, Diego Baptista, fols. 191–191v.

Domingo: *bajonero*.

1647, sale of land.
ANH/Q, Notaría 1ª, vol. 186, 1647, Diego Baptista, fols. 69–70v.

Pascual: blacksmith.

1647, sale of land.
ANH/Q, Notaría 1ª, vol. 186, 1647, Diego Baptista, fols. 69–70v.

Joan: carpenter.

1647, sale of land.

ANH/Q, Notaría 1ª, vol. 186, 1647, Diego Baptista, fols. 171–172v.

Diego: master sculptor.

1662, purchase of land.
ANH/Q, Notaría 1ª, vol. 207, 1662–1663, Francisco Hernández Marcillo, fols. 36v–38v.

1666, purchase of land.
ANH/Q, Notaría 5ª, vol. 56, 1666, Juan de Arce y Velarde, fols. 235–236.

1669, sale of land.
ANH/Q, Notaría 5ª, vol. 60, 1669, Juan de Arce y Velarde, fols. 238–238v.

Roque (Rimache Illa Inga): carpenter.

1689, heir of Joan Rimache.
ANH/Q, Notaría 1ª , vol. 248, 1676–1689, Juan García Moscoso, fol. 742v.

Lorenzo and Geronimo ("alias los Yngas").

1692, rental of land.
ANH/Q, Notaría 1ª, vol. 269, 1692–1701, Manuel Francisco Calderón, fols. 19v–20.

Tituaña (Tituguaña) (Otavalo?)

"Yndios Tituañas": carpenters.

1552, contract with governor.
AMH/Q, Actas del Cabildo de Quito, vol. 5, 1552–1568, fol. 97v.

Luis: carpenter.

1608, private contract.
ANH/Q, Notaría 1ª, vol. 53, 1608, Alonso López Merino, fol. 606.

Lorenzo: carpenter.

1624, purchase of land.
ANH/Q, Notaría 1ª, vol. 95, 1620–1625, Fernando Zurita, fols. 130v–132v.

Marcos: master carpenter.

1659, contract with confraternity.
ANH/Q, Notaría 4ª, vol. 17, 1659, Antonio de Verzossa, fols. 120–120v.

Estéban: stonemason.

1716; contract with La Merced.
AHOM/Q, C.VI, G. 8, 1700–1736, "Libro de Gasto y reciuo," fol. 36v.

Gregorio: carpenter.

1760, carpentry workshop.
Fernando Jurado Noboa, *Calles, casas y gente del Centro Histórico de Quito* I (Quito, 2004), 123–124.

Tomayco (Tomaico) (from Huánuco region of Peru)

"Yndios Tomaycos": carpenters.

1582, "Relación de Oyumbicho."

> Caillavet, *Étnias del norte*, 432.

"Yndios Tomaycos": carpenters.

1602, letter to Viceroy.

> ANH/Q, Notaría 1ª, vol. 21, 1602, Francisco de Zarza Monteverde, fols. 234–234v.

Joan: carpenter and *principal de los yndios carpinteros*.

1602, letter to Viceroy.

> ANH/Q, Notaría 1ª, vol. 21, 1602, Francisco de Zarza Monteverde, fols. 234–234v.

Bartolomé Josep: master carpenter.

1628, purchase of land.

> ANH/Q, Notaría 1ª, vol. 120, 1627–1628, Álvaro Árias and Diego Rodríguez Docampo, fols. 1246–1247v.

1630, sale of land.

> ANH/Q, Notaría 1ª, vol. 130, 1629–1631, Joan del Castillo, fols. 373v–375.

Poetics of Representation in Viceregal Peru:
A Walk round the Cloister of San Agustín in Lima

Sabine MacCormack

My topic is the cycle of thirty-eight paintings depicting the life of Saint Augustine in the cloister of the Augustinian convent of Our Lady of Grace in Lima.[1] The convent was founded in 1551 by the first Augustinian friars to arrive in Peru. Interrupted by earthquakes and tremors, construction proceeded gradually but steadily, and the paintings were installed in the cloister, which is still their home, between 1742 and 1746. The first canvas in the series (Fig. 1) shows the secular and spiritual descendants of Augustine's parents Patricius and Monica, flanked by the two Augustinian friars under whose patronage and guidance the entire cycle was painted. They are on the right fray Roque de Yrarrasabal y Andia, who

was Augustinian provincial of Peru when the paintings were created, and on the left fray Fernando de Luna y Virues, "prior of the (Augustinian) convent in Cuzco, where he ordered this Life (of Augustine) to be painted."[2] The painter was Basilio Pacheco from Cuzco, who in one of these paintings left us his self-portrait (Fig. 2, lower right). By Pacheco's time, the narrative of Augustine's life had developed several strands, depending on who told the story. The first narrative is by Augustine himself, who in the *Confessions* wrote about his infancy, youth, and early adulthood up to his conversion to Christianity in 386 CE with an emotive and spiritual intensity that still moved him when he reviewed his writings in old age,[3]

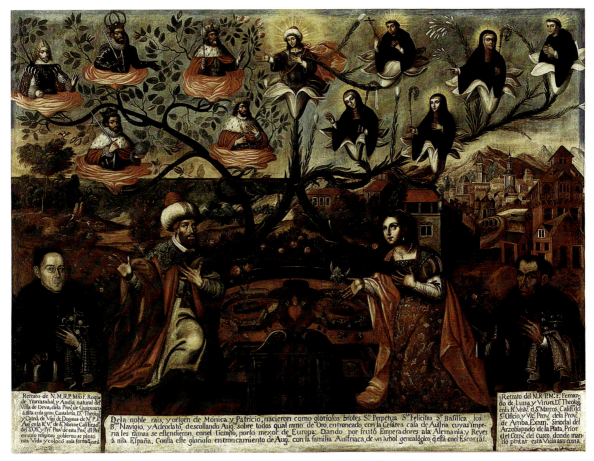

Fig. 1. Basilio Pacheco, *Augustine's parents Patricius and Monica as spiritual parents of Augustinian nuns and monks, and of secular devotees of Augustine*. Oil on canvas. Cloister of San Agustín, Lima (number 1 in the sequence). Photo: D. Giannoni.

just as it has moved readers ever since. The *Confessions* can be supplemented by statements Augustine made about himself elsewhere in his many writings, and also by the short factual biography that his disciple Possidius wrote after his death.[4] Augustine was born in 354 CE in the small town of Thagaste in Roman North Africa. His conversion to Christianity—a high point in the *Confessions*—occurred in 386,[5] and he died in 430 as bishop of the small seaport of Hippo Regius in North Africa, while the city was being besieged by Vandal invaders. Shortly after his death, Hippo fell and after some 500 years of relative peace, Roman rule in North Africa disintegrated.

Of Augustine's writings, it was his *Ordo monasterii* (*Regulations for a Monastery*), a brief outline of conduct for men living as a religious community, that was of immediate and practical interest to his followers. A more detailed rule known as *Praeceptum* (*Rule*) was

written for a community of lay brothers living near Hippo.[6] Among other texts of Augustinian monastic precepts, a spurious so-called *First Rule*[7] supplementing what Augustine had written was attributed to him until the sixteenth century and beyond. Religious communities living under Augustine's *Rules* and their offshoots spread throughout Europe, and during the sixteenth century, the friars founded new houses not only in Peru, but also in India, Mexico, and the Philippines. Over the centuries, religious communities living by Augustine's precepts read his writings and reflected on the life of their founder, reimagining that life in light of their own struggles, aspirations, and ideals. They also reflected on the life of Augustine's mother Monica, who played a powerful role in his conversion, and whom he remembered in the *Confessions* and elsewhere. Jacopo de Varazze, author of the immensely popular thirteenth-century

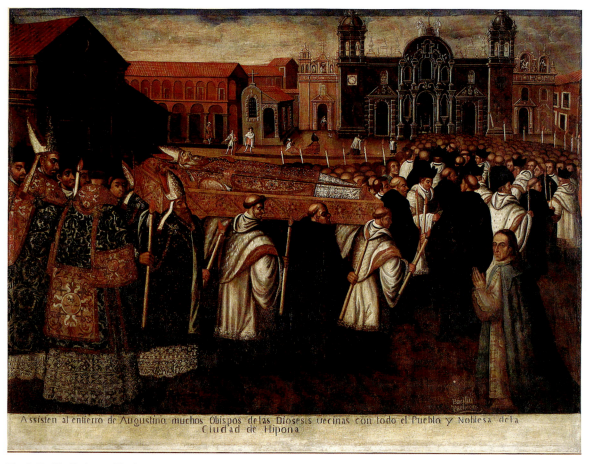

Assisten al entierro de Augustino muchos Obispos de las Diosesis uecinas con todo el Pueblo y Noblesa de la Ciudad de Hipona

Fig. 2. Basilio Pacheco, *The funerary procession of Augustine crossing the main square of Cuzco*. The painter's self portrait is in the lower right corner. Oil on canvas. Cloister of San Agustín, Lima (number 36 in the sequence). Photo: D. Giannoni.

collection of biographical narratives about Christian saints known as the *Golden Legend,* told Monica's life story alongside that of Augustine, making two independent but intertwined narratives. In the sixteenth century, the Spaniard Alonso de Villegas followed suit in his *Flos Sanctorum* (*Flower of Saints*). By this time, the lives of both Augustine and Monica had been amplified by legendary additions, which in the later seventeenth century the learned authors of the *Acta Sanctorum* (*Doings of the Saints*) sought to separate from historically verifiable information. But the legendary additions had come to stay.[8] In both Europe and the Americas, pictorial cycles of the life of Augustine intertwined that life with the life of his mother Monica and adorned both with additions that were imagined by Augustine's medieval devotees. Basilio Pacheco followed this augmented, partly legendary biographical narrative about mother and son. Moreover, in this Peruvian retelling, the ancient story acquired additional themes linking

Augustine's life with that of his followers in Lima and in the Andes at large. Like many Andean painters, Pacheco followed—or perhaps was instructed to follow—European originals. His rendering of the life of Augustine built, *inter alia,* on a cycle of engravings by the Flemish engraver Schelte Adams Bolswert. But at times, Pacheco followed Bolswert selectively or not at all, and on occasion he used other originals or painted images of his own invention.[9]

Let us therefore enter the Augustinian convent in Lima through the eighteenth-century baroque portal with the founder's statue looming over it.[10] The statue shows Augustine raising in his right hand the burning heart, the heart consumed by divine love that absorbed his early modern Spanish and Spanish American readers and that—as we will see—is also evoked in one of Pacheco's paintings (Fig. 22).[11] Turning into the cloister, we come upon the scenes that Pacheco painted of Augustine's childhood and youth as described in the *Confessions*[12]

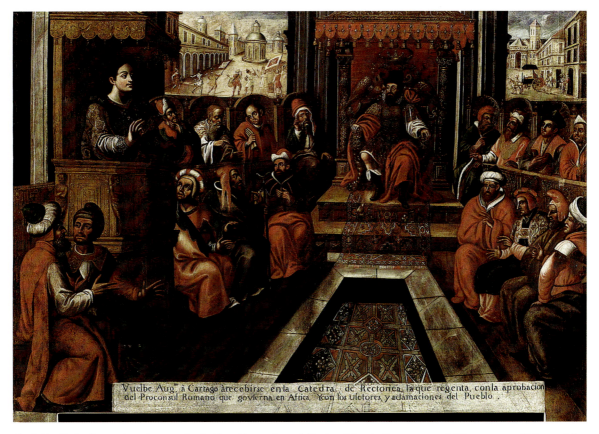

Fig. 3. Basilio Pacheco, *Augustine competing for his position as rhetor of Carthage before the Roman proconsul.* Oil on canvas. Cloister of San Agustín, Lima (number 6 in the sequence). Photo: D. Giannoni.

and as reimagined in eighteenth-century Lima. Augustine was not happy at school. "What miseries I experienced at this stage of my life," he recalled:

> if ever I was indolent in learning, I was beaten. This method was approved by adults, and many people living long before me had constructed the laborious courses which we were compelled to follow by an increase of the toil and sorrow of Adam's children.[13]

But Augustine did not suffer in silence for long: his intelligence awakened, he enjoyed being a trial to his teachers by asking awkward questions about Roman mythology and Latin literature. By way of pointing to these episodes from the *Confessions*, Pacheco painted a schoolroom of eighteenth-century Lima where the young Augustine distracts a fellow student by upsetting his inkwell, not quite ready as yet to study the formidable volumes of Greek and Hebrew, of Plato, Aristotle, and Cicero, that line a bookcase in the background. In due course, Augustine himself became a teacher of rhetoric in Carthage. Pacheco (Fig. 3) portrayed him competing for the position under the watchful eye of the Roman proconsul by public examination or *oposición*,[14] that is, by the same method as was used at the University of San Marcos in eighteenth-century Lima and throughout the Spanish world to select professors. Clothed in a fanciful mingling of Roman and early modern attire, the proconsul is seated beneath the double-headed crowned eagle, the armorial device of the Holy Roman Empire of Pacheco's own time. The eagle is framed by a pair of columns that hint at the triumphal emblem of the emperor Charles V, *Plus Ultra*, "more lies beyond."[15]

In the *Confessions,* Augustine recalled these years of youthful success, of cutting loose from the small-town life of Thagaste and from the influence of Monica. Escaping from her and from provincial confinement in North Africa, Augustine taught first in Rome and then in Milan, where Monica followed him, where he met the redoubtable local bishop Ambrose, and where he began rethinking his ideas about God and Christ and how to live. Before long (Fig. 4), in a secluded garden in Milan, he found himself making the decision that transformed his life (Fig. 5):

> Suddenly I heard a voice from the nearby house chanting as if it might be a boy or a girl—I do not know which—saying and repeating over and over again "Pick up and read, pick up and read."[16]

Rendering the child's voice visible, Bolswert and Pacheco both depicted the voice coming from an angel—from one of those beings whom an early modern Spanish painter's manual defined as "the bodies of human thought."[17] Following that thought, Augustine opened the book next to him and read words of the apostle Paul that ended his hesitations: some months later he was baptized by Ambrose. Departing from Bolswert's image (Fig. 6), Pacheco (Fig. 7) depicted the baptism as the event that it had become in later tradition, with musician angels performing the *Te Deum,* the morning hymn of the Catholic church.[18] Among the onlookers we see Monica, clothed as a nun. The Augustinian friars in Lima and perhaps Pacheco himself would have read the story in the *Golden Legend* or the *Flos Sanctorum*. In the words of the former, immediately after baptizing Augustine,

> Ambrose said, "We praise you Oh God *Te Deum laudamus*" and Augustine responded, "We confess you Oh Lord, *te Dominum confitemur*" and so the two composed this hymn by turns, and sang it to the end, as is also affirmed by Honorius in his book called *Mirror of the Church*. Also, in some old books this title is placed at the beginning: "Song composed by Ambrose and Augustine."[19]

Beyond attributing the *Te Deum* to Ambrose and Augustine, the authors of the *Golden Legend* and *Flos*

Solitudinem ad flendi negotium exquirens AVGVSTINVS, secessit ab Alipio remotius; vbi sub quadam fici arbore stratus, inter flumina lacrymarum suarum audiuit vocem a Deo missam; Tolle lege, Tolle lege. Lib. 8. Confess. 12.
A. Bon enfant excu Auec priuilege du Roy

Fig. 4. Schelte Adams Bolswert, *The conversion of Augustine*, 1624. Engraving. Plate 4 from the Series on the Life of Saint Augustine. Jeanne & Pierre Courcelle, *Iconographie de Saint Augustin* Vol. III. Paris, Études Agustiniennes 1972.

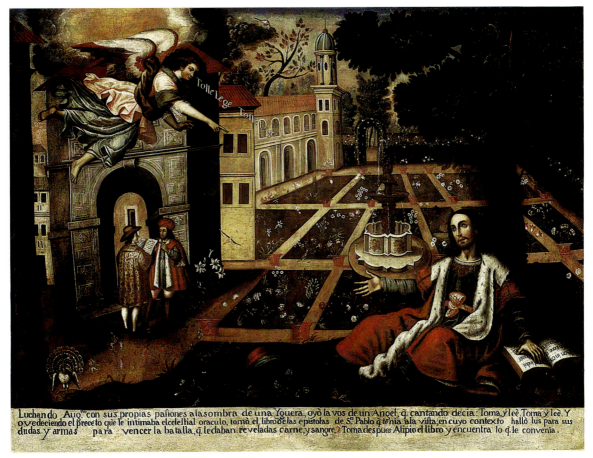

Luchando Aug.no con sus propias pasiones a la sombra de una Yguera, oyò la vos de un Angel, q. cantando decia: Toma y lee, Toma y lee. Y ovedeciendo el preceto que le intimaba el celestial oraculo, tomè el libro de las epistolas de S.n Pablo q. tenia a la vista, en cuyo contexto hallò lus para sus dudas y armas para vencer la batalla, q. le daban reveladas carne, y sangre. Toma despues Alipio el libro y encuentra lo q. le convenia.

Fig. 5. Basilio Pacheco, *The conversion of Augustine*. Oil on canvas. Cloister of San Agustín, Lima (number 10 in the sequence). Photo: D. Giannoni.

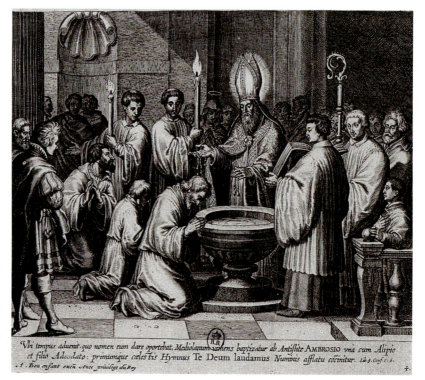

Fig. 6. Schelte Adams Bolswert, *Augustine's baptism by bishop Ambrose, with Monica in the background*, 1624. Engraving. Plate 4 from the Series on the Life of Saint Augustine. Jeanne & Pierre Courcelle, *Iconographie de Saint Augustin* Vol. III. Paris, Études Agustiniennes 1972.

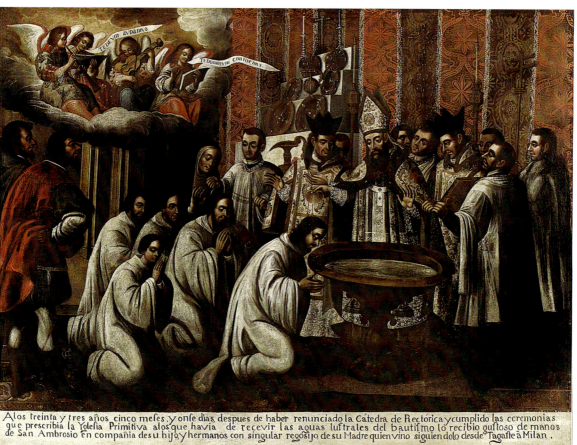

Fig. 7. Basilio Pacheco, *Augustine's baptism by bishop Ambrose while angels sing the Te Deum*. Monica, clothed as a nun, is among the on-lookers. Oil on canvas. Cloister of San Agustín, Lima (number 12 in the sequence). Photo: D. Giannoni.

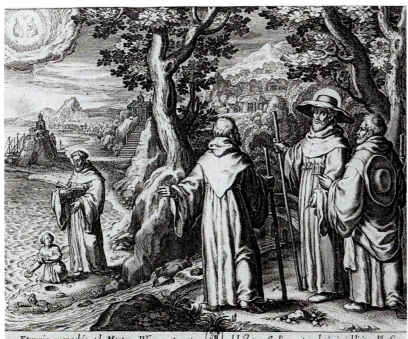

Etruriæ monachis ad Montem Pisanum et centum silvas delectatus, studio contemplationis addicitur: librosq̃ de Trinitate scribendos suscipit; sed pueruli monitu rursum subsistens, placito sancto removetur à turbis. AA. xxv̄ij.

A. Bon enfant exeū Auec priuilege du Rey 5.

Fig. 8. Schelte Adams Bolswert, *Augustine's vision of the mysterious boy attempting to empty the sea*, 1624. Engraving. Plate 6 from the Series on the Life of Saint Augustine. Jeanne & Pierre Courcelle, *Iconographie de Saint Augustin* Vol. III. Paris, Études Agustiniennes 1972.

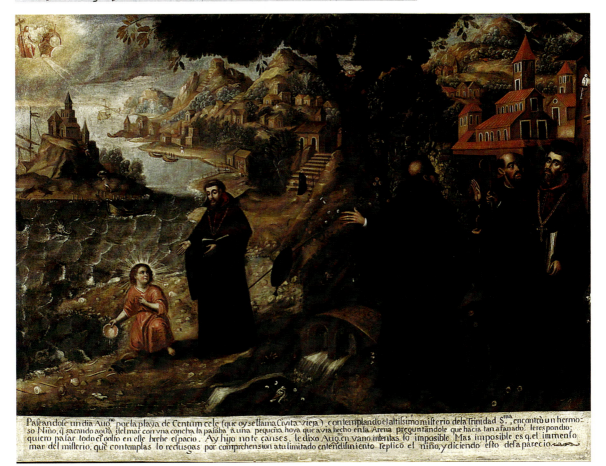

Paseandose un dia Aug.⁰ por la playa de Centum cele (que oy se llama Civita vieja) contemplando el altissimo misterio de la Trinidad S.ᵐᵃ, encontró un hermo- so Niño, q̃ sacando agua del mar con vna concha la pasaba à una pequeña hoya que avia hecho en la Arena preguntandole que hacia tan afanado. le respondio: quiero pasar todo el golfo en esse brebe espacio. Ay hijo no te canses, le dixo Aug. en vano intentas lo imposible Mas imposible es q̃ el immenso mar del misterio, que contemplas lo reducgas por comprehension a tu limitado entendimiento replicó el niño, y diciendo esto desaparecio.

Fig. 9. Basilio Pacheco, *Augustine's vision of the mysterious boy attempting to empty the sea*. Oil on canvas. Cloister of San Agustín, Lima (number 14 in the sequence). Photo: D. Giannoni.

Sanctorum had it that after baptizing him, Ambrose clothed Augustine in the monastic habit and leather belt that in their day were worn by Augustinian friars and hermits, and of course by the friars in whose cloister Pacheco's paintings were hung. Working in Antwerp, an international metropolis of printing and publishing, Bolswert was in a position to know that the earliest monks, among them Augustine, had not been clothed ceremonially in the distinctive monastic habit that became customary centuries later. But historical accuracy mattered much less than the continuity that religious communities living by Augustine's monastic precepts felt to exist between their founder and themselves. This spiritual and didactic trajectory became all the more salient in Pacheco's renderings of these images, destined as they were to be hung in an Augustinian cloister. Walking round their cloister day in day out, the friars came face to face with an ever-present pictorial meditation on their founder's long and eventful life, on which they were called to model their own.

Following those friars, we come upon the monk Augustine (Fig. 8) paying a visit to a group of solitaries.[20] Here, walking by the seaside (Fig. 9), as we learn from the legend of the painting, which in turn was taken from the *Golden Legend* or *Flower of Saints*,

Augustine contemplating the highest mystery of the most holy Trinity encountered a beautiful little boy, who, taking water from the sea with a shell, poured it into a little hollow he had made in the sand. Augustine asked the boy what he was doing so laboriously and he replied, 'I want to bring this entire sea into the hollow here.' 'My child, do not weary yourself,' Augustine said. 'In vain you attempt the impossible.' The little boy replied, 'It is yet more impossible that within your limited understanding you will contain the immense sea of the mystery you are contemplating,' and saying this he vanished.

Who was this child—perhaps Christ himself? We are not told but instead are exhorted to think about the precondition for such visionary experiences when coming face to face with Pacheco's autonomous rendering of the legendary story about

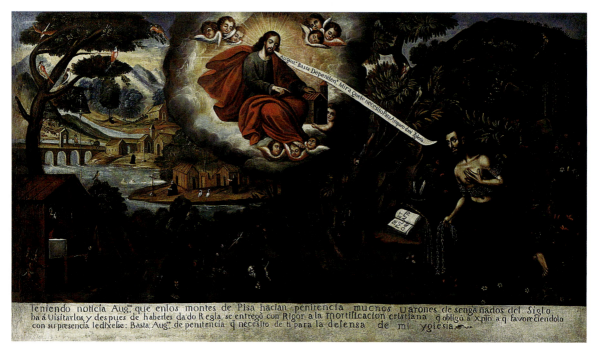

Fig. 10. Basilio Pacheco, *Augustine as a hermit in the wilderness*. Oil on canvas. Cloister of San Agustín, Lima (number 15 in the sequence). Photo: D. Giannoni.

Augustine the penitent in a wilderness (Fig. 10). Before him on a rock lies the work of his earlier worldly aspirations *On Beauty and Proportion,* while Christ appears on a cloud and says, "Augustine, enough of penitence, I need you for the defence of my church"[21]—words that build on but change Augustine's recollection in the *Confessions* that he had wished to live in philosophic seclusion, but "you have commanded me to serve your servants my brothers if I wish to live with you,"[22] and again:

> Terrified by my sins and the pile of my misery, I had racked my heart and had meditated taking flight to live in solitude. But you forbade me and comforted me by saying: "That is why Christ died for all, so that those who live should not live for themselves but for him who died for them."[23]

Next, the pictures take us to the seaport of Ostia, where Monica and Augustine planned to embark for Africa, and where Monica died. In the words of the *Confessions,*

> the day was imminent when she was to depart this life....It came about...that she and I were standing leaning out of a window overlooking a garden...where far removed from the crowds, after the exhaustion of a long journey, we were recovering our strength for the voyage. Alone with each other, we talked very intimately. Forgetting the past and reaching forward to what lies ahead, we were searching together in the presence of the truth which is you yourself. We asked what quality of life the eternal life of the saints will have, a life which neither eye has seen nor ear heard, nor has it entered into the heart of man.[24]

Like Bolswert, Pacheco omitted this visionary turning point in the *Confessions* and instead depicted Monica

dying with the words "Jesus, Jesus" on her lips, while Augustine, surrounded by fellow monks, reads from a liturgical book. Ever interested in the written word, Pacheco added, on the pages of the book Augustine is holding, the words of his prayer: "Lord have mercy...Holy Trinity, highest God have mercy on us." The volume by Monica's bedside communicates another verbal message, from the book of Tobit, "Remember not, Lord, my offences or those of my parents...."[25] The window in the background of this image turns the viewer's attention not to the otherworldly vision seen through a window that Augustine described in the *Confessions.* Rather, we see through this window the ship on which Augustine sailed back to Africa, about which the *Confessions* are silent.

In Africa,[26] the narrative continues with another wilderness episode (Fig. 11). Augustine, having founded a monastic community in his native Thagaste, is washing the feet of a pilgrim and while doing so discovers that the pilgrim is Christ. While Bolswert depicted this legendary scene as a simple encounter between Christ and Augustine, Pacheco (Fig. 12) here as elsewhere shows Augustine assisted by his monks, an invitation to the friars of Lima to think of themselves as coworkers with their founder. Above, two cherubs trail a scroll saying, "Great Father Augustine, today you were found worthy to see the Son of God in the flesh," to which Christ adds the words: "To you I commend my church." The ecclesiastical career on which the Augustine of pious legend was being launched by Christ himself is pursued in subsequent images: he was ordained as priest and shortly thereafter consecrated as bishop of Hippo. But there were also the claims the Augustinian order made on Augustine after his death, in compliance with which another monastic scene follows in the pictorial cycle. Bolswert depicted the secluded garden dwelling that, according to Possidius, bishop Valerius of Hippo gave to Augustine and his friends as a place of respite from the obligations of pastoral care.[27] Augustine hands to these friends and fellow monks a book opened at the beginning of the *Regulations*

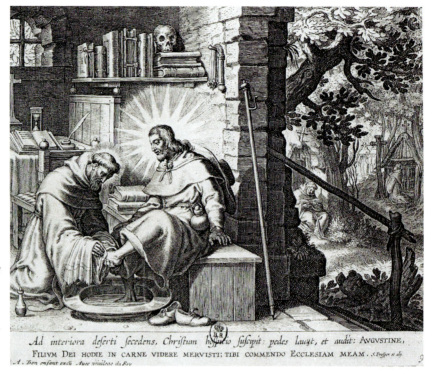

Fig. 11. Schelte Adams Bolswert, *Augustine sees Christ in a vision and washes his feet*, 1624. Engraving. Plate 9 from the Series on the Life of Saint Augustine. Jeanne & Pierre Courcelle, *Iconographie de Saint Augustin* Vol. III. Paris, Études Agustiniennes 1972.

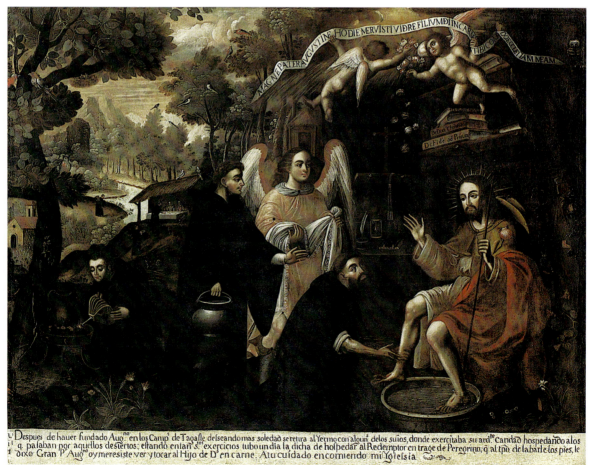

Fig. 12. Basilio Pacheco, *Augustine sees Christ in a vision and washes his feet*. Oil on canvas. Cloister of San Agustín, Lima (number 18 in the sequence). Photo: D. Giannoni.

for a Monastery, "Above everything, dearest brothers, you should love God."[28] Pacheco (Fig. 13) rethought the episode and also identified the book on the desk next to Augustine as the treatise on the religious life titled *De cognitione verae vitae* (*Knowledge of True Life*), which was attributed to him during the Middle Ages.

Throughout, Basilio Pacheco added to Bolswert's images the portraits of Augustine's monastic companions along with words being spoken or sung by the persons represented, and identifications of books that explained, changed, or expanded the significance of different episodes in Augustine's life. These changes of imagery were most likely contributed by fray Fernando de Luna y Virués, who commissioned the paintings (Fig. 1), or by another Augustinian friar. By incorporating Augustine's writings and biblical texts into the story of his life, the friars affirmed the nature of their own obligations and aspirations, in short of their vocation. Hence,

for example (Fig. 10), Pacheco's penitent Augustine in the wilderness contemplates the book *On Beauty and Proportion*, which, as he wrote in the *Confessions,* he regretted writing and dedicating to a famous orator whose career he hoped to emulate.[29] Conversion to the monastic life entailed renunciation of precisely such aspirations. Likewise, the friars will have supplied the titles of volumes we see on a shelf over the head of the pilgrim Christ (Fig. 12): Augustine's treatise *On Christian Doctrine* along with *On Baptism* and *On Faith to the Deacon Peter.*[30]

While linked to Augustine's self-portrayal in the *Confessions* and elsewhere, these scenes are elaborations of what he wrote: products of the imagination that arose as much from the search for origins and authenticity that preoccupied members of Augustinian religious communities as they did from the founder's own writings. In the course of this search for origins, numerous works were attributed to Augustine that

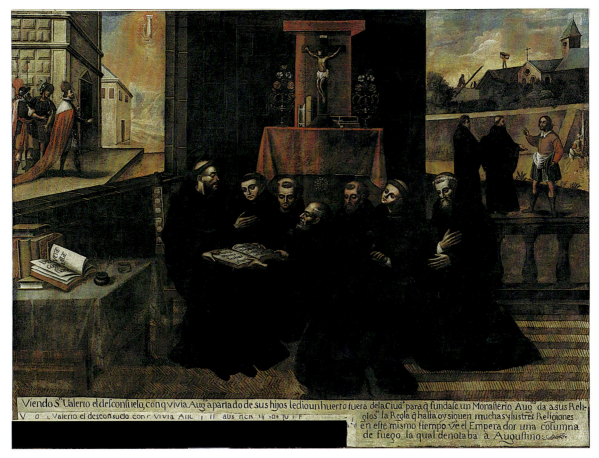

Fig. 13. Basilio Pacheco, *Augustine and his monks in the garden retreat given to them by bishop Valerius of Hippo.* Oil on canvas. Cloister of San Agustín, Lima (number 20 in the sequence). Photo: D. Giannoni.

the friars liked but that he did not write. The task of distinguishing Augustine's genuine from his spurious writings was undertaken systematically by his early modern editors, foremost among them the humanist Erasmus, who as a young man had escaped from an Augustinian religious community and who produced the first critical edition of Augustine's works, in ten folio volumes published in Basel in 1543. The edition included the spurious works, but they were prefaced by Erasmus's acerbic evaluations. Thus about the little treatise *On Faith to the Deacon Peter*:

> That this work is not by Augustine is clear primarily from the mode of expression, which is both more popular and more disjointed than that of Augustine....Besides, the work keeps repeating that children who depart from this world without baptism are to be tormented in eternal fire: which I have not read Augustine saying anywhere else.[31]

About *Knowledge of True Life* (Fig. 12), Erasmus wrote:

> I need hardly point out that this work is not by Augustine. The style rather indicates some rustic or better, a misguided person.... Chapter three overrates dialectic. Chapter six says that the angels know and foreknow everything. Likewise other things that Augustine never wrote. The work seems to be an exercise of some monkish beginner in theology who wanted in this book to provide a sample of how far he had progressed in scholastic philosophy[32]

—a discipline Erasmus despised. As for the "First Rule," purportedly written for Augustinian canons, of whom Erasmus had been one, he wrote: "I beseech you, reader, with what kind of intelligence or thought can you credit people who attribute these trifles to a grown man?"[33] Other writings fared equally poorly, including the sermons Augustine had reportedly addressed to "the brothers in the wilderness" of Italy. Here, the bone of contention was not merely the corpus of Augustine's writings, but the chronology of his life. How was it possible to fit two periods of monastic seclusion, one after Augustine's baptism, and the other before his return to Africa, into the chronology that emerged from his *Confessions*?[34] The simple solution was to recognize that the entire corpus of seventy-six sermons was spurious—as Erasmus did with the concise observation that they had been

> cobbled together from the *Rule* of Augustine, for they contain nothing of Augustine's in any other respect. The artificer who produced the sermons did so to commend the Order described as Augustinian to the world.[35]

It followed that Augustine did not spend a prolonged time in Italy living the ascetic life; hence, neither the vision of Christ exhorting him to care for the church (Fig. 10) nor the vision of the mysterious child by the seashore (Fig. 9) was historical.

In 1587, forty-three years after Erasmus's edition of Augustine was published, the *Liber Vitasfratrum*, "Book of the Lives of the Brothers," by Jordan of Saxony appeared in print in Italian, with a Latin edition following in 1625.[36] Dating back to the mid-fourteenth century,[37] the *Vitasfratrum* celebrates the often obscure and sometimes glorious history of the religious who lived under the *Rules* of Augustine[38] from the founder's lifetime to Jordan's own. The underlying theme that forged the many biographical details that make up the *Vitasfratrum* into a coherent whole is Jordan's periodic commentary and meditation on the virtues that were exemplified in Augustine's life and the lives of the followers who lived by his monastic precepts. Thus it is from Jordan of Saxony's meditations on the *Praeceptum* or *Rule* that someone derived the idea that Augustine in the wilderness of Thagaste was visited by Christ (Figs. 11 and 12) in the guise of a pilgrim and washed

his feet, in obedience to the evangelical command that Jordan quoted, "I was a stranger and you have received me."[39] As for the years that Augustine supposedly spent as a monk in Italy, Jordan, while recognizing the chronological difficulties, adhered to the traditional story, since he thought the *Sermons to the Brothers in the Wilderness* were authentic.[40] The publication of Augustine's works by Erasmus, that cornerstone of patristic editing, had no impact on the printed text of the *Vitasfratrum*, which circulated unmodified, just as it had been written originally.

Directly or indirectly, and independently of Erasmus's strictures on spurious Augustinian texts, the *Vitasfratrum* also entered the thoughtworld of Alonso de Villegas in the *Flos Sanctorum*, who picked up on Augustine the visionary conversing with the mysterious child,[41] and on Augustine the monk guiding his small community in the garden he received from his bishop Valerius.[42] In Peru, the *Vitasfratrum* was read by and inspired Antonio de la Calancha, who for many years lived in the Augustinian convent of Lima and while there wrote a voluminous history of his order in Peru that was published in 1638.[43] Calancha was of course long dead when Basilio Pacheco painted the life of Augustine, but his history, the *Corónica moralizada* as he described it, contributed to the life of Augustine in its Peruvian context.

Calancha read the *Vitasfratrum* as a prophetic work. Extrapolating from the holy lives that Jordan of Saxony described, Calancha thought that just as his order had—in his view—been at the forefront of the evangelization of the Mediterranean and just as other religious orders were all offshoots of this earliest of all religious orders, so in Peru Augustinians had been pioneers in the labor of evangelization.[44] Peru was the new heaven and the new earth that John saw in the *Apocalypse*:

> I will speak in the same sense as Saint John in the *Apocalypse* speaks of a new land, or new world that he saw on Patmos, not because it is another world in substance, but because it is better and more excel-

lent in its qualities—this being language that Isaiah also employed, and so did the Apostle Saint Peter. By revelations and the knowledge about times and centuries that was provided for us by the old law, this land (of Peru) is called New World.[45]

The visionary of this hitherworldly reading of the *Apocalypse* was Jordan of Saxony, whose hopes and aspirations for his fellow Augustinians in the Old World—so Calancha believed—were fully realized in the New.[46] Although such an understanding of the mission of the Augustinian order was vigorously contested by Peruvian Franciscans and Dominicans, they were nonetheless all passionately convinced of their own providential role in the history of Peru. America really was the new heaven and new earth, the theatre—as Calancha understood it—where the Augustinian virtues on which Jordan of Saxony had meditated could find their ultimate realization in the work of converting the Incas and their former subjects to Christianity.

The *Vitasfratrum* is a meditation, not a book of history: it left unexplained whatever precise historical connection might have existed between the monastic lives of Augustine and his followers in their day and the lives of Augustinian religious in subsequent times. This connection, a matter of establishing a chronology of Augustinian monasticism, is the theme of the *Monasticon Augustinianum* of 1623 by the German Nicolaus Crusenius (Fig. 14). Crusenius took cognizance of the great edition by Erasmus and his critique of spurious works but defended these works as authentic. Citing the *Sermons to the Brothers in the Wilderness*, he thus traced Augustine's monastic vocation and identity back to his baptism and even earlier,[47] just as Bolswert and Pacheco in due course depicted it. Crusenius's titlepage, showing Augustine with the open codex of the *Regulations for a Monastery* on his knees, surrounded by representatives across the ages of the Augustinian family, announces the program of the *Monasticon*, while the frontispiece (Fig. 15) show-

ing Augustine, now a bishop, with his monks in the "garden of Valerius" explains its continuance. Crusenius's arguments left the learned authors of the *Acta Sanctorum*[48] unconvinced, but this did not compromise the reception of his work in Peru.

In any case, what mattered in Peru differed somewhat from what mattered in Europe. Jordan of Saxony and Nicolaus Crusenius provided Antonio de la Calancha and his fellow Augustinians in Peru with their sense of historical identity and providential mission. Crusenius was deeply preoccupied with the sufferings and martyrdoms of Augustinian religious that resulted from the Protestant Reformation,[49] but what mattered in Peru, in this "Indian Bethlehem,"[50] was the virtues, evangelical labors, and martyrdoms of local Augustinian friars, for which Crusenius provided antecedents and historical context. To be precise, what mattered to Calancha

was that the Peruvian province had been included in Crusenius's list of Augustinian provinces, and that Crusenius mentioned two Peruvian Augustinians whom Calancha regarded as foundational figures in the history not just of the Augustinian order in the Americas but of Peru as a country. They were the saintly bishop of Popayán, fray Agustín de la Coruña,[51] and fray Diego Ortiz, who had died a martyr's death in his endeavor to convert the last Incas. Calancha claimed Diego Ortiz as Peru's first martyr.[52] What mattered as well was that Crusenius, like others before him, described Augustine (to whom Calancha consistently refers as "mi padre San Agustín") as a martyr because of the burden of episcopal responsibility, defense of the church, and human compassion that his life epitomized.[53] In short, Augustine was the example on whom the founders of the Peruvian province and their suc-

Fig. 14. Frontispiece. Nicolaus Crusenius, *Monasticon Augustinianum* (Munich: I. Hertsroy, 1623).

Fig. 15. *Augustine and his monks in the garden retreat given by Valerius.* Nicolaus Crusenius, *Monasticon Augustinianum* (Munich: I. Hertsroy, 1623).

cessors had modeled their lives: they lived ascetic lives, preached the Gospel, and defended the faith.

In a painting composed independently of Bolswert,[54] Pacheco (Fig. 16) thus showed Augustine debating with the Manichee Felix,[55] whom he cornered so effectively that Felix was left with no choice other than converting to Christianity. This outcome of a historic and historical debate was modified in later legend as depicted by Pacheco into Felix losing the ability to speak and being healed of the affliction by Augustine himself. This recalls the legendary episode about Augustine's rhetorical skills from the *Flower of Saints* that Pacheco also painted: in the background of the first encounter between the as yet unconverted Augustine and bishop Ambrose, he showed Ambrose praying with his clergy, "From the logic of Augustine" "Oh Lord deliver us."[56] When Christ in another

legendary episode (Fig. 10) exhorted Augustine to set aside penitence and defend the church, it was precisely those rhetorical skills that he had in mind.

Several paintings depict Augustine's struggles, both historical and legendary, with representatives of the schismatic Donatist church of North Africa. In an episode worthy of legend (Fig. 17) but recounted by Augustine himself[57] and by his biographer Possidius,[58] Augustine, traveling in the countryside near Hippo, lost his way, thereby avoiding a group of Donatist assassins who had been sent to kill him. But the account of Augustine's journey to Italy, undertaken to request from imperial authorities sterner measures against the Donatist Church, arose from an erroneous interpretation of Possidius.[59] Augustine never made such a journey, but Bolswert (Fig. 18) depicted him and his monk companion receiving a gracious welcome from the Roman

Fig. 16. Basilio Pacheco, *Augustine in debate with Felix the Manichee. In the background, right, Augustine heals Felix, who according to legend has been struck dumb in the course of the debate.* Oil on canvas. Cloister of San Agustín, Lima (number 21 in the sequence). Photo: D. Giannoni.

emperor Honorius, attired in the robes and wearing the crown of the Holy Roman Empire as they were in the seventeenth century. Pacheco (Fig. 19) followed suit. The contrast between imperial purple and ermine on the one hand and the black attire of Augustine, who is set apart only by his simple episcopal shoulder cape, on the other,[60] combined with the emperor's welcoming gesture and Augustine's gesture of deference, captures a theme of Peruvian politics that was played out in Lima almost daily: the need for cooperation and accommodation between church and state, viceroy and archbishop. In 1667, the Augustinian fray Gaspar de Villarroel, bishop of La Imperial, published the second of two folio volumes on this troublesome topic, which had lost none of its urgency when in 1738, not long before Pacheco's paintings were installed, the entire work was reprinted.[61] Augustine's conduct demonstrated the correct way to proceed. For, as the next image

in the cycle indicates, the African church gained the imperial support it sought: the image shows Augustine presiding at the resulting conference of bishops in Carthage, which imposed conformity with the Catholic Church on the dissenting Donatists. The fact that the historical Augustine did not preside, although he did draft and finalize the acts of this conference, was of less interest to his early modern pictorial biographers. What mattered instead—in both Spain and the Americas—was the *patronato real*, the protection and patronage of the church by the Spanish crown that in legislative terms replicated Roman imperial patronage and protection of the church of Augustine's day.[62]

By the reckoning of his own time and also by the reckoning of early modernity, Augustine was an old man by now. He continued as bishop of Hippo until not long before his death, and left one of his most extensive works of theological controversy, the

Fig. 17. Basilio Pacheco, *Augustine having lost his way thereby avoids being killed by Donatist brigands*. Oil on canvas. Cloister of San Agustín, Lima (number 24 in the sequence). Photo: D. Giannoni.

Fig. 18. Schelte Adams Bolswert, *Augustine meets the emperor Honorius in Italy,* 1624. Engraving. Plate 14 from the Series on the Life of Saint Augustine. Jeanne & Pierre Courcelle, *Iconographie de Saint Augustin* Vol. III. Paris, Études Agustiniennes 1972.

Fig. 19. Basilio Pacheco, *Augustine meets the emperor Honorius.* Oil on canvas. Cloister of San Agustín, Lima (number 25 in the sequence). Photo: D. Giannoni.

treatise against the Pelagian bishop Julian of Ecla-
num, unfinished. At issue was the overarching power
of divine grace, which Augustine defended against
Pelagius's insistence on the sufficiency for salvation
of human free will. Fray Fernando de Luna y Virués
or his spokesperson understood the centrality of this
issue in Augustine's thought, and so it is that Pacheco
(Fig. 20) painted an autonomous image of Augus-
tine's birth, indicating as much: while Monica is being
served a bowl of soup to speed her recovery from
giving birth, a red zigzag line, emanating from the
baby Augustine like lightning, strikes another baby
who has just been born across the water; as the leg-
end of the painting explains, this was Pelagius, who
was born in Britain on the same day as Augustine
was born in North Africa. The story, while apocry-
phal, appears in Alonso Villegas's *Flos Sanctorum*.[63]

Augustine's life as contemplative and theolo-
gian fills the concluding images of both Bolswert's

and Pacheco's cycles. In an autonomous painting,
Pacheco (Fig. 21) distinguished between divinely
sanctioned and human visionary experiences. Augus-
tine, writing the book *De verbis domini* (*On the Words of
the Lord* [in the Gospels]), sees Jerome, with whom he
had exchanged letters about scriptural exegesis. One
of these, *Ad Hieronymum*, addressed by Augustine to
Jerome, has been pushed to the back of the desk.
In real life, the relationship between Jerome and
Augustine was not without tensions, but here, as the
legend of the painting explains, "Since in life Jerome
was unable to visit his friend Augustine as he desired,
he came to visit him at the point of death, before
ascending to heaven."[64] The blaze of light surround-
ing Jerome indicates the divine nature of this vision.
In the background, by contrast, Augustine's student
Eulogius, puzzling over a passage in Cicero, has a
human vision: Augustine appeared to him and solved
the difficulty.[65] Describing the incident, Augustine

Fig. 20. Basilio Pacheco, *The birth of Augustine*. Oil on canvas. Cloister of San Agustín, Lima (number 2 in the sequence). Photo:
D. Giannoni.

could not explain how this and similar dreams or visions could happen. But he did know that it was his image, not himself, that had appeared to Eulogius, so Pacheco painted Augustine standing before Eulogius as an insubstantial dark shadow, a nothing. But the holy Jerome, who—as legend had it—really did appear, is a luminous and recognizable figure.[66]

Reviewing his writings in old age, Augustine wrote that he had thought about the fifteen books *On the Trinity* for a long time. While he was still occupied with book twelve, some admirers, eager to read the work, removed and published it without the author's consent. Although displeased, Augustine yielded to the entreaties of friends, lightly revised those earlier books, and completed the remaining ones. "I began the work as a young man and finished it when old,"[67] he wrote to Bishop Aurelius of Carthage. These circumstances gave rise to the legend (Figs. 8 and 9) about Augustine's conversation about the Trinity

with the mysterious little boy. It was not the only legend surrounding the composition of *De Trinitate*. Bolswert captured a moment in the old Augustine's life. Surrounded by books, having set the miter, the insignia of his burdensome episcopal office, aside on the floor, Augustine is engrossed in reading and writing and fails to notice a woman who is asking for his advice. Disappointed, she departs, but later sees Augustine saying Mass and simultaneously adoring the Trinity in heaven. The search for the most holy Trinity that the mysterious child told Augustine was an impossible undertaking had thus come to fruition after all. And what is the book on Augustine's desk, as painted by Pacheco, that the Peruvian friars wanted to see identified? *Sermones ad fratres,* the *Sermons to the Brothers in the Wilderness.*

Bolswert rounded out Augustine's heavenly vision of the Trinity with an image of more intimate piety. The Christ child, seated on Our Lady's lap,

Dudando la inteligencia de un lugar de Ciceron Eulogio dicipulo de Augustin que estaba muchas leguas distante, se le apareció como una sombra y le explicó el verdadero sentido Y que San Geronimo no logro en vida ver como deseaba a su amigo Augustino al punto que murio fue avisitarlo antes de subir al cielo

Fig. 21. Basilio Pacheco, *Augustine sees his friend Jerome in a luminous celestial vision while his student Eulogius in an earthly vision sees only a dark shadow of Augustine.* Oil on canvas. Cloister of San Agustín, Lima (number 28 in the sequence). Photo: D. Giannoni.

pierces Augustine's heart with an arrow, bringing to mind the imagery of the *Confessions* where Augustine prays, "give answer to me and say to my soul, 'I am your salvation'"[68] and "you pierced our hearts with the arrow of your love."[69] Pacheco (Fig. 22) expanded this divine epiphany by adding to it a vision seen by Augustine's friend Paulinus of Nola. The two men had exchanged letters, and Augustine wrote the *Confessions* in response to Paulinus's inquiries about his conversion. Furthermore, various medieval authors claimed to know that Paulinus had visited Augustine in Africa.[70] This visit is the subject of Pacheco's image. While Augustine converses with Virgin and Child, Paulinus sees Augustine, in the words of the legend of the picture, "raised up in the form of a seraph before the throne of the most holy Trinity"[71]—thereby expanding Bolswert's simple domesticity of Augustine's study into a celestial panorama.[72] In another visionary image

by Pacheco (Fig. 23), Augustine stands between Christ, who offers him the blood of his body in the Eucharist, and the Virgin, who offers him the consoling milk of her breast, with which she had nurtured Christ himself. Of the blood, Augustine speaks the words "here I am fed from the wound," and of the milk he says, "here I drink milk from the breast."[73] These mystical experiences—the piercing of Augustine's heart by an arrow from the hand of the Christ child who is described as "divine Cupid" in the legend of one painting, and the sustenance he is offered by the "two Majesties" of Christ and the Virgin in the other—portray Augustine not so much as a bishop and theologian of the early church, but rather as a mystical visionary of the Spanish Counter-Reformation, a man traveling on the road that was also traversed by Teresa of Avila and John of the Cross. Furthermore, the complementarity of piety centered on Christ and piety centered on Mary

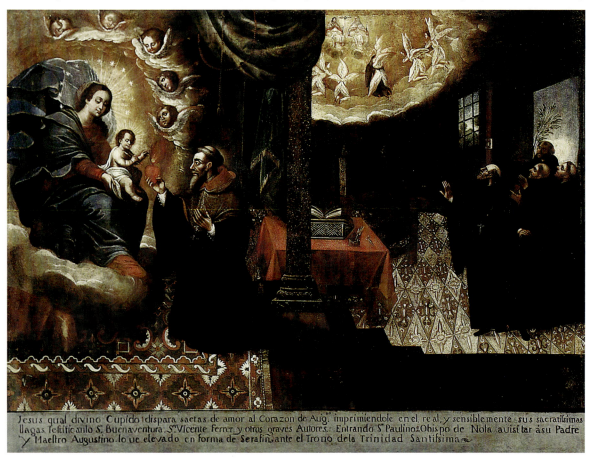

Fig. 22. Basilo Pacheco, *Augustine's heart is transfixed by the arrow of divine love*. Oil on canvas. Cloister of San Agustín, Lima (number 29 in the sequence). Photo: D. Giannoni.

that speaks in these images, while it bears only tangentially on the thought of the historical Augustine, formed an ongoing topic of reflection and debate in the convents and universities of Spanish America.[74]

The old Augustine's visions of heaven were complemented on earth by his works of mercy and pastoral care. Here also, American themes refocused the imagery. His hair and beard now snow white, Augustine exorcised a woman possessed by a demon, and even on his deathbed, while the Vandals were besieging Hippo, he cured a man who implored his help. While both these stories entered Augustine's pictorial biography from the *Life* written by Possidius,[75] they were especially relevant in Peru, where the ability to bring God's healing presence into human existence was considered to be the proof of sanctity par excellence.[76] The Augustinian order's own Saint Nicolas Tolentino, its Peruvian martyr Diego Ortiz, and the Dominican Saints Rose of Lima and Martín de Porras, along with other less renowned individuals, all demonstrated the favor they held in God's eyes by performing miracles of healing and exorcism—and they did it in the footsteps of the holy Augustine. Such, at any rate, was the pious hope of Augustinian friars.[77]

The Augustinian friars for whom Pacheco worked added their voice throughout the story of their founder's life. From Possidius we know that the dying Augustine asked for copies of the penitential psalms to be fixed to the wall of his room, and in Bolswert's image we see on the wall an open book with the first words of Psalm 6 faintly visible. Pacheco added the heading "Penitential Psalms" with legible text:

Oh Lord, rebuke me not in your anger, and do not chasten me in your displeasure. Have mercy on me for I am weak, heal me oh Lord for my bones are troubled. My soul

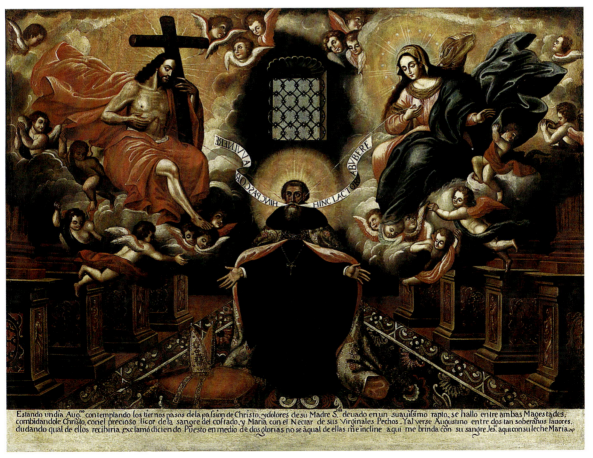

Fig. 23. Basilio Pacheco, *Augustine, contemplating Christ's passion and the sorrows of the Virgin Mary, is invited to partake of Christ's eucharistic blood and the Virgin's own milk.* Oil on canvas. Cloister of San Agustín, Lima (number 30 in the sequence). Photo: D. Giannoni.

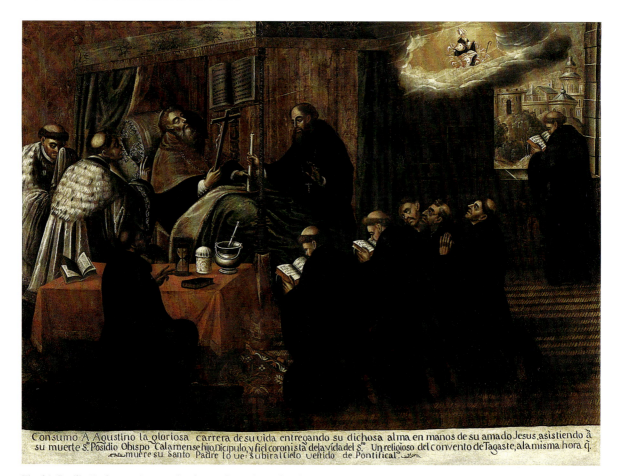

Fig. 24. Basilio Pacheco, *Augustine lies dying as his soul ascends to heaven*. Oil on canvas. Cloister of San Agustín, Lima (number 35 in the sequence). Photo: D. Giannoni.

Fig. 25. Schelte Adams Bolswert, Augustine's funerary procession in Hippo. 1624. Engraving. Plate 14 from the Series on the Life of Saint Augustine. Jeanne & Pierre Courcelle, *Iconographie de Saint Augustin* Vol. III. Paris, Études Agustiniennes 1972.

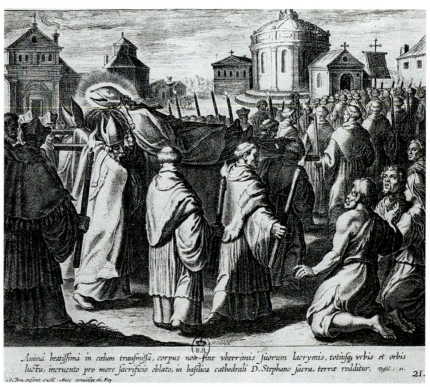

is greatly troubled—but you, oh Lord, how long? Return, oh Lord, [deliver my soul][78]

Finally, Augustine dies surrounded by his monks, their breviaries opened—in Pacheco's image (Fig. 24)—on a prayer to Our Lady. The page of the book on the wall has been turned over to the next psalm, and in accord with the prescribed ritual of the period Augustine holds the crucifix in one hand and a lighted candle in the other while his soul ascends to the eternal vision he had sought to apprehend in time during so many years. Bolswert hinted at the visionary experience, whereas Pacheco, here as elsewhere, made it explicit: he painted Augustine ascending to heaven in a blaze of light; his crozier, the insignia of so burdensome an office, is now carried by a cherub, and below, unaware of it all, the monk standing at the window is engrossed in Our Lady's breviary.

It was an exemplary death, but the story is not yet quite finished. Bolswert (Fig. 25) depicted the funerary procession that laid Augustine's body to rest in the church of Saint Stephen in Hippo, whose miraculous cures Augustine himself had celebrated in the last book of the *City of God*.[79] Pacheco (Fig. 2), however, depicted the procession crossing the central square not of Hippo but of Cuzco, and heading towards Cuzco's cathedral, with himself as onlooker (lower right). Pacheco depicted Augustine from baptism to death in primarily monastic, conventual settings and always in monastic clothing. Bolswert did likewise. In the paintings, however, the black color of the Augustinian habit sets its wearers apart more saliently. Viewed in light of the philosophy and theology that occupied contemporaries, the wearers of those habits—the central characters of a pictorial narrative alive with color—

represent before our eyes and simultaneously imprint on our heart high spirited and heroic actions, whether of patience, or of justice, chastity, gentleness, compassion or contempt for the world.[80]

Also, the changes and additions that Pacheco made to the received images highlighted the interests and preoccupations of Augustinian religious communities in Peru: hence Pacheco's periodic identifications of Augustine's writings, whether authentic or spurious, the emphasis in his paintings on visionary and mystical experience, and the Peruvian environments in which he located some episodes of Augustine's life.

Little is said here of the historical Augustine's profound commitment to the "people and house of God,"[81] the laity, to whom he addressed many hundreds of sermons, whose disputes he settled day in and day out, and for whose well-being he considered himself to be accountable before God. However, the utterly unmistakable identification of the main square of Cuzco, the ancient capital of the Incas, where Augustine's body is being laid to rest (Fig. 2),[82] modifies and expands this portrayal of an Augustine secluded in his religious community: he is a person in the world, a person who had an impact on the world after all.

Moreover, it is a Peruvian, Andean world, not a Roman one, as many details of Pacheco's paintings have made clear. A similar point is made by the imagery of lilies and roses (Fig. 1) in Pacheco's portrayal of the Augustinian family both past and present. The portraits of two Peruvian Augustinian friars frame and define this composition, which shows the lily on which the youthful Augustine in secular clothing is enthroned, emanating from his parents Patricius and Monica. The inner Augustinian family, represented by nuns and friars who were Augustine's sisters and friends, sits on lilies that emerge from Monica, whom Augustinian tradition had made a nun in her later years. The outer Augustinian family, ensconced on the roses that emerge from the late convert Patricius, are of the secular world, including, according to the legend of the painting, "the kings of our Spain," and, of course, of Peru as well. From the garden in the background, the friars living in Lima's convent of Our Lady of Grace were invited to pick the lily of their vocation. As for the friars' guests, whom they showed round their cloister, they were invited to pick a lily or a rose.

Notes

[1] I offer heartfelt thanks to Daniel Giannoni for sending me digital images of the entire cycle of paintings by Basilio Pacheco and for allowing me to reproduce those that appear here. Ramón Mujica Pinilla generously read an earlier version of this paper and sent comments, which I have done my best to respond to. In addition, our conversations on earlier occasions encouraged me to take on the topic in the first place, and I thank him warmly. I can only hope that he will not be disappointed with the result. Thanks also to Adam Snider for help with the bibliography.

[2] On the foundation of the convent see Antonio de la Calancha, *Corónica Moralizada del Orden de San Agustín en el Perú* (Barcelona: Lacavallería, 1638; Lima: Prado Pastor, 1974), Book 1, chap. 21, pp. 311–313. The descriptions on the painting read: *Center*: Dela noble rais y origen de Mónica y Patricio, nacieron como gloriosos brotes S.ta Perpetua S.ta Felicitas S.ta Basílica los B.tos Navigio, y Adeotato descollando Aug.no sobre todos qual ramo de Oro entroncado, con la Cesárea casa de Austria cuyas Ymperia les ramas se estendieron. conel tiempo, porlo mexor de Europa; Dando por frutó Emperadores ala Alemania, y Reyes à nra España. Consta este glorioso entroncamiento de Aug.no con la familia Austriaca, de un arbol genealògico q. està en el Escorial.
Left: Retrato de N.R.P. Mro F. Roque de Yrarrasabal, y Andia, natural dela Villa de Deva; de la Prov.a de Guipuscua, sita enla gran Cantabria. D.or Theolog.o y Cated. de Visp. de Dogmas de N.o P. S.n Aug.n en la R.l U.d de S.n Marcos. Calificad.r del S.o Ofi.o y Pri.or Prov.l de esta Prov.a dl Per.u en cuio religoso gobierno se pinto esta Vida y colocò en la forma q està.
Right: Retrato del N.R P.M.o F. Fernando de Luna y Virues, D.or Theolog.o en la R.l Univ.ad d. S.n Marcos, Califi.or del S.to Oficio, y Vic.o Prov.l dela Prov.a de Arriba. Exam.or Sinodal de Arzobispado de la Plata, Prior del Conv.o del Cusco, donde mando pintar esta Vida asu costa.
I would like to thank Ramón Mujica Pinilla for confirming that the cycle of paintings was indeed painted for the Augustinian cloister in Lima. He write: "Ricardo Estabridis es un historiador de arte virreinal professor de la Universidad de San Marcos que tiene un artículo inédito sobre la serie de San Agustín y me ha enviado el dato confirmando tu impresión que la serie de la Vida de San Agustín fue pintada expresamente para el convento de Lima. Aquí va textualmente: 'El cronista anónimo de *Anales del Cusco* de 1600 a 1750 (Biblioteca Nacional publicado por Ricardo Palma, 1901, p.104) dice que Fr. Fernando de Luna "mandó pintar cuatro docenas de cuadros grandes para el convento de Lima remitiendolos el ano de 1745." Dicha información también aparece en Diego de Esquivel y Navia, *Noticias Cronológicas de la Gran Ciudad de Cuzco* T. II, Biblioteca Peruana de Cultura Fundacíon Wiese, Lima 1980, p. 344.'"

[3] Augustine, *Retractationum libri II*, ed. A. Mutzenbecher, *Corpus Christianorum* vol. 52, (Turnholt: Brepols, 1984), 2:6.

[4] Possidius, *Vita Augustini*, ed. Wilhelm Geerlings, in Augustinus, *Opera - Werke* (Paderborn: Schöingh, 2005), Latin text, German translation with excellent introduction and commentary.

[5] For Augustine's life, see Peter Brown, *Augustine of Hippo. A Biography. A New Edition with an Epilogue* (Berkeley: University of California Press, 2000).

[6] George Lawless, OSA, *Augustine of Hippo and his Monastic Rule* (Oxford: Clarendon Press, 1987). See also George Lawless, OSA, "*Ex Africa semper aliquid novi*: The Rules of Saint Augustine," *Augustinian Studies* 36, 1 (2005): 239–249. The authenticity of the *Ordo monasterii* has been questioned, but has most recently been defended by Lawless, cf. *Ex Africa* 249. Luc Verheijen, *La règle de saint Augustin. I. Tradition manuscrite. II. Recherches historiques*. 2 vols. (Paris: Études Augustiniennes, 1967) remains fundamental. The *Ordo monasterii* begins with the words *Ante omnia, fratres carissimi, diligatur deus* ("above everything, dearest brothers, love God"). This is the rule that the Augustine of Pacheco's paintings gave to his monks in Hippo (below Fig. 13, at n. 28) and that may be seen on Augustine's lap in the frontispiece of Crusenius, *Monasticon Augustinianum* (below Fig. 14, at nn. 46–47).

[7] See below, at n. 33, the opinion of Erasmus about this rule.

[8] See Frederick Van Fleteren and Joseph C. Schnaubelt, OSA, "Literary Sources for the Iconography of Saint Augustine," in *Augustine in Iconography*, ed. Joseph C. Schnaubelt, OSA, Frederick Van Fleteren, and George Radan, 7–62 (New York: Peter Lang, 1999).

[9] See Jeanne and Pierre Courcelle, *Iconographie de Saint Augustin. Les cycles du XVIe et du XVIIe siècle*

(Paris: Études augustiniennes, 1972), containing reproductions of the entire cycles by both Bolswert and Pacheco. On Bolswert see further F. W.H. Hollstein, *Dutch and Flemish Etchings, Engravings, and Woodcuts ca. 1450–1700*, 72 vols. (Amsterdam: M. Hertzberger, 1949–), vol. 3, nos. 201–208. For Italian cycles of the life of Augustine, see Luigi Dania Demetrio Funari, *S. Agostino. Il Santo nella pittura dal XIV al XVIII secolo* (Picena: Silvana Editore, 1988). Bolswert's engravings also inspired the cycle of paintings for the cloister of San Agustín in Quito by Miguel de Santiago. For this cycle and the one by Pacheco in Lima, see the website of the "Project on the Engraved Sources of Spanish Colonial Art" (PESSCA), http://colonialart.org, with a complete set of images, comments, and bibliographies. PESSCA cites authorities arguing that the cycle in Lima was originally designed for the Augustinian convent in Cuzco and was moved to Lima later. But the paintings fit exactly into the spaces of the cloister in Lima, and the wording of the legends on the first painting (here, Fig. 1) seems to point to Lima as the possible original location.

[10] Antonio San Cristóbal Sebastián, *La Iglesia y el Convento de San Agustín en Lima* (Lima: Colegio San Agustín, 2001), 445–484.

[11] See below at nn. 68–69.

[12] José de Mesa and Teresa Gisbert, *Historia de la Pintura Cuzqueña*, 2 vols. (Lima: Fundación Wiese, 1982), 1:203–204.

[13] Augustine, *Confessions*, trans. Henry Chadwick (Oxford: Oxford University Press, 1991), 1:9, 14.

[14] Such at any rate was the ideal; cf. Richard Kagan, *Students and Society in Early Modern Spain* (Baltimore: Johns Hopkins University Press, 1974), 136–149 passim.

[15] Sabine MacCormack, *On the Wings of Time: Rome, the Incas, Spain and Peru* (Princeton: Princeton University Press, 2007), 228–235.

[16] Augustine, *Confessions*, trans. H. Chadwick, 8:12, 29.

[17] Cf. Francisco Pacheco, *Arte de la pintura*, 2 vols. (Madrid: Instituto de Valencia de Don Juan, 1956), 1:12 on angels as the bodies of human thought. The task of the creator of religious images was to arouse in the viewer "desire of virtue and horror of vice, which are the principal paths that lead to blessedness" (1:217). These paths could be found more readily by the viewer with the help of angels, since their images were formed in the "thought and consideration of the soul" and could therefore be embodied in visual representation (1:12). Beyond complementing Augustine's words in this way, Basilio Pacheco added color to Bolswert's monochrome lines, and in doing so followed in the footsteps of God himself, who at the creation clothed a monochrome world in color. See Pacheco, 1:20 f.; cf. 246 f. on the freedom of the fully formed artist. But see also 1:212, with an interesting textual problem pointed out by Sánchez Cantón: "El fin de la pintura en comun será, mediante la imitación, representar la cosa que pretende con la valentía y propriedad posible, que de algunos es llamada la alma de la pintura, porque la hace que paresca viva; de manera que la hermosura y variedad de colores y otros ornatos son cosas accessorias. De donde dixo Aristóteles que de dos pinturas, una adornada de belleza de colorido y no muy semejante, y otra formada de líneas simples, pero muy parecida a la verdad, aquélla será inferior y ésta aventajada; porque aquélla contiene los accidentes y ésta abraza el fundamento y la sustancia, que consiste en representar y exprimir mediante el buen debuxo, con perfeción lo que se quiere imitar." According to an editorial note by Sánchez Cantón on the text, "accessorias" is a change made in the proofs of the first edition, to replace "necesarias."

[18] Ernst Kähler, *Studien zum Te Deum und zur Geschichte des 24. Psalms in de Alten Kirche* (Göttingen: Vanderhoeck & Ruprecht, 1958).

[19] Jacobus de Voragine, *Legenda aurea / Iacopo da Varazze; edizione critica a cura di Giovanni Paolo Maggioni*, 2 vols. (Tavarnuzze-Firenze: SISMEL edizioni del Galluzzo, c1998), 2:847: "Tunc, sicut fertur, Ambrosius Te Deum laudamus inquit et Augustinus Te dominum confitemur respondit et sic ipsi duo hunc hymnum alternatim composuerunt et usque in finem decantaverunt, sicut etiam testatur Honorius in libro suo qui dicitur Speculum ecclesie. In aliquibus etiam libris antiquis titulus talis preponitur: Canticum ab Ambrosio et Augustino compilatum." For Villegas, the edition I consulted is Alonso de Villegas, *Flos sanctorum nueuo y historia general de la vida, y hechos de Iesu Christo, Dios y Señor nuestro, y de todos los Santos de que reza, y haze fiesta la Iglesia Catholica: conforme al Breviario Romano, reformado por Decreto del Sancto Concilio Tridentino... Collegido todo de Auctores graves, y aprovados. ... por el Licenciado Alonso de Villegas* (En Barcelona: En casa de Iuan Pablo Mane[?], 1587. Colophon f. 492r ... Barcelona

en casa de Iayme Cendrad Impressor de Libros. Año de la Natividad de nuestro Señor Iesu Christo 1587), f. 245r: After Ambrose poured the baptismal water, "afirma San Dacio, quarto Arcobispo de Milan despues de Sant Ambrosio *Sant Dacio en su chronica li. 10 cap. 1* que dixo en alta voz *Te Deum laudamus* y Augustino respondio, *Te Deum confitemur,* y assi llevaron aquel Hymno hasta le acabar."

[20] The still youthful Augustine who heard the child sing "pick up and read" is now a mature man: contrast the scene in the garden in Milan as imagined by Basilio Pacheco (number 10 in the sequence, here Fig. 5) showing a youthful Augustine with Bolswert's equivalent (here Fig. 4) showing a mature man. Bolswert appears not to have been interested in Augustine's evolution from youth to full adulthood, which is a pervasive theme in the *Confessions*. Basilio Pacheco's Augustine did, however, mature; see Pacheco's rendering of Augustine's vision of the little boy (number 14 in the sequence, here Fig. 9).

[21] There is no equivalent to this painting by Bolswert. The iconography is related to depictions of Jerome in the wilderness, beating his chest with a stone, as Augustine is doing here. In these images, Jerome does penitence for his love of the classics-cf. Eugene F. Rice, Jr., *Saint Jerome in the Renaissance* (Baltimore: Johns Hopkins University Press, 1985), 75–83, 84–87—and so, in a sense, does Augustine, who is reminded of his pre-Christian love of philosophy and literature by his book *De pulchro et apto* on the lectern before him.

[22] Augustine, *Confessions,* trans. H. Chadwick,10:4,6.

[23] *Confessions*, trans. H. Chadwick, 10:43,70.

[24] *Confessions,* trans. H. Chadwick, 9:10,23.

[25] The book at Monica's bedside, as depicted by Pacheco (number 16 in the cloister sequence) reads, "ne reminiscaris, Domine delicta mea, vel parentum meorum, neque vindic"—slightly misquoted from Tobit 3:3, "Et nunc, Domine, memor esto mei, et ne vindictam sumas de peccatis meis, neque reminiscaris delicta mea, vel parentum meorum."

[26] Skipping the miraculous cure of Innocentius in Carthage, painted by Pacheco, number 17 in the sequence, following Bolswert number 8. For Augustine's account of the miracle, see Augustine, *Concerning the City of God against the Pagans*, trans. H. Bettenson (London: Penguin, 1972), book 22, chap. 8.

[27] Possidius, *Vita* (above n. 4), chap. 5.

[28] Cf. above n.6.

[29] Augustine, *Confessions* 4:13, 20-14, 21, about dedicating *De pulchro et apto* to the rhetor Hierius. Chadwick translates the title of this work as *On the Beautiful and the Fitting*. This is the book that lies open before the penitent Augustine in Figure 10.

[30] The titles of the books stowed away over Christ's head in this painting are identified as *De fide ad Petrum*, a spurious work, *De doctrina christiana*, a book that Augustine did write, and *De bapti(smo)*, probably referring to his *De baptismo contra Donatistas*, which he also wrote.

[31] Augustine, *Tertius tomus operum D. Aurelii Augustini episcopi Hipponensis ...* (Basileae ex officina Frob. anno M.D.XLI) , col. 209 *De fide ad Petrum Diaconum*: "Nec hunc librum esse Augustini in primis arguit ipsa phrasis, primum abiectior quam est illius, ad hoc impurior...Praeterea toties hic iteratur infantes qui citra baptismum hinc decesserint aeternis ignibus cruciandos: quod alias apud Augustinum nusquam legi, licet poenae, damnationis & interitus vocabulis utatur frequenter...videtur & hoc opus collectum ex Augustini lucubrationibus."

[32] Augustine, *Nonus tomus operum D. Aurelii Augustini episcopi Hipponensis...* (Basileae ex officina Frob. anno M.D.XLII), col. 842. "Hoc opus Augustini non esse non est quod admoneam. Stilus magis refert Iovinianum quempiam vel febricitantem potius. Cap. iii. nimium tribuit dialecticae. cap. vi. dicit angelos cuncta scire et praescire. Item alia quae numquam scripsit Augustinus. Apparet esse progymnasma monachi tyronis theologiae, qui quantum in philosophia scholastica profecisset voluit hoc libro dare specimen."

[33] Augustine, *Omnium operum D. Aurelii Augustini Hipponensis episcopi primus tomus ad fidem vetustorum exemplarium post omnium in hunc usque diem editiones denuo summa vigilantia repurgatorum a mendis innumeris, ut optimo iure tantus Ecclesiae doctor renatus vieri possit... Froben* (Basileae M.D.XLIII), col. 818: Regula prima clericis tradita ut habebat titulus. Obsecro te lector quid habent frontis ac mentis qui tales naenias adscribunt viro?

[34] On Jordan of Saxony's attempt to deal with this problem, see Rudolphus Arbesmann, OSA, and Winfridus Hümpfer, OSA, eds., *Jordani de Saxonia Ordinis Eremitarum S. Augustini Liber Vitasfratrum* (New York: Cosmopolitan Science & Art Service Co., 1943), l-li, lxxiv-lxxxii; also Luc Verheijen, *La règle de Saint Augustin*. II. *Recherches historiques* (Paris:

Études Augustiniennes, 1967), 9–18.

[35] Augustine, *Decimus tomus operum D. Aurelii Augustini Hipponensis episcopi, continens reliqua tractata apud populum, quorum summam indicabit haec pagina versa. Froben* (Basileae ex officina Frob. anno MDXLIII), col. 1273: "Oratio consarcinata ex Augustini regula, nihil alioqui habens Augustini. Artifex qui finxit hoc agit ut ordinem qui Augustiniensium dicitur orbi commendaret." Literally translated, the sermons were "bundled together."

[36] See Rudolphus Arbesmann, OSA, and Winfridus Hümpfer, OSA, eds., *Jordani de Saxonia Ordinis Eremitarum S. Augustini Liber Vitasfratrum*, xlvii–lxxi. For the two printed editions, Rome 1587 and Antwerp 1621 (with possibly a third edition from Antwerp), see lxviii–lxxi.

[37] To be precise, 1357; see Arbesmann (above n. 34), lii-lvi.

[38] *Rules* both genuine and spurious. On the learned discussion of them subsequent to Erasmus, see Verheijen (above n. 6), 2:19–70.

[39] Jordan of Saxony, *Vitasfratrum* II, 5, p. 100, commenting on Augustine's *Rule* (now referred to as *Praeceptum*, formerly also known as the *Regula secunda*): "Omnes ergo unanimiter et concorditer vivite, et honorate in vobis invicem deum cuius templa facti estis." For the text, see George Lawless, OSA, *Augustine of Hippo and His Monastic Rule* (Oxford: Clarendon Press, 1987), 80–103, at p. 82 (*Praeceptum* I, 8). See also the critical edition by Luc Verheijen, *La règle de Saint Augustin* (above n. 6), 2:417–437. After quoting "omnes ergo," Jordan recalls an episode from Rufinus, *Historia monachorum*, where the monk Apollonius ordered the brothers to welcome strangers in obedience to Christ's saying (Matthew 25:35) *hospes fui et suscepistis me*. This quotation does not appear in the modern edition of Tyrannius Rufinus, *Historia monachorum sive de vita sanctorum patrum*, ed. Eva Schulz Flügel (Berlin: De Gruyter, 1990), VII,15,1 p. 304, but it does appear in the older edition of this text in *Patrologia Latina* vol. XXI col. 418D.

[40] See above n. 34.

[41] Villegas, *Flos Sanctorum* (above n. 19), f.245r Aqui (at Monte Pisano, after death of Monica): "se dize que conpuso los libros de Trinitate, y le acaescio la revelacion del niño que le fico estar cavando con sus manos junto a la marina una pequeña hoya. Preguntole sant Augustin, que era su intento? Dixo, que para passar alli el mar. Riose desto el sancto

Doctor, y dixole, que era cosa impossible aquella: El niño le respondio, A ti se te haze cosa esta dificultosa? Pues yo te digo que lo es mas el negocio en que tu entiendes dela Trinidad, pretendiendo conprehender y apear tan alto mysterio con tu flaco entendimiento. Desaparecio luego el niño, Por donde entendio sant Augustin que era embiado de Dios para advertirle de su atrevimiento. Y assi paro (limando mas) en lo que avia hecho."

[42] Villegas, *Flos Sanctorum*, ff. 245v-246r.

[43] Antonio de la Calancha, *Corónica* (ed. Prado Pastor, above n. 2).

[44] Calancha, *Corónica* I, 1 pp. 25, 28; p. 36: "el argumento pues desta Coronica es probar que a sido i oy es i asta la fin será en este Perú la Religion de san Augustín mina rica de espirituales vetas, i que su raíz que fueron los fundadores, correspondieron en las vidas a su Padre san Augustín, y en el zelo al oro de su paternal caridad, probaré que se an estendido sus Religiosos en este Reyno como ramas i que ablandando pedernales an produzido tesoros en la pobreza desta gentilidad, verase que an sido los sucesores minas de apurada virtud." The allusion to mining refers to the silver mines of Potosí, of which, so Calancha claimed, St. Augustine was the patron. On evangelizing the world including Peru, Calancha, *Corónica* I, 3 p. 56. In connection with the phrase "Religiosos en este Reyno como ramas" one can recall the iconography of Pacheco's painting of the Augustinian family, here Figure 1.

[45] Calancha, *Corónica* I, 4 p.75 (Calancha's scriptural citations in the margin of the first edition of 1638 are here given in square brackets): "Ablaré en el sentido que san Juan llamó en el Apocalipsi [21] tierra nueva, o mundo nuevo a lo que en Patmos vido, no porque sea otro mundo en la sustancia, sino en ser mejor y más ecelente en las condiciones, lenguaje, que también usó Isaias [cap.65 ecce ego creo terram novam], i el Apóstol San Petro [ep.2,3]. Por revelaciones, o noticias del tiempo i siglos de la ley antigua se llamó esta tierra Nuevo mundo."

[46] For details, Calancha, *Corónica* I, 3.

[47] Nicolaus Crusenius, *Monasticon Augustinianum in quo Omnium Ordinum sub Regula S. Augustini militantium...Origines atque incrementa Tribus Partibus explicantur* (Monachii apud Ioan. Hertsroy MDCXXIII), 16 and elsewhere.

[48] *Acta Sanctorum Augusti... collecta... a Ioanne Pinio, Guilemo Cupero P.M. Ioanne Stilgingo e Societate Iesu Presbyteris Theologis Tomus VI...* (Parisiis & Romae

apud Victorem Palme MDCCCLXVIII, this being a reprint of the original publication of 1643); for August 28, see month of August vol. 6, p. 235B-E. The author of the entry on Augustine was Guilelmus Cuperus. For Crusenius's Augustine and the book he is holding (Fig. 14), cf. above n. 6.

[49] See Brad S. Gregory, *Salvation at Stake: Christian Martyrdom in Early Modern Europe* (Cambridge, MA: Harvard University Press, 1999).

[50] Calancha, *Corónica* III, 4 p. 1267 Indiano Belén.

[51] In Part III chap. 39, Crusenius mentions fray Agustín de la Coruña; see Calancha, *Corónica* III, 33 p. 1583, 1560 CE. Calancha ascribed the baptism of the Inca Tupac Amaru to Fr. Agustín.

[52] Crusenius, *Monasticon* III, 46 mentions fray Diego Ortiz, who died a martyr while endeavoring to convert the Incas of Vilcabamba; see Calancha, *Corónica* IV, 6 p. 1855 (ed. Prado Pastor).

[53] Calancha, *Corónica* I, 2, p. 44 (ed. Prado Pastor), citing Crusenius, *Monasticon* chap. 1 [i.e., Part I, 1 p.2]: "porqué cual Mártir de los desta esfera murió entre mayores martirios de dolor, i en manos más crueles de la conpasion, que mi Padre San Agustín?"

[54] Bolswert's engraving number 12 depicts Augustine's debate with Fortunatus, in an image that Pacheco did not use at all. Bolswert's caption runs, "Haereticorum omnium accerimus insectator, etiamnum presbyter plures verbi gladio confodit, adeoq; confundit, ut inter reliquos Fortunatus biduo coram notariis exagitatus, sese ultro subducat." Possidius, *Vita* (above n. 4), 6 is correctly cited as the source for this episode.

[55] The caption for Pacheco 21 in the cloister sequence (here Fig. 16) appears to have been wrongly restored, apparently in 1858. As it now stands, the caption runs, "Habiendo Agustino convencido en publica disputa a Fortunato cabeza de los herejes Donatistas, sale a la demanda de Felix hereje mas presumido y no convencido de la fe, quedo repentinam.te mudo. Restituyele la habla Augustino tocandole la boca con el dedo." In the left lower corner: "P. Astudillo 1858." Fortunatus was a Manichee, not a Donatist. Also, the entire painting in its present state is about the Manichee Felix, since the person being healed in the background is identical with the person debating with Augustine in the foreground. The other problem is the place that this painting should occupy within the chronological sequence. The debate with Felix took place in 404, when Augustine was bishop, whereas he is here shown as a simple friar and priest, which would apply to the debate with Fortunatus, which occurred in 392.

[56] In the cloister sequence of Pacheco's paintings, this is number 8. The primary image is of Augustine meeting Ambrose. The legend of the painting reads: "Despues de haver Aug. enseñado Rectorica algun Tiempo ala juventud Romana, desasonado porla disoluciom desus dicipulos, pasa aenseñarla á Milan donde tubo ocacion de tratar, y disputar con S.o Ambrosio sobre los Mysterios de nuestra S.ta Fee. 2 Temiendo el S. Arzo. quela agudesa del ingenio de Aug.no y fuersa de los sylogismos de su Dialectica pervirtiesen la ignorancia del Pueblo, instituiò una publica rogatiba, pidiendo a D.los librase dela logica de Augustino." In the background of the painting, Ambrose and his clergy and congregation are depicted praying responsorially: "A logica Augustini / libera nos Domine."

[57] Augustine, *Enchiridion ad Laurentium de fide spe et caritate*, Corpus Christianorum Series Latina vol. XLVI (Turnholt: Brepols, 1969), 5, 17. Translation by J. B. Shaw, Saint Augustine, *Enchiridion on Faith, Hope and Love* (Washington, DC: Gateway, 1996), 19.

[58] Possidius *Vita* (above n. 4), 12, 2.

[59] Possidius, *Vita*, 13, 1ñ4.

[60] On the relation between line (Bolswert) and color (Pacheco), see above n. 17.

[61] Gaspar de Villarroel, *Govierno eclesiastico pacifico y vision de los dos cuchillos, pontífico y regio*, 2 vols. (Madrid: Domingo Garcia Morràs, 1656–1657). Alejandra B. Osorio, *Inventing Lima: Baroque Modernity in Peru's South Sea Metropolis* (New York: Palgrave, 2008).

[62] Cayetano Bruno, SDB, *El derecho público en la iglesia en Indias* (Salamanca: Consejo Superior de Investigaciones Científicas, 1997), 131–154; Antonio Garrido Aranda, *Orgaización de la iglesia en el reino de Granada y su proyección en Indias* (Sevilla: Escuela de estudios hispanoamericanos del C.S.I.C., Córdoba, 1979).

[63] This painting, number 2 in the sequence, opens Pacheco's depiction of the life of Augustine. The legend reads: "En el mismo dia q fue 13 de Nov.e del año del Señor 354 nacieron Aug.no en Tagaste Ciudad de Africa, y Pelagio en Ynglaterra: este para ruina dela Yglesia, y aquel para su defensa, cuya bien cortada pluma fue rayo que dissipo la secta de

aquel pestifero Herecliaca" [sic, for Heresiarcha]. The story also appears in Alonso de Villegas, *Flos Sanctorum* (above n. 19), f.243v: "dize Bulphilas, autor grave que en el mismo dia que nacio Augustino en Africa nacio en Inglaterra Pelagio, herege: Augustino contrario suyo grandissimo. para que se vea la clemencia del Señor, que con una mano da la llaga, y con otra la medicina."

[64] The painting is number 28 in the sequence. Cf. Jacobus de Voragine, *Legenda aurea* (above n. 19), 858 about the correspondence between Jerome and Augustine; Jerome writes to Augustine, expressing his desire to see him: "Domino sancto ac beatissimo pape Augustino Ieronimus. Omni quidem tempore beatitudinem tuam eo quo decet honore veneratus sum et habitantem in te dilexi dominum salvatorem, sed nunc si fieri potest cumulo aliquid addimus et plena complemus ut absque nominis tui mentione ne unam quidem horam preterire patiamur." On Augustine's vision of Jerome, see also Patricia Fortini Brown, "Carpaccio's St. Augustine in His Study: A Portrait within a Portrait," in Schnaubelt, *Augustine in Iconography* (above n. 8), 507–547.

For the historical (as distinct from the spurious) correspondence of Augustine and Jerome, see Ralph Hennings, *Der Briefwechsel zwischen Augustinus und Hieronymus und ihr Streit um den Kanon des Alten Testaments und die Auslegung von Gal.2, 11–14* (Leiden: Brill, 1994).

[65] For this episode see Augustine, *De cura pro mortuis gerenda* 13, Corpus Scriptorum Ecclesiasticorum Latinorum, vol. 41 (Vienna: Temsky, 1900). Augustine observed that he could not explain how this and similar dreams or visions could occur.

[66] According to the legend of Pacheco's painting (number 28 in the cloister sequence), "Dudando la inteligencia de un lugar de Ciceron Eulogio dicipulo de Augustin que estaba muchas leguas distante sele aparecio como una sombra y le explico el verdadero sentido 2 Ya que San Geronimo no logro en vida ver como deseala a su amigo Augustino al punto que murio fue a visitarlo antes de subir al Cielo." On Augustine's desk, one book reads, "Augustinus de verbis Domini"; the other reads, "Epistola AD HIERONIMUM." A series of sermons, "De verbis domini salvatoris," on the four Gospels is collected in *Decimus tomus operum d. Aurelii Augustini...Froben* (Basileae ex officina Frob. Anno MDXLIII), cols. 5-247.

[67] Augustine, *Retractationum libri II* (above n. 3), 2:15. See also Augustine, *Epistula 174*, ed. A. Goldbacher, in Corpus Scriptorum Ecclesiasticorum Latinorum (Vienna: Tempsky, 1904) to Bishop Aurelius of Carthage. For a fine modern translation with helpful introduction and notes, see Augustine, *The Trinity*, trans. Edmund Hill, OP (Hyde Park, NY: New City Press, 1991).

[68] Augustine, *Confessions*, trans. after H. Chadwick, 9:1, 1.

[69] Augustine, *Confessions*, trans. H. Chadwick, 9:2, 3.

[70] The vision of Paulinus was the product of later tradition. Augustine exchanged letters with Paulinus and wrote the *Confessions* at his request; see Augustine, *Confessions*, ed. A. Solignac, *Oeuvres de saint Augustin 13*, Bibliothèque Augustinienne (Bruges: Desclée, 1962), 1:27–29. Solignac mentions that the suggestion that the *Confessions* were written in response to a request by Paulinus was first made by Baronius, *Annales Ecclesiastici* a.a. 395, which helps to explain the origin of Pacheco's imagery.

[71] Pacheco, cloister series number 29. The legend reads, "Jesus qual divino Cupido dispara saetas de amor al Corazon de Aug.no imprimiendole en el, real, y sensiblemente sus sacratissimas / llagas. Testificano S.to Buenaventura, S.n Vicente Ferrer y otros graves Autores. Entrando Sn Paulino 2 Obispo de Nola a visitar a su Padre / y Maestro Augustino lo ve elevado en forma de Serafin ante el Trono dela Trinidad Santissima." Contrast Bolswert's more sober legend: "In abdito cordis recessu sacrorum vulnerum Christi stigmatis sauciatus, amoris tenerrimi in Deum et Deiparam Virg.em suspiriis, lacrymis, dictisque mirificis signa praebet. AA. varii."

[72] Visions of heaven in Pacheco's series are rounded out on earth by the minutiae of monastic existence. From the *Golden Legend* (862) came the following story, painted by Pacheco (number 31 in the cloister series): meeting with the devil carrying a large register of human sin, Augustine asked whether the register contained any sins of his. "Yes, the office of Compline that on such and such a day you did not recite." Whereupon Augustine recited the office and asked to see the register again, but the devil could not find the sin and angrily departed.

[73] For an iconographical antecedent of this image, see Jeanne Courcelle, *Iconographie de Saint Augustin. Les cycles du XVIe et du XVIIe siècle* (Paris: Études

augustiniennes, 1972), 24, discussing C. Lancilottus, *S. Aurelii Augustine Vita* (Antwerp 1616), containing a portrait of Augustine with the words HINC PASCOR A VULNERE, HINC LACTOR AB UBERE, which also appear in Pacheco's painting, number 30 in the cloister sequence, here Figure 23.

[74] See the splendid pair of essays by Ramón Mujica Pinilla, "El arte y los sermones," in *El Barroco Peruano* (Lima: Banco de Crédito, 2002), 219–324, and "Identidades alegóricas: lecturas iconográficas del barroco al neoclásico," in *El Barroco Peruano* (Lima: Banco de Crédito, 2003), 251–346.

[75] Possidius, *Vita* (above n. 4), 29, 4ñ5.

[76] This is a central theme in all the conventual histories of early modern Peru, among which special mention can be made of Diego de Córdova Salinas, *Crónica Franciscana de las Provincias del Perú* (Lima 1651; Washington, DC: Academy of Franciscan History, 1957) and Juan Melendez, *Tesoros verdaderos de las Indias. En la historia de la gran provincia de San Juan Bautista del Perú de el orden de predicadores...*, 3 vols. (Rome: Nicolas Angel Tinassio, 1681–1682). Both authors included, on behalf of their orders, vigorous rejoinders to Calancha's claims that the Augustinians were the earliest and primary missionary order in Peru.

[77] Calancha's claims were toned down in the more sober abridgement of his *Corónica* by Bernardo de Torres, *Epitome del tomo I del P. Antonio de la Calancha (1639) reducido a compendio por el P. Bernardo de Torres (1657)*, ed. Manuel Merino, OSA, *Crónicas Agustinianas del Perú*, vol. 1 (Madrid: C.S.I.C., 1972).

[78] Number 34 in the cloister series is Pacheco's painting depicting Augustine on his death bed curing a sick man who lies on a portable bed facing him. On the wall is an open book identified as "Psalmi NE." After this heading follows the text of Psalm 6, 3–5, "Miserere mei, Domine, quoniam infirmus sum; sana me, Domine, quoniam conturbata sunt ossa mea. Et anima mea turbata est valde. Sed tu, Domine, usquequo? Convertere Domine."

[79] Bolswert's caption runs, "Anima beatissima in caelum transmissa, corpus non sine uberrimis suorum lacrymis, totiusque urbis et orbis luctu, incruento pro more sacrificio oblato, in basilica cathedrali D. Stephano sacra, terrae redditur. Possid. c. 31. (His most blessed soul was conveyed to heaven, and after the customary bloodless sacrifice [of the Mass] has been offered, his body was returned to the earth in the cathedral basilica sacred to Saint Stephen, not without an abundance of tears [being shed by] those who knew him and [amidst] mourning by the entire city and the world.)" On the miracles of St. Stephen that moved the old Augustine, see Augustine, *City of God*, 22:8.

[80] Francisco Pacheco, *Arte de la pintura* (above n. 17), 1:217.

[81] The phrase is from Josef Ratzinger, *Volk und Haus Gottes in Augustins Lehre von der Kirche* (St. Ottilien: Eos Verlag, 1992, first published 1954).

[82] Augustine was buried in Hippo; see Possidius, *Vita*, 31, 2–7. Later accounts of his life and death add that because of the Vandal invasion, his remains were moved to Sardinia, and subsequently, so as to save them from Muslim invaders, from there to Pavia; see Johannes Stiltingh, "The Account in the 'Acta Sanctorum' of the Body of St. Augustine," in Schnaubelt, *Augustine in Iconography* (above n. 8), 65–112. The last two paintings in Pacheco's cycle, numbers 37 and 38, depict these two episodes, omitting the miracles that tradition attributed to Augustine and that were illustrated by Bolswert.

Mediterranean Material Culture in the Andes: Spanish Furniture in Guaman Poma de Ayala's *El Primer Nueva Corónica y Buen Gobierno*

Jorge F. Rivas-Pérez

Objects produced or shaped by human action are so closely related to their cultural origins that histories of entire civilizations have been written just from archeological remains. Objects—including furniture—transcend the purely utilitarian. Furniture is connected to religion and is a symbol of power and authority. Furniture style mirrors the social order and the hierarchical structure of its society. Thus we might expect that furniture style could tell us much about intercultural contact, especially between conquerors and conquered. Still, one might ask, "Why choose furniture if there are many other relevant examples of material culture?"

The answer is simple: the furniture we know and use today, and in particular the four-legged chair, is absolutely Western and "Mediterranean." We inherited chairs from the Roman world. But their origins can be traced back to other ancient Mediterranean cultures, as Roman furniture design derives from the Greek repertoire. Greeks codified and formally standardized their furniture designs around 500 B.C.E. This classical Greek repertoire shared some features with the Egyptian and Near Eastern types and was very different from the Mycenaean precedent.[1]

The case of China is a good comparative example for the use and development of chairs. China was the only East Asian culture that adopted the use of high chairs before premodern times. The Chinese began using chairs very late—circa 1000 C.E.—in comparison with Mediterranean civilizations. Until then the customary Chinese seating posture was to rest kneeling on the floor.[2]

In ancient pre-Columbian cultures furniture consisted only of low ceremonial seats. The Inka wooden seat, called a *tiana* (Fig. 1), was used exclusively by the elite. In the Caribbean basin and in other temperate regions hammocks acted as a sort of

furniture. In Mesoamerica, besides the low wooden ceremonial seats, there were some official seats executed in a basket-weave technique. Pre-Columbian cultures had nothing comparable to specialized European furniture and the elaborate spaces that housed it. Thus furniture and its inseparable companion, architecture, as depicted in Guaman Poma de Ayala's *El Primer Nueva Corónica y Buen Gobierno,* offer a perfect case study to analyze the impact of Spanish artifacts outside their original Mediterranean context.

Assimilation and acculturation of the colonists and colonized produced an original form of Mediterranean society up in the Central Andes. The new society that emerged after the fall of the Inka empire was forged on the conceptual model of ancient Rome. The conquerors interpreted the geography, the natural world, and the cultures of the new continent through the lens of the ancient classical world.[3] Spaniards built houses, churches, and convents following old Mediterranean traditions. They furnished the newly built structures with a range of objects whose use and manufacture

Fig. 1. *Tiana.* After Felipe Guaman Poma de Ayala, *Nueva Corónica y Buen Gobierno,* drawing no. 4, 1615. Drawing by the author.

were unknown to the people of the Andes. *El Primer Nueva Corónica y Buen Gobierno* vividly depicts the initial cultural contact between the Spaniards and the complex Inka culture; it exposes a dramatic moment of change for both societies. It was such an immense transformation for the traditional Andean societies that the author, Don Felipe Guaman Poma de Ayala, painfully claims that their world was turned upside-down—*el mundo al revés*—by the conquerors.

Much has been written about Felipe Guaman Poma and his work since the discovery of the manuscript in the early twentieth century. *El Primer Nueva Corónica y Buen Gobierno* has become one of the most valuable documents on the history of pre-Columbian and post-conquest Peru. History, society, and life in the Andes—from ancient pre-Inka times to the early colonial era—are depicted in the nearly 1200 pages, written in Spanish and Quechua, and the 398 full-page illustrations of the chronicle. The book, finished around 1616 and addressed to Philip III of Spain, exposes the injustices and excesses committed by Spaniards in Peru. It is unknown if the Spanish king ever received the original manuscript and there are no precise records of how it ended up in the Danish Royal Library in Copenhagen.

The life of the author himself is as complex as the history of his book. Don Felipe Guaman Poma de Ayala was born to a native indigenous noble family between the mid-1530's and 1550's in Huamanga, in the Peruvian Andes. He lived during the tumultuous years of the fall of the Inka Empire and the transformation of the ancient Andean society by the hand of the Spanish conquerors. Guaman Poma's native tongue was Quechua; his contact with Spanish language and culture occurred later in life, most probably as a result of his contact with Christian churchmen.

El Primer Nueva Corónica y Buen Gobierno's text and illustrations have been studied during the last century by recognized experts in very diverse disciplines,[4] but very little attention has been given to the European aspects of the book, including the household interiors and furnishings depicted in the

Spanish style. Because there is no surviving Peruvian furniture dating from the sixteenth and early seventeenth centuries, the highly detailed drawings of furniture and interiors by Guaman Poma constitute an exceptional graphic source for the study of architecture and early colonial woodworking in the Andean region. The life span of furniture is often very short. The wear and tear of daily use, changes in fashion or customs, natural disasters, and human events all challenge its survival. In the specific case of Peruvian furniture, the frequent earthquakes, like the one of 1650 in Cuzco, were a major cause of the destruction of early furniture and buildings.

The Hapsburg Furniture Repertoire and Interiors in *El Primer Nueva Corónica y Buen Gobierno*

In the late sixteenth and early seventeenth century in Spain and its overseas territories, interiors were sparsely furnished. The Spanish furniture repertoire, very much influenced by the itinerant court of the Catholic kings, comprised only a very few light and movable pieces that combined European and Islamic types. Furniture evolved into more massive and elaborate designs during the reign of Philip II, but the basic shapes changed very little throughout most of the seventeenth century. Even in the sumptuous interiors of palaces and noble houses, furniture was limited to the few pieces from the basic repertoire, albeit often executed in a more refined manner. At that time, lavish textiles and luxury objects were more important than furniture as status symbols.

The basic sixteenth- and seventeenth-century Spanish furniture repertoire includes tables in their different variations (*mesas, bufetes*), benches *(escaños)*, stools *(bancos)*, chairs *(sillas, sillones)*, chests *(cajas, arcas)*, trunks *(baúles)*, shelves *(estantes)*, cupboards *(armarios, alacenas)*, beds *(camas)*, and luxury pieces like writing desks *(escritorios, contadores)* and dressers *(aparadores)*.[5]

This repertoire is well represented in forty of the 398 illustrations of *El Primer Nueva Corónica y Buen Gobierno*, which include every possible sort of western-style furniture with two notable exceptions:

benches and stools, both frequently used types. Benches and stools had often been illustrated in European prints since the Middle Ages, and their absence from the *Corónica*'s illustrations is one of the puzzles that this essay attempts to solve.

The following list records the frequency of appearance of each item of the repertoire in *El Primer Nueva Corónica y Buen Gobierno*:

23 armchairs (two of them depicted frontally)
9 tables
6 altar tables
6 thrones
2 trunks
2 wood chests with iron locks
2 wood doors with iron locks (from cupboards)
2 music stands
1 bed
1 bookshelf
1 *tenebrario*, a very large triangular candleholder for fifteen candles used in Roman Catholic churches during Holy Week (in this case the piece holds only thirteen candles)
Total number: 55 pieces of furniture

The first intriguing feature of the book's illustrations of furniture is the differentiated way in which the different types of furniture have been drawn. Two groups can be identified according to the degree of detailing in their depiction. The first group includes pieces with a low definition or imprecise rendering: the bed, the thrones, the altar tables, the two music stands (fig. 2), the *tenebrario* (fig. 3), and the bookshelf. A possible explanation for the lack of detail in the drawing of this group is that Guaman Poma had little or no access to Spanish houses or buildings that may have contained this sort of furniture. Only in a prominent house or palace was it possible to see a rich state bed or a throne like the ones illustrated in the book. The Spanish tradition dictated that the state bed should be placed in the *alcova* or main bedroom, usually next to the drawing

Fig. 2. Music stand. After Felipe Guaman Poma de Ayala, *Nueva Corónica y Buen Gobierno*, drawing no. 680, 1615. Drawing by the author.

Fig. 3. *Tenebrario*. After Felipe Guaman Poma de Ayala, *Nueva Corónica y Buen Gobierno*, drawing no. 28, 1615. Drawing by the author.

Fig. 4. *A royal administrator sleeps peacefully beside his wife, while Don Cristóbal de León serves punishment for defending his people*. In Felipe Guaman Poma de Ayala, *Nueva Corónica y Buen Gobierno*, drawing 201, 1615. Courtesy of the Royal Library, Copenhagen, Denmark.

Fig. 5. *The hemorrhaging woman is healed; Jairus' daughter is raised*. In Jerónimo Nadal, *Evangelicæ Historiæ Imagines*. Antwerp: Christoffel Plantin, 1593.

room. Thrones, like the ones the author uses exclusively for seating the pope, were very uncommon pieces of furniture in early Spanish America. The only possible place one could have seen this kind of seat would have been in a very important noble house, perhaps the governor's residence, in which a throne—to be used on the improbable occasion of a visit by the king—was customarily placed on a raised platform in the main drawing room.

Without access to a real bed or throne, Guaman Poma most probably relied upon graphic sources for his drawings. His bed and thrones seem vaguely reminiscent of similar subjects depicted in European woodprints. In the case of the bed (Fig. 4), the composition of the scene (1/3 and 2/3) and the bed canopy are close to plate 31 of the 1593 edition of Jerónimo Nadal's *Evangelicæ Historiæ Imagines* (Illustrations of the Gospel Sto-

ries) (Fig. 5).[6] Guaman Poma used the same kind of canopy, but he changed the position of the bed. The remaining third of the illustration is occupied by a man trapped in wooden stocks. In this case the image was most probably taken from an early printed version of the *Speculum humanæ salvationis*.[7]

Altar tables are represented as simple box-like forms with no visible construction details and are often covered with nicely delineated altar cloths. The depiction of the altar tables seems to be inspired by block-prints by the German printer Günter Zainer in Jacobus de Voragine's 1475 *Legenda Aurea*.[8]

The more complex scroll leg structure of the music stands (Fig. 2) and the *tenebrario* (Fig. 3) were depicted in an approximate and imprecise fashion. In this case it is difficult to indicate a possible source. Even if the style of the scroll legs is correct and contemporary with the date of the book (this scroll leg

Fig. 6. *A native scribe of the municipal court, or qilqay kamayuq, drafts a will.* In Felipe Guaman Poma de Ayala, *Nueva Corónica y Buen Gobierno*, drawing no. 307, 1615. Courtesy of the Royal Library, Copenhagen, Denmark.

Fig. 7. *"The author Ayala" presents his Corónica to Philip III, King of Spain.* In Felipe Guaman Poma de Ayala, *Nueva Corónica y Buen Gobierno*, drawing no. 343, 1615. Courtesy of the Royal Library, Copenhagen, Denmark.

Fig. 8. Table. After Felipe Guaman Poma de Ayala, *Nueva Corónica y Buen Gobierno*, drawing no. 198, 1615. Drawing by the author.

Fig. 9. Door. After Felipe Guaman Poma de Ayala, *Nueva Corónica y Buen Gobierno*, drawing no. 305, 1615. Drawing by the author.

shape superseded the more massive solid or triangular forms used in the previous centuries), the absence of construction details on the drawings may indicate that Guaman Poma was unable to use real objects as models for the music stands and the tenebrario.

It is accepted that Guaman Poma had privileged access to at least one well-stocked European library. After years of intense debate on the subject, today it is acknowledged that the most probable owner of this library was either Cristóbal de Albornoz or fray Martín de Murúa, and there is the chance that he could have used both collections. Yet the drawing of the bookshelf (Fig. 6) and the books is very inaccurate and late medieval in style. The total absence of construction detail in the bookshelf illustration may suggest that for the drawing of the only bookshelf in his *Nueva Corónica y Buen Gobierno,* he used a graphic source, possibly an image from the previously mentioned edition of the *Legenda Aurea* by the printer Günter Zainer.

The second and larger group of furniture comprises the pieces depicted in a very accurate and precise manner. It includes chairs (Figs. 4, 7), tables (Fig. 8), doors (Fig. 9), chests, and trunks (Fig. 10). For this group, the inspiration probably came from real furniture. In the furniture on this list every single construction detail is visibly represented. The joins are correctly positioned, with clear indications of every part, including minute pieces like pegs on the ends of the open mortise and tenon joins customarily used by Spanish cabinetmakers on chairs. In real furniture, the pegs are obscured by either the final finish or the subtle color variation due to the varying grain direction of the wood.

The metallic parts—locks and nails in doors, chests, and trunks—of this furniture group are also correctly placed and perfectly drawn. The drawings are so precise that it is possible to reconstruct any of the pieces (Fig. 11). The style and design are very accurate and contemporary to the time in which Guaman Poma lived. The precision and correctness of the drawings of the second group contrasts sharply with the archaic and abstract rep-

resentation of the first group.[9] Only the tables raise some questions, as their leg shape is very uncommon for a four-legged piece. I believe that in this case Guaman Poma adapted a large refectory table into the drawing of this small four-legged version.

This extreme detail may indicate that the author was familiar with those pieces. He may have used this sort of furniture, but even a frequent user is typically unaware of the construction technique employed in making furniture. Guaman Poma's knowledge of furniture making is beyond the user level. He was conscious of the technical complexities in furniture manufacturing. In some of his drawings there is a clear indication of the overlapping wood pieces in a single joint. The great attention to woodworking details indicates that he was possibly versed in cabinetmaking, or at least very interested in the craft.

Carpentry would have been a new and exciting craft for a Native American like Guaman Poma. The varied and specialized Spanish furniture shapes and their production process using "high-tech" iron cutting tools were novelties in the New World. The ancient Inka woodworking technology was based in less efficient copper tools and a very basic joinery that used rope to fasten the pieces. The only kind of Inka furniture—the *tiana*—was a symbol of nobility and power. Guaman Poma included a *tiana* in his own "fabricated" coat of arms on the frontispiece of the manuscript, a fact that has been extensively analyzed by Cummins (1992) and is a key to understanding the use of furniture in *El Primer Nueva Corónica y Buen Gobierno*.[10]

Guaman Poma's Graphic Sources for Furniture and Interiors

Several researchers have tried to identify the European engravings and pictorial sources that served as models for Guaman Poma's drawings. Among them are Mercedes López-Baralt,[11] Teresa Gisbert,[12] Thomas Cummins,[13] and Maarten Van de Guchte,[14] whose work on the printed sources from the Low Countries is an important contribution to the subject. Van de Guchte located several images in Dutch, French,

Fig. 10. Trunk. After Felipe Guaman Poma de Ayala, *Nueva Corónica y Buen Gobierno*, drawing no. 215, 1615. Drawing by the author.

Fig. 11. Model of a chair. After Felipe Guaman Poma de Ayala, *Nueva Corónica y Buen Gobierno*, drawing no. 210, 1615. Computer-generated drawing by the author.

or German publications that could have served Guaman Poma as a source of inspiration, including *Biblia germanica* (Cologne: Heirich Quentell, 1478), *Le triomphe des neuf preux* (Abbeville: Pierre Gerard, 1487), *Speculum humanæ salvationis* (Basel: Bernhardt Richel, 1476), and Jacobus da Voragine, *Legend des Helingen, Wintertreil* (Augsburg: Johan Bämler, 1475).

Van de Guchte also pointed out several other printed sources, such as a German playing card from the fifteenth century as well as single-leaf prints by Albrecht Dürer and other German artists. As the author acknowledges, the unanswered question in Van de Gutche's essay is how to explain the copious presence of late medieval northern European books and prints in Spanish America. A possible answer can be found by analyzing the Spanish American book trade in the sixteenth century.

The Book Trade
in Sixteenth-Century Spanish America

A book transiting from Europe to Spanish America needed to follow a path cobbled with numerous obstacles and bureaucratic regulations devised by the Spanish authorities to collect customs duties and to prevent the circulation of forbidden material in the New World. A few years after Columbus's initial voyages, the Spanish authorities created an organization to control and regulate all the activities of conquest, exploration, and trade. By a royal decree of February 14, 1503, signed at Alcalá de Henares, the House of Trade—*Casa de Contratación de Indias*[15]—was set up at Seville's port. The laws for the trade monopoly between Seville and the Indies were set by royal decree. To transport books overseas, one had first to fulfill a set of administrative procedures in Seville.

The first step was to prepare a detailed record—*registro*—of each shipment. The next step, required by a royal decree of 1550, was to obtain approval from the Holy Office of the Inquisition, to prevent the passage of forbidden—heretical—books to the New World. Passengers could carry with them books for their own personal use, in which case the titles were listed in a less formal document called a *memoria*, which also required the approval of the Inquisition.[16]

Very little research has been done on early Peruvian libraries and the book trade. Only a few Peruvian early *registros* of books have been published; further research in the field will certainly provide better information on the possible European graphic sources used by Guaman Poma. The few published Peruvian documents contain no information on the printing place of the books, and in most cases the titles on the records had several editions done in different places.[17] However, some published New Spanish (Mexican) *registros* include more detailed information. A 1576 Mexican document[18] is annotated as follows: "Blibia [sic], ynpresa en Anberes, con figuras, yn folio a 30 reales" (Bible printed in Antwerp, with single leaf block prints, in folio, 30 *reales*); "25 Blibias ynpressas [sic] en Leon de Francia yn 8° con figuras a 14 reales" (25 bibles printed in Lyon, France, in 8°, illustrated with block prints, 14 *reales*). Another Mexican document dated in 1600[19] lists "Bliblia [sic.] en latin con figuras ynpreso en Francofort. En doze rreales" (Bible in Latin, illustrated with prints, published in Frankfurt, twelve *reales*), and "(a) Nueuo Testamento. En griego con la esplicacion latina ynterlinear; (b) y mas la Biblia Ebraica con la ynterlinea latina ynpreso por Plantino [Christoffel Plantin, Antwerp]. En treinta rs." [(a) New Testament. In Greek with the Latin explanations; (b) and the Hebrew Bible with the Latin interline. Published by Plantin [Christoffel Plantin, Antwerp], thirty *reales*)].

This extensive inventory contains a large number of nonreligious titles, including an illustrated French version of the *Hypnerotomachia Poliphili*; several scientific books by German authors, such as *Almanach nova plurimis annis venturis inserentia* by Johannes Stöffler; and emblem books by Andrea Alciato, Hadrianus Junius, and Johannes Sambucus. The inventories also contain a substantial number of books written in Italian and French. But most of the titles on Mexican or Peruvian *registros* are books written in Spanish and Latin. The books printed in Germany or the Low Countries were most likely on religious subjects and written in Latin. The Spanish

laws applied to all Spanish overseas territories; if it was possible to import German or Dutch material to New Spain, the same would be true for Peru. Because there was a regular trade among the different Spanish viceroyalties, books imported to New Spain could have found their way to Peru. Therefore it is possible to conclude that the Peruvian libraries frequented by Guaman Poma could have had in their holdings illustrated German and Dutch printed material.

At the height of the expansion of the Spanish empire, the Spanish book industry was a highly specialized trade. Books, prints, and paintings were produced in the most remote parts of the empire to match the exact specifications of the Iberian market. Even if the major Spanish cities had a developed printing industry, Antwerp was the center of Spanish book production. Renowned printers like Christophe Plantin supplied the huge Spanish and Spanish American markets. One of the identified sources for Guaman Poma de Ayala's drawings, Jerónimo Nadal's *Evangelicæ Historiæ Imagines* (Illustrations of the Gospel Stories) (1593),[20] was printed by Plantin with a later edition by Martinus Nutius. Plantin's prestige was so great that his name is often included in the *registros*.

In a complex panorama of production and trade, books for the Spanish market were also produced in other cities outside the Spanish territories. Venice and Lyon were the two most significant of these. A good example of this non-Spanish book production for the Spanish market is another possible source for Guaman Poma drawings: Hans Holbein, *Historiarum Veteris Testamenti icons* (Old Testament illustrations), Spanish edition (Lyon: Trechsel and Frellon, 1543);[21] the French and Latin editions of the book are well known to art scholars. Furthermore, from the late fourteenth century onwards northern European (German, Flemish, French, or Swiss) printers worked in Spain.[22] German woodprints are frequently seen in Spanish books because either Spanish or German printers working in Spain recycled German wood blocks in the Spanish editions of some very popular books.[23] And it is worth mentioning that in Seville another German, Jacob Cromberger, started one

of the most successful printing dynasties in Spain. His son Juan Cromberger secured the privilege (by royal permission) of printing in Mexico in 1539. The complexities of the Spanish book trade and the enormous influence of northern European printers in the Spanish book industry may be one reason for the abundant presence of late medieval German and Dutch woodblock prints, or books illustrated with them, in early seventeenth-century Cuzco.

Guaman Poma Illustrations

Pre-Columbian America was a mosaic of varied art traditions. Those variations influenced the further development of European style art in the New World. There was no writing or drawing tradition among the Central Andes pre-Columbian cultures. The Inka painting practice is still little known. Only a few enduring wall painting fragments and some written references on wall painting decorations in Inka palaces remain.[24]

Other cultural specifics of pre-Columbian Andean cultures may have influenced Guaman Poma's work. An important difference between Mexico and Peru—the two most advanced pre-Columbian cultures—is the paper. Paper was a common commodity in pre-Columbian Mesoamerica but unknown in the Andes. The Mexican amate (*amatl*) was a sort of paper manufactured by boiling and pounding flat the inner bark of several tree species. Spaniards used amate paper for some of the early documents produced in Mexico. Native Mesoamericans also produced ink and various other colored pigments. Drawing and pictographic writing were practiced by Mesoamerican cultures but not by the Andean peoples. In the Andes *quipus*, long strands of cotton or alpaca cord with numeric and other values encoded by knots, were the closest instruments to writing.

Painting and drawing in the western tradition were part of the cultural agenda promoted by the conquerors. Arts and crafts schools for natives were successfully established and run by religious orders in New Spain (Mexico) and in Quito, and at later dates also in southern South America by the Jesuits. In

Fig. 12. *Nativitas*. In Jerónimo Nadal, *Evangelicæ Historiæ Imagines*. Antwerp: Christoffel Plantin, 1593.

Peru, those schools lasted just a few years. In the Andes, art teaching was based primarily on the guild system of apprenticeship in the workshop of a master.

Several churchmen trained in art were active in Spanish America after the conquest. The art schools for natives in Mexico and Quito were organized by Flemish Franciscan churchmen: in Mexico by Friar Pieter van der Moere, also known as fray Pedro de Gante, and in Quito by Friar Pieter Gossael. Gossael also produced some illuminated manuscripts and choral books that may have found their way to Cuzco.[25]

Guaman Poma presumably received his basic writing training when he was introduced to the Christian faith by churchmen from one of the religious orders active in his birth town of Huamanga; his artistic preparation probably had the same origin. The close relationship between Guaman Poma and the Mercedarian Friar Martín de Murúa probably had some impact on Guaman

Poma's artistic development, but it occurred later in the author's life. At the time Guaman Poma was approached by Murúa to complete his *Historia general del Pirú*, he was already a trained artist.[26]

It is worth mentioning that Guaman Poma had access not only to a library but also to paper and ink, both expensive items in the colonial Andes. Because there was no local tradition of papermaking in Peru, paper needed to be imported from Europe. Since Spanish paper was expensive compared to that from other European sources, and not of the best quality, Spaniards relied on paper supplied from the Low Countries and Italy (Genoa). The paper used in *El Primer Nueva Corónica y Buen Gobierno* is probably European, but the study of the watermarks is not conclusive on its precise origin;[27] the paper used by Murúa in another work—the Poyanne Manuscript—may have had a Genoese origin.[28]

European prints, not paintings, were the main graphic source of inspiration for *El Primer Nueva Corónica y Buen Gobierno*'s illustrations. Guaman Poma used them for many of his drawings, but he never really copied the original prints. Instead, he developed a very personal working method, adapting the European printed images to his own ideas. In most cases he extensively appropriated, transformed, and reworked the original sources; in other cases he combined and adapted elements of different sources in a single drawing. These significant transformations make identification of the original European graphic sources a difficult task.

A good way to explain Guaman Poma's use of European sources is to compare the Nativity plate[29] from Jerónimo Nadal's *Evangelicæ Historiæ Imagines* (Fig. 12) to the two drawings on the same subject in *El Primer Nueva Corónica y Buen Gobierno* (Fig. 13).[30] The wood structure of the shed is identical in the three images, including the curious way the poles support the trusses. Guaman Poma simplifies the background of his two illustrations, removing the entire landscape scene and adding a star. He also gets rid of the cave and all the angels and cherubs. In one of his two illustrations even the cow and mule

Fig. 13. *The birth of Jesus Christ in Bethlehem*. In Felipe Guaman Poma de Ayala, *Nueva Corónica y Buen Gobierno*, drawing no. 11, 1615. Courtesy of the Royal Library, Copenhagen, Denmark.

Fig. 14. (*detail*) *Nativitas*. In *Speculum Humanae Salvationis Cum Speculo S. Mariae Virginis*. Augsburg: Günther Zainer, 1473, woodcut. The Pierpont Morgan Library, New York. PML 129, fol. 46v. Photography: Graham Haber, 2009.

are erased; in the other he just changes the position of the mule that resembles a llama. In one of the compositions the Holy Family is close to Nadal's depiction; in the other it seems that the source is the Nativity scene employed twice in the 1473 edition of the *Speculum humanæ salvationis* by the German printer Günter Zainer (Fig. 14).[31] Guaman Poma moves the Holy Family out of the shed in both illustrations.

The rather archaic style of *El Primer Nueva Corónica y Buen Gobierno*'s images, executed in a simplified contour line woodblock print style rather than the more contemporary and precise copperplate engraving style, is one of the most intriguing features of the Peruvian manuscript. Woodblock printing allows a very limited degree of detail. Woodprints tend to be contoured line figures, in some cases with a coarse line pattern for shading. Even when Guaman Poma's figures are simply outlined, we find very subtle shading and a lot of detail in the particulars. He meticulously draws decorations, embroideries, stitches, and fringes on textiles; nails or pegs on the furniture; and surface decoration in the case of books to a degree impossible to obtain in a woodblock print.

Why did Guaman Poma choose this archaic style for his drawings, when he belonged to a non-European cultural context? For a Spanish artist contemporary to Guaman Poma the election of a rather archaic drawing style might have had some meaning; the style *all'antica* was considered almost a mandatory requisite for a good work of art.[32] But for

a Native American, the idea that he was trying to associate his artistic production with an unknown past is senseless. I believe that even if Guaman Poma had access to contemporary books and images, as some of his identified sources prove,[33] he appreciated the clear compositions and the simple drawing technique of the late medieval German and Dutch woodblock prints. Perhaps he saw in those late medieval prints some kind of graphic affinity to the pre-Columbian design principles found in Inka ceramics or textiles.

For Guaman Poma's drawings of furniture and western-style interiors, one book, *Speculum humanæ salvationis* (probably a version that used woodblocks from any of the early Dutch editions), can be cited as a very influential source. To an inexperienced observer this assertion may seem highly speculative given the notable differences between *El Primer Nueva Corónica y Buen Gobierno*'s drawings and the *Speculum humanæ salvationis* prints, but in both books there is a sort of standardized code in the way things and spaces are represented. This pictorial standardization process is the key to understanding the similarities between the two books.

Patterns in floors and walls, organization of the elements in the space, axes and symmetry, window composition and representation are very simple and perfectly codified and standardized in every single interior illustration of both books (Fig. 15). Even if the same architectural features may appear in many other European sources of the time, the

architectural pictorial code in other books is never as simple and direct as in the early Dutch editions of the *Speculum humanæ salvationis*. A detailed comparison leaves little room for doubt on the influence of this book on Guaman Poma de Ayala's work.

Speculum humanæ salvationis was a very popular book during the Middle Ages. Its manuscript version was much copied and translated into different idioms. The first printed version was issued in the Low Countries (c. 1468), and it became so popular that it had four editions, two of them in Dutch. By the end of the fifteenth century sixteen editions by eleven different printers had been issued all over Europe. It is possible that more than one of those versions was available in the Cuzco library frequented by the author. The question is, was it an illuminated manuscript or a printed version that Guaman Poma used? In both cases the drawings tend to be similar, but the standardization of the illustrations is more evident in the printed versions.

If Guaman Poma used a printed version, it would be very difficult to establish which edition, because the blocks used in some versions of the *Speculum humanæ salvationis* were reused by different printers for later editions. As I noted earlier, this recycling of the blocks went far beyond national borders. For example, the blocks from the famous Günther Zainer Augsburg 1473 *Speculum humanæ salvationis* edition were reused in the Reinhard 1482 Lyon edition and again in the Pablo Hurus 1491 Saragossa edition.[34] However, the interior spaces of the Dutch editions, as well as the ones in some *Biblia Pauperum* editions of the same provenance, are more closely related to the spaces in *El Primer Nueva Corónica y Buen Gobierno* than the spaces represented in illuminated manuscripts or in other printed editions, including the 1473 *Speculum humanæ salvationis* edition by Zainer that can be quoted as one of the sources for the Nativity scene in *El Primer Nueva Corónica y Buen Gobierno*.

Another very popular book printed by Günter Zainer, *Legenda Aurea* (c. 1471–1472), can be cited as a source for the bookshelf and some of the buildings in *El Primer Nueva Corónica y Buen*

Fig. 15. Detail of an interior. In *Speculum Humanae Salvationis*, an early Dutch edition In Wilson, Adrian and Wilson, Joyce Lancaster. 1985. *A Medieval Mirror. Speculum Humanae Salvationis 1324–1500*. Berkeley: University of California Press.

Gobierno. Many of Guaman Poma's drawings of houses and other edifices (Fig. 16) are derived from Zainer's woodblocks (Fig. 17). Guaman Poma even reproduced the same textures used by Zainer to represent tiles or straw in his depictions of roofs.

Another possible graphic source for Guaman Poma's drawings is the little prints used to illustrate Spanish romances of chivalry. Some of Guaman Poma's views of American coastal cities seem inspired by a woodblock repeatedly used in Juan Cromberger's 1528 printing of "*Libro del esforzado caballero Don Tristan de Leonis y de sus grandes hechos en armas*."[35] Cromberger used the same miniature woodblocks to illustrate many of his publications, making it difficult to identify which was the precise book used by Guaman Poma. A print from the same book depicting an interior may have partially inspired Guaman Poma's rooms.

Fig. 16. Church. After Felipe Guaman Poma de Ayala, *Nueva Corónica y Buen Gobierno*, drawing no. 215, 1615. Drawing by the author.

Fig. 17. (*detail*) Saint and a church. In Jacobus de Voragine, *Legenda aurea sanctorum, sive Lombardica historia*. Augsburg: Günther Zainer, 1475, woodcut. The Pierpont Morgan Library, New York. PML 27324. Photography: Graham Haber, 2009.

In Conclusion

The Spanish furniture illustrated in *El Primer Nueva Corónica y Buen Gobierno* is representative of the types that probably furnished early Andean Spanish interiors. Those novel and different furnishings and interiors, anchored in the European Mediterranean tradition, probably sparked the curiosity of the Andean author about European woodworking and furniture types.

The detailed images of most of the furniture suggest that Guaman Poma de Ayala was versed in the technical aspects of furniture making. He understood the technological differences between the ancient pre-Columbian woodworking techniques and their Spanish counterparts. The archaic style of some of the luxury pieces, bed and thrones, clearly indicates that Guaman Poma did not have the chance to see real examples of those more elaborate Western types but must have come to know of their existence through graphic or textual sources.

The furniture illustrated in *El primer Nueva Corónica y Buen Gobierno* is part of a complex and personal mixed-media (text-image) communication system devised by Felipe Guaman Poma de Ayala to complement his texts. In composing his pictorial system, the author departs from the element of the ancient Inka tradition closest to western drawings, standardized abstract symbolic figures set in a geometrical grid pattern. In the creation of his personal pictographic system the author adopted Andean and European elements from many different sources that include not only real objects but graphic images of unknown things as well. Owing to the complex nature of the operation, the standard representations of the chosen components are simplified versions of the original sources, but in many cases a good degree of detail is kept. Once the standard figure of the graphic code is created and its symbolic value assigned, it is repeated without major changes in the manuscript illustrations that require this pictogram. The result of this operation is a personal and cryptic code hard to decipher and interpret by today's standards.

Seats are a good example of Guaman Poma's

coded system: a *tiana* is a symbol of Inka nobility, a throne a symbol of religious power, a chair[36] a symbol of Spanish authority. Benches or stools are absent because they were too widely used to encode specific social signification.

Another case of Guaman Poma's codification using architectural elements is houses. In his drawing the shape of houses is roughly the same for Spanish or Inka dwellings. The major visual difference is the texture applied to the roof cover, for the Inka straw and for the Spanish tiles. I believe that the repetitive and consistent use of Spanish furniture and architecture in *El Primer Nueva Corónica y Buen Gobierno* implies a conscious use of those elements to create a pictorial system.

I agree with the thesis proposed by Van de Guchte: Guaman Poma recognized and adopted the European practice of using the same composition to depict different events related only by the action occurring in both. Consider, for example, two almost identical illustrations that include the king of Spain and a kneeling person petitioning him. In one illustration the gentleman is Pedro de la Gasca,[37] and in the other he is Guaman Poma himself[38] in an imaginary visit to the king (Fig. 7). Both drawings may have come from ideas borrowed from the Spanish edition of Hans Holbein's *Historiarum Veteris Testamenti icons*. The composition is very close to the one in a plate depicting King David (Fig. 18). Regardless of time and historic considerations, if a specific composition scheme was used in a European source to signify the submission and respectful gesture of a vassal before a king—an in this case Old Testament sovereign: Solomon, David, or Ahasuerus of Persia—the same composition was used by Guaman Poma to indicate a gesture of submission and respect to Charles V or Philip III of Spain. Because chairs have an associated graphic value for Guaman Poma, he seated the king of Spain on his standardized version of the *frailero* style chair, which in his personal code is associated with political authority.

I would like to suggest that Guaman Poma de Ayala's pictorial system went beyond the simple

Fig. 18. Hans Holbein, King David. In *Historiarum Veteris Testamenti icons*, 1543, woodcut.

use and adaptation of the northern European graphic customs and conventions. In my opinion his extensive reworking of the original sources suggests that Guaman Poma developed a more sophisticated and complex coding of furniture, architecture, and textures to differentiate and explain "type" compositions. With this very simple device Guaman Poma avoided possible mistakes in the interpretation of his drawings—a problem perhaps he faced while studying European publications that had the same block-print repeated several times in a single book but accompanying different texts.

Regarding the interior spaces in which Guaman Poma depicts the furniture, some further considerations can be offered. First, the space is always described by two planes: floor and back wall. Sides or ceilings are never depicted in the interiors; only in exterior views of buildings is it possible to see more planes. The two-plane representation is consistent throughout the book, and it probably was a personal and conscious choice. I think that this choice was probably influenced by the representational devices employed by Günter Zainer to define the spaces in his woodblock prints. There is a certain degree of affinity between the distorted medieval-style perspective projections in Zainer's block-prints and Guaman Poma's perspectives. Zainer, like Guaman Poma, restricted to a minimum the use of planes for defining the space.

Fig. 19. *Don Juan de Mendoza y Luna, Marquis of Montesclaros, the Tenth Viceroy of Peru.* In Felipe Guaman Poma de Ayala, *Nueva Corónica y Buen Gobierno,* drawing no. 190, 1615. Courtesy of the Royal Library, Copenhagen, Denmark.

Second, fenestration—the design and disposition of windows and doors—probably encodes meaning. The portrait of viceroy Don Juan de Mendoza y Luna, Marquis of Montesclaros (Fig. 19), is a fine example of this coded system. The marquis is framed by four different kinds of windows disposed in a square grid pattern, in the same fashion as an Inka textile design in which each square—*tocapu*—has a fixed meaning (Fig. 20). In this illustration each window should have an associated symbolic meaning. Although it is quite difficult to identify the meaning of these windows, I have clues for two of them. The top window on the left side may be a covered wood balcony like the ones used in Lima's noble houses, so it probably denotes nobility. The window in the bottom right is an arrow loop typical of military constructions, so it may indicate the viceregal rank of the marquis within the Spanish military establishment. The two other windows are too generic to be linked to a specific building type, making it impossible to associate a meaning with them.

Third, textures in floors and walls and other interior elements function as differentiating elements in the compositions. The double line segments disposed in a diamond-like pattern texture he uses to identify stucco walls and the straw or tile textures I previously mentioned are good examples of his standardized code for textures in buildings.

Rolena Adorno[39] and Mercedes López-Baralt[40] have analyzed Guaman Poma's disposition of figures in pictorial space and its possible meaning according to the traditional Inka values of *hanan/urin* (upper/lower–left/right). I would like to suggest that Guaman Poma de Ayala went beyond the traditional Inka *hanan/urin* interpretation of space. His use of furniture and architecture as elements of a personal pictographic system suggests a far more complex approach that takes into account not only the spatial position and gestures of the subjects represented but also the type of object depicted and its symbolic value. Guaman Poma developed his own *mestizo* system based on his improved personal version of the representational conventions of the

Fig. 20. *Tocapu* design. After Felipe Guaman Poma de Ayala, *Nueva Corónica y Buen Gobierno*, drawing no. 34, 1615. Drawing by the author.

northern European block printers, incorporating as well some of the spatial organization concepts taken from traditional Inka culture, such as the *hanan/urin* notion. Texts and standardized texture patterns add additional and precise information in each case. In *El Primer Nueva Corónica y Buen Gobierno* the emblematic object value is no longer the traditional Inka value but a *mestizo* value—neither European nor Inka, but Latin American.

El Primer Nueva Corónica y Buen Gobierno was, I believe, conceived and drafted by the author in the same Inka ordering system and conceptual fashion as a typical Inka textile or ceramic vessel. The book format itself can be thought of as a kind of metaphorical Andean-inspired abstract grid within which the text and graphic information is organized. The meaning and significance of the figures and objects that illustrate the manuscript—including the furniture—cannot be interpreted without considering the *unicitas* of the work. For Don Felipe Guaman Poma de Ayala, to write and draw in the European fashion was as new and exciting as the Spanish furniture and objects he probably used while working

on his manuscript. Through his writing and drawings Guaman Poma created a personal theoretical bridge between two different conceptions of the universe: the ancient Inka and the western European. *El Primer Nueva Corónica y Buen Gobierno* can be considered as a *Speculum* (mirror) of the individuality and creativity of an exceptional man who lived in a time when his world was turned upside-down—*el mundo al revés*.

Notes

[1] On ancient furniture see Morley 1999.

[2] On Chinese seats see Clunas 1988, 15–17.

[3] See MacCormack 2006.

[4] On the hundredth anniversary of the discovery of the manuscript, the Danish Royal Library published a bilingual (English/Spanish) book on Guaman Poma scholarship. See Adorno 2001.

[5] On sixteenth- and seventeenth-century Spanish furniture see Aguiló Alonso 1993.

[6] *Evangelicæ Historiæ Imagines* (Illustrations of the Gospel Stories) (1593) was printed in Antwerp by Christoffel Plantin with a later edition by Martinus Nutius. The book includes 153 engravings produced by Bernardino Passeri, Marten de Vos, and Jerome and Anton Wierix. See Nadal [1593] c2001.

[7] See Wilson and Wilson 1985.

[8] Jacobus Da Voragine, *Legenda Aurea Sanctorum, Sive Lombardica Historia.* (Augsburg: Günther Zainer, 1475).

[9] A possible exception for the second group is a chair with curved arms illustrated in drawing 235, "Don Juan Pilcone, local native authority, or kuraka kamachikuq, files a written complaint against the royal administrator with the help of the parish priest," which seems inspired not by real furniture but by a chair illustrated in the print "Catechizing Inca Tupac Amaru," c. 1571–1620. For an image of this print see Cummins 1992, 51.

[10] Cummins 1998.

[11] Lopez-Baralt 1992.

[12] Gisbert 1992.

[13] Cummins 1992 and 1996.

[14] Van de Guchte 1992.

[15] The official name for the institution was *Casa y Audiencia de Indias*.

[16] On the Spanish book trade see Leonard 1992.

[17] Leonard 1940.

[18] Leonard 1992, document 2.

[19] Leonard 1992, document 5.

[20] Nadal [1593] c2001.

[21] Holbein [1543] c2001.

[22] The first recorded Spanish book printer was the German Johannes Parix, native to Heidelberg (*Sinodal de Aguilafuente*, Segovia: 1472).

[23] The books printed in the Saragossa workshop of the Swiss Pablo Hurus and the German Johannes Plank offer a perfect example of block recycling. Hurus's 1491 *Speculum humanæ salvationis* edition recycled earlier (1473) woodblocks by Günther Zainer. See Wilson and Wilson 1985, 208.

[24] Gisbert 1992, 77.

[25] Gisbert 1992, 79.

[26] On Guaman Poma and the *Historia General del Pirú* see Cummins 1992.

[27] Adorno and Boserup 2003, 133–140.

[28] Ibid.

[29] Plate 3 in the 1593 edition: *IN NOCTE NATALIS DOMINI - Nativitas Christi*.

[30] Drawing 11, The fifth age of the world: the birth of Jesus Christ in Bethlehem; Drawing 27, The birth of Jesus Christ in Bethlehem; Guaman Poma 1615.

[31] *Speculum Humanae Salvationis Cum Speculo S. Mariae Virginis*, edited by Frater Johannes of the Monastery of SS. Ulrich and Afra of Augsburg (Augsburg: Günther Zainer, 1473).

[32] On the subject see Gömbrich, 1966, 122–28.

[33] Jerónimo Nadal's *Evangelicæ Historiæ Imagines* (1593) is a fine example of a Guaman Poma contemporary source.

[34] Wilson and Wilson 1985, 208.

[35] *Libro Del Esforçado Cauallero Don Tristan De Leonis Y De Sus Grandes Hechos En Armas* (Sevilla: Por Juan Croberger, 1528).

[36] Guaman Poma adopted a very specific type of Spanish chair in which the legs lean on a pair of long stretchers (*zapatas*), one on each side of the chair. This type was fashionable in sixteenth- and seventeenth-century interiors.

[37] Drawing 168, King Charles V of Spain sends president Pedro de la Gasca to Peru with a letter requesting the loyalty of Gonzalo Pizarro and his soldiers; Guaman Poma 1615.

[38] Drawing 343, "The author Ayala" presents his Corónica to Philip III, King of Spain; Guaman Poma 1615.

[39] Adorno 2000, 89–99.

[40] López-Baralt 1992.

Works Cited

Adorno, Rolena. 2000.
 Guaman Poma: Writing and Resistance in Colonial Peru. 1986. Second edition with a New Introduction. Austin: University of Texas Press.
------. 2001.
 Guaman Poma and His Illustrated Chronicle from Colonial Peru: From a Century of Scholarship to a New Era of Reading. Copenhagen: Museum Tusculanum Press - University of Copenhagen - The Royal Library.
Adorno, Rolena and Boserup, Ivan. 2003.
 New Studies of the Autograph Manuscript of Felipe Guaman Poma De Ayala's Nueva Corónica Y Buen Gobierno. Copenhagen: Museum Tusculanum Press.
Adorno, Rolena, Mercedes López-Baralt, Tom Cummins, John V. Murra, Teresa Gisbert, and Maarten van der Guchte. 1992.
 Guaman Poma de Ayala: The Colonial Art of an Andean Author. New York: Americas Society.
Aguiló Alonso, María Paz. 1993.
 El mueble en España, siglos XVI-XVII. Madrid: Antiqvaria.
Clunas, Craig. 1988.
 Chinese furniture. London: Victoria and Albert Museum.
Cummins, Thomas B. F. 1992.
 "The Uncomfortable Image: Pictures and Words in the *Nueva corónica i buen gobierno*." In Adorno et al. 1992: 46–59.
------. 1998.
 "Let Me See! Reading Is for Them: Colonial Andean Images and Objects 'como es costumbre tener los caciques Señores.'" In Hill Boone, Elizabeth and Cummins, Tom (eds.) 1998: 91–148.
Cummins, Thomas B. F. (author) and Anderson, Barbara (editor). 2008.
 The Getty Murúa: Essays on the Making of the "Historia general del Piru." Los Angeles: J. Paul Getty Museum.
Gisbert, Teresa. 1992.
 "The Artistic World of Felipe Guaman Poma." In Adorno et al. 1992: 75–91.
Guaman Poma de Ayala, Felipe. 1615.
 El primer Nueva corónica y buen gobierno [1615]. Gl. Kgl.S. 2232, 4°. Copenhagen: Royal Library of Denmark. http://www.kb.dk/perma-link/2006/poma/info/en/frontpage.htm
Gömbrich, E. H. 1966
 Norm and Form. London: Phaidon.
Holbein, Hans. [1543] c2001.
 Imágenes del Antiguo Testamento / edición y estudio de Antonio Bernat Vistarini; precedido de La Biblia come ariete artístico moderno de Francisco Calvo Serraller. Palma de Mallorca: José J. de Olañeta.
Hill Boone, Elizabeth and Cummins, Tom (Editors). 1998.
 Native Traditions in the Postconquest World. Washington: Dumbarton Oaks Research Library and Collection.
Leonard, Irving A. 1940.
 "Don Quixote and the Book Trade in Lima, 1606." *Hispanic Review*, 8, no. 4 (Oct. 1940), pp. 285–304.
------.1992
 Books of the Brave. Being an Account of Books and of Men in the Spanish Conquest and Settlement of the Sixteenth-Century New World. Berkeley: University of California Press.
López-Baralt, Mercedes. 1992.
 "From Looking to Seeing: The Image as Text and the Author as Artist." In Adorno et al. 1992: 14–31. New York: Americas Society.
MacCormack, Sabine. 2006.
 On the Wings of Time. Princeton: Princeton University Press.
Morley, John. 1999.
 The History of Furniture: Twenty-Five Centuries of Style and Design in the Western Tradition. Boston: Little, Brown and Company.
Murúa, Martín de. [1616] 2008.
 Historia general del Pirú. Los Angeles: J. Paul Getty Museum.
Nadal, Gerónimo. [1593] 2001.
 The Illustrated Spiritual Exercises (Evangelicæ historiæ imagines). Scranton, Pa.: University of Scranton Press.
Van de Guchte, Maarten. 1992.
 "Invention and Assimilation: European Engravings as Models for the Drawings of Felipe Guaman Poma de Ayala." In Adorno et al. 1992: 92–109.
Wilson, Adrian and Wilson, Joyce Lancaster. 1985.
 A Medieval Mirror. Speculum Humanae Salvationis 1324–1500. Berkeley: University of California Press.

Beginnings:
Art, Time, and Tito Yupanqui's Virgin of Copacabana

Luisa Elena Alcalá

The late sixteenth century saw the rise of some of the most enduring and symbolically charged devotions in Spanish America.[1] Of them, the origin story of the miracle-working sculpture of the Virgin of Copacabana stands out (Fig. 1) because it was made by the Indian Francisco Tito Yupanqui, and we know a fair amount about his experience from a reportedly autobiographical statement published in the first chronicle devoted to the cult, written by the Augustinian friar Alonso Ramos Gavilán in 1621.[2] Tito Yupanqui's personal account of becoming an image maker in colonial Peru is unique for all of Spanish America. The main parts of the story are as follows.

In the early 1580s the inhabitants of the town of Copacabana on the shores of Lake Titicaca decided that they wanted to found a confraternity in their local parish church and dedicate it to a saint or an advocation of the Virgin that could bring protection to the local community. They were divided between those who wanted to devote their confraternity to Saint Sebastian, a traditional protector against plagues and illness, and those who favored the Virgin. As Sabine MacCormack has demonstrated, this division of opinion reflected a larger ethnic rift between Anansayas and Urinsayas in the town that was related to pre-Hispanic Andean and Inca rivalries.[3] Eventually, the Virgin camp, the Anansayas, won out, and one of their group, Francisco Tito Yupanqui, an Indian of noble Inca descent, decided that he wanted to make the image of the Virgin, a Candlemas-type, himself. With astounding determination, he embarked on an adventure that would take him to various Andean cities and back again.

First, he travelled to Potosí to train with the Spanish sculptor Diego Ortíz. From there, he went to visit the bishop of Charcas in Chuquisaca (also known as La Plata, and later Sucre). He showed the bishop a sample painting and asked permission to

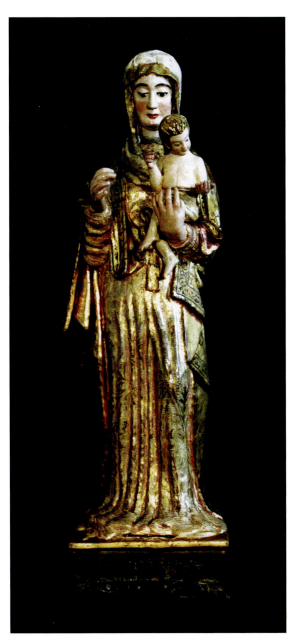

Fig. 1. Francisco Tito Yupanqui, *Virgin of Copacabana*, c. 1582–1583. Sanctuary of Nuestra Señora de Copacabana, Bolivia. Photo: Carlos Rúa. Courtesy of Rafael Ramos Sosa.

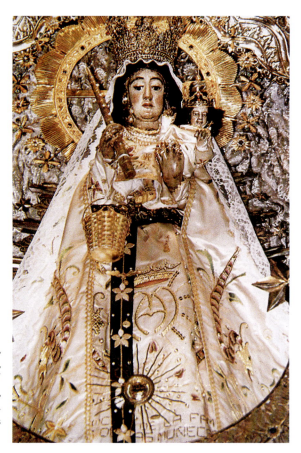

Fig. 2. Francisco Tito Yupanqui, *Virgin of Copacabana* (dressed), c. 1582–1583. Sanctuary of Nuestra Señora de Copacabana, Bolivia. Photo: by Carlos Rua. Courtesy of Rafael Ramos Sosa.

Fig. 3. View of the Sanctuary of the Virgin of Copacabana against Lake Titicaca. Photo: courtesy of Suzanne Stratton-Pruitt.

become an official artist of religious images. The response could not have been more negative: some in the bishop's coterie said the Virgin appeared bearded; the bishop, that he should devote himself to painting monkeys.[4] Nonetheless, he persisted and returned to Potosí, where he had left his sculpture. When it was finished, he went to Chuquiabo (today La Paz) to enlist the assistance of a local gilder by the name of Vargas in the final stages of production. As if the human obstacles had not been enough, Tito Yupanqui also had his share of bewildering encounters with the supernatural. Strange things were constantly happening to his image. Some days it seemed fine and finished, and then it would somehow become ruined again, only to fix itself. Divine intervention was taking over the process, guaranteeing an appropriate miraculous origin story for one of the great devotions of Spanish America. Tito Yupanqui eventually returned to Copacabana with his sculpture, and although at first it met with local opposition, in the end, the image was enthroned on its altar (Fig. 2). That very day, February 2, 1583, a miracle occurred when a candelabra fell on the head of the *corregidor* and he was unharmed, a promise of the future gifts that the Virgin would bestow upon Copacabana (Fig. 3).[5]

Many aspects of this cult's history have been studied. Sabine MacCormack exposed the complex sociopolitical backdrop that explains what was at stake for the Anansaya in promoting the devotion. Her analysis demonstrated that there were continuities between pre-Hispanic social and political divisions and the way Spanish colonial society was organized in the area around Lake Titicaca. In her pioneering study on Andean iconography Teresa Gisbert delved into the complex issue of religious belief and questions of syncretism. She demonstrated that the Virgin of Copacabana replaced pre-Hispanic deities in the Lake Titicaca region and in the process inevitably became identified with them.[6] Following Gisbert, Veronica Salles Reese further explored the recontextualization of the sacred in Lake Titicaca.[7] Religious history's intersection with literary

creativity has also been a fruitful field of study, and many have analyzed plays and poems written about the cult both in Peru and in Iberian Spain, such as the famous play written in 1672 by the court writer in Madrid, Pedro Calderón de la Barca.[8] Curiously, art historical approaches have been less common.[9]

This essay investigates ways to engage the Virgin of Copacabana, the object and not the devotion, in art historical inquiry. It seeks to integrate and relate the history of the object to the trends that marked the broader development of artistic production in the Andean highlands during the last quarter of the sixteenth century. Instead of treating Tito Yupanqui's authorship as an exceptional case of image production under unusual conditions, I investigate the extent to which some aspects of his experience were normative. How does Tito Yupanqui's role as an emerging sculptor fit into the broader artistic climate of his time? Miraculous intervention aside, how does the shortage in supply and the rising demand for religious images in the Andean highlands shed light on why and how he was able to produce this work? How does his sculpture stylistically compare to contemporary works, and what do these comparisons reveal? While the first part of this essay excavates a context for Tito Yupanqui in contemporary artistic practice, the final section addresses the inherent limitations and tensions in this approach. Many elements in Tito Yupanqui's narrative conform to the codified, hagiographic tradition of histories of miracle-working images in the Christian world.[10] Consequently, one cannot treat him unproblematically as an emerging artist in colonial Peru either. One of the aims of this study is to explore how the hagiographic genre informs the foundational texts of the devotion, while not losing sight of their value as some type of truthful testimony about an early colonial artist.

Beginnings

The word "Beginnings" in the title of this essay signals that Tito Yupanqui's experience belongs to a period when art in a European style was still relatively

new in many parts of the Viceroyalty of Peru. Tito Yupanqui supposedly started his sculpture towards the middle of 1582, and it was placed on its altar in Copacabana in February 1583. As we will see, the years 1582–1583 mark a kind of watershed in art production in this part of colonial Peru. Time, then, but also place is an essential parameter by which to frame the production of the Virgin of Copacabana.[11] In terms of place, the problem for undertaking any study of sculpture in the region of Lake Titicaca is that it is not at the center of the viceroyalty. Understandably, most of the literature on colonial Peruvian art is about the major artistic centers: Quito and Lima from the mid-sixteenth century onward, and increasingly towards the end of the century, Cuzco as well. With the exception of Teresa Gisbert and José de Mesa, most historians of Peruvian colonial art from this early period rarely focus on the smaller developing artistic centers, cities like Sucre or La Paz. Consequently, the tendency is to regard Tito Yupanqui's story in a vacuum, with little sense for how the artistic atmosphere around him was changing as he worked away on his image. I propose a closer look at both the smaller geographical radius in which our artist travelled and the chronological frame of the years before and after 1582–1583.

Throughout the viceroyalty of Peru, sculptural works from the earliest period after the conquest—starting around the mid-sixteenth century—typically had one of three provenances: they were made by arriving European artists, mostly Spaniards but also some Italians; they were directly imported from Spain; or they were produced by indigenous hands, the case of Tito Yupanqui. Most of the Spanish sculptors who came to Peru in the mid-sixteenth century followed a pattern of notable itinerancy. In general, they tried to work in Lima but then gravitated towards the Bolivian highlands, lured by the riches of Potosí, which explains how the city developed into a flourishing artistic center.[12] An example of this type of artist is provided by the Spanish sculptor Diego Rodríguez. In 1583, the Mercedarian convent in Chuquisaca (La Plata/ Sucre) commissioned him to create a *retablo* for the high altar just as the church building itself was being completed. The contract stipulated that once the *retablo* was finished, he should be available to install it, even if he was in Potosí at the time.[13] Although this type of stipulation is not uncommon in contracts for altarpieces, in this case and at this time it may be indicative of a larger problem for churches in small localities: artists partially completing their works and then moving on, leaving part of the job unfinished, which is what Rodríguez did in the end despite his contractual obligations. Rodríguez's example reveals that small towns depended on itinerant artists for church decoration. This was true even of important localities like Chuquisaca, the see of the bishopric of Charcas, suggesting precarious artistic conditions throughout the region.

Most religious institutions aspired to having a work imported from Spain as the centerpiece in their *retablo*. The 1583 contract with the artists who adopted the commission that Diego Rodríguez abandoned in La Merced of Chuquisaca is telling in this respect. The contract with two of the most successful Spanish sculptors then available, Gómez Hernández Galván and his brother Andrés, specifies that they were to leave the central niche empty because it was reserved for an image belonging to the Mercedarians, most likely a European piece.[14] Imported Spanish works were considered better than those made locally, even by Spanish artists.[15] Indeed, the surviving sculptures identified as Spanish in the Viceroyalty of Peru, such as the *Virgin and Child* attributed to Roque Balduque in the Cathedral of Lima (c. 1551) (Fig. 4), present a rather high standard of quality. Chronicles often remark that these images were gifts from Charles V himself, a seemingly legendary origin that needs to be reassessed more carefully. While it was part of royal Hapsburg tradition to donate religious images to newly Christianized territories, and a compelling precedent for Charles was set by Queen Isabella in Granada,[16] the assignation of royal provenance to many objects in the viceroyalties was fabricated.[17] Nonetheless, whether

it was because of quality or a real or imagined provenance, or both, these images occupied a special place in the early churches of Spanish America.

Iberian works arrived in the viceroyalties not just as royal gifts, but increasingly through the commercial monopoly in Seville. Local Spanish sculptors contracted with agents to facilitate direct exportation to the New World. Anyone could serve as an agent: ship captains, family, friends, and institutional connections. Even bishops got involved. For instance, the incoming bishop of Chuquisaca, Fernando González de la Cuesta, agreed to sell four pieces of a *retablo* by the famous Sevillian sculptor Roque Balduque, mentioned above; after the bishop died unexpectedly in Panama in 1560, the works were eventually sold in Lima.[18]

Correspondence and documents attest to the impediments in decorating the churches of many parts of early colonial Spanish America. Exports reached the ports first, and it was not always easy for them to travel to destinations in the interior of the viceroyalty.[19] Decades ago, Mario Chacón Torres published an interesting document dating to 1578 and regarding legal action to ensure that a load of eight images that were stuck at the port of Arica should be sent to Potosí. Apparently, the owner had waited more than a year to have them delivered.[20] Distance, then, and the concomitant elevated costs that it generated, complicated the acquisition and arrival of European works in the Andes. In November of 1568, the canons of the Cathedral of La Plata reported to King Philip II that "las cosas de Castilla que son necesarias para el servicio del culto divino, valen precios muy excesivos" (the things from Castile necessary for the celebration of the Divine service are valued at very excessive prices).[21] They went on to explain that ornaments for their new church—less pleasing but decent nonetheless—had been made locally, revealing that the expense of imported works may also have encouraged the development of local artistic production.

The overall appearance of church interiors in the years between 1550 and 1580 is difficult to assess because little remains. Surviving edifices in the Lake Titicaca region, including the Chucuito area, suggest a prototype of mostly adobe churches with unusually long single naves (up to 200 feet), few windows, and one or perhaps two modestly adorned doors on the façade, often using finer materials such as cut stone. At this time, interior church decoration was modest as well: a simple image or triptych set up on an altar table,[22] or at most a small *retablo*, not the large machines of woodcarving and gilding that are typically associated with the pan-Latin American baroque style of later decades. Some of the early altarpieces were not even made of wood, since it was not readily available in all localities. Instead, local artisans used their ingenuity to reproduce the appearance of a carved altarpiece by using bricks,

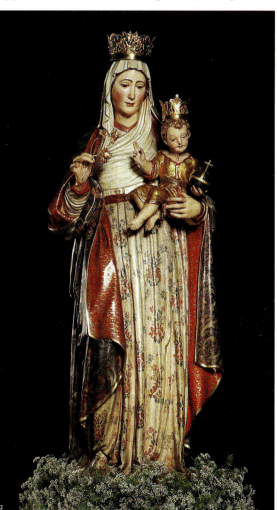

Fig. 4. Attributed to Roque Balduque, *Virgin and Child*, Cathedral of Lima. Photo: courtesy of Daniel Gianoni.

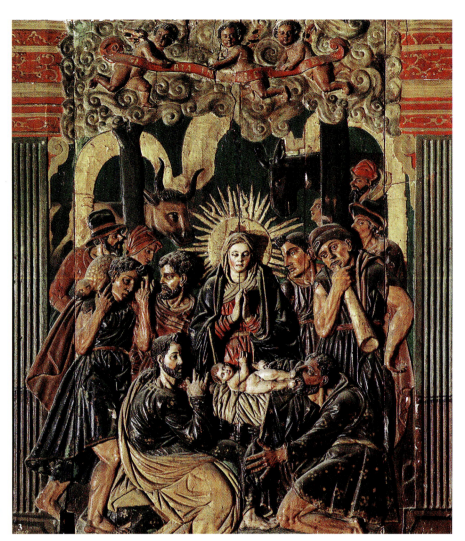

Fig. 5. Alonso Gómez, *Adoration of the Shepherds*, c. 1558, Cathedral of Lima. Photo: courtesy of Daniel Gianoni.

gesso, and paint.[23] Mural painting—cheaper to come by—also became widespread as a means of decorating the long walls of the naves in these churches.

As for sculptural decoration, an example by which to gauge the local production is found in one of the earliest extant reliefs in Peru, the *Adoration of the Shepherds*, dated to 1558 and attributed to a Spaniard working in Lima, Alonso Gómez (Fig. 5). It is believed to have been part of the original *retablo* of the high altar in Lima's second cathedral. Gómez died in 1565, and he is credited with being one of the first to bring knowledge of Spanish sculpting techniques and styles to Peru.[24] Comparisons with the few other surviving works of the period suggest that this piece is representative of the type of works available in Peru at this time and for the

following twenty years.[25] The figures are clearly legible, and the composition is neatly organized, with the central axis of the Virgin and Christ Child dominating the attention of the figures on the sides and below. Gómez's work is competent, but overall it displays limited artistry and aesthetic impact. Even if we account for poor states of conservation and for sometimes unhappy restorations, none of the handful of surviving early works produced in Peru and Bolivia display exceptional quality. In the early decades after the conquest many of the Spanish artists were travelling to America in search of material wealth from other enterprises and businesses. They were mostly second-rate artists, and they found work in the viceroyalty at a time when there was an urgent need for images to advance

the process of acculturation and evangelization.

Further documentation corroborates that in this period the demand for religious art far exceeded the available supply. The paper trail regarding the construction of the Cathedral of Chuquisaca in the 1550s and 1560s demonstrates how desperate some situations became. The first cathedral was begun in 1551–1552, when the bishopric was established. A simple, single-nave building was erected, but at completion in 1561 it was considered too modest and even indecent. By then, the architect, Juan Miguel de Veramendi, had moved to Cuzco, and he was recalled to Chuquisaca and then sued for negligence. Because the local authorities feared that he might not stay in Chuquisaca to complete and improve the building according to plans, they asked that he be obligated not to leave the province for twenty-one years.[26] Another illuminating example is found in the letter that Bernardo Bitti's assistant, the Jesuit Pedro de Vargas, wrote to the general of the Society of Jesus in Rome dated January 18, 1585. In it, he explained how he and Bitti had made the *retablo* for the Jesuit church in Cuzco a few years earlier, and how they worked in sculpture because "*Fue necesario hacernos más que pintores*" (it was necessary to become more than just painters), implying an absence of skilled craftsmen in this art.[27] Travelling in the Viceroyalty of Peru in the early seventeenth century, friar Diego de Ocaña offers similar arguments in his diary-account. Complaining of the lack of prints to cultivate a devotional following, he felt compelled to make his own images of the Virgin of Guadalupe in Sucre and Potosí.[28] Even if the authors of some of these texts (especially Ocaña) may have exaggerated the local situation in order to aggrandize their own achievements, collectively these documents suggest that it was not easy to come upon skilled and reliable artists in the Andean highlands.

Another means to reconstruct the artistic scene at the time that Tito Yupanqui embarked on his project is by taking stock of the building history of churches in Andean towns. The resettlement policy aggressively pursued by viceroy Francisco de Toledo in the 1570s had important consequences in terms of urban development, and towns in the Andean highlands grew significantly in the following decade.[29] Those on commercial routes or with newly acquired civil and religious institutional responsibilities emerged as regional centers. New *doctrinas*—networks of mission churches—were also founded, and more church buildings became necessary.

Chuquisaca was one such expanding city. It was the capital of the *Audiencia* and became the see of a bishopric in 1552. In 1605, it was elevated to the rank of archbishopric as a result of the growth in the area. Of the cities that Tito Yupanqui visited, it is the one that best conserves sixteenth-century monuments. One of its earliest churches, San Lázaro, was built around 1544. However, most other church buildings were in developing stages in the late 1570s and early 1580s.[30] San Francisco was being built between 1577 and 1618; La Merced was begun in 1578; around that time, construction of the church of Santo Domingo was progressing slowly, and a new contract in 1585 was necessary to reinvigorate the project; San Agustín was not begun until 1590.[31]

Potosí, where Tito Yupanqui went to train as a European-style sculptor, was the wealthiest city in the region, and much more developed in the 1550s and 1560s than Chuquisaca. However, its urban planning was markedly chaotic until Viceroy Toledo's reorganization policies of the 1570s. By 1572, it had seven parish churches for Indians with six more under construction. Most of the major churches of the religious orders were just beginning to be built around 1580: the church of Santo Domingo was started in 1581 and finished in 1606; it is assumed that La Merced was built between 1570 and 1620; and the Jesuit church was begun in 1581 and finished in 1590.[32]

La Paz, where Tito Yupanqui arrived in search of a gilder to help him finish his image, was in a state of fervent building activity around 1590. Because of its location, on the road between Cuzco and Potosí, it evolved into an important commercial center, becoming the see of a new bishopric in 1607. Its first and for a long time most important church was

San Francisco, finished in 1550. The main secular church (later the cathedral) was begun in 1556, and a good portion seems to have been finished by 1584. However, in what seems to have been a recurrent pattern in these smaller towns, many churches were not begun until later: San Agustín was started in 1598; Santo Domingo was finished in 1609; and the Jesuit church was not built until 1608 even though the first Jesuits had arrived in 1582. The Mercedarians had an old church that can be dated at least as far back as 1556, but by 1617 a new building had replaced it.[33] In sum, throughout the area building activity increased significantly towards the 1580s and especially in the 1590s, but not earlier.[34] Plans for church furnishing and decoration would logically follow, mostly from the 1590s onward.

Although little survives in the way of altarpieces for the period before 1580, fortuitously two of the earliest surviving *retablos* in Bolivia date to the time right around when Tito Yupanqui created his image. One of these, dated by contract to 1583, was the one that the Hernández Galván brothers, Gómez and Andrés, completed for the Mercedarian church of Chuquisaca, mentioned above (Fig. 6).[35] Gómez is credited with some of the most important commissions in the viceroyalty in the 1580s and 1590s. In 1580, he was paid for the completion of the high altar in the Cathedral of Lima. Earlier, in 1573, he had been working in Chuquisaca. Fitting into the pattern of a predominantly itinerant career, Gómez settled in Potosí in the early seventeenth century.[36] In Chuquisaca, only the bottom two sections of the *retablo* survive (Fig. 7), and they show a preference for figures in low relief rather than modelled fully in the round. In this and their overall heavy treatment of form, they are similar to the low relief of the *Adoration of the Shepherds* from the Cathedral of Lima (Fig. 5).

Mesa and Gisbert believe that one of the other earliest surviving *retablos* (Fig. 8), housed in the church of Ancoraimes, a small locality on the eastern shores of Lake Titicaca, is by the Hernández Galván brothers as well.[37] However, because there is a clear difference in the stylistic treatment of the

figures, they distinguish between the two brothers, suggesting that here Gómez was the designer of the altarpiece and possibly also the sculptor, while in Chuquisaca his brother Andrés, who never displayed a mannerist figural vocabulary, would have produced the sculptures. Leaving aside the issue of attribution, Mesa and Gisbert see an obvious contrast between the two altarpieces in terms not just of style but also of quality. They consider the Ancoraimes altarpiece as the first *retablo* in this area that warrants consideration as "art."[38] Although heavily repainted and probably by more than one hand, many of the relief figures display a deliberate manipulation of form in the elongation of their limbs, suggesting mannerist models and even aesthetic intention (Fig. 9).

Mesa and Gisbert have also proposed that this altarpiece was originally made for the Franciscan church in Chuquiabo (La Paz) and that it was the one that the gilder Vargas was working on when Tito Yupanqui came to see him there in 1582.[39] The implication is that this was the altarpiece that Vargas and Tito Yupanqui collaborated on. We know from the chronicler Ramos Gavilán that they had come to an agreement by which Tito Yupanqui would help Vargas work on a *retablo* by day while at night they would tend to the image of the Virgin. While this hypothesis is appealing, there is no documentary proof for it, although it does seem likely that the Ancoraimes altarpiece was of some importance and originally belonged to a Franciscan church, because it includes various Franciscan saints. Even if one agrees with Mesa and Gisbert's hypothesis, comparing Tito Yupanqui's image with the relief figures in Ancoraimes reveals that there is no formal artistic relationship here. If Tito Yupanqui knew the Ancoraimes altarpiece, it did not influence his own completion of the Copacabana image (Fig. 1). The Virgin of Copacabana's garments fall in rigid, narrow parallel folds, and there is little sense for the anatomy of the figure. Instead of using drapery to echo or accentuate the Virgin's timid contraposto triggered by the slightly protruding knee, the verticality of the folds completely mask it. Exactly the

opposite occurs with the treatment of the figures and their clothing in Ancoraimes. Even though the artist has opted for deliberate elongation, these figures are modelled more naturalistically, and they distinctly and accurately outline the bodies of the figures below (Fig. 10). Furthermore, in contrast to Copacabana's frontality, these figures strike profile and twisted poses. Some of them have terribly exaggerated extremities, making Tito Yupanqui's image seem stocky and contained by comparison.

The contrast between the reliefs in these two contemporary altarpieces (Chuquisaca and Ancoraimes) and Tito Yupanqui's Virgin of Copacabana suggests that different styles coexisted in the region around the time he was finishing his image. The altarpiece in La Merced in Chuquisaca was more traditional: the figures are more fully rounded and wider; the folds of the garments are not treated as thinly as in the Virgin of Copacabana while some of the capes are given undulating forms to activate the figures and suggest movement, something which is entirely absent in the hieratic presentation of the Virgin. The *retablo* at Ancoraimes suggests newer developments especially when compared to the Chuquisaca

Figs. 6–7. Gómez and Andrés Hernández Galván, Altarpiece, c. 1583, La Merced, Sucre. Photo: courtesy of Hiroshige Okada.

retablo. Here, a new kind of relationship between figure and frame emerges with the saints bursting out of their niches, especially on the top and bottom edges. And, as noted above, the drapery clings to the anatomy of the figures and does not have a life of its own as in the other two examples.[40] In conclusion, Tito Yupanqui's sculpture relates neither to the Ancoraimes *retablo*, nor to the one in Chuquisaca.

Overall, the surviving record of both free-standing sculpture and sculptural reliefs for the period before 1583 is sparse enough that it may never be possible to write a convincing stylistic history that interrelates these objects in a neat and meaningful way. Rather, their stylistic incongruence begs other ways of thinking about them. One such alternative approach turns to the documentary history reviewed earlier in this essay; it facilitates a vivid picture of the difficulties and realities of image production at this time in the Andes. Another entirely rethinks what kind of historical narrative these works can shed light on.

The history of Andean colonial sculpture has largely been mapped out by José de Mesa and Teresa Gisbert in their still unsurpassed 1972 monograph. Earlier, in 1949, Harold Wethey had published an equally pioneering monograph on sculpture and architecture in Peru.[41] Since then, all art historians have been aware of how precarious the artistic scene was before the end of the sixteenth century in many of these localities.[42] Mesa and Gisbert refer to the time before the 1580s as "disorganized" and rather chaotic, a characterization that sums up the challenges of the period.

Nonetheless, these scholars had some long-standing tools to help them organize the available material in ways that would make it comprehensible. Wethey divided the sculptural section of his book—much shorter than the one dedicated to architecture—by types of works: choir stalls, pulpits, and *retablos*, dealing only marginally with figure sculpture. Gisbert and Mesa applied a chronological framework. And both used overarching stylistic period categories. Given the years in which their books were written, it is completely understandable that they were deeply interested in and dependent on a stylistic framework. The works that we have been dealing with were clustered in two periods: objects

Figs. 8–10. (*opposite and above*) Attributed to Gómez Hernández Galván, Altarpiece, c. 1582–1583, Church of Ancoraimes. Photo: courtesy of Hiroshige Okada.

from before 1580, the dark period about which so little is known; and works from about 1580 to 1620 or 1630, characterized as a mix of late Renaissance and Mannerism.[43] While the overall implications of these schemas are useful, broad stylistic periodization does not necessarily help us understand the complexities of artistic practice and development in all *places* at the given time. Furthermore, these period categories do not always fit the heterogeneous corpus of surviving works. In revisiting the chronology, I am concerned with how to conceive of the passing of time around the pivotal years of the 1580s—not so much with the sum of the years between 1580 and 1620–1630 as with how time passed within them.

George Kubler's characterization of different kinds of duration in *The Shape of Time* (1962) illuminates the artistic process that Tito Yupanqui underwent. Kubler was concerned with structuring how we think of groups of images. He proposed various ways of classing objects around precise usages and principles of time that were nonnumerical. He sought to apply the "language of measurement without numbers, as in typology, where relationships rather than magnitudes are the subject of study."[44] He wrote about "linked solutions" and "sequence classing" as alternatives to the traditional art historical methods of periodization, artists' biographies, and even iconographic analysis. Ultimately his dissatisfaction with contemporary art historical methods led him to propose a more dynamic approach to "the history of things," the subtitle of his book. In terms of his challenge to traditional periodization, he writes:

> Establishing chronological order is not enough, for absolute chronology merely arranges the moments of time in their own sidereal succession. The perpetual problem confronting the historian has always been to find the beginning and the end of the threads of happening.[45]

Elsewhere, he adds,

The difficulty with delimiting the categories of time has always been to find a suitable description of duration, which would vary according to events while measuring them against a fixed scale.[46]

One of the ways in which Kubler suggested approximating durations more efficiently was through the dichotomy of fast and slow happening. Ultimately, Kubler was concerned with innovation, with identifying the conditions that favored original inventions. While this specific question is not central to this study of the Virgin of Copacabana, Kubler's distinction between slow and fast happening is helpful in reconceptualizing the overall artistic climate presented in the first half of this essay. Art did not develop at the same rate everywhere, and less is known about developments in the nonfast, noncentral areas, such as the Andes. The period in which Tito Yupanqui made his first image was one of slow development. Shortly after, the pace of artistic production in this region accelerated significantly, with repercussions to which I come back at the end of the essay.

Situating Tito Yupanqui's Virgin of Copacabana at the beginning of this transitional period also sheds light on the creation narrative of the image that has come down to us in two versions: in Ramos Gavilán's chronicle and in Tito Yupanqui's autobiographical statement, included in Ramos Gavilán's book. I want to read these texts against the background of artistic practice in the Andean highlands, with Kubler's ideas about slow and fast time in mind. What can the miraculous origin accounts of the cult tell us about society and artistic practice in the early colonial period?

Omission and Elaboration: Tito Yupanqui versus Ramos Gavilán

The autobiography by Tito Yupanqui included in Ramos Gavilán's chronicle was supposedly given to him by Tito Yupanqui's brother after he died in 1608.[47] Although there is no proof of its authenticity, it is different enough from Ramos Gavilán's own account to suggest that it is in some way original.[48]

Ramos Gavilán was writing in Lima in the second decade of the seventeenth century, and his purpose was to consolidate the fame and legitimacy of this relatively new devotion, which had come under the ministry of his religious order, the Augustinians, in 1589. In addition, he was using it as proof of successful extirpation of idolatry, one of the most controversial issues at the time.[49] In fact, the first section of his book describes the pre-Hispanic cults that dominated the region around Lake Titicaca and the way in which this famously idolatrous area was prepared to receive the Christian faith in part through the earlier presence of one of Christ's disciples in nearby Carabuco (see below, note 65).[50] By contrast, Tito Yupanqui's brief text provides glimpses into a personal experience of artistic production; it is much more direct and even believable than Ramos Gavilán's official narrative, which both omits material from and adds material to Tito Yupanqui's account.

One of Ramos Gavilán's omissions is about the first image that Tito Yupanqui made of the Virgin. In the very first sentence of his account, Tito Yupanqui states that he made an image of the Virgin and that it stayed in the local church of Copacabana—then a secular church—for almost a year and a half before a new parish priest rejected it, thus leading to his decision to train with an official master:

> *El primer vez que lo impesabamos, don Felipe de Lion me hirmano con mego, on echora del Vergen di barro, di on bara di grande, in tempo di on patre quelrrigo, llamado Antonio di Almeda, que mi lo dexo poneldo in altar, in dondi lo estava mas que su año con medio, y despues vino otro padre...*[51]

Ramos Gavilán makes no mention of this ill-fated first image. It is the normalcy with which this fact is presented by Tito Yupanqui that is most revealing. Tito Yupanqui was not acting in any unusual way by taking the initiative to provide a religious image for his church; it is likely that others in the region had done the same.[52] In light of the artistic panorama presented earlier in this essay,

this would not be surprising. The church needed an image, Spanish artists were not easily available nor were imported European images easy to come by and affordable, the local community wanted to get involved, and a local artist, nonprofessional but somewhat experienced, made one.[53] The dynamics of artistic production were soon going to change, but for now, Indians made images, often using simple techniques and the locally available materials.

So what changed in 1582? And why was Tito Yupanqui forced to remove his image by the newly arriving priest, Antonio de Montoro? Did Montoro dislike the original image because he had more sophisticated taste? Or had he received some instructions as to the mounting importance of decorum in sacred images? As other scholars have noted, the emergence of the cult of the Virgin of Copacabana coincides with some major changes in the Peruvian church.[54] The new archbishop of Peru, Toribio Alfonso de Mogrovejo, arrived in Lima in 1581, and he would leave his mark on his archdiocese in profound ways. Infused with a reformative spirit, he immediately organized the first synod ever celebrated in his diocese.[55] More importantly, in August 1582, Mogrovejo inaugurated the Third Provincial Council of Lima, which lasted until October 1583.[56] Part of the council's mission was to deal with the local religious situation and the rising concern with idolatrous practice in various areas of the viceroyalty, but it was also meant to implement the reforms published in the decrees of the Council of Trent as well as those of the Second Council of Lima, celebrated in 1567–1568.[57] As is well known, the impact of Trent in Counter-Reformation Spain and its viceroyalties increased ecclesiastical control over the production of religious images.[58] Though the Decrees of the Council of Trent were cursory on the types of images that the church preferred, church decrees published by provincial councils and synods tended to be more detailed and pragmatic on all issues, including images.[59] One of the results of the Third Provincial Council was the publication of a summary of decrees from the Second Council. Decree 53 specified

que los ovispos vissiten las ymagenes y las que
hallaren mal hechas e indecentes o las aderecen o
quiten del todo y la imagen de nuestra señora o de
otra qualquiera santa no se adorne con bestidos
y trages de mugeres, ni le pongan afeites o colores
de que usan mugeres, podra empero ponerse algun
manto rrico que tenga consigo la imagen.[60]

It is at the local level, then, that we can find examples of Mogrovejo's concern with decorum in church decoration. Correspondence related to his numerous *visitas* of the diocese reveals the dire and indecent conditions of many churches, especially those of the indigenous population. At the same time, he wanted to curb the rapidly increasing number of indigenous confraternities in any one community because they were often a financial drain on the population.[61] Yet, while guarded on the issue, he supported new local devotions and miracles that signalled the potential to Christianize this territory.[62]

While more archival research needs to be undertaken to determine the personality and role of the churchmen directly involved in the emergence of the cult of the Virgin of Copacabana, it seems that in this region, the new policies that were being promoted by the highest ecclesiastical authority in Lima trickled down to the local level. The new priest at Copacabana, Montoro, was assigned to this post by the bishop of Chuquisaca, Alonso Graneros de Avalos (Dávalos in some documents), who had taken charge of his office in 1581 after arriving from Mexico, where he had worked as *fiscal* for the Inquisition. Graneros de Avalos attended the Third Provincial Council although he arrived rather late and after Tito Yupanqui's image was enshrined in Copacabana.[63] Tito Yupanqui met him sometime after June 1582 (the date he supposedly began working on his image) to petition to become an official artist of religious works. But, as detailed in the introduction, the bishop and his coterie mocked him cruelly, telling him to leave such tasks to Spaniards. In that same audience, Graneros de Avalos—notorious for his hard and strict governance—also rejected the petition from

Tito Yupanqui's relatives to found the confraternity to the Virgin. In this, the bishop was following the archbishop's policy of limiting indigenous confraternities. With respect to the image itself, various factors probably played a role in Graneros de Avalos's rejection. The derogatory comments recorded by both Ramos Gavilán and Tito Yupanqui about the encounter suggest that some degree of ethnic prejudice certainly interfered insofar as he did not believe Indians could be as good artists as Spaniards. At the same time, however, it is likely that the bishop felt that he was being true to his responsibility to ensure the decorum of religious images, and that this image did not meet the new standards then being reinforced by contemporaneous ecclesiastical measures. Either way, it is important to note that Montoro and Graneros de Avalos came into their respective offices at the same time as Mogrovejo, and that all of them seemed to have had firm new ideas about religious practice and the role of confraternities and their images in indigenous churches.

The 1580s thus heralded a time of change not just in the capital of the viceroyalty but at the local level in a number of areas, including artistic production: new artists were arriving,[64] and the pace of artistic production was accelerating; cult images were beginning to emerge locally and find support from certain church sectors; but these processes were also coming under greater scrutiny from colonial authority than ever before. Indeed, the Virgin of Copacabana's story is one of the clearest Latin American examples of how the Counter-Reformation Church in Spanish America promoted the use of images—that is, Europeanized images—and their potential to perform miracles, in order to spread the Catholic faith. At the same time, the history of this gestation is also representative of the way in which greater ecclesiastical control came to play a role in the development of colonial religious art. It is against this backdrop of renewed church reform and control that we should contextualize the rejection of Tito Yupanqui's first image by Montoro as well as the priest's role in encouraging Tito Yupanqui to become a more

professionalized, regulated, and Europeanized artist.

Another way in which Tito Yupanqui's autobiography offers a window onto artistic practice is with respect to materials and technique. He reports that the first image, discussed above, was made of clay and was of a modest scale, about 83 centimeters ("*una vara*"). When he trained as an apprentice in Potosí with Diego Ortíz, Tito Yupanqui explains, that he worked his image first in molds and then in "*lienzo.*" The latter suggests the technique of modelling a dressed sculpture by using plastered cloth laid over a solid stabilizing core and then polychroming it.[65] Working in these alternative methods rather than sculpting from wood was common at this time in many parts of the viceroyalty, especially in areas where wood was scarce, and the techniques have both Spanish and Andean roots. The use of thin trunks of local maguey plants bundled together, following a pre-Hispanic tradition, to form the core of such mixed-media sculptures has been extensively studied.[66] By contrast, while known, the use of molds and plastered cloth for the serial manufacture of religious images by European artists in both Spanish America and Europe has been less explored as a context for the technique Tito Yupanqui describes. Felipe Pereda has recently discussed the remarkable commission from Queen Isabella to a Flemish artisan, Huberto Alemán, to produce dozens of images using molds, mostly of the Virgin and Child, to distribute for Christianizing purposes in and around Granada. Alemán proposed to use a technique that was novel in Spain but that he had practiced in the Low Countries with considerable success; it employed molds, vegetable fibers, and paste.[67] Rafael Ramos Sosa has also called attention to an interesting document about a certain Cristóbal Gómez de Sarabia who arrived in Seville from Lima in 1574.[68] He was planning on returning to Peru, but first he wished to learn a particular sculpting technique. To that end, he set up an apprenticeship contract in Seville with a local master named Francisco Ramos for three months. In that time, Gómez de Sarabia was to be taught how to be a "*pintor de imaginería e impresor de ellas*" (a painter of images and molder of them), namely he was going to learn how to make images in relief and also in the round using molds, gesso, and some kind of paste, a combination of materials that is similar to Alemán's technique. The experienced artisan guaranteed Gómez de Sarabia that he would learn everything he needed to know in this short time, roughly equivalent to the duration of Tito Yupanqui's apprenticeship in Potosí. He also promised to give Gómez de Sarabia a full set of sample molds to get him started. We know of several other Spanish artisans who were using this technique in Spain during the 1570s and 1580s as well.[69] Could it be then that when Tito Yupanqui notes his use of molds, he was referring to a similar technique? His reference to the use of some kind of cloth or *lienzo* in the second phase of production is also reminiscent of the commission documents of December 22, 1573 whereby the same Diego Ortíz, with whom Tito Yupanqui trained in Potosí, asks for a large piece of *lienzo* (cloth or canvas) to make a Crucified Christ.[70] In sum, these sources suggest that there is still a lot to investigate regarding the evolution of the sculpting technique that Tito Yupanqui briefly describes and that in all likelihood was part of the norm of artistic practice in this region around the time he made his image.

There is one final aspect of Tito Yupanqui's account that warrants greater scrutiny for the history of colonial art, and that is the way in which he presents his interaction with other artists, especially Spaniards, and ecclesiastical and civil authorities. Unlike Ramos Gavilán, he does not always use ethnic identifiers—naming everyone as either Indian or Spanish. For example, saying that he went to Chuquiabo (La Paz) looking for a gilder to help him finish the image, Tito Yupanqui identifies the gilder by name: "Vargas." By contrast, Ramos Gavilán has no interest in naming the gilder and simply notes that he was a "Spaniard."[71] On the other hand, Ramos Gavilán elaborates extensively on the collaboration that developed between our Indian sculptor and the Spanish gilder. He writes that when Tito Yupanqui

arrived in Chuquiabo, he was shattered to discover that his image had once again inexplicably become spoiled. The gilder was so profoundly affected by Tito Yupanqui's religious fervor that he encouraged him to fix it, promising to help him gild it.[72] In this way, Ramos Gavilán dramatizes the power of the image, and the Virgin herself, to enlist early followers, including Spaniards, and even suggests that the creation was a collaborative effort between an Indian and a Spaniard in the final phase, thereby adding credibility to the origin story, from an official standpoint.

Another episode that Ramos Gavilán embellished significantly involves the time Tito Yupanqui and his companions stopped in Hayohayo on their way to La Paz from Potosí. It was night, and they sat to rest with the bundled image on the steps of the Town Hall. According to Tito Yupanqui, the *corregidor* thought it was a corpse and told them to remove it. The Indians tried to explain that it was a religious image but were not understood until one of them, who spoke Spanish, clarified. Ramos Gavilán adds that when the *corregidor* discovered that it was a religious image, he knelt before it, ordered light to be brought, and then spent the entire night in adoration of the Virgin.[73] Within the narrative scheme of Ramos Gavilán's book, the *corregidor*, undoubtedly a Spaniard or Creole, legitimates the cult, for he is the first person to recognize the image as a viable sacred object.

Finally, there is a third moment in Ramos Gavilán's text where the intervention of a Spaniard is introduced as a legitimating element. This is when Tito Yupanqui deposits his image with the Franciscan monk, Francisco Navarrete, while he travels on to convince a sector of the inhabitants in Copacabana, the Urinsayas, to accept the Virgin for their church. Tito Yupanqui says that he left the image in Chuquiabo before returning for it, and nothing else. Ramos Gavilán tells us that during Tito Yupanqui's absence the Franciscan friar noticed that the image emitted rays of light and communicated this to Tito Yupanqui and his companions.[74] This then should be considered the first miracle of the image, or at least the first public recognition that it was mi-

raculous. Before, strange things had happened to it, and divine intervention had certainly been at work, but these were private experiences lived by Tito Yupanqui alone as part of a higher test of his faith.

Just as there are episodes from Tito Yupanqui's autobiographical account that Ramos Gavilán embellishes, there are others he simply ignores. Besides the production of a first image, mentioned earlier, he fails to comment on the time that Tito Yupanqui went to a group of painters in Potosí to ask for their opinion on his finished image. According to Tito Yupanqui's description of this encounter, some of them responded favorably while others did not:

> *E yo lo lleve en casa de los pentores, para saber que me lo dizen los pentores, y lo ego [luego] me lo dexeron los pentores que esta mexorado, e que era mal hecho y otros lo dexeron que era bien hecho....*[75]

As is typical of Tito Yupanqui, he does not identify those artists as Spaniards or Indians. Nonetheless, they probably were Spaniards or Creoles or, at the very least, members of a professionalized body that he considered authoritative.

The fact that these painters were divided in their opinions—and that their ethnic identity remains unclear—complicates the tendency to characterize the creation story of Copacabana as one of indigenous triumph over Spanish opposition and prejudice, and even to see Spanish-Indian relations in the early colonial period as exclusively antagonistic. As Kenneth Mills has recently argued, in the last quarter of the sixteenth century certain church sectors in Spanish America favored "joint creation" or Spanish-Indian collaboration, rather than an ethnically divisive polarization of Spaniards and Indians.[76] Ramos Gavilán embraced this theme in one of the chapter headings of his book that stressed the unity of colonial society: "*Como la Virgen de Copacabana, recogio debajo de su protección, y amparo a toda la gente del Perú.*" (How the Virgin of Copacabana gathered under her protection and favour all the people of

Peru.)[77] That a new colonial order was emerging is further substantiated by the decrees of the Third Provincial Council. The previous two Councils published separate sets of decrees for Spaniards and Indians. The Third Provincial Council abandoned this division and legislated for one church.[78] Thus, although we can find dramatic moments of Spanish rejection and even humiliation of Tito Yupanqui, a close reading of both Tito Yupanqui's text and Ramos Gavilán's chronicle offers a more nuanced and balanced view supporting Mills's thesis. As we have seen, Ramos Gavilán, especially, goes to great lengths to introduce Spaniards who supported Tito Yupanqui in his endeavor: the gilder, the Franciscan friar, and the *corregidor* of Hayohayo. If Ramos Gavilán did not include the episode in which Tito Yupanqui meets with a mixed group of painters of diverse opinion, it was probably because it seemed too ambivalent to seem useful to his construct of discourse.

There is another way in which the meeting of the painters with Tito Yupanqui is significant, and that is as a window onto artistic practice. What were these painters doing gathered together? Where was this "*casa de los pentores*" (house of painters) he describes, and what exactly was it? Although there was no official guild for either painters or sculptors in Potosí at this time, this does not mean that artists were not organized on a corporate level.[79] Tito Yupanqui's description suggests an incipient sense of professional affiliation that was in all likelihood beginning to exert pressure on competitive nonofficial artistic production, such as that undertaken by Indians working freely or under the supervision of a religious figure. Indeed, a parallel process of professionalization had taken place in New Spain slightly earlier,[80] and was quite common in many Iberian Spanish cities throughout this period as well, where guilds, where they existed—and more informal corporate alliances where they did not—fought to keep unregulated competitors at bay.[81] These changing attitudes, and the way in which the highest religious and secular authorities embraced and supported the rise of professionalization, played

a role in forcing Tito Yupanqui and others like him to conform to a Spanish system of production.

To conclude, the differences between the two texts—the autobiography and the chronicle—lie in the fact that Tito Yupanqui's words give the impression of being more spontaneous: he meets a gilder, they work together, he travels back home, he stops and is met with some opposition, he then leaves his image temporarily in a convent church to deal with other matters. His account is about problems that needed to be solved and eventually were. Ramos Gavilán's text, on the other hand, is highly self-conscious about how it presents both its Indian star and the Spaniards who interacted with him. His treatment of the story reveals how ideas of ethnicity and power in the colonial world were manipulated in order to redefine official colonial discourse in a crucial period that would determine the direction and shape of the viceroyalty for some time to come.[82] For this reason, Ramos Gavilán's account revolves around broader categories: the Spaniards, the Indians, idolatry, the image, and divine intervention. By contrast, if we decide to give credence to the authenticity of the autobiography of Tito Yupanqui, the larger questions of how colonial society should be constructed, projected, or "read" in a chronicle appear irrelevant to him.

Multiple Beginnings

It is at this point, in the inevitable way in which art history and religious history converge upon the Virgin of Copacabana, that the usage of "beginnings" in the title of this essay takes on a new meaning. Drawing on the primary sources (the texts by Ramos Gavilán and Tito Yupanqui) inevitably inscribes the object—the sculpture of the Virgin of Copacabana—in its devotional history, revealing that the art historical story explored here is also about other beginnings: namely, the rise of local cults to miraculous images, a phenomenon that was just taking off in Spanish America in the 1580s. This was a period of gestation for the devotions that would increasingly resonate with Creole aspirations in the

seventeenth and eighteenth centuries, and then with protonationalistic and nationalistic ones in the nineteenth and twentieth centuries: the Virgin of Chiquinquirá in Santa Fe de Bogotá and the Virgin of Guadalupe in Mexico City, to name but two of the other best-known examples. Leaving aside the origins of these cults and the beginnings of what is sometimes called a Spanish American church, in this essay I have focused on how the material creation story of the Virgin of Copacabana intersects with our understanding of the development of artistic practice in this part of the Andes. However, ultimately, the reason Tito Yupanqui is such a crucial figure in this period is because his dual experience, as an Indian and as an artist, embodies two contemporary processes: the emergence of new devotions in which indigenous agency plays a role, and the incorporation of the Indians into a Europeanized system of artistic production. His story offers at least two paths of inquiry. One is the path that leads to a history of a religious cult, about which a fair amount is known; the other delves into the artistic history of the early colonial period. Paradoxically, these paths can be only partially separated because the role of artists in relation to cult images was in itself a literary topos that had become codified through a growing body of hagiographic literature throughout the Christian world. In these texts the autonomy of the artist was always sacrificed in favor of divine intervention in the production of a miraculous image.[83] The artist of a miracle-working image had to be a good Christian and demonstrate his religious fervor. His work became satisfactory only when divine intervention willed it to be so, and he was worthy of such a gift because of his dedication and piety. Tito Yupanqui's experience is subsumed into this tradition.

Nevertheless, Tito Yupanqui's account resists submitting to its genre. In its frank and direct tone, in the ways it does not conform to colonial discourse (as configured by Ramos Gavilán, for example) but at the same time, does not contradict it either, this singular text invites probing questions about what this Andean region was

like both before he made his image and after.

For example, did Tito Yupanqui's story, including the fact that his sculpture became a miraculous image, influence other Indian artists of religious images in the region? Did it contribute to changing the status of the indigenous artist in the colonial Andes, or was it only part of a local religious phenomenon? In Kubler's terms, did Tito Yupanqui contribute to the acceleration of artistic production by the late 1580s in this region? These are not entirely new questions. One of the chapters in Mesa and Gisbert's monograph on Bolivian sculpture is titled "*Tito Yupanqui y los escultores indios.*" The names they provide have since become signposts for mapping the rise of indigenous craftsmen and artisans in the Andean highlands. Copacabana became not only a devotional pilgrimage site but also an artistic center where a workshop run by Indians—at first a family business for Tito Yupanqui and his relatives—distributed copies of the Virgin of Copacabana throughout the viceroyalty and beyond.[84]

The prestige of Tito Yupanqui's original image was indeed infectious, and some of these copies went on to enjoy a strong devotional following of their own. The Virgin of Cocharcas is a well-known example.[85] Replicas made by other Indians became miraculous in their own right as well. The Virgin of Characato was a copy of the Copacabana image made by an Indian that at first met with opposition because it was considered too vulgar; however, it soon began to prove otherwise by working miracles (Fig. 11).[86] At the end of the sixteenth century, more and more miraculous origin stories for local devotions in the Andes involved the figure of an indigenous artist, suggesting that a new topos was being created. The message of these scripted accounts was that even those considered low on the colonial social ladder, the Indians, could by their faith and rejection of idolatry and through God's compassion and intervention become good Christians and, as such, make religious images. Nonetheless, in these legends, the native artist of miracle-working images was only possible through divine intervention. In

Fig. 11. Cipriano de Toledo y Gutiérrez, *Virgin of Characato*, signed 1771, oil on canvas, 35 x 27 inches (88.9 x 68.7 cm). Collection of Marilynn and Carl Thoma.

Fig. 12. Pedro Francisco Ynchavachin (*ensamblador*), Altarpiece of Saint Francis, 1614, San Jerónimo de Tunan, Jauja. Photo: courtesy of Rafael Ramos Sosa.

Fig. 13. Detail of inscription on the lower right part of the *retablo* of Saint Francis inscribed with the name of the native *ensamblador*, Pedro Francisco Ynchavachin, and dated January 30, 1614. San Jerónimo de Tunan, Jauja. Photo: courtesy of Rafael Ramos Sosa.

other words, official religious discourse about these cult images did not recognize the artistry of the Indian; in fact, it was often assumed that if the artist was an Indian, the image would be rougher, as in the Characato narrative. This theme even appears in later accounts of Tito Yupanqui's own experience. The 1663 chronicle of the Virgin of Copacabana by friar Gabriel de León states in no uncertain terms, "*pues, como se vera, formo Dios, Artífice Divino, con su mano y buril, lo que al Indio le falto en el arte.*" (for, as it will be seen, God, Divine Artifice, shaped with his hand and burin what the Indian lacked in art.)[87] In part, this paradoxical denial of the Indian as an autonomous artist but not of the Indian as good Christian was the necessary adjustment that Europe's hagiographic tradition made in the Latin American colonial context. In the localization of Spanish American cults, artists were subsumed and effaced by the introduction of divine intervention in the origin narratives of their images, just as in the European tradition of miracle-working images. Yet these new cult myths needed the Indian to appear in some capacity, since his agency signified a locally specific Spanish American church.

Significantly, Indians seem to figure as artists of miraculous images more often in the Andes than in New Spain.[88] In the latter, Indians typically played other intermediary roles in creation stories, very often as privileged witnesses of apparitions or miracles performed by an image. This disparity has both religious and artistic explanations. Considering the obstacles that Christianization encountered in many parts of the Andes, and the grave concern over continuing idolatry at the end of the sixteenth century, grounding direct involvement by good Christianized Indians in the emergence of cults was the most dramatic and effective means of insisting on the possibility of sacralizing the territory. However, this does not explain why indigenous participation appeared specifically in the form of artistic authorship. It may well be that the prominence of indigenous artists in the histories of some of the Andean cult images corresponded to their increasing role in artistic production. In New Spain, the situa-

tion of the indigenous painter or sculptor was to be quite different. After enjoying a period of splendor under the tutelage of the mendicant orders in the first decades after the conquest, the participation and prominence of the indigenous artist declined. By the 1560s, professional Hispanic and Hispanicized artists were rapidly organizing themselves through the establishment of guilds, effectively challenging the earlier models of operation. Within a few decades, artistic production became highly centralized, with works distributed from Mexico City to the entire viceroyalty. This, of course, does not mean that there were no indigenous artists in New Spain—there were many—but they were operating in a professionalized and Hispanicized mode of production dominated by the Spaniards. These changes came slightly later to the Viceroyalty of Peru, and they were more notable in the larger cities whereas in the smaller communities, the impression is that indigenous artists continued to play an important role. In other words, it may be that the Andean topos of the indigenous artist crafting a miracle-working cult image within the accepted parameters of Counter-Reformation decorum, is in part a reflection of a very real process taking place in Andean colonial society: the gradual emergence and acceptance by the local communities of the indigenous artist.[89]

The role of the Indians in artistic production in Spanish America involves a complicated history of social and colonialist relations that extends beyond the scope of this essay. In the case of miracle-working images, the situation of the native artist is partly masked by colonial texts with their own particular agenda and literary tradition. However, it is safe to say that both within cult image production—perhaps even because of the power of these objects—and outside it, indigenous artists became more "visible" in the Andes in the seventeenth century. An extensive paper trail of contracts has long attested to their overwhelming importance in the construction and decoration of Andean churches, but it is in the early seventeenth century that a clearer sense of their role in local communities begins to emerge.[90]

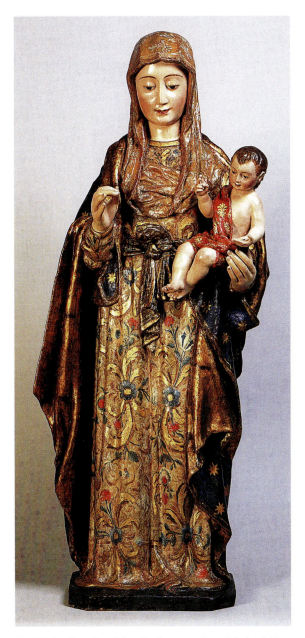

Fig. 14. Attributed to Sebastián Acostopa Inca, *Virgin of Copacabana*, c. 1617, maguey and polychromed cloth, 100 x 47 x 25 cm. Convento Madre de Dios, Seville.

A sense of pride, status, and distinct identity, for example, is found in the bold and large inscriptions found on the predellas of some altarpieces in small localities commemorating specific patrons and *ensambladores* (altarpiece-makers) (Figs.12 and 13).[91]

Notably, by the early seventeenth century, Tito Yupanqui's own status had changed. In his chronicle of the Augustinian order, Antonio de la Calancha notes that when Tito Yupanqui made his first image he was a mere "*Indio aprendiz*" (Indian apprentice), but that he made his later copies as a professional artist.[92] He was no longer the inexperienced aficionado, but a recognized professional who had gone through an apprenticeship. He was able to set up shop successfully in part because of that professionalization, and in part because his image had become miraculous. Perhaps the most famous Indian artist of this later period in the region is Sebastián Acostopa Inca. Considered Tito Yupanqui's disciple, he probably produced the image of the Virgin of Copacabana that is currently in a Sevillian convent (Fig. 14).[93] In 1618, he completed a new high altar in the church of Copacabana, today relocated to the presbytery.[94] His professional success stands in stark contrast to Tito Yupanqui's own dim beginnings forty years earlier, and might not have happened without that precedent. According to Mesa and Gisbert, besides Copacabana, Chuquisaca also became a flowering center for indigenous sculptural production. A primary figure there, the Indian sculptor Diego Quispe Huaillaisaca, appears on the scene in the early seventeenth century.[95]

The artistic scene of the early seventeenth century, the way artists circulated and interacted with each other professionally, the way they dealt with patrons, materials, sources, and models, was quite different than in Tito Yupanqui's own time. Throughout the seventeenth century, indigenous artists would continue to collaborate with their Spanish and Creole colleagues; they would also sometimes compete with them, and undoubtedly they often had to deal with the same ethnic and racial prejudices that had once discouraged Tito Yupanqui. But these new artists and artisans operated within a professionalized Hispanicized order of sculptural production that had not quite been in place when Tito Yupanqui thought nothing of placing his first image of the Virgin in the church of his hometown. The early seventeenth century was indeed a new time, and most likely we should consider that time itself had changed.

Notes

[1] The material covered in the second half of this essay was first presented in a paper titled "La implantación de las nuevas devociones marianas y sus narraciones. Nueva España y Perú como teatro de prodigios" in the *Curso de Verano de El Escorial* "Imágen e imaginarios virreinales. Los libros como recurso y discurso del arte. Nueva España-Perú 1550–1680," organized by Jaime Cuadriello (July 23–27, 2007). Further research for this essay was undertaken as part of the group research project *En las fronteras de las imágenes: consideraciones metodológicas y fuentes para el estudio de la imagen religiosa en el Antiguo Regimen*, HAR2008-04324, sponsored by the Spanish Ministry of Science and Innovation (MICINN). I would like to thank Daniel Gianoni, Hiroshige Okada, Rafael Ramos Sosa, Suzanne Stratton, and Marilynn Thoma for their generosity and assistance in gathering the photographic material included. I would also like to thank Donna Pierce for her insightful editorial comments.

[2] Alonso Ramos Gavilán, *Historia del Santuario de Nuestra Señora de Copacabana* [Lima 1621] (Lima: Ed. Ignacio Prado, 1988), 234–238. An English translation of Tito Yupanqui's account is available in *Colonial Latin America: A Documentary History*, ed. Kenneth Mills, William B. Taylor, and Sandra Lauderdale Graham (Wilmington, DE: SR Books, 2002), 167–172.

[3] Sabine MacCormack, "From the Sun of the Incas to the Virgin of Copacabana," *Representations* 8 (1984): 30–60.

[4] "…e melo respondió que no lo quiero dar el licencia para que los seays pentor, ne que lo hagyas las hechoras del Vergen, ni vultos y si lo quereys ser pentor pintaldo la mona con so mico [,,,,] que me lo dexeron no estava bien el Imagen, e que lo parece como hombre, y lo está con sus barbas que lo parece barbas, e lo hecharon molta falta que no es boena, e malo dexeron que no lo haga…" Ramos Gavilán, 1988, 236. The English translation: "I

do not want to grant you a license to be a painter, nor to be one who makes images of the Virgin, nor statues, and if you wish to be a painter then paint a monkey with its long tail, for I do not want to give you permission to paint [sacred things]. […] For they [others with whom he spoke in the bishop's company at Chuquisaca] told me that the image was not well made, and that it looked like a man with a beard or what appeared to be whiskers. They found much fault in it, much that was not good, and they told me I should not carry on making it." Mills, Taylor and Graham, 2002, 171.

5 Ramos Gavilán, 1988, 216–233.

6 Teresa Gisbert, *Iconografía y mitos indígenas en el arte* (La Paz: Gisbert S.A., 1980), 21–22 and 51–55.

7 Veronica Salles-Reese, *From Viracocha to the Virgin of Copacabana: Representation of the Sacred at Lake Titicaca* (Austin: University of Texas, 1997). For a more recent analysis of chronicles and the Virgin, see Vanessa K. Davidson, "Tito Yupanqui and the Creation of the Virgin of Copacabana: Instruments of Conversion at Lake Titicaca," in *Imagery, Spirituality, and Ideology in Iberia and Latin America*, ed. Martha Bustillo and Jeremy Roe (Nottingham, UK: Cambridge Scholars Publishing, 2010).

8 Pedro Calderón de la Barca, "La Aurora en Copacabana," in *Cuarta parte de comedias nuevas* (Madrid: Buendía, 1672). Among the numerous studies on the famous poem by Valverde on the Virgin of Copacabana, see Teresa Gisbert, *El paraíso de los pájaros parlantes. La imagen del otro en la cultura andina* (La Paz: Plural, 2001, 1st ed. 1999), 117–147; and José Antonio Mazzotti, "Fernando de Valverde y los monstruos andinos: criollismo místico en el peregrinaje a Copacabana," in *La formación de la cultura virreinal II. El siglo XVII*, eds. Karl Kohut and Sonia V. Rose (Frankfurt: Vervuert Iberoamericana, 2004).

9 The most comprehensive art historical analysis of Tito Yupanqui's Virgin of Copacabana is still José de Mesa and Teresa Gisbert, *Escultura Virreinal en Bolivia* (La Paz: Academia Nacional de Ciencias de Bolivia, Publicación no. 29, 1972), 74–87.

10 The classic study that first drew attention to hagiographic patterns in histories of miracle-working images in the Hispanic world is William A. Christian, Jr., *Apparitions in Late Medieval and Renaissance Spain* (Princeton: Princeton University Press, 1981); see also, by the same author, *Local Religion in Sixteenth-Century Spain* (Princeton: Princeton Uni-

versity Press, 1981). The literature on this tradition in colonial Latin America, and especially the way it was involved in the formation of colonial identities, has grown considerably in the last decade, and has also branched out to include the way in which pictorial representations of devotions constructed and supported these hagiographic traditions. Some of the major contributions include Carolyn Dean, "The Renewal of Old World Images and the Creation of Colonial Peruvian Visual Culture" in *Converging Cultures: Art and Identity in Spanish America*, ed. Diana Fane (New York: The Brooklyn Museum in association with Harry N. Abrams, Inc, 1996), 171–182; Juan Carlos Estenssoro Fuchs, *Del paganismo a la santidad: La incorporación de los indios del Perú al catolicismo, 1532–1750* (Lima: Instituto Francés de Estudios Andinos, Pontificia Universidad Católica del Perú, Instituto Riva-Agüero, 2003), 439–459; and Ramón Mújica Pinilla, *El Barroco Peruano II* (Lima: Banco de Crédito, 2003), especially 61–97 and 258–289; and for the Viceroyalty of New Spain, the ground-breaking work, Jaime Cuadriello, "Tierra de Prodigios. La ventura como destino" in *Los Pinceles de la historia. El origen del Reino de la Nueva España, 1680–1750*, 180–227 (México: Museo Nacional de Arte, 1999). For an analysis of how the Jesuits were intimately involved in this process at the end of the seventeenth century in Mexico, see Luisa Elena Alcalá, "The Jesuits and the Visual Arts in New Spain, 1670–1767," (Ann Arbor, Michigan: UMI Dissertation Services, 1998), chapters one and two..

11 On the importance of time in understanding the colonial world, see Tom Cummins, "The Madonna and the Horse: Becoming Colonial in New Spain and Peru," in *Native Artists and Patrons in Colonial Latin America. Phoebus* 7, ed. Emily Umberger and Tom Cummins, 1995, 55.

12 Mario Chacón Torres, *Arte virreinal en Potosí. Fuentes para su historia* (Seville: CSIC, 1973), 64. Another example of an itinerant artist who worked in Cuzco, Charcas, and Potosí in these early years is Juan Ponce, both painter and gilder. See José de Mesa and Teresa Gisbert, *Historia de la pintura cuzqueña* (Lima: Fundación Augusto N. Wiese, 1982), 1:54. For Spanish artists in Peru, see Jorge Bernales Ballesteros, "Arquitectos y escultores de las tierras del Duero en el Virreinato del Perú (siglos XVI y XVII)," in *Relaciones artísticas entre la Península Ibérica y América. Actas del V simposio*

Hispano-Portugués de Historia del Arte, ed. Juan José Martín González (Valladolid: Universidad de Valladolid, 1990), 33–39.

[13] Mesa and Gisbert, 1972, 41.

[14] Ibid, 43–46.

[15] For a discussion of the ideological and not just artistic reasons for the preference for Spanish images in the context of Andean sixteenth-century Christianization, see MacCormack, 1984, 50.

[16] After the reconquest of Granada in 1492, Queen Isabella personally oversaw the production and donation of religious images for local churches. Felipe Pereda, *Las imágenes de la discordia: política y poética de la imagen sagrada en la España del cuatrocientos* (Madrid: Marcial Pons, 2008), 292–295.

[17] Jeffrey Schrader, "The House of Austria as a Source of Miraculous Images in Latin America," in *Art in Spain and the Hispanic World: Essays in Honor of Jonathan Brown*, ed. Sarah Schroth (London: Paul Holberton Publishing, 2010).

[18] Mesa and Gisbert, 1972, 30.

[19] Contemporary documents such as reports and letters to the viceroy provide further evidence of difficult communications in the Andean region. For example, viceroy Enríquez de Almansa (1581–1583) tried to improve the postal system because news from La Plata or Potosí could take up to four months to reach Lima. See Rubén Vargas Ugarte, *Historia general del Perú*, vol. 2 (Lima: C. Milla Batres, 1971), 278.

[20] They seem to have been paintings on panel, and they are described as "*ocho piezas de imágenes de pincel al óleo que son dos Ecce homos y dos Cristos con sus puertas, una imagen de Nuestra Señora con un Niño y otras dos imágenes de la Magdalena y otra imagen del de san Dunio [sic] de la Cruz, puestas todas en sus tablas grandes....*" (eight works, of images in oil painting, that are two Ecce Homos and two Christs with their doors, an image of Our Lady with the Christ Child and two other images of the Magdalene and another image of saint Dunio [sic] of the Cross, all of them on their large panels.) Chacón Torres*, 1973, 169–170.

[21] Enrique Marco Dorta, *Fuentes para la historia del arte hispanoamericano. Estudios y documentos* (Seville: CSIC, 1960), 2:220.

[22] For example, in the 1560s, the Cathedral of Chuquisaca did not have a *retablo*, but only "*unas ymagenes pequeñas sobre un dosel Viejo*" (some small images on an old canopy); Marco Dorta, 1960, 228. Also see Bernales Ballesteros, *Historia del Arte Hispanoamericano* (Madrid: Alhambra, 1987), 2:302.

[23] An example is found in one of the altarpieces in the Church of La Asunción in Juli. See Damian Bayón and Murillo Marx, *History of South American Colonial Art and Architecture* (New York: Rizzoli, 1992), 82 and fig. 203.

[24] Rafael Ramos Sosa, "La grandeza de lo que hay dentro: escultura y artes de la madera," in *La Basílica Catedral de Lima* (Lima: Banco de Crédito, 2004), 116–117.

[25] For some of the other early works, see Mesa and Gisbert, 1972, figs. 1–21; also see *La Basílica Catedral de Lima,* 116–124, and Ballesteros, 1987, vol. 2.

[26] José de Mesa and Teresa Gisbert, *Monumentos de Bolivia,* 4th ed. (La Paz: Editorial Gisbert, 2002), 194–198. Also see Marco Dorta, 1960, 73–86.

[27] Rubén Vargas Ugarte, *Ensayo de un diccionario de artífices coloniales de la America meridional* (Lima: Talleres Gráficos A. Baiocco y Compañía, 1947), 105–106; Luisa Elena Alcalá, "'Fue necesario hacernos más que pintores...' Pervivencias y transformaciones de la profesión pictórica en Hispanoamérica," in *Las sociedades ibéricas y el mar a finales del siglo XVI*, 85–105 (Lisbon: Exposición Mundial de Lisboa, 1998).

[28] Ocaña's diary was published by A. Alvarez, ed., *Un viaje fascinante por la América hispana del siglo XVI. 1599–1606* (Madrid: Studium, 1969). For a recent analysis, see Kenneth Mills, "Diego de Ocaña's Hagiography of New and Renewed Devotions in Colonial Peru," in *Colonial Saints: Discovering the Holy in the Americas, 1500–1800*, ed. Allan Greer and Jodi Bilinkoff (New York: Routledge, 2003), 51–75.

[29] On the significance of Toledo's program of resettlement, see Sabine MacCormack, *Religion in the Andes: Vision and Imagination in Early Colonial Peru* (Princeton: Princeton University Press, 1991), 140–151; also Mesa and Gisbert, 2002, 29.

[30] When viceroy Francisco de Toledo visited in 1574, the city still did not have a proper building to house the *Audiencia*. Vargas Ugarte, 1971, 235.

[31] The building history of Chuquisaca is in Mesa and Gisbert, 2002, 183–193.

[32] For Potosí: ibid., 117–118.

[33] For the churches of La Paz: ibid., 66–69.

[34] This does not mean that there were no churches before the 1580s. Typically, a rudimentary church was built as soon as missionaries arrived. Some years later, these buildings would be replaced with more solid and dignified constructions. Thus, some of the dates given here probably correspond to

these later phases that marked the beginning of consolidation in church construction. Unfortunately, the lack of more complete documentation for the Copacabana region impedes more precise assessments and chronologies. Discussions of early building activity in the Andean highlands have tended to concentrate on the Province of Chucuito, where more documentation is available. Copacabana, however, did not belong to this province. Furthermore, there is no consensus on how to interpret the Chucuito documents. It is generally accepted that the Dominicans, the first missionizing order in part of the area around Lake Titicaca, organized and built a number of churches beginning at midcentury. Valerie Fraser suggests a period of decline in local church building after the Dominicans were expelled from the area in 1572 and lasting until around 1590. Valerie Fraser, *Architecture of Conquest. Building in the Viceroyalty of Peru, 1535–1635* (Cambridge: Cambridge University Press, 1990), 20 and 160–161. For the resurgence in building activity in the 1590s, the source often mentioned is a contract for sixteen churches to be built in seven towns in three years. However, there are further documents that suggest that ten of them had not yet been begun in 1595 and that only four were completed by 1601. On these grounds, years ago, Marco Dorta raised doubts as to the actual extent of Dominican building activity. See Enrique Marco Dorta, "Iglesias renacentistas en las riberas del Lago Titicaca," *Anuario de Estudios Americanos* (Seville) 2 (1945): 702–706. Also see Harold E. Wethey, *Colonial Architecture and Sculpture in Peru* (Cambridge, Harvard University Press, 1949), 34–35.

[35] Among the interesting details provided in the contract for the *retablo* is the admission that the high chapel of the church was not yet erected. The artists were given the estimated measurements by the church builder (*maestro*), Juan de Vallejo. This demonstrates remarkable planning on the part of the Mercedarians, who were hoping the *retablo* would be finished just in time to be fitted into the new chapel, towards the end of 1583. Whether they did this because they suspected the Hernández Galván brothers might move on and be unavailable to do the work at a later time is unclear. For the contract and a detailed discussion of the *retablo*, see Mesa and Gisbert, 1972, 42–47.

[36] Chacón Torres, 1973, 64.

[37] Mesa and Gisbert, 1972, 54–57.

[38] Ibid., 54.

[39] Ibid., 57.

[40] It is tempting to think that the manneristic figures of the Ancoraimes *retablo* owe something to the influence of the Jesuit Bernardo Bitti. Originally from Italy, Bitti is credited with giving significant impulse to a mannerist, European style of sculpture and painting in the Lake Titicaca region and elsewhere in the Viceroyalty of Peru. However, if Mesa and Gisbert's dates of 1582 for the Ancoraimes *retablo* are correct, then it predates Bitti's arrival in the area since he reached Peru in 1575 and did not go to the area of Titicaca until 1584. For this same reason, it does not seem likely that Tito Yupanqui could have come into contact with Bitti before completing his image, nor does there seem to be any stylistic influence between them. For Bitti's chronology, see Mesa and Gisbert, 1982, 1:56–59; José de Mesa and Teresa Gisbert, "El Hermano Bitti-Escultor," *Andalucía y América en el siglo XVI* (Sevilla: Escuela de Estudios Hispano-Americanos, CSIC, 1983).

[41] Wethey, 1949.

[42] Others who have studied the Andean sculpture include Bayón and Marx, 1992, 73–101; and especially several publications by Pedro Querejazu Leyton: "Sobre las condiciones de la escultura virreynal en la región andina," *Arte y Arqueología* (La Paz) 5/6 (1978): 137–152; "El arte barroco en la Antigua Audiencia de Charcas, hoy Bolivia," in *Barroco Iberoamericano. De los Andes a las Pampas*, ed. R. Gutierrez (Barcelona: Lunwerg, 1997a), 155–158; and "A World in Wood in the City of the Silver Mountain: Wooden Sculpture and Architecture in Potosí," in *Potosí: Colonial Treasures and the Bolivian City of Silver*, exhibition catalogue (New York: Americas Society Art Gallery, 1997b), 50–63.

[43] The periodization varies slightly from author to author. Querejazu, for example, divides sculpture into a Mannerist period (1550–1630), a Baroque or Realist period (1630–1680), and a *mestizo* baroque or hyperrealist period (1680 to 1790). See Querejazu, 1997a, 157. By contrast, earlier on, Mesa and Gisbert included a prior period of the late Renaissance from 1550 to 1580, while their Realism period began closer to 1620. Mesa and Gisbert, 1972, 29 and 107.

[44] George Kubler, *The Shape of Time: Remarks on the History of Things* (1962; repr. New Haven: Yale

University Press, 2008), 76.

45 Ibid., 79.

46 Ibid, 96.

47 Ramos Gavilán, 1988, 234.

48 On the impression that Tito Yupanqui's account is an authentic text of some kind, see Mills, Taylor, and Graham, 2002, 165–167.

49 The theme of the Virgin of Copacabana as triumphant over idolatry and as a means to successful conversion is found in all of the chronicles on the cult. Among others, see Antonio de la Calancha, *Chronica moralizada del orden de San Agustín en el Perú* (Barcelona, 1638), 1:896: "*Venturoso Indio, que lo escogio Dios para que las imagenes que iziese admiraran con Milagros, I fuesen portento de maravillas, queriéndolo Dios asi, para que los Indios incrédulos conociesen las omnipotencias de la gracia….*" (Fortunate Indian, whom God chose so that the images he made would be admired for their miracles and would be portent of marvels, God wishing it so in order that the incredulous Indians should know the omnipotence of his grace…)

50 Certain religious sectors in the second half of the sixteenth century promoted the idea of an earlier pre-Hispanic Christianization in the Andes. MacCormack, 1991, 312–327, and Estenssoro Fuchs, 2003, 439–459.

51 Ramos Gavilán, 1988, 234. The English translation: "The first time my brother Don Felipe de León and I began to make an image of the Virgin —[we worked] in clay and [ultimately produced a form] one *vara* in height—was during the tenure of the priest Antonio de Almeda. He [Almeda] told me to place it on the altar, where it remained for more than a year and half. Later, another priest named Bachiller Montoro came…" Mills, Taylor, and Graham, 2002, 169–170.

52 An interesting image from the early period with which to compare the Virgin of Copacabana is the sculpture of Saint Sebastian that is also in the sanctuary and may even predate it. In its poor manipulation of the human figure, it suggests an inexperienced artisan, whom Mesa and Gisbert believe to be an anonymous Spanish artisan. Mesa and Gisbert, 1972, 34 and fig. 9.

53 The willingness of native Andean communities to purchase images and finance the construction and decoration of their churches despite their poverty is repeatedly noted in the *visita* records of Archbishop Toribio de Mogrovejo. See José Antonio Benito, "Introducción," in *Libro de visitas de Santo Toribio Mogrovejo (1593–1605)* (Lima: Fondo Editorial Pontificia Universidad Católica de Perú, 2006), xxxiii. For a discussion of what was at stake for the indigenous population in doing so, see Fraser, 1990, 161–162.

54 For a lucid account of the complex processes taking place in the viceroyalty at this time, see Estenssoro Fuchs, 2003.

55 Benito, 2006, xxvii.

56 It was Philip II himself who had instructed Mogrovejo that the first thing he must do in Peru was to celebrate this Third Provincial Council. For the council history, see Rubén Vargas Ugarte, *Concilios Limenses (1551–1772)* (Lima, 1951–1954), 3:54–97.

57 Vargas Ugarte, 1951–1954, 1:313–320 and 334; also 3:94.

58 The fact that Tito Yupanqui went to ask the bishop of Charcas for permission to become a religious artist is an example of the increased control of ecclesiastical authorities over religious art. A parallel example of requisite ecclesiastic authorization of a cult image is found in the biography of friar Diego de Ocaña: K. Mills, 2003, 61. For an example of control over church decoration and construction in the council decrees, see Vargas Ugarte, 1951–1954, 1:363.

59 Alfonso Rodríguez G. de Ceballos, "La repercusión en España del decreto del Concilio de Trento acerca de las imágenes sagradas y las censuras al Greco," in *Studies in the History of Art,* Vol. 13, *El Greco: Italy and Spain*, ed. Jonathan Brown and José Manuel Pita Andrade (Washington: National Gallery of Art, 1984), 153–158.

60 "That the bishops visit [inspect] images, and the ones they find poorly executed and indecent they should either fix or remove; and that the image of Our Lady and any other female saint not be adorned with dresses and female clothing, nor should they put makeup or colors which women use, although the image can wear a rich mantle if she owns it." In Vargas Ugarte, 1951–1954, 1:231.

61 Vargas Ugarte, 1951–1954, 1:360. That this policy was being implemented widely is supported by other examples of rejected confraternity initiatives for the indigenous population. In the early seventeenth century, Friar Diego de Ocaña found similar opposition to his plans to establish a confraternity to the Virgin of Guadalupe for native Andeans in Potosí. See K. Mills, 2003, 60. However, Potosí

already had various indigenous confraternities operating in parish churches, which does not seem to have been the case in Copacabana.

[62] For example, he went to visit the site where Christ's disciple (alternatively St. Bartholomew or St. Thomas) had left his footprints in a stone slab near Carabuco and recognized it as a holy place: Ramos Gavilán, 1988, 74. His interest in the famous copy of the Virgin of Copacabana in El Cercado in Lima should also be noted in this context; for a recent analysis of the polemic that arose around this image, see Gabriela Ramos, "Nuestra Señora de Copacabana. Devoción india o intermediaria cultural?" in *Passeurs, mediadores culturales y agentes de la primera globalización en el Mundo Ibérico, siglos XVI–XIX*, ed. Scarlett O'Phelan Godoy and Carmen Salazar-Soler, 163–179 (Lima: Pontificia Universidad Católica del Perú, Instituto Riva-Agüero, Instituto Francés de Estudios Andinos, 2005).

[63] Vargas Ugarte, 1951–1954, 3:66–67.

[64] Such as Bitti. See note 42 above.

[65] In his text, Tito Yupanqui expresses frustration because his molds kept breaking. After ordering a mass in order to ask for a better outcome, he states "*dispoés disto lo trabajamos con lienço.*" Although Mills, Taylor, and Graham (2002, 170) translate this phrase as "After this, we wiped it with cloths," I suggest the alternative and more literal translation "after this, we worked it with canvas [or cloth]." In other words, although Tito Yupanqui is not clear, the original text is suggestive of the mixed-media techniques that inform the production of many Andean colonial images at this time by which cloth was often added to the basic core of an image in order to replicate the drapery of the figure. Ramos Gavilán, 1988, 235. On colonial sculpting techniques see Querejazu, 1997a, 155–156.

[66] The theory that the use of maguey in Andean sculpture marked a strong continuity with the pre-Hispanic past emerged in the first half of the twentieth century in the work of various historians with marked nationalistic agendas. See especially Martín S. Noel, "El Santuario de Copacabana de la Paz a Tihuanaco," in *Documentos de Arte Colonial Sudamericano, Cuaderno VII* (Buenos Aires: Academia Nacional de Bellas Artes de la República Argentina, 1950), xv. Subsequently, in 1980, Gisbert elaborated on this theory, arguing that the use of fabric, molds, and paste in many Andean sculptures had pre-Hispanic precedents in the way in which

cloth was used for preparing mummies: Gisbert, 1980, 100; this argument was repeated more recently in Teresa Gisbert, "La identidad étnica de los artistas del Virreinato del Perú," in *Barroco Peruano 1* (Lima: Banco de Crédito, 2002), 135. Nonetheless, Querejazu has underscored that it is difficult to establish the exact influence of pre-Hispanic sculpture on colonial artistic practice. Querejazu (1978), 138–143.

[67] Pereda, 2008, 295–300.

[68] Rafael Ramos Sosa, "Reflexiones y noticias sobre escultores y ensambladores indígenas en Bolivia y Perú, siglos XVI y XVII," in *Memoria del Encuentro Internacional Barroco Andino* (La Paz, 2003), 247.

[69] Pereda, 2008, note 157.

[70] Mesa and Gisbert, 1972, 36; and Santiago Sebastián López, José de Mesa, and Teresa Gisbert, *Arte iberoamericano desde la colonización a la independencia* (Madrid: Espasa-Calpe, 1985), 400.

[71] Compare Ramos Gavilán, 1988, 224–225 and 237.

[72] Ibid., 224–225.

[73] Ibid., compare 221 and 237.

[74] Ibid., compare 226–227 and 237.

[75] Ibid., 236. In the English translation: "I [then] took the image to the painters´ house in order to learn their opinion. Some told me that while it was better [than what I had done before], it was [still] poorly made, while others told me it was well done." Mills, Taylor, Graham, 2002, 170. The passage following this one is somewhat confusing because Tito Yupanqui says that he thinks the painters were trying to mislead him because, in his opinion, the sculpture was finished. Thus, with this statement he seems to be referring to his decision to go on with his work despite the contradictory opinions of the painters.

[76] Mills, 2006, 27 and 35.

[77] Ramos Gavilán, 1988, 238. For a fascinating analysis of the ethnically plural following that the Virgin of Copacabana came to enjoy in cities like Cuzco and Lima by the mid-seventeenth century, see Ramos, 2005, 163–179.

[78] Mary M. McGlone, "The King's Surprise: The Mission Methodology of Toribio de Mogrovejo," *The Americas* L/ I (1993), 71.

[79] For guilds and working conditions in Bolivia, see Mesa and Gisbert, 1972, 17–18.

[80] The increased control over artistic production in artists' corporations is reflected in the early guild

ordinances for painters in New Spain. See Manuel Toussaint, *Pintura Colonial en Mexico*, ed. Xavier Moyssén (Mexico: UNAM, 1990), 220–226. Also Rogelio Ruiz Gomar, "El gremio y la cofradía de pintores en la Nueva España," in *Juan Correa, su vida y su obra*, ed. Elisa Vargas Lugo, José Guadalupe Victoria, and Gustavo Curiel (Mexico: UNAM, 1991), vol. 3; and more recently, Paula Mues Orts, *La libertad del pincel. Los discursos sobre la nobleza de la pintura en Nueva España* (Mexico: Universidad Iberoamericana, 2008), especially 191–197.

[81] Miguel Falomir, "Artists' Responses to the Emergence of Markets for Paintings in Spain, c. 1600," in *Mapping Markets for Paintings in Europe, 1450–1750*, ed. Neil de Marchi and Hans J. Van Miegroet (Turnhout, Belgium: Brepols, 2006).

[82] For more on the "politics of identity-making," to use this author's words, see Irene Silverblatt, "Becoming Indian in the Central Andes of Seventeenth-Century Peru," in *After Colonialism: Imperial Histories and Postcolonial Displacements*, ed. Gyan Prakash, 279–298 (Princeton: Princeton University Press, 1995); MacCormack, 1991; Estensoro Fuchs, 2003, especially chapter 6; and Kenneth Mills, "The Naturalization of Andean Christianities," *The Cambridge History of Christianity*, Vol. 6: *Reformation and Expansion, c. 1500–c.1660*, ed. R. Po-chia Hsia, 504–535 (Cambridge and New York: Cambridge University Press, 2007).

[83] For more on the tension between miraculous images and the role of the artist, see Luisa Elena Alcalá, "The Image and Its Maker: The Problem of Authorship in Relation to Miraculous Images in Spanish America," in *Sacred Spain: Art and Belief in the Golden Age*, ed. Ronda Kasl, exhibition catalogue (Indianapolis Museum of Art, 2009), 55–73; also see the essay in this catalogue by Javier Portús.

[84] There are records of copies sent to Pucarani, Huarina, and Humahuaca in northern Argentina, and over ten copies just for the first decade after the image was made: Mesa and Gisbert, 1972, 86. Also see Ramos Sosa, 2003, 250.

[85] On the Cocharcas narrative, see Dean, 1996, 177; Estenssoro, 2003, 458–459; and Kenneth Mills, "Religious imagination in the Viceroyalty of Peru," in *The Virgin, Saints and Angels: South American Paintings 1600–1825 from the Thoma Collection*, ed. Suzanne Stratton-Pruitt (Milan: Skira, 2006), 35–36.

[86] Suzanne Stratton-Pruitt, *The Virgin, Saints, and Angels: South American Paintings 1600–1825 from the Thoma Collection* (Milan: Skira, 2006), 158.

[87] Fr. Gabriel de León, *Compendio del origen de la esclarecida y milagrosa imagen de N.S. de Copacabana, Patrona del Perú* (Madrid: Pablo de Val,1663), 21.

[88] More comparative studies between the viceroyalties need to be undertaken, but this is a general impression that arises if one compares central New Spanish cults, like those of the Virgin of Remedios, San Miguel del Milagro, or the Virgin of Guadalupe herself, to Copacabana, Characato, and Cocharcas in the Andes. Indigenous authorship is documented in the origin of some cult images in New Spain (Nuestra Señora de la Salud of Patzcuaro, for example), but it does not appear as a symbolically charged leitmotif in the official accounts of these images to the same extent as it does in Peru. For more on this, see Alcalá, 2009, 67.

[89] Indigenous (and also *mestizo*) artists would come to dominate certain sectors of artistic production by the late seventeenth and early eighteenth centuries in some major Andean artistic centers, especially Cuzco. This development has been studied by Teresa Gisbert, most recently in "La conciencia de un arte propio en la pintura virreinal andina," in *Tradición, estilo o escuela en la pintura iberoamericana. Siglos XVI–XVIII* (México, 2004).

[90] This is true not just of indigenous artists, but also of indigenous patrons, as seen through the portrayal of donors in a growing number of paintings. See, for example, Dean, 1996, 180.

[91] Ramos Sosa, 2003, 253–256.

[92] Calancha, 1639, 896.

[93] See the catalogue entry by Rafael Ramos Sosa in *Los siglos de oro en los virreinatos de América 1550–1700*, exhibition catalogue (Madrid: Museo de América, 1999), 348.

[94] On Sebastian Acostopa Inca, see Mesa and Gisbert, 1972, 89–91.

[95] On this artist, see Chacón Torres, 1973, 66.

D. C. Stapleton:
Collecting Spanish Colonial Art in Colombia and Ecuador from the Gilded Age to the First World War

Michael A. Brown

In 1991, the Denver Art Museum received an extraordinary gift: over five hundred objects from the Stapleton Foundation of Latin American Colonial Art, including paintings, sculpture, furniture, silver, rare books, and manuscripts. Around eighty additional colonial-era objects are housed at the Smithsonian's National Museum of American History, while the majority of Stapleton's pre-Columbian pieces can be found at the National Museum of the American Indian. Denver's gift was made possible by the Renchard family—Stapleton's descendants—in an arrangement initially cultivated by Robert Stroessner, the Denver Art Museum's first curator of Spanish Colonial and pre-Columbian art. During his negotiation with the Stapleton Foundation, Stroessner enlisted the help of the Denver Art Museum's director, Lewis Sharp, and its chairman, the late Frederick Mayer. Facing competition from other American museums, Sharp and Mayer traveled to Washington, D.C., to present Denver's case before the foundation's board in November 1990.[1] Sharp and Mayer were armed with powerful written support from Governor Roy Romer and Mayor Federico Peña; the key selling point, however, was that the strength of Denver's existing Spanish Colonial collection (supported by Frederick and Jan Mayer) guaranteed that the objects would be exhibited, studied, and conserved with unparalleled care and dedication. The Denver Art Museum was the only major museum in the United States with gallery space permanently dedicated to Spanish Colonial art. The Stapleton gift now constitutes the most important collection of colonial artwork from northern South America anywhere outside countries of origin.

This essay comprises two distinct sections. The first examines the remarkable biography of D. C. Stapleton, in particular his years in South America, putting in context the motives behind his acquisitions. Stapleton was a near-contemporary of many of the so-called robber barons of the East Coast: Archer M. Huntington, who founded the Hispanic Society of America, Henry Clay Frick, Andrew Mellon, and J. P. Morgan. Like Frick, Stapleton collected everything from paintings to furniture to silver and books. However, the differences between Stapleton and these giants of art collecting far outweigh the similarities. First, he had no art-historian advisors; at the time, South America was virtually unknown to the American establishment. Second, the vast majority of his acquisitions were made during a period of concentrated collecting, rather than over the course of his lifetime. Third, the philosophy behind his collecting was grounded in the two major pillars of his life: his Roman Catholic faith, and his wife, Stella Hamilton.

The second section may be called a "selected catalogue" of Stapleton objects—all but one are published here for the first time.[2] As research is ongoing, the selection is not intended to provide exhaustive details for individual pieces; rather, the objective here is to generate scholarly discussion by reproducing a small group of objects and discussing them in brief entries. The collection itself is not only an undiscovered chapter in the history of art collecting in the United States, but also a window into an extraordinary life.

Daniel Casey Stapleton (February 7, 1858–May 3, 1920) amassed his extensive collection of Latin American art during the years c. 1895–1914, while he lived and worked in northern South America. During this time, Stapleton resided mostly in Ecuador and Colombia (part of an area known during the eighteenth century as the Viceroyalty of Nueva Granada), until the outbreak of World War I forced

his return to the United States.[3] During his time in the region, Stapleton witnessed (and sometimes participated in) many historic and geopolitical events, including the United States's peaceful acquisition of the Danish West Indies (1902–1917), the independence of Panama from Colombia (1903), the rediscovery of Macchu Picchu (1911), and the completion of the Panama Canal (1913).[4] He left behind a treasure trove of correspondence, first compiled by his wife, Stella Hamilton, and later transcribed by his daughter, Stellita Stapleton Renchard. The letters are currently maintained by his granddaughter, Stella Mae Seamans, and many are kept in transcribed form in the archives of the Denver Art Museum. Stapleton's correspondence indicates that the greatest flurry of collecting occurred between 1911 and 1914.[5] The following biography relies mainly on these original documents, along with a privately published memorial volume of the written recollections of his family and friends, and on the two brief published accounts of his life.[6] The picture that emerges is of a life every bit as extraordinary as the collection Stapleton assembled.

Daniel Casey Stapleton (fig. 1) was born in Joliet, Illinois in 1858—the same year that state's favorite son, Abraham Lincoln, began his meteoric rise in American politics. Stapleton's parents, William Stapleton and Ann Casey, were Roman Catholic émigrés from the British Isles who traced their roots to Ireland on his mother's side and Wales and England on that of his father. While they claimed aristocratic lineage, the Stapletons' faith was unfashionable in Victorian England and may have contributed to their decision to leave for America. Later in life, Daniel himself would pine for Britain; however, his lifelong plans for a retirement in the English countryside were cut short by his death in 1920.[7] At the age of eighteen, Stapleton joined the Marquardt Company, a wholesale jeweler in Iowa City. After Iowa City, he tried his luck at homesteading in Nebraska, which had joined the Union in 1867 and held the promise of federal land grants. Stapleton soon acquired considerable land holdings in Nebraska, and he settled in Omaha. From there he went to London, where he first worked for Johnson Matthey, a precious metals concern. He then joined the London-based Ecuador Land Company, which sent him to South America to oversee its mining, real estate, and agricultural ventures. Stapleton's pioneering experience in Nebraska would prove invaluable as he was charged with an even more inhospitable frontier in the southern hemisphere.

Ecuador Land posted Stapleton to Quito, but the properties he administered were far-flung across the old boundaries of the Viceroyalty of Nueva Granada, which included present-day Ecuador, Colombia, Panama, and Venezuela.[8] By 1911, Stapleton had come to represent another British company, the Playa de Oro Estates, which owned land in both Ecuador and Colombia.[9] Stapleton, an adept freelancer, would go on to represent the Anglo-Colombian Development Company's concessions in the gold and platinum-laden rivers in the remote, inhospitable Chocó region of Colombia. Stapleton was a fluent Spanish speaker, but the consistency of the misspellings—often phonetic—in his letters suggests that he learned the language by ear rather than through any formal training. By inference from the accounts of his friends and acquaintances, it is also likely that Stapleton had at least some knowledge of the indigenous languages spoken by the laborers he oversaw.

By 1911, Stapleton had agreed to oversee the famed Muzo emerald mines, which had been in operation since pre-Hispanic times and continue to produce the world's highest quality emeralds. In all, Stapleton oversaw land holdings from coastal Esmeraldas (Ecuador) to the Amazonian jungle to the high plains of Colombia (map p. 173). The mines and plantations on these properties, which were accessible only by mule or canoe in many cases, produced platinum, emeralds, coffee, coconuts, timber, and the South American tagua nut. With such vast responsibilities, and as one of the few resident Anglophones with close ties to the New York, Washington, and London élite, Stapleton soon found himself moving in social circles that included the most influential fig-

Fig. 1. Undated photograph (c. 1918), Daniel Casey Stapleton and his daughter, Stellita.

ures in South America, from diplomats and dictators to prelates and statesmen. Having amassed a considerable fortune and an extensive roster of contacts, Stapleton began collecting in earnest about 1910.

As Stapleton's letters make clear, aesthetic sensibility was not the driving force behind his acquisitiveness. As an active and devout Roman Catholic, Stapleton was informed by a strong sense of charity, focusing his philanthropy on religious institutions in his adopted homes of Ecuador and Colombia. Stapleton accepted numerous gifts from churches and convents in return for his ongoing endowments. His philanthropic endeavors took many forms, and he financed projects ranging from modest student scholarships to construction campaigns. The recipi-

ents, such as the Convent of Santa Clara in Bogotá, Colombia, often showed their gratitude by giving Stapleton objects such as silver and paintings (see silver plaque in Cat. 14). While silver candlesticks and gold chalices had demonstrable monetary value as precious metals, it would have been harder for Stapleton to judge the value of paintings or sculpture except from the religious perspective that so thoroughly defined his life. Thus, while there are many exquisite household items in Stapleton's collection, the overall character of the paintings and sculpture in the collection is overwhelmingly devotional and Catholic.

While his Catholic sense of charity certainly informed his collecting, it was Stapleton's devotion to his future wife, Stella Hamilton, that provided the

catalyst for the most intense period of acquisition.[10] The collecting spree coincided with their courtship, about 1911–1914, leading up to his final return to the United States. Stapleton's letters from this time document the shipments he sent back via boxcar to the mansion in Omaha where Stella and her aunt (the wife of Nebraska's first governor) lived. Writing somewhat sheepishly from Bogotá in 1913, Stapleton explains one particular shipment to his fiancée:

> I have bought a lot of old furniture quite rare, some paintings and old books…I shipped the whole lot to Omaha, Nebraska. There was just a solid carload. Now don't be angry. I did not know where else to ship to. Everything is more than one hundred years old, so there should be no duty. One painting of the Crucifixion, is certified as the painting used at the Mass in Bogotá, August 6, 1538. Then I have a lot of little things for you which I will bring up. I thought of you in acquiring all of these things and really only of you.[11]

Likewise, one of his earliest letters to Stella makes clear Stapleton's perspective on his collecting.[12] Writing from Holland House, the New York hotel where he stayed before embarking on his trips to Europe or South America, Stapleton describes his meeting with Archer Huntington, the founder of the renowned Hispanic Society of America in Audubon Terrace. Stapleton recounts Huntington's attempts to buy his antique Spanish gold jewelry: "I might name my own price. But Stella dear, you were in my mind—these little gold things are yours and no one else shall have them."

The apocryphal story of Stapleton and Stella Hamilton's first meeting describes a chance encounter in 1913 at an Amazonian mission chapel while Stella was traveling the globe.[13] According to the story, they were the only two foreigners in attendance at Mass, which was celebrated weekly by an itinerant missionary priest. However, while the two certainly attended such masses together, the serendipitous scene of the two lone Americans kneeling to take Communion on the packed mud of a makeshift sanctuary's floor in eastern Colombia is more romantic mythology than historical truth. In reality, Stella Hamilton and Dan Stapleton had become acquainted several years earlier in Nebraska through their mutual friend Major Harry O'Neill.[14] Stapleton had assisted O'Neill in his homesteading efforts in western Nebraska early in life. Though Stapleton never settled in the area, O'Neill and the other residents named the town in his honor after Stapleton helped bring the railroad in, allowing Stapleton to become the seat of Logan County, Nebraska.[15] Harry O'Neill's sister, Mother Pauline O'Neill, was the founder of St. Mary's College in Notre Dame, Indiana, where she acted as an important mentor to Stella Hamilton. It was through these family connections, along with their shared activity in the church life of Omaha, that Stella and Dan became acquainted—long before her courageous journey to South America.[16]

Rather than chancing upon his future wife during her exotic "Grand Tour," Stapleton was likely the catalyst for Stella's ambitions to travel; in a letter of August 4, 1911, he implores Stella to "see Quito some day before it changes too much."[17] Thus, Ms. Hamilton's voyage was a "Grand Tour" of her own singular design; it included Egypt, the Far East, Amazonian South America, the Andes, and, of course, "Old Quito." Without doubt, she was a woman of great intellectual curiosity, adventurous spirit, and considerable courage. In any event, Dan Stapleton was sufficiently impressed to abandon the bachelorhood he had maintained into his fifties. When Stella left South America in 1913, he promised he would find her upon her return to the United States.[18] However picturesque the story, Stapleton indeed met her ocean liner when it docked at the port of Vancouver, British Columbia, and he and Stella Hamilton were married in Omaha on July 19, 1914.

Stapleton's letters during three years of courtship with Stella not only shed light on the personal histories of the collector and his wife, but also

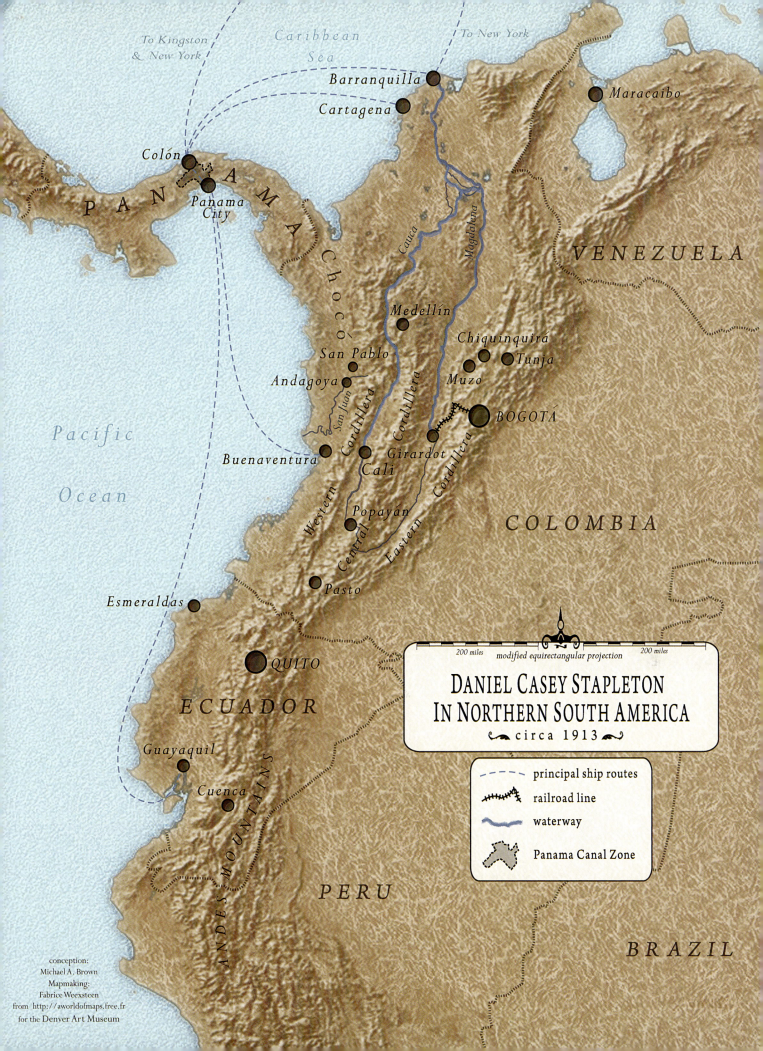

To Kingston & New York

Caribbean Sea

To New York

PANAMA

Colón

Panama City

Chocó

Cauca

Magdalena

Barranquilla

Cartagena

Maracaibo

VENEZUELA

Medellín

San Pablo

Chiquinquirá

Tunja

Andagoya

Muzo

San Juan

Cordillera

Cordillera

BOGOTA

Buenaventura

Girardot

Cali

Cordillera

Western

Central

Eastern

Popayán

COLOMBIA

Pacific Ocean

Pasto

Esmeraldas

QUITO

ECUADOR

ANDES MOUNTAINS

Guayaquil

Cuenca

PERU

BRAZIL

200 miles modified equirectangular projection 200 miles

DANIEL CASEY STAPLETON
IN NORTHERN SOUTH AMERICA
❦ circa 1913 ❦

— — — principal ship routes

railroad line

waterway

Panama Canal Zone

conception:
Michael A. Brown
Mapmaking:
Fabrice Weexsteen
from http://aworldofmaps.free.fr
for the Denver Art Museum

remind the reader of the difficulties involved in traveling this region.[19] For example, Stapleton details a typical itinerary to his destination near the Chocó mines: following several days' train from Omaha, a steamer from New York would call at the ports of Kingston (Jamaica), Colón (Panama), and Cartagena (Colombia) before landing in Baranquilla; from there, Stapleton would take the weekly riverboat down the Magdalena, changing after eight days for a smaller craft for the two-day sail to Giradot, where a slow train would shuttle travelers up into the northern Andes, taking two days to reach Santa Fé de Bogotá (Bogotá), Colombia's capital. From there, Stapleton would then undertake—after sufficient rest to acclimatize to the altitude—the ten-day trek over the Andes (often ascending higher than 12,000 feet) into the Chocó region by mule. He often spent weeks in a canoe, surveying company holdings from Medellín as far south as Cali, Buenaventura, and the Colombia-Ecuador border region.[20] His harrowing descriptions of the journeys, while often amusing and self-deprecating, highlight some of the reasons there had not been more interest on the part of foreign collectors and scholars in this geographical region. An isolated and often inhospitable landscape ensured that Stapleton would not have his own version of Bernard Berenson guiding him toward masterpieces.

All told, the trip from New York to his Chocó properties took upwards of five weeks, barring missed connections and foul weather, which were both all too common. Stapleton enjoyed describing his travels south in appreciable detail with wry humor. In 1912, he wrote from his riverboat:

> It was a motley lot of passengers—one Canadian…and the vicar of the Santa Maria diocese going to Bogotá…[and] a Fransciscan friar with sandals and a long beard. We four sit together at table and as I brought with me from New York a box of provisions, which I divide with them. I bought a case of White Rock [soda water] which I share also and we got on fairly well.

> The boat food is horrible; the bath is really laughable, the water being pumped directly from the river…the chocolate liquid…is really something dreadful, to think of using it for cleansing purposes.[21]

His devout travel companions were all too happy to help relieve Stapleton of his burdensome supply of whisky, fresh soda water, and biscuits from New York, which he appears to have transported in a solid trunk that served as something of a grown-up picnic basket complete with antique La Granja (Spain) glass bottles (now in the Denver Art Museum). When a group of Spanish priests boarded his riverboat from their own flagging craft bound for Giradot, their appetites compelled Stapleton to lament that "I now have four more mouths to feed and moisten."[22]

While he does not often record the locations where he acquired certain objects, Stapleton's descriptions of his journeys are detailed enough to map his routes with some precision. For example, between late June and early August 1911, Stapleton traveled (mostly via canoe) from the Chocó area to Buenaventura, a coastal town in southwestern Colombia, then on to Ecuador.[23] Back in Buenaventura, he rode nine hours on horseback to Cali, "crossing the western Cordillera and dropping down into the Cauca Valley," and thence back to the coast to help pilot a launch up the San Juan River to the village of San Pablo. This was the first time that a motorized craft had reached San Pablo, and Stapleton recounts that

> the people of the town gave us a hearty welcome with much cheering…for you see the country has been settled for four hundred years and San Pablo has always been served by canoes only…I was asked [by the mayor] the name of the launch and though it has no name, "Santa Maria" came into mind and mouth simultaneously.

Stapleton concedes that he made this last remark about the Santa Maria by more than pure chance: he

had had Columbus's fleet in mind; moreover, a group of missionaries from the Congregation of Sons of Mary Immaculate had recently settled in the village and Stapleton notes the happy coincidence that "Santa Maria is to be our patroness."[24] Stapleton's use of the possessive pronoun was not an accident; he had agreed to serve as a patron to the fledgling mission.

In his letters of 1912, Stapleton also regaled Stella with tales of the wonders of Bogotá—a city then accessible by a treacherous, winding train route through the western range of the Andes. He describes an immaculately kept city with delicacies such as fresh radishes, lettuce, and artichokes, and especially strawberries: "just think of it, in December, all the fresh strawberries one can eat!" As a man accustomed to traveling with his own bed linens, he was also impressed with his quarters in Bogotá. While there, he made a point of visiting the cathedral of the Immaculate Conception, the Jesuit church of St. Ignatius, and the Convento del Sagrada Corazón, where he met Mother Dunn, one of two English nuns in the capital, who told him of their school's success and their needs for more student housing.[25] While Stapleton's ostensible purpose for staying in Bogotá was his extended inspection of the Muzo emerald mines (two days' journey on muleback from the capital), he also met with both American and British legations while in the capital.

Stapleton describes a Bogotá business deal with the president and his cabinet ministers, in which Stapleton acted as liaison between the Colombian government and European gem brokers, primarily for the sale of great quantities of emeralds. Some of the wealth he accrued through such transactions was put to philanthropic use. In particular, he had close ties with the Convent of La Sagrada Corazón in Bogotá, and he tells Stella of one young girl who wished to enter the convent but lacked the dowry to do so, which he provided without hesitation. He also tells of how one of his maids was pleased to learn of his Catholicism; he would later endeavor to sponsor the maid's child, forced by her poverty to live at the convent's orphanage.

Stapleton's philanthropic activities must have been a welcome respite from the arduous journeys to the mines north of Bogotá. He writes to Stella,

> Did you ever try to ride a mule? Well, don't; walk instead. You can run about the paved streets of Omaha in your elegant electric brougham, but just try to navigate on the hurricane deck of a long, four-legged black mule over mountain trails for sixty miles or so. I left at 8:30, stopped for a poor luncheon in a dirty hovel of a hotel, then struck out for Carmen, about 20 miles further which took six hours.

The next day, he had forty miles to cover, which he says was "indescribable: There must have been a Devil's dance going on when this part of the world was in the making with some wild Irishman with a hand in the doing of it," he says, making poetic reference to the region's abundance of emerald. During his journey on muleback, Stapleton crossed a mountain above subalpine height, without the aid of stirrups (his boots were far too large for the local equipment). He wrote at one point that "night reached us before we'd arrived and it was darker than a streak of black cats. At this point, the mule balked, sending me into the stream." The rest of the journey he undertook soaking wet in darkness without stirrups. Despite his derision of these sure-footed, but notoriously stubborn beasts of burden, Stapleton nevertheless saw fit to collect more than a half-dozen Colonial-era figurines of mules during his sojourn in the region.

Stapleton spent most of his adult life living in South America or frequently traveling to the region. His letters provide numerous insights into the political upheavals that characterized early twentieth-century South America. Because of his circumstances, Stapleton often found himself in the midst of geopolitical intrigue. With close friends like Major O'Neill at the United States Department of Justice, and Secretary of State William Jennings Bryan (his fellow Nebraskan, to whom he wrote weekly), Staple-

ton was pressed into unofficial diplomatic service as the best-connected American in the region. Official or not, his accepted title in Washington became ambassador-at-large for Latin America.[26] The closest of Stapleton's relationships in South America were with the British railroad baron Lord Murray of Elibank and with the Italian prelate Monsignor Montagnini. His circle also included his collecting rival, the British ambassador in Panama, Claude Mallet, and the British minister in Colombia, Percy Wyndham (see Fig. 2, photograph of Murray and Wyndham in Colombia). Mgr. Montagnini, a Vatican agent whose expulsion from Paris in 1906 on charges of espionage made headlines on both sides of the Atlantic, was in the region representing Rome's interests leading up to the opening of the Panama Canal.[27]

This consistent cast of characters, whose residence shifted as circumstances warranted from Quito to Bogotá to the Canal Zone, formed the nucleus of an informal dining society. Stapleton and Murray founded the "Savage Lambs," a wry reference to their sometimes difficult existence at the edges of civilization. Comprising about a dozen expatriates, the "Savages" met for dinner every Thursday; the feasts were as movable as the "Savage Lambs" themselves. Inevitably, the discussion focused on American politics and the imminent opening of the Panama Canal. The canal was the most important technological innovation of the early twentieth century: it promised an efficiency of global shipping never before possible. The French government had given up on the project in the 1890s after more than 20,000 laborers had perished from malaria and yellow fever. However, the United States had negotiated to complete the canal (by this time there were vaccines and treatments for malaria). International powers like Britain, France, Spain, and Italy all sent delegates to the region in order to position themselves advantageously. Stapleton not only bore witness to the dealings surrounding the canal's completion; he was also in contact with some of Washington's most important politicians. While he was reluctant to become entangled in

the complexities of the canal negotiations, he did act as a liaison between Washington and several of the region's governments, especially those of Ecuador and Colombia. In particular, Stapleton used his close association with William Jennings Bryan, who was then Woodrow Wilson's secretary of state, to help negotiate a settlement with President Carlos Eugenio Restrepo (1910–1914) of Colombia, who held former President Theodore Roosevelt accountable for the secession of Panama from Colombia. While Stapleton shows nothing but respect and admiration for "T. R.," as he calls the former president in his letters, he was also sympathetic to the Colombian people and worked his contacts in Washington on Colombia's behalf.

After the outbreak of the First World War, Stapleton's travels to South America were curtailed by the threat of German torpedoes. By April 1918, however, Stapleton had returned to Colón, Panama, to continue his work. At this time Stapleton realized that along with his mining and agriculture interests, his lands in Ecuador were full of another valuable commodity: balsa wood. The United States Navy had begun researching military applications of this lightweight wood, and Stapleton found himself once again in an advantageous position.[28] It was also at this time that Stapleton renewed his project with Ambassador Maurice Francis Egan to negotiate the sale of the Galapagos Islands from Ecuador to the United States. Egan, who had known Stella Hamilton when she was at St. Mary's College (Indiana), had secured the transfer of the Danish West Indies (now the Virgin Islands) to the United States. In his words, Egan believed "there was only one man in the United States who had the key to the problem of the peaceful acquirement of the Galapagos," and that was D. C. Stapleton. The islands were to be used for a massive U.S. naval installation to provide the western defense for the Panama Canal (with the U.S. Virgin Islands and Puerto Rico serving its eastern front). However, Stapleton's death in 1920 put a permanent end to the Galapagos negotiations, and the islands remain an ecological sanctuary governed

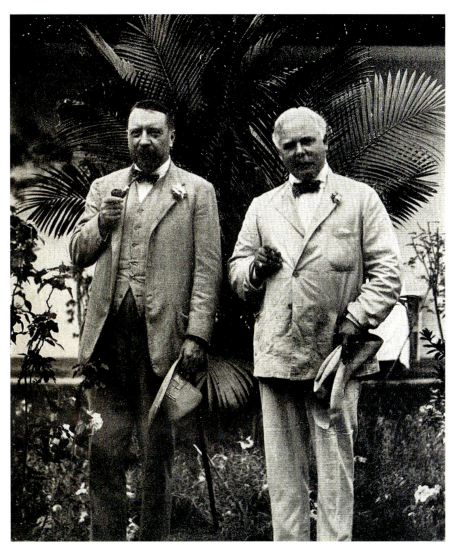

Fig. 2. Lord Murray of Elibank (left) and Percy Wyndham (c. 1913). From A. C. Veatch with an Introduction by Lord Murray of Elibank, *Quito to Bogota*. London: Hodder & Stoughton, 1917. Photo by A. C. Veatch.

by Ecuador.[29] Ultimately, such a substantial naval base proved unnecessary for the protection of the Panama Canal; for a century, it has survived without one. The greatest historical ramification of the collapse of the Galapagos deal remains hypothetical: had it been successful, it would have doubled the United States' naval and air presence in the Pacific before the 1941 attacks on Pearl Harbor, Hawaii.

Stellita Anne Francis Stapleton (fig. 3) was born in Omaha on July 9, 1915. Upon Daniel Stapleton's death five years later, her mother compiled a lengthy memorial volume of correspondence, death notices, and accounts of his life written by friends and family. Included were the cables and letters of congratulations that arrived from around the world celebrating Stellita's birth. The memorial book, after

all, was for her. Upon his death, D. C. Stapleton left many endowments, including those to universities like American, Catholic, Notre Dame, and Georgetown; he also sent a considerable sum to St. Mary's College (Stella Hamilton's alma mater) along with other donations to numerous churches, convents, and dioceses in the United States and South America. One of his most important gifts, however, may have been to his daughter in the form of an early Spanish Colonial gold cross, encrusted with emeralds and pearls (see Cat. 11; book cover). Stapleton knew he was already ailing, and the gold cross was one of his prized possessions; the Omaha newspapers even saw fit to report the gift. While it is among the smallest pieces in the collection, it is perhaps its centerpiece. The object's components parallel the evolution

of Stapleton's collecting: the emeralds, cut in pre-Hispanic times, recall his business interests in South America, while the cruciform gold setting reflects the central role of his Catholic faith. Stapleton may never have known of the historical importance of the objects he collected in Ecuador and Colombia; more importantly to him, Stapleton intended the objects to enrich the lives of his beloved wife and daughter.

In 1979, Mrs. Stellita Stapleton Renchard purchased the Codman-Davis House in Washington, D.C. (adjacent to her own residence on Capitol Hill); she soon secured National Registry status for the 63-room mansion, and having recently created the Stapleton Foundation, she wrote, "my idea is to use the great rooms of the house for a museum of Latin American Colonial Art."[30] While plans for such a museum never materialized, many of the objects that D. C. Stapleton collected in South America are exhibited today in the galleries of the Denver Art Museum. Were he able to see the recognition his collection is beginning to receive now, Stapleton might react with a happy modesty and the same bemused surprise he often showed during his lifetime upon learning of yet another major award. In 1912, Stapleton was en route to the emerald fields of Muzo when he learned of his election to the American Institute of Social Sciences, a humanitarian society. In his own words,

> I am told that something done for humanity or science are the requisites for membership and I am told I am further eligible under both; I do not know at all what I have done…when a man goes to a foreign country, he owes it to his country as well as to himself to be on his good conduct and to do the best possible to bring credit to himself and his country.[31]

In 1913, Pope Pius X made him a Knight of the Order of Saint Sylvester, one of the Holy See's oldest and most prestigious chivalric honors, on the basis of the conspicuous integrity of your life and for the fame of your Christian charities, by your noteworthy benefactions to religious orders, especially to the Congregation of the Missionaries [of] Chocó.[32]

The insignia of the Order features an eight-pointed star framing a medallion with the image of the titular pope on one side and his tiara and the crossed keys of St. Peter on the reverse. Apart from the wearing of the insignia, the highest papal orders grant members only one earthly privilege (never implemented, as far as we know): to ride horseback through the interior of the Basilica of St. Peter's. Had Daniel Stapleton ever exercised this privilege, one can imagine he might well have chosen to do so on one of the sure-footed mules that carried him safely, however uncomfortably, across the great Andean Cordillera.

Selected Objects: Highlights of the Stapleton Collection*

Gift of the Stapleton Foundation of Latin American Colonial Art, made possible by the Renchard Family.

Fig. 3. Bookplate (c. 1923), Stellita Stapleton (Renchard) and her dog, sitting among Stapleton's South American objects at the Stapleton residence at 1617 Massachusetts Avenue, Washington, D.C. The chair is pictured here, in Cat. 16.

* Unless otherwise noted all objects Denver Art Museum.

b.

c.

1.
Stapleton Codex

Probably Spain, dated 1597
Tempera, ink and gold leaf on paper
13 x 9 in. (33.0 x 22.9 cm.); S-0290

This extraordinary folio (1a) is from a manuscript commissioned by Francisco Quintano de Villalobos, a native of Extremadura who spent his adult life in Potosí, the Bolivian city known for its silver mining wealth. The velvet-bound manuscript is Quintano's formal application for a patent of nobility, which would exempt his family from taxation, and grant them privileges such as land ownership and rent collection (1c). Acceptance to the noble hierarchy was dependent upon certain proven qualifications such as the petitioner's purity of blood (*limpieza de sangre*), and his family's allegiance to the crown and its unique role as Defender of the Faith. The document is signed and dated 1597 on the final page by the jurists who approved the petition in Granada.

The most lavish of such petitions (known as *cartas de hidalguía* or *cartas ejecutorias*), like the Stapleton Codex, take the form of illuminated manuscripts. Sent back to Quintano de Villalobos in Potosí after the successful review of his petition, the manuscript features illuminated folia including a coat-of-arms (1b), a full-page image of Santiago the Moor-Slayer (1d) and an exquisite miniature portrait of Philip II (1e). The illuminated page with the Holy Family (1a) is framed by ornate margins that feature a profusion of flowers and creatures set on a gold ground. Among the species represented are quail, jays, a mockingbird, caterpillars, butterflies, beetles, ladybugs, and a single professorial owl, who stares back at the viewer.

The figures depicted in adoration beneath the image of the Holy Family likely represent Quintano and his family. The inscription between the portraits and the Holy Family identifies the recipient of the petition, "Don Phelipe," meaning Philip II of Spain. The composition is reminiscent of sixteenth-century Spanish portraits of donor families, most notably by artists working in Seville such as Pedro de Campaña

a.

and Francisco Pacheco. In fact, one of Pacheco's collaborators, Diego de Gómez, specialized in illuminating such *cartas de hidalguía*. Gómez's style, while not dissimilar from that of the Stapleton Codex, is distinctive enough to rule out his authorship of the present manuscript.[33] The artist of the Stapleton Codex, whose style reveals an intimate knowledge of current artistic trends in Seville, remains unknown, although he has left his "signature" in the form of a violin-shaped rubric on several pages of the manuscript (1e). [34] In the context of the visual arts of South America, the Codex serves to show the crucial role that patrons such as Francisco Quintano de Villalobos played in the interchange of artistic styles between Spain and its trans-Atlantic colonies.

d.

e.

Fig. 4. Gregorio Vásquez de Arce y Ceballos (Colombian, 1638–1711), *Virgin Mary in Prayer*. Second half 17th century. Oil on panel. Sagrario Chapel, Cathedral of Bogotá.

Fig. 5. Gregorio Vásquez de Arce y Ceballos (Colombian, 1638–1711), *Virgin Mary in Prayer*. C. 1660. Drawing, ink on paper. Museo de Arte Colonial, Bogotá.

2.
Virgin in Prayer
Attributed to Juan Bautista Vásquez de Arce y Ceballos (c. 1630–1677)

Colombia, second half of the 17th century
Oil on panel
19½ x 13⅝ in. (49.5 x 34.6 cm.); S-0478

A highly skilled artist in his own right, Juan Bautista Vásquez de Arce y Ceballos appears to have spent much of his career in the workshop and shadow of his younger brother, Gregorio.[35] Gregorio Vásquez Ceballos, the renowned Colombian painter and draughtsman, worked in Santa Fé de Bogotá from the late seventeenth century until his death in 1711; Juan Bautista died in 1677. The panel in Denver depicting the *Virgin in Prayer* is one of the finest works that Stapleton acquired in South America. It is very close in composition, dimensions, and style to a painting of the same subject in the Sagrario Chapel of the Cathedral of Bogotá, which has been ascribed to Gregorio (fig. 4).[36] Both the Sagrario and the Denver panel show a bust-length Virgin with hands together and head bowed in a serene attitude of prayer. This composition is found throughout much of South America during the viceregal era. In this type, the Virgin's headdress, with its diaphanous veil and narrow hair fillet, is distinctly Netherlandish. In fact, the composition likely originated with Albrecht Dürer and proliferated in Italy and Spain before appearing in the New World in works by artists such as Bernardo Bitti (1548–1610), fray Pedro Bedón (1556–1621), Angelino Medoro (c. 1567–1633), and Pedro de Vargas (active in New Granada 1575–1596).

The Stapleton *Madonna* shares numerous details with the Sagrario panel beyond the readily apparent similarities in facial features like rounded, heavy eyelids and delicate, slightly pursed lips. The depiction of the hands bears a close resemblance: long, elegant fingertips barely touch, and cuticles are subtly but clearly defined. The Virgin's chemise also features a similar central fold directly below her chin. In addition, while the Denver panel is slightly smaller, its

ratio of height to width is very close to that of the Bogotá picture, making the figure's disposition in the pictorial space of both paintings nearly identical.

An extant drawing by Gregorio Vásquez of the same composition (Museo de Arte Colonial, Bogotá) helps to reveal both the master's source and his working method (fig. 5).[37] The drawing's linear style, marked by a distinct and rather heavy outline, suggests that the artist worked from a two-dimensional visual source, such as a print, rather than from life. To judge from close compositional similarities, the likeliest source for the drawing is a copy of a work by the Italian painter Sassoferrato (1609–1685). Sassoferrato produced at least seven versions of his so-called Northern Headdress Madonna, a copy of which (oil on canvas, private collection, Bogotá) arrived in Colombia during the viceregal era.[38] While conclusive evidence may never emerge, it remains possible that Gregorio Vásquez modeled his drawing on this Sassoferrato copy.

Gregorio's drawing appears to have provided the model for both the Sagrario and the Denver panels. This shared source, coupled with the panels' nearly identical dimensions, suggests that the two paintings were produced in the same workshop, perhaps around the same time.[39] The most recent catalogue of the Vásquez Ceballos oeuvre lists eleven extant versions of the composition, not including the Denver painting, all of similar dimensions. The majority of these eleven are also on wood panel and may be classified as workshop pieces.[40] Fernando Gil Tovar has ascribed some of these variants to the hand of Juan Bautista, whose apparent skill with the brush suggests that he was more than a mere studio assistant to his brother. Until further evidence comes to light, Juan Bautista, as the senior hand in Gregorio's studio, appears the most likely candidate for the attribution of the Denver panel.

3.
Ecce Homo

Colombia, 17th century
Oil on canvas
21 x 19½ in. (53.3 x 49.2 cm.); S-0106

This arresting painting depicts a scourged Christ after the flagellation and crowning with thorns. The episode, recounted in John 19, describes Pontius Pilate's presentation of the captive Jesus of Nazareth before a crowd. As Pilate proclaims "Ecce homo!" ("Behold the man!"), the mob clamors for his execution. In the present depiction, the scene is stripped of the narrative details and secondary characters described in the scriptural passage. Christ is seen in stark solitude, with blood and tears streaming down his face. He is dressed mockingly by his captors in a monarch's crimson robe, a role that was further ridiculed with the plaque on the cross that identified the prisoner as "Jesus of Nazareth, King of the Jews." The figure is shown nearly life-size, emerging from the darkness of the background and illuminated dramatically from the left. The painting highlights the physical suffering of Christ's torture, which is brought even closer to the

a.

viewer through details like the single thorn piercing the subject's brow. The painting was conceived as a devotional image through which the viewer might contemplate Christ's sacrifice and ultimate salvation. The violence and immediacy that characterize this depiction had become prevalent in Spanish painting of the late sixteenth century, especially in scenes of Christ's Passion, resulting from Counter-Reformation emphasis on the humanity of Christ. Luis de Morales, whose works were known throughout the viceroyalties of Peru and New Granada, was one of the foremost exponents of this style of devotional painting in Spain and Portugal. Baroque sculpture in Spain and the Americas is also characterized by a similarly high degree of naturalism.

The frame of the painting, which appears to be original, is a prime example of the *estofado* technique, in which the gilt frame is polychromed and then incised to reveal the gold beneath (3a). The elaborate style and rich, saturated colors of the frame are hallmarks of workshops in the Popayán region of Colombia.

4.
The Penitent Magdalene

Colombia or Ecuador, 17th century
Oil on panel
13 x 11 in. (33 x 27.9 cm.); S-0118

This small panel depicts a seated Mary Magdalene resting her head in her proper left hand while her right hand sits atop a human skull. This contemplative posture, which ultimately derives from Dürer's *Melencolia* (1514) (fig. 6), had become standard in depictions of the Magdalene in Italian and Spanish painting by the seventeenth century. Images of the Magdalene that included *vanitas* themes, in which the subject's mortality or the fleeting nature of worldly luxuries is emphasized, became widespread in viceregal painting, especially in South America. While the iconography of the present painting is notably austere, later examples from New Granada often depict the Magdalene surrounded by an array of jewelry and opulent finery alluding to her rejection of these luxuries. The intricate still-life details

Fig. 6. Albrecht Dürer (German, 1471–1528), *Melencolia I*. 1514. Engraving. Harris Brisbane Dick Fund, 1943. The Metropolitan Museum of Art / Art Resource, NY.

of such pictures offered the artist an opportunity to employ bravura techniques in the depiction of glass, textiles, and precious metals and stones.

While popular elsewhere in seventeenth-century Europe (in the work of Georges de la Tour, for example), depictions of the repentant Magdalene were not very common in Spain.[41] However, European artists often employed illustrated "chapbooks" of established iconography, often produced by the religious orders in Rome, and this was likely the case in the Spanish Americas, too.[42] Easily portable and affordable, chapbooks provided a way for artists to transmit standard compositions and iconography across the Atlantic world (and beyond). The presence of Italian painters in South America is well known, and it is possible that they had brought this particular type of Magdalene to South America in the form of chapbook illustrations. This would help to explain why scenes of the Penitent Magdalene became so popular in South America but not elsewhere in the Spanish empire.

In this seventeenth-century panel, it is the Magdalene's remorse for her spiritual shortcomings that is highlighted, rather than the trappings of temporal excess. In this sense, the sober composition hews more closely to earlier European models than the many later South American examples, which often display a profusion of riches and baubles, a treatment that became much more prevalent throughout the Spanish colonies. The artist of the small panel demonstrates a powerful interest in tenebrism, which by this date had emerged as a widespread phenomenon throughout the artistic centers of the American viceroyalties.

5.
Mary Virgin of Sorrows
St. Joseph

Colombia, c. 1800
Oil on canvas
17 x 14 in. (43.2 x 35.6cm.); S-0138, S-0117

During conservation treatment undertaken by the Denver Art Museum, inscriptions along the top edge of both canvases were revealed, the full text of which reads in both cases "A devoción de Don José María Lemos y Hurtado." These inscriptions confirm that the two paintings were commissioned by the same donor and were intended to hang as a pair. According to church documents, Lemos y Hurtado was from a prominent *criollo* family in Popayán, in present-day Colombia, was baptized there on June 13, 1780 and married in 1803 to Mariana Velasco y Riascos, also a native of the same town in the Cauca region. Lemos y Hurtado was a member of the Popayán *cabildo*, or city council, and later emerged as a military hero during Colombian independence.[43]

This pair of devotional images features depictions stripped of virtually all peripheral detail: the

Virgin contemplates a crown of thorns, while St. Joseph holds a lily and bows his head in humility. While the artist remains unidentified, the modeling, shading, and palette of the depictions reveal the hand of an accomplished master. Pinks and cool blues combine subtly in the delicate modeling of the Virgin's hands, lending her fingers a porcelain appearance; it is an effect similar to that achieved in the depictions of hands in the famed sculpture workshops of nearby Quito. The painter has taken a similar approach to passages like the Virgin's forehead and nose. Meanwhile, St. Joseph is depicted in earthier tones, and the robust, dark pink highlights give his hands a warmer, worn feel befitting the biblical carpenter. The ochres and dusty blues of his garments contrast successfully with the Virgin's attire, which is characterized by deep reds and a translucent blue glaze. Although it is not known where Stapleton acquired the pair, in all likelihood the two paintings were executed in the same workshop. If executed in Popayán, as seems likely, these canvases attest to the presence of a sophisticated painting workshop in a town historically better known for its silver and woodworking.

a.

6.
The Annunciation
Attributed to José Sánchez
(active Lima, from c. 1740)

Peru, second half of the 18th century
Oil on copper
15¼ x 12¾ in. (38.73 x 32.38 cm.); S-0059

The attribution of this small oil on copper to José Sánchez, a prominent painter in Lima of the mid-eighteenth century, is based on similarities to known works by the same painter in the Thoma collection (Chicago).[44] Not only did Sánchez sign other oval paintings on copper, but the sophisticated style and palette employed here suggest that the same hand is at work. Unfortunately, beyond this small group of paintings on copper, nothing is known of the painter's life.

While there is some paint loss in the Denver copper, notably in the lower edges and in the crimson cloth covering the Virgin's prie-dieu, the overall condition of the paint surface is excellent. Copper was a common support during the viceregal era in the Spanish Americas because the plates were easier to transport than bulky rolls of canvas, and they weathered difficult ocean crossings better than any type of woven fabric.

The present painting is characterized by a radiant palette and a general fussiness to the drapery, especially in the handling of the angel's gold robe and the Virgin's blue and red garments, which together bring a sense of movement and drama to the small devotional scene. The Virgin's heavy eyelids and ovoid features point to the persistence of Italo-Flemish influence brought to the New World by artists such as Bernardo Bitti and Mateo Pérez de Alesio (da Lecce in his native Italy) in the late sixteenth century (6a).

7.
Triptych of the Virgin of the Rosary of Chiquinquirá

Colombia, 18th century
Oil paint and gold on panel
11¼ x 25¾ in. (28.6 x 65.4 cm.) (open);
S-0088

This piece, which features the patroness of Colombia in its central panel (7a), was meant to serve as a portable altarpiece (7b). Chiquinquirá, Colombia's most important pilgrimage site, is located about sixty miles from Bogotá. Like Mexico's Basilica of Our Lady of Guadalupe, Chiquinquirá boasts a miraculous image dating from the sixteenth century whose devotion was spread far and wide through the proliferation of copies and reproductions. According to church doctrine, the original tempera on cotton was painted by Alonso de Narváez in 1556 and was badly damaged as a result of neglect. Upon its rediscovery, the painting was miraculously restored overnight, and from then on has enjoyed pride of place at the Basilica in Chiquinquirá. Copies and versions of the icon are found from Caracas on the eastern coast of New Granada to Quito and Lima.

a.

b.

c.

The central panel of this portable altarpiece reproduces the original composition, in which the Virgin of the Rosary is flanked by Saint Anthony of Padua and Saint Andrew. On the interior of the doors are depictions of Saint Jerome and Saint Francis of Assisi. The exterior of the closed triptych is decorated with the Virgin's monogram (7c), which echoes the design of the eighteenth-century gold frame that adorns the original miraculous image in the Basilica of Chiquinquirá, suggesting that this piece was made in the vicinity (or from a print source that included a depiction of the frame). Portable altarpieces such as this one were important in the viceregal era for the dissemination of both artistic and devotional trends. Missionaries could employ such objects in the evangelization of native populations outside the urban centers of Cartagena, Bogotá, or Quito. Daniel Stapleton must have appreciated the significance of an itinerant friar's ability to open such a triptych, thereby transforming a makeshift altar with a blaze of gold and images of saints like Jerome and Francis, both of whom spent time in meditation in wilderness settings. Stapleton's interest in this particular subject is confirmed by his acquisition of at least four paintings of the Virgin of Chiquinquirá, plus several books on her veneration, one of which includes a lavishly engraved frontispiece of the miraculous image, dated 1735, by Juan Pérez (fig. 7).[45]

Fig. 7. Juan Pérez, *Virgin of the Rosary of Chiquinquirá*. 1735. Engraving. Frontispiece in Fray Pedro de Tobar, *Verdadera historica relación del origen, manifestación, y prodigiosa revovación por si misma, y Milagros de la imagen de la Sacratissima Virgen María, Madre do Dios Nuestra Señora de el Rosario de Chiquinquirá*. Madrid, 1735.

8.
Mary, Mother of Jesus
St. Joseph

Quito, Ecuador, 18th century
Polychromed wood and gold
9 in. (22.9 cm), 9½ in. (24.1 cm.); S-0378, S-0373

This pair of figurines was originally the central part of a much larger Nativity scene, in which figures of shepherds, kings, farm animals, musicians, angels, and other merrymakers were assembled during the Advent season (on Christmas, a sculpted Christ Child would arrive to complete the *mise-en-scène*). Quito workshops specialized in this small-scale, highly detailed wood statuary, which incorporated a form of the Iberian technique of *estofado*. In Spain, this technique consisted of first covering the wood sculpture in gold leaf, then polychroming the piece with one or more layers of oil-based pigment.[46] The paint layer was then incised to reveal the gold beneath. In some cases, translucent pigments were also used over the layer of gold, giving the garments depicted a shimmering glow. Classic *estofado* was a costly technique, but one that was unparalleled for conveying the quality of silk and fine embroidery. In eighteenth-century Quito, workshops had developed a process, seen here and in the archangel figurine (see Cat. 10), which imitated the opulent technique by applying gold paint with a fine brush over the polychrome pigment layer.

In most Quiteño nativity scenes (known as *Belenes*, Bethlehems, or *nacimientos* in the Spanish Americas), the figures of the Virgin Mary and Saint Joseph were larger than the secondary characters in the theatrical assemblage.[47] Both figurines are missing hands, which would have been sculpted separately by a specialist and attached using pins or pegs. Nativities manufactured and displayed in Quito often included dozens of figures representing many of the regional ethnicities, social strata, local costumes, and professions that characterized late colonial society in Ecuador.

9.
St. Peter of Alcántara Penitent

Quito, Ecuador, 18th century
Polychromed wood
12 in. (30.5 cm.); S-0074

St. Peter of Alcántara was born in 1499 to an aristocratic family in the town of the same name in Extremadura (Spain). After his education at the University of Salamanca, Peter became a Franciscan reformer and traveled to Portugal in this role. After his return to Spain, he became confessor to St. Theresa of Ávila, who followed his reformist example in founding the order of Discalced Carmelites. Peter of Alcántara was an ascetic who practiced strict poverty and, like Theresa, often experienced ecstatic visions. Peter of Alcántara, whose legend states that he died on his knees in prayer in 1562, was canonized by pope Clement IX in 1669. In this depiction, Peter holds a human skull in his left hand and the implement of his self-abnegation, an iron scourge, in his right. The figure's torso displays the privations of penitence: flayed shoulders from self-flagellation, and ribs and sternum laid bare from repeated strikes with a rock. The sculpture captures the saint in a quiet moment while contemplating the temptations and ephemeral nature of worldly existence, with the skull as his *memento mori*. This brilliant small-scale figure echoes the life-size sculpture of the same subject in the Cantuña Chapel in Quito's church of San Francisco.[48] The Franciscan church in Quito also has a small polychromed wood example of the penitent saint that is close enough in style and scale to the Denver figure as to suggest that both were made in the same workshop.[49]

The bloody, naturalistic violence of the Stapleton figure is not unlike examples in wood sculpture of the penitent St. Jerome, which were common throughout the Spanish world (for example, that by Martínez Montañés in Santiponce outside Seville, and others in the Americas). While images of St. Peter of Alcántara are perhaps not as common as those of St. Jerome, the Franciscan became an important figure in the New World because of his Spanish origins, his reformist, ascetic character, and his close association with St. Theresa, whose Discalced Carmelites had an important presence in New Granada.

10.
Archangel with Tiara and Wings

Quito, Ecuador, 18th century
Polychromed wood, gold and silver
15½ in. (39.4 cm); S-0090

During the eighteenth century, Quito sculpture workshops reached an apex of both volume and quality of production. Contemporary sources record the high esteem in which Quiteño sculpture was held.[50] Sculpture in all sizes was produced in Quito; life-size figures adorn altar pieces such as that in the church of San Francisco (see especially the *Penitent St. Francis*), and small-scale pieces, like this one of a winged archangel, abound. Quito workshops were known, even in viceregal times, for their rigorous technical standards and naturalistic depiction of faces and hands (a technique known as *encarnación*). In order to heighten the realism of figures of all sizes, Quiteño artists often employed glass eyes, human hair, and lavish clothing. Their prolific use of gold is also characteristic and is based on the elaborate and sumptuous Spanish *estofado* process, in which the piece was first covered entirely in gold leaf, then polychromed, with details incised in the pigment layer to reveal the gold beneath. This object is an example of a highly effective but less costly process which became especially prevalent in eighteenth-century Quito in which the piece is covered in gesso, polychromed and details are added in gold paint.

Small sculptures such as this one were used in a number of ways. Intimate devotional shrines (*oratorios*) were common in wealthy households and convents and often included multiple figures for scenes such as Calvary or the Baptism of Christ. The elaborate, life-sized sculptural scene of the *Dormition of the Virgin* at the convent of Carmen Alto in Quito, which is composed of dozens of pieces of sculpture, furniture, silverwork, and paintings, includes two large angels also wearing silver tiaras, in poses similar to that of the figure in the Stapleton collection.[51] In addition, smaller-scale angels like this one were installed in Quito's renowned Nativity scenes, like the remarkable example at Carmen Bajo. This figurine exhibits not only the technical proficiency of Quito's wood sculpture workshops, but also the graceful movement and rich polychromy that made these objects so appealing throughout the Spanish Americas.

11.
Finial cross

Colombia, 17th century
Gold, emeralds, pearls
4 in. (10.2 cm.); S-0519

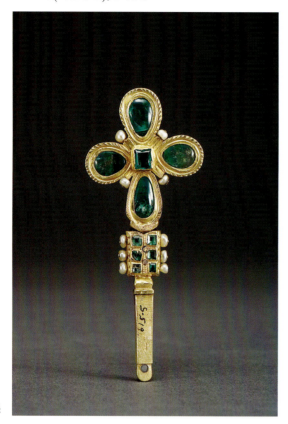

back

Fig. 8. Dagger. Colombia/Ecuador, c. 1650. Gold and emeralds. 2 ½ x ½ in. (6.35 x 1.27 cm.); S-0518.

While this piece is one of the smallest in the Stapleton Collection, it is also one of its centerpieces. The gold setting features eleven emeralds, four of which were cut using pre-Hispanic tools and techniques (the stones were polished again later before being inserted into their current gold setting). All the gems were likely mined in Colombia, and the central stone has been identified as coming from the renowned Muzo fields, where Stapleton's mining concern was located.[52] Muzo is still considered to yield the finest emeralds in the world, and during the viceregal era, Muzo stones were collected by Asian as well as European nobility and royalty. The cross also features ten baroque pearls, which have been identified as Venezuelan.

Crosses like this one often decorated the top of a monstrance or a crown, not unlike the Stapleton crown here (Cat. 12) or well-known examples from the Compañía de Jesus in Arequipa and the cathedral in Bogotá.[53] At the base of the finial cross is a housing and screw that would have been used to attach it to the four gathered cross-bands of the crown. From the cross's size, it was likely destined for a nearly life-size crown. Unfortunately, the vertical bands of the silver-gilt crown illustrated here have not survived intact, so it is impossible to know if the two objects ever fit together. While it seems most likely that this cross, like the silver-gilt crown and a miniature gold dagger also in the Stapleton collection (fig. 8), was most likely intended for a statue of the Virgin Mary, gem-encrusted crosses also adorned monstrances in some cases, such as the well-known example from the monastery of Santa Catalina in Quito.[54]

From Daniel Stapleton's letters, it is clear that this emerald and gold cross was a personal favorite of the collector. It nearly ended up with Archer Huntington at the Hispanic Society of America in New York, but Stapleton refused to sell it. Instead, he retrieved the cross from Huntington and presented it to his daughter, Stellita Stapleton Renchard, on her first birthday. Denver Art Museum curators discovered "Stellita's cross" in a secret drawer of one of Stapleton's desks only after the objects had entered the museum's collection in 1991.

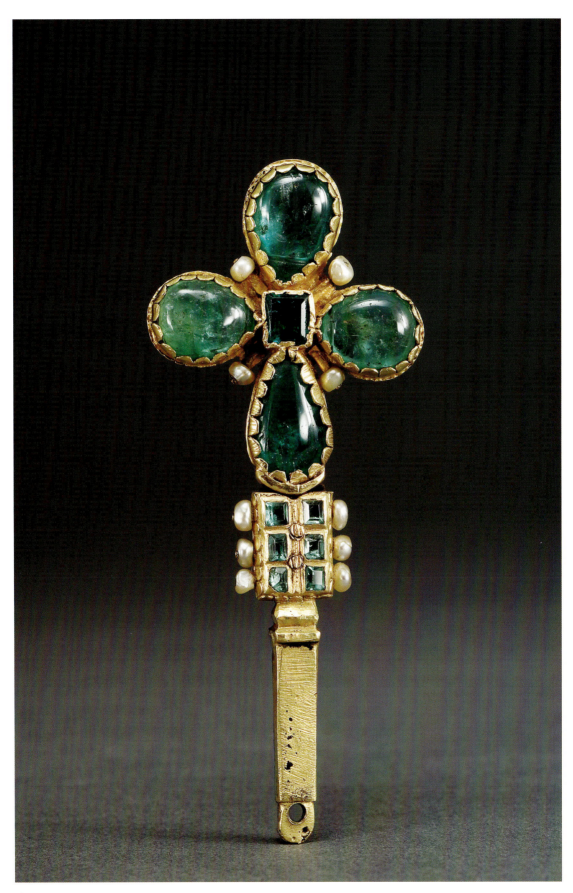

front

a.

12.
Crown

New Granada, 17th or early 18th century
Silver gilt, repoussé and chased
11 x 10½ in. (27.9 x 26.7 cm.); S-0163

Crowns such as this one were used to adorn statues of the Virgin Mary in churches and chapels throughout the Spanish world. The dimensions of this crown suggest that it was made for a life-size sculpture. Such objects were usually constructed using separate cross-bands for the upper section of the crown, which were often fixed in the center by a cruciform finial (Cat. 11). The broad, recessed band along the base of the crown originally would have housed precious stones and gems.[55] This crown's repoussé decoration features flowering vines and grapes which, along with the missing gemstones, would have been appropriate motifs for a statue of the Virgin Mary or Jesus himself (12a).

The crown's openwork foliage and acanthus-leaf pattern is characterized by intricate yet solid craftsmanship, a balanced composition, and an overall symmetry of design. Some of the finer details, like the grapes and venation of the leaves, are achieved through the technique of chasing (hammering from the front of the piece). The style of the crown's decoration suggests that the piece was made before the fashion for asymmetrical foliage, delicate rocaille, and ornate c-scrolls emerged during the eighteenth-century.[56]

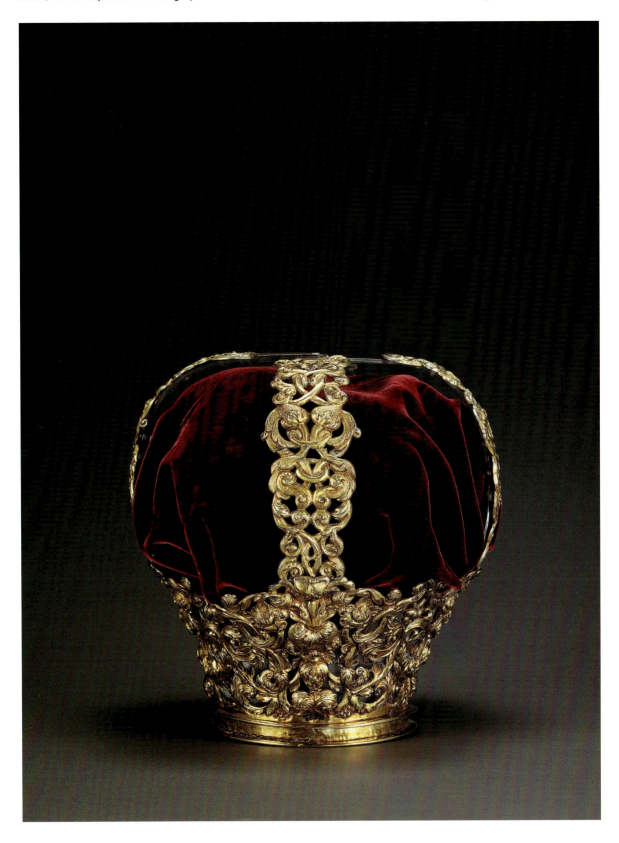

13.
Missal cover

Bolivia, 18th century
Silver, repoussé and chased, and velvet
13¾ x 9 x 2½ in. (34.9 x 22.9 x 6.3 cm.);
S-0278

a.

b.

As Stapleton records in a letter of 1913, he acquired six missal covers from the Carmelites and St. Clares in Quito (see also Cat. 14).[57] Five of Stapleton's silver book covers reside in the Denver Art Museum, though we do not know if this piece was one of the six he purchased in Quito. It is clear from several of his letters that Stapleton acquired antique books and related objects in Bogotá and other places during his travels. The decoration of the present silver piece suggests that it was not made in Quito or Bogotá, but in Bolivia. The central medallion on both recto and verso of the cover features a lion rampant in chased and repoussé silver (13a). In each corner is a square plaque, also in hand-wrought silver, showing a basket of flowers flanked by a pair of long-beaked birds, which appear to be pollinating hummingbirds (13b). The flowing, four-feathered tails of the birds are commonly found in Bolivian silverwork of this period.[58]

Because this silver and red velvet book cover bears no religious imagery or decoration, it may have been made to house something other than a liturgical text—perhaps a document like the Stapleton Codex, which was lavishly illustrated but secular in nature. This is not outside the realm of possibility, given the two objects' shared Bolivian origins. The manuscript (Cat. 1), which was first discovered within one of Stapleton's silver book covers only after the objects had entered the Denver Art Museum, was probably executed in Spain at the end of the sixteenth century for a patron in Potosí (Bolivia) named Francisco Quintano de Villalobos.[59] It is possible that several generations later, Quintano's heirs had the silver-adorned binding crafted to house the Codex in order to preserve the heirloom for posterity. As Stapleton does not record visiting Bolivia, we can only speculate how the manuscript and this handsome silver missal cover eventually found their way into Stapleton's sphere by the early twentieth century.

a.

14.
Plaque from Santa Clara convent

Ecuador, 18th century
Silver, repoussé, chased and incised
9 x 7 in. (22.9 x 17.8 cm); S-0262

In a letter of July 7, 1913, Daniel Stapleton recounts to his fiancée, "Dear Stella, I went broke in Quito on old hand wrought silver. I secured over three thousand ounces by permission of the Archbishop. The St. Clares and two Carmelite convents offered me their old silver and I just cleaned them out....They all fear if they have another revolution everything will be taken from them. I got some rare old candlesticks...six missal covers, crowns, diadems, indeed all sorts of things; really very little of practical domestic use or service."

This plaque, like many of the metalwork objects Stapleton collected in South America including the wings and tiara in the archangel figurine (Cat. 10), is decorated using the repoussé technique, in which the main forms are hammered from the reverse. Smaller details are often chased (the opposite of repoussé) using a smaller tool from the front. During these complementary processes, which exploit the malleability of softer metals like silver and gold, no material is lost.

This plaque is one of more than a dozen that Stapleton acquired. All are similar in shape, with slight variations in size and technique, and each is inscribed "Soi [soy] de Santa Clara (I am of St. Clare)" (14a). The incised inscription is encircled by a framing decoration of hearts, flames, and floral patterns. Such plaques, often called *mayas* in South America, adorned convent cell doors and nuns' trunks, and also were originally mounted on wood armatures for use as candle reflectors on altars.[60]

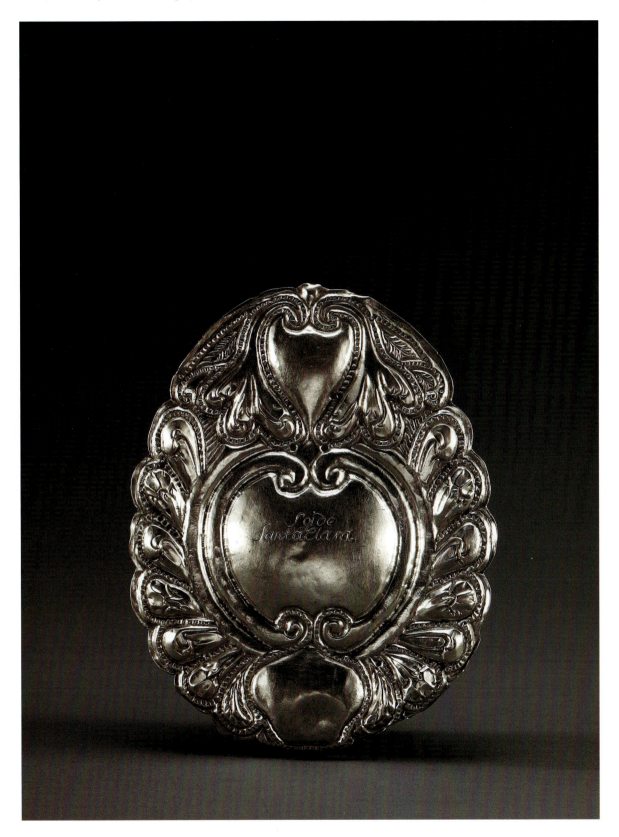

15.
Arm chair (*frailero* type)

New Granada, 17th or 18th century
Wood, embossed and polychromed leather
43 x 28 in. (109.2 x 71.1 cm.); S-0005

This type of chair has its origins in Renaissance Spain and is found throughout the New World colonies, including South America and New Mexico. The type is misleadingly known as a *sillón de frailero*, or friar's chair, a popular term that emerged in the nineteenth century among antique dealers. Although the term suggests monastic origins, this type of chair (a master's chair) was found in aristocratic homes as well as convents and other institutions throughout the Spanish empire.[61] These armchairs use mortise and tenon construction and are characterized by a wide stretcher (known as a *chambrana* in Spain),

carved in most cases, set high in the front of a rectangular chair frame.[62] The decoration of the embossed leather (a technique originating in the Muslim world) stretched to form the back and seat of the chair earned such chairs the label "Granada style," from the leather workshops of Andalucía (15a). These armchairs could also be upholstered in fringed velvet or fine silk. In this example, which may date from as early as the late seventeenth century, a scene of the penitent Mary Magdalene is embossed and painted on the leather back. The depiction once again echoes Dürer's *Melencolia*, the pose of which had become synonymous with contemplative remorse and atonement (Cat. 4). While we do not know exactly where Stapleton acquired this piece of furniture, similar examples are known throughout Ecuador and Colombia.

a.

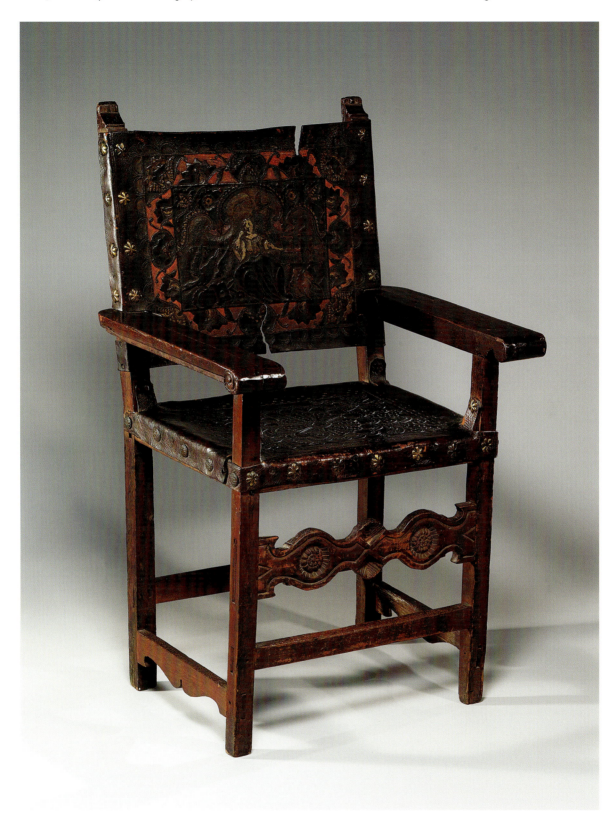

a.

16.
Chair

Probably Colombia, 18th century
Polychromed wood, gesso, gold leaf, velvet
upholstery
46 x 28 in. (116.8 x 71.1 cm.); S-0001

This chair, which was likely a product from a work-
shop in an Andean center like Bogotá, is a lavish
example of the furniture arts of New Granada (see
also fig. 3). The velvet upholstery, though probably
not original, appears to have been made from a litur-
gical vestment (16b). The claw-and-ball feet, which
suggest a late eighteenth-century date, adorn only the
front legs of the chair (16a). This chair appears to
be missing its rear feet; similar examples of this type
show feet swept backwards in a gentle volute, which
would have raised the back of the seat slightly. While
this ornate, armless variety is usually referred to as a
"bishop's chair," that label is misleading because this
type was also found in wealthy private residences in
Europe and the Americas, such as the extant examples
in the Casa del Marqués de San Jorge, in Bogotá.[63]
In her bookplate, Stellita Stapleton is shown seated
in this chair as a child, surrounded by many of the
objects her father collected in South America (fig. 3).

b.

17.
Chest with drawers and mirror

Colombia, 18th century
Polychromed wood, *barniz de pasto*, silver leaf, glass, bone
7½ x 13½ x 11½ in. (19.1 x 34.3 x 29.2 cm.); S-0025

This small chest would have been used for storing jewelry, pocket watches, and other precious items or heirlooms. The chest's colorful decoration is known as *barniz de pasto* (literally "varnish of Pasto"), an indigenous, lacquer-like technique, named after the original production center in San Juan de Pasto in southern Colombia (later, however, workshops in both Popayán and Bogotá began to produce similar material). In the *barniz de pasto* technique, the gum of the Andean mopa-mopa shrub is prepared (often chewed) to create a resin varnish (often with pig-

ment added) for the wooden surfaces of household wares or pieces of furniture. In pre-Hispanic times, the technique was used by the Inca for the pictorial decoration of ceremonial *quero* (kero) cups.[64] In the most lavish examples of the technique, like this domestic chest, polychromed silver leaf is used in tandem with the resin varnish and low relief detailing.

Here, the exterior of the lid features depictions of pomegranate flowers, grapes, jaguars, pumas, and the two-headed eagle that is commonly found throughout the visual culture of northern South America. Colorful birds with arrangements of fruit and flowers adorn the exterior sides of the chest, and similar decoration continues on the interior. On the inside of the lid is affixed a small mirror in a marbled frame of reverse painted glass. Such boxes or small chests were luxury items enjoyed by both female and male members of the elite of the viceroyalties of New Granada and Peru.

18.
Lap desk

Ecuador, late 18th century
Wood, hardwood inlay, silver
8 x 23½ x 17½ in. (20.3 x 59.7 x 44.5 cm.);
S-0049

This portable piece of furniture, with its ornate hardwood marquetry embellishments of flora, fauna, and architectural vistas, is similar to examples produced by a Quito cabinetry workshop.[65] Known as *escritorios* (writer's chests), such boxes were used for the storage of paper, pens, ink, and other writing paraphernalia during the viceregal period. The exterior of the lid features a cityscape vista within a floral frame; the interior of the lid is decorated with two vases full of flowers, with several animals including a llama, a lion, and two dogs. There are three interior drawers, which also feature architectural views.

The technique of marquetry was first introduced to Spain from the Muslim world during the Middle Ages and has flourished there, especially in southern Spain, until the present day. The technique became prevalent throughout the Spanish Americas with significant centers of production in Puebla and Oaxaca in Mexico and Peru and Quito in South America.

In this object, the marquetry scenes are particular to Ecuador and some of the animals depicted have held local significance since Inca times. For instance, parrots populate the exterior, while the silver keyhole is flanked by a pair of coati, the mischievous raccoon-like mammal common in South and Central America.[66] On the back, two more parrots sit atop floral arrangements while a pair of toucans poses in the corners. Cityscapes are common in the some of the finest marquetry furniture of Quito, and in some cases the buildings can be identified. Here, the panel on the drawer on the left depicts two white towers flanking a dome in what appears to be a representation of the cathedral of Quito (18a).

a.

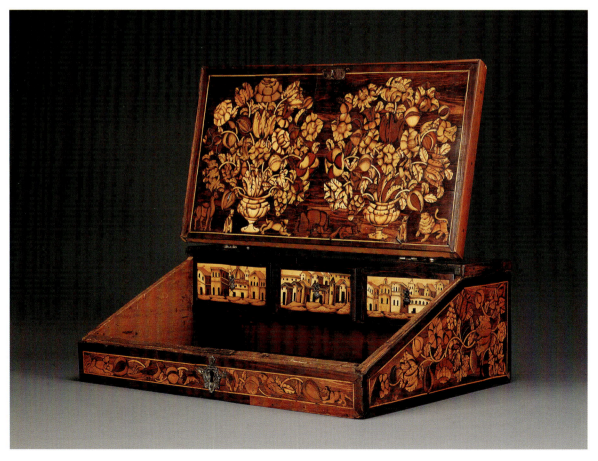

19.
Desk

Ecuador or Colombia, 18th and 19th century
Wood with ivory, bone and shell inlay
84 x 46½ x 35½ in. (213.4 x 118.1 x 90.2 cm.);
S-0027

From the toes of its claw feet to its crowning pediment (originally topped with a miniature balustrade), this extraordinary piece of furniture measures approximately seven feet in height. After its sheer size, the most remarkable characteristic is the profusion of tortoiseshell, bone, and ivory inlay (as well as some hardwood marquetry). Divided into three detachable tiers (presumably for ease of transport), this monumental writing desk is designed along the lines of a church retablo. Indeed, the three central ivory plaques, incised in black ink, represent (from top to bottom) St. Michael Archangel in Victory, the Virgin of the Rosary (Pomata?) (19a), and the Virgin of the Immaculate Conception (19b). The latter is set in an archway between two Doric pilasters surrounded by tortoiseshell inlay, crowned by the dove of the Holy Spirit and a pair of putti in the transom of the arch, which is flanked by two censing angels in the ivory spandrels. Extending from the beak of the dove is a small doorknob, which allows the entire panel to be opened to reveal a deep interior chamber. In total, the desk's exterior has over thirty such compartments and drawers. The numerous smaller bone panels are also decorated in black and feature depictions of animals, foliage, agricultural seasons, and angels.

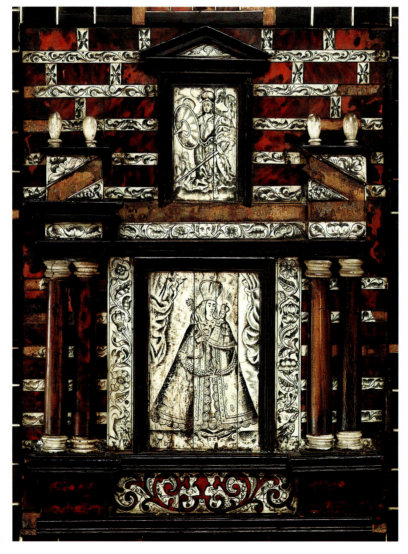

a.

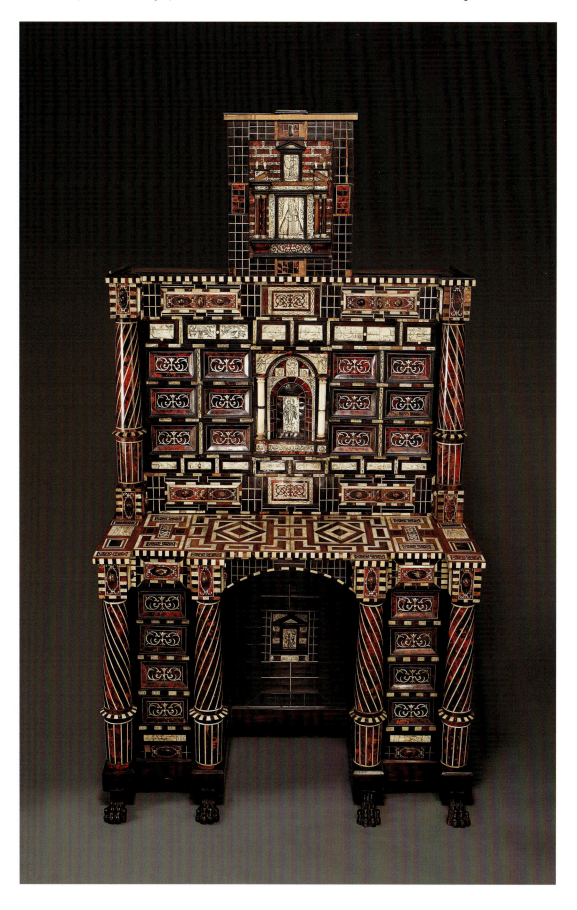

The elaborate nature of the desk, with its profusion of architectural elements, costly materials, and jumble of different decorative styles, suggests that it may have been crafted as a *capricho* (something of a cabinet-maker's flight of fancy) for a particular patron during the nineteenth century out of mostly viceregal-era materials. The Virgin of the Immaculate Conception ivory has been cut down on its left side, and consequently fits its space but in a slightly off-center disposition. Likewise, the other principal ivories, as well as the many peripheral panels, appear to be spolia from earlier pieces. The artist(s) of the ivory decoration appear to have adapted their designs from northern and Spanish prints. On the underside of several of the drawers, the desk bears a stamp identifying the cabinet-maker as Gregorio Cruz. While the historical details of this creative craftsman remain obscure, he appears to have worked at the end of the nineteenth and early twentieth century re-fitting colonial pieces into his whimsical, but solidly constructed designs. Acquired in Bogotá in 1913, this is one of several pieces from Cruz's workshop in Stapleton's collection. Perhaps astonished that it required three separate crates for shipment to Omaha, Stapleton saw fit to alert Stella to the desk's imminent arrival in two letters.[67]

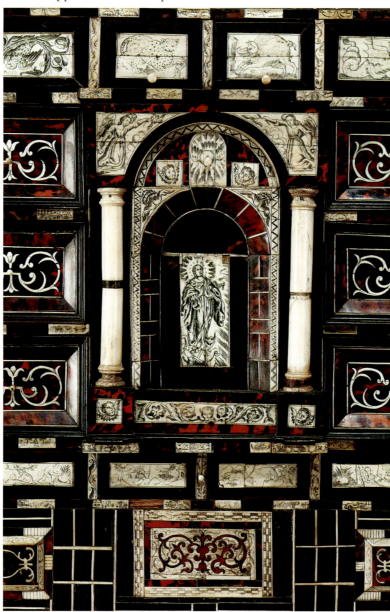

b.

Notes

* I wish to thank Dr. Donna Pierce for her scholarly and editorial guidance on this project. I owe a debt of gratitude also to Julie Wilson Frick and Patricia Tomlinson. And to Mr. and Mrs. Frederick Mayer, whose support has allowed this project and many others, my thanks. Several Stapleton paintings were treated in 2003 with funding from the IMLS.

[1] Stellita Stapleton Renchard's four children (Daniel Stapleton's grandchildren) formed the board of directors of the Stapleton Foundation.

[2] The one exception is the magnificent Stapleton Codex, which was published by the Denver Art Museum's Anne Tennant in 1997. See Anne W. Tennant, "The Illumination of an Hidalgo," *Américas* 49 (May/June 1997): 6–13. I owe my gratitude to Anne for her invaluable input for this paper.

[3] The region was administered by Spain under the Viceroyalty of Peru until 1717, when northern South America was formally reorganized as the Viceroyalty of Nueva Granada (with Bogotá as its capital).

[4] The details remain murky regarding Stapleton's involvement in the Yale expedition led by Hiram Bingham. While he may have known of the existence of ruins, there is no evidence to support the claims that he assisted in Bingham's discovery.

[5] Although Stapleton returned to the United States after his marriage in 1914, he would return to the region several times before his death to tend to business matters and diplomatic negotiations.

[6] Stella Hamilton Stapleton, ed., *Daniel Casey Stapleton: Pioneer, Patriot, Christian-Knight* (Washington, DC: Leonard Wilson Press, 1922). This volume is a privately published collection of correspondence, photographs, and other articles assembled by Ms. Hamilton Stapleton for her daughter following Dan Stapleton's death. The original resides with Stapleton's heirs; facsimile editions are kept at the Denver Art Museum and the courthouse library in Stapleton, NE. All further references to letters can be found in this volume or the Stapleton archives at the Denver Art Museum. See also Stellita Renchard, "Daniel Casey Stapleton (1858–1920)," in *Colonial Art of Ecuador: Selections from the Collection of the Stapleton Foundation of Latin American Art, Inc.* (Washington, DC: Museum of Modern Art of Latin America, 1982), n.p.; and Anne W. Tennant, "Family Jewels, Part II: The Stapleton Foundation of Latin American Colonial Art, Made Possible by the Renchard Family," in *News from the Center* (newsletter of the Center for Latin American Art and Archaeology and the Alianza de las Artes Américanas, Denver Art Museum), June 2001, 8–10.

[7] By today's standards, Stapleton's death would be considered premature. However, Stapleton's career and livelihood relied to a large extent on his health and ability to endure the hardships of South American travel. According to a statement signed by his physicians, Stapleton died of complications from "cirrhosis of the liver." Stapleton may have contracted Hepatitis B, which remains the leading cause of cirrhosis and was then common on ocean liners and in ports, particularly in equatorial South America. In one letter, Stapleton mentions his quarantine in Panama. The implication from the body of correspondence left by Stapleton and his closest acquaintances is that the privations of his travels in South America were the cause of his chronic liver disease and ultimate death. The diagnosis was signed by Stapleton's physicians, Drs. Charles C. Marbury and Roy D. Adams, on February 24, 1920. See Hamilton Stapleton 1922, 26–27 and 61.

[8] After Simón Bolívar's defeat of Spain, Nueva Granada became known as the Republic of Gran Colombia, with Bolívar as its first president in 1819. Gran Colombia comprised parts of what are now ten different countries, including Ecuador, Colombia, Venezuela, Panama, and Brazil. Three administrative capitals were established at Quito, Bogotá, and Caracas. Bolívar's short-lived republic dissolved in 1831.

[9] Stapleton would later own a controlling interest (along with an English friend, Stuart Coats) in the Playa de Oro lands. See Hamilton Stapleton 1922, 225 (letter from Coats to George E. Hamilton).

[10] Stella Marie Margrete Hamilton was born in Omaha, Nebraska, July 6, 1871, and died at Washington, DC December 11, 1965.

[11] Stapleton to Stella Hamilton, March 19, 1913, from Bogotá, Colombia.

[12] Stapleton to Stella Hamilton, January 10, 1911, from Holland House, New York City.

[13] This account, as retold by Stellita Stapleton Renchard, appears in Renchard 1982.

[14] O'Neill to Stellita 1922, 70. In his memorial letter to young Stellita, Major O'Neill states that it was his "privilege to introduce him to your mother

and to observe the progress of the courtship that resulted in their happy union."

[15] I owe a debt of gratitude to the Brosius family, Mary Keslar, and the residents of Stapleton, NE, for welcoming me to the beautiful St. John's Catholic Church and generously allowing me access to documents at the Logan County courthouse library. Constructed with funds from D. C. Stapleton, St. John's has survived intact to this day.

[16] Stella Hamilton founded the Omaha chapter of the National Christ Child Foundation, a Catholic children's charity, in 1906. Stapleton was also involved with the archdiocese of Omaha, which began construction on its Spanish Renaissance Revival Cathedral of St. Cecilia in 1905.

[17] Stapleton to Stella Hamilton, August 4, 1911, from Panama.

[18] The earliest extant letter mentioning Stapleton's desire to marry Hamilton dates from January 1911. Stapleton to Stella Hamilton, January 10, 1911, from Holland House, New York City.

[19] Here I borrow from A. C. Veatch, *Quito to Bogotá* (London, 1917). The book includes lengthy descriptions of the 1913 voyage undertaken by the author and Lord Murray of Elibank, Stapleton's close friend and lifelong correspondent.

[20] Letter from Buenaventura, July 2, 1911; also, Letters, November 13, 1912, from Holland House, New York City.

[21] Stapleton to Stella Hamilton, December 1, 1912.

[22] Stapleton to Stella Hamilton, December 3, 1912.

[23] All quotations in the following paragraph are from Letters, July 2, 1911, from Buenaventura, Colombia, and August 4, 1911, from Panama City, Panama.

[24] While the wording of the letter is not conclusive, Stapleton's letter implies that he took an interest in this mission and that he may have provided it with needed assistance.

[25] December 13, 1912, from Bogotá. Stapleton undoubtedly contributed to this project.

[26] Dorothy McCardle, "How Is a Home Selected for Washington Guests," *The Blade (Toledo, OH)*, September 2, 1963.

[27] "Mgr. Montagnini Dead," New York Times, October 26, 1913. Montagnini was arrested by French authorities and escorted to the Italian border during an anti-ecclesiastical conflagration between the Republic of France and the Vatican. See also Joseph C. Sasia, *The True View of the Present Persecu-tion in France: An Appeal to the Unbiased Judgment of the American People* (San Francisco, CA.: Archdiocese of San Francisco, 1907), 10.

[28] Stapleton to Stella Hamilton, April 24, 1918, from Havana, Cuba.

[29] See Hamilton Stapleton 1922, Foreword by Ambassador Maurice Francis Egan, 7–9. Egan details how he and Stapleton were working with the president of Ecuador to negotiate a peaceful transfer of the Galapagos to the United States.

[30] From a handwritten note to Richard Ahlborn of the Smithsonian Institute, July 1979, National Museum of American History archives. My thanks to curator Steven Velasquez for his help in reviewing the Stapleton objects and files at the NMAH. For the Codman-Davis House, which received landmark status from the National Register of Historic Places October 11, 1979, see http://pdfhost.focus. nps.gov/docs/NRHP/Text/79003100.pdf.

[31] Letters, Stapleton to Stella Hamilton, October–November 1912.

[32] A translation from the Latin of the original document to English, by Henry J. Shandelle of Georgetown University, is included in the foreword of the memorial volume. The original is signed by the Holy See's Secretary of State Cardinal Merry del Val y Zulueta.

[33] For Gómez, see Juana Hidalgo Ogayar, "Diego Gómez, pintor-iluminador del siglo XVII," in *Velázquez y el arte de su tiempo: V Jornadas de Arte*, (Madrid: Departamento de Historia del Arte Diego Velazquez, Centro de Estudios Historicos, Editorial Alpuerto, 1991), 239–246.

[34] See Tennant 1997, 6–13. The violin-shaped rubric also appears in a manuscript dated 1568 made in Andalucía, Spain, now in the collection of the Hispanic Society of America.

[35] Such workshops were often family affairs at the time; Gregorio's daughter, Feliciana (b. 1675) was also trained at her father's side in the art of painting.

[36] For the Sagrario panel, see F. Gil Tovar, *La obra de Gregorio Vásquez* (Bogotá: Carlos Valencia Editores and Museo de Arte Moderna, 1980), 84–85.

[37] See F. Gil Tovar, *Dibujos* (Bogotá: Dirección de Información y Propaganda del Estado, 1955) and Roberto Pizano Restrepo, *Gregorio Vásquez de Arce y Ceballos* (Bogotá: Editorial Siglo XVI, 1985); see also Luisa Elena Alcalá's cogent entries in *Los Siglos de Oro en los Virreinatos de América: 1550–1700* (Ma-

drid: Museo de América, 1999), 326–332.

[38] As of 1968, the Sassoferrato copy was in a Bogotá private collection. See Carlos Arbelaez Camacho and F. Gil Tovar, *El arte colonial en Colombia* (Bogotá: Ed. Sol y Luna, 1968) 160–161.

[39] The drawing, Pizano Restrepo D-13, measures 42 x 31cm and is in the Museo de Arte Colonial, Bogotá.

[40] Pizano Restrepo 1985, 282. Only C-36 (Capilla del Sagrario, Bogotá) supports a plausible attribution to the master; the others remain, for now, under the "workshop" rubric.

[41] A notable exception would be the painting by Cornelis de Beer (Dutch, active Spain 1630–1640) of the subject in the Seville Cathedral, in which the Magdalene is surrounded by what may be described as a modest display of riches. Apart from the de Beer, Valdivieso and Serrera count only four paintings of the subject in Seville, far fewer than those of many other saints.

[42] For the use of chapbooks, see Pamela M. Jones, "Female Saints in Early Modern Italian Chapbooks, ca. 1570–1670: Saint Catherine of Alexandria and Saint Catherine of Siena," in *From Rome to Eternity: Catholicism and the Arts in Italy, ca. 1550–1650*, ed. Pamela M. Jones and Thomas Worcester, 89–120 (Leiden, Boston, Köln: Brill, 2002).

[43] Quintero Guzmán, Miguel Wenceslao, *Linajes del Cauca Grande: Fuentes para la Historia, vol. I* (Bogotá: Universidad de los Andes, Facultad de Ciencias Sociales, 2006), 1317.

[44] For a catalogue of the Thoma collection, see Suzanne L. Stratton-Pruitt, *The Virgin, Saints and Angels: South American Paintings 1600–1825 from the Thoma Collection* (Stanford: Skira and Cantor Center for Visual Arts, 2006). Other works by Sánchez are discussed on pp. 108–109.

[45] Apart from the present triptych, there are two other small paintings of the subject at the Denver Art Museum, and one additional one in the collection of the National Museum of American History (Smithsonian Institute). The books acquired by Stapleton include the following: P. Fr. A. Mesanza, OP, *Nuestra Señora de Chiquinquirá, y monografía histórica de esta villa* (Bogotá: Imprenta Eléctrica, 1913); and Fr. Pedro de Tobar, *Verdadera historica relación del origen, manifestación, y prodigiosa revocación por si misma, y Milagros de la imagen de la Sacratissima Virgen María, Madre do Dios Nuestra Señora de el Rosario de Chiquinquirá* (Madrid: Antonio Marín, 1735).

[46] See Marjorie Trusted, "Exotic Devotion: Sculpture in Viceregal America and Brazil, 1520–1820," in *The Arts in Latin America: 1492–1820*, ed. Joseph Rishel and Suzanne L. Stratton-Pruitt, especially pp. 251–253 (Philadelphia: Philadelphia Museum of Art, 2006).

[47] Gabrielle G. Palmer, *Sculpture in the Kingdom of Quito* (Albuquerque: University of New Mexico Press, 1987), 124.

[48] Orden Miracle, Ernesto la. *Elogio de Quito* (Bilbao: Ediciones Cultura Hispanica, 1950), plate 32.

[49] See Kennedy and Fajardo 1992, 32.

[50] See Alexandra Kennedy, "Baroque Art in the Audiencia de Quito," in *Barroco de la Nueva Granada: Colonial Art from Colombia and Ecuador*, ed. Alexandra Kennedy and Marta Fajardo de Rueda, 61–77 (New York: Americas Society, 1992).

[51] See José Gabriel Navarro, *La escultura en el Ecuador durante los siglos XVI, XVII y XVIII*, 2nd. ed. rev. (Quito: Fundación José Gabriel Navarro, 2006), 36; and Alexandra Kennedy, "Mujéres en los claustros: artístas, mecénas y coleccionistas," in *Arte de la Real Audiencia de Quito, siglos XVII–XIX: patronos, corporaciones y comunidades*, ed. Alexandra Kennedy, 118 (Madrid: Nerea, 2002).

[52] Object files, Denver Art Museum.

[53] See Cristina Esteras Martín, *Platería del Perú virreinal: 1535–1825* (Madrid and Lima: Grupo BBV and Banco Continental, 1997), cat. 28.

[54] See Kennedy 2002, 156. For the monstrance known as "La Preciosa" in Bogotá, see Kennedy and Fajardo 1992, 12.

[55] For a similar crown, which retains its gemstone encrustation, see the example from the Arzobispado de Arequipa in Phipps et al. 2004, cat. 85.

[56] Comparable styles of decoration are found in examples from about 1675–1725 in Cuzco, Arequipa, and other centers of the Viceroyalty of Peru. See Esteras Martín 1997, cats. 20 and 28.

[57] See above entry for S-0262.

[58] Cristina Esteras Martín, 2002.

[59] Tennant 1997, 12.

[60] See entries 97a and 97b in Elena Phipps, Johanna Hecht, and Cristina Esteras Martín, *The Colonial Andes: Tapestries and Silverwork 1530–1830* (New Haven and London: Yale University Press and the Metropolitan Museum of Art, 2004).

[61] Gil Tovar 1977, 897; and Sara Bomchil and Virginia Carreño, *El mueble colonial de las Américas y su circunstancia histórica* (Buenos Aires: Editorial

Sudamérica, 1987), 232.

[62] See Donna L. Pierce, "New Mexican Furniture and Its Spanish and Mexican Prototypes," in *The American Craftsman and the European Tradition: 1620–1820,* ed. Francis J. Puig and Michael Conforti, 185 and 198–199 (Hanover and London: University Press of New England and The Minneapolis Institute of Art, 1989).

[63] See F. Gil Tovar, "La Casa Colonial," in *Historia del Arte Colombiano*, vol. 4 (Barcelona and Bogotá: Salvat, 1977), 889.

[64] See Thomas Cummins, "Images for a New World," in *The Virgin, Saints, and Angels: South American Paintings 1600–1825 from the Thoma Collection*, ed. Suzanne Sttratton-Pruitt, 13–14 (Stanford: Iris & B. Gerald Cantor Center for Visual Arts at Stanford University, 2006). An excellent, concise discussion of the technique is found in Mitchell A. Codding, "The Decorative Arts in Latin America, 1492–1820," in Rishel and Stratton-Pruit 2006, 98–113.

[65] See Jorge Rivas's entry in Rishel and Stratton-Pruitt 2006, 506.

[66] My thanks to Margaret Young-Sánchez for her help in identifying these species.

[67] Hamilton Stapleton 1922, 160 and 168.